How to Do Everything
Digital Camera

Fifth Edition

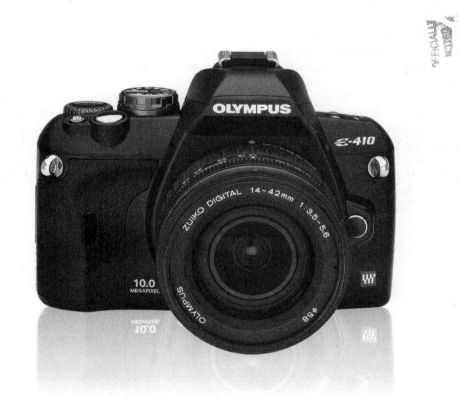

About the Author

Dave Johnson writes about technology from Seattle, Washington. He writes a weekly e-newsletter on digital photography for *PC World* magazine and is the author of three dozen books that include *Robot Invasion: 7 Cool and Easy Robot Projects, How to Do Everything with MP3 and Digital Music,* and *How to Do Everything with Your Palm Handheld* (the latter two with Rick Broida). His short story for early readers, *The Wild Cookie,* has been transformed into an interactive storybook on CD-ROM. Dave is a wildlife photographer and plays drums in The Batch 10, a band best known for its punctuality.

Dave started writing professionally in 1990, before anyone had a chance to talk him out of it. Prior to that, he had a somewhat unfocused career that included flying satellites, driving an icecream truck, loading bombs onto B-52s in a remote region of Michigan, stocking shelves in a Jersey City grocery store, teaching rocket science, photographing rock bands, and writing about interstellar penguins.

About the Technical Editor

Bill Bruns is the webmaster for the Student Center at Southern Illinois University Carbondale (www.siucstudentcenter.org) and also serves in a volunteer capacity as Chapter Advisor for the Beta Chi Chapter of Tau Kappa Epsilon (www.tkebx.org). He has been involved in computing since 1988, holding faculty and administrative positions at New York University, the University of Illinois, and SIUC. For over 10 years, he has been a technical editor, working on more than 125 books related to the Internet, web servers, HTML, multimedia, and office applications. Bill holds bachelor's degrees in Telecommunications and English Literature from Indiana University and a Masters of Public Administration from New York University. Bill, his wife Debbie, daughter Marlie, son Will, and two bearded dragons live on the edge of the Shawnee National Forest in Carbondale, Illinois.

How to Do Everything
Digital Camera

Fifth Edition

Dave Johnson

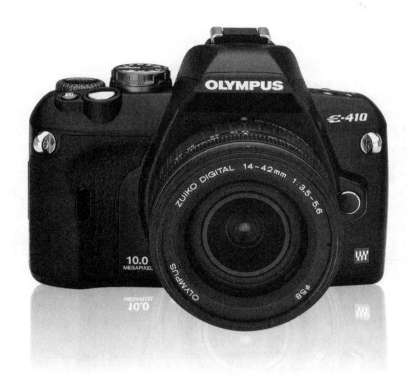

New York Chicago San Francisco Lisbon
London Madrid Mexico City Milan New Delhi
San Juan Seoul Singapore Sydney Toronto

The *McGraw·Hill* Companies

Cataloging-in-Publication Data is on file with the Library of Congress

McGraw-Hill books are available at special quantity discounts to use as premiums and sales promotions, or for use in corporate training programs. To contact a representative, please visit the Contact Us pages at www.mhprofessional.com.

How to Do Everything: Digital Camera, Fifth Edition

1234567890 FGR FGR 0198

ISBN 978-0-07-149580-6
MHID 0-07-149580-0

Sponsoring Editor
Megg Morin

Editorial Supervisor
Jody McKenzie

Project Manager
Samik Roy Chowdhury,
International Typesetting
and Composition

Acquisitions Coordinator
Carly Stapleton

Technical Editor
Bill Bruns

Copy Editor
Sally Engelfried

Proofreader
Megha Roy Chowdhury

Indexer
Broccoli Information
Management

Production Supervisor
James Kussow

Composition
International Typesetting
and Composition

Illustration
International Typesetting
and Composition

Art Director, Cover
Jeff Weeks

Cover Designer
Jeff Weeks

For Newt
1987–2000

Contents at a Glance

Contents

Acknowledgments

Thanks to all the great folks at McGraw-Hill who are always fun to work with—especially folks like Megg Morin and Carly Stapleton. I'd also be remiss not to thank Kristin Hersh, Bob Mould, Jack White, and Peter Himmelman—because their music, as usual, was the soundtrack that played through months and months of writing, editing, and photography. Finally, let me thank all the selfless models who posed for me as I shot picture after picture for this book—including Kris, Evan, and Marin.

Introduction

Welcome to *How to Do Everything: Digital Camera, Fifth Edition.* This is not your typical book on digital photography—I wrote this book with the intention of answering all the questions I had about digital cameras and photography techniques when I was starting out, and then slipping this back in time through a wormhole. I never found the wormhole, but I did write the book for today's fledgling digital photographers.

I've been taking pictures for over 20 years, and in that time I've read a lot of books and magazines about the art and science of photography. It seems that this is a good time for a book that explains everything you could possibly need to know about digital photography in the space of a few hundred pages.

A tall order, I know.

Nonetheless, I know what it feels like to have a new digital camera and search fruitlessly for the answers to seemingly obvious questions. I've read too many books that make passing references to "control your depth of field with the aperture" without explaining what either the aperture or depth of field actually is. Or they mention that you need a lot of pixels to print an 8×10-inch picture without ever telling you how many pixels you actually need.

So when I wrote this book I mapped out all of the things I wondered about when digital cameras were new back in 1996 and when I was starting out as a film photographer in the 1980s. I went right to the beginning and decided to cover photography techniques like lighting, composition, and close-ups. And hopefully you'll find that the book walks you through the key steps of using a digital camera, from working with memory cards to file formats to editing images on a PC to printing and finally, to sharing your images.

The world of digital photography is changing fast. It's finally crawling out of its infancy, but it has a way to go before digital is as easy to use as a point-and-shoot film camera. But this is a great time to purchase and use a digital camera, and I hope that some of my enthusiasm for the digital medium comes through. I love the freedom and flexibility that a digital camera gives me; armed with my Nikon D200 or Canon Powershot G7, I can take pictures without worrying about buying film. I can instantly preview my work and download just the images I want to keep. And I particularly like the fact that I can print 8×10- or 13×19-inch enlargements exactly the way I want without trying to convey imprecise instructions to some tech in a photo shop. I even use a digital camera underwater when scuba diving, and that, too, is a whole new and exciting world of photography that is made dramatically easier by digital cameras.

I wrote this book so that you could sit down and read it through like a novel if you'd like to—but I realize few people will actually do that. If you're looking for specific information, I've organized the book so topics should be easy to find. Part I kicks things off with the basics of using your camera. I begin by explaining how to shop for a digital camera and how to operate the most common controls on digital cameras. From there, I delve into stuff you need to know no matter what kind of camera you have—stuff like composition, lighting, close-ups, and how to take advantage of the special features on your camera.

Part II of the book is all about getting the images from the camera into your PC. I talk about how to use file formats like JPG, TIF, and RAW, and how to care for the memory cards that come with your camera.

I'm guessing that most of you will be keenly interested in Part III—at least that's one of the most exciting parts for me. This is where you can learn how to edit digital images as if your PC were a sort of digital darkroom. Sure, there are simple techniques in here like how to crop and resize images, but I also write about cool special effects—making panoramas, super-saturated high dynamic range photos, and even creating Hollywood-style "bluescreen" effects.

Finally, the book ends with Part IV, a few chapters that explain how to print and share your photos. I tell you exactly what you need to know to get great results—like optimizing your printer, using the right paper, and calculating how large you can print your image based on how many pixels it has. And then you can learn how to share your images—on the computer screen, in e-mail, on the Web, and more.

To help you along, you can find special elements to help you get the most out of the book:

- **How-To** These special boxes explain, in a nutshell, how to accomplish key tasks throughout the book. You can read the How-To box for a summary of what the chapter at-large is explaining.

- **Notes** These provide extra information that is handy for trivia contests but isn't essential to understanding the current topic.

- **Tips** These tell you how to do something a better, faster, or smarter way.

- **Did You Know** These sidebars talk about related topics that are pretty darned interesting, but you can skip them if you prefer.

- Within the text, you'll also find words in special formatting. New terms are in italics, while specific phrases that you will see on the screen or need to type yourself appear in bold.

Want to e-mail me? You can send questions and comments to me at:

cameraquestions@davejoh.com.

My web site is located at davejoh.com, and there you'll find occasional posts with digital photos tips and techniques. You're welcome to visit there and check out other books or my photography anytime you like. I also write a free, weekly e-mail newsletter for *PC World* magazine called Digital Focus. You can subscribe to Digital Focus by visiting pcworld.com and clicking on the newsletters link. Each week I offer digital photo and editing tips, answer reader questions, and award prizes to reader-submitted photos. Join—it's a blast!

Thanks, and enjoy reading the book!

Part I

Your Camera

Chapter 1

Go Digital

How to...

- Navigate around your digital camera
- Distinguish between point-and-shoot and professional camera features
- Pick a camera resolution based on print size
- Conserve battery power
- Tell the difference between a digital and optical zoom
- Shop for a new digital camera
- Choose gear and accessories for a digicam

If you've recently purchased your first digital camera, congratulations! In some ways, it's not all that different than the film cameras we all used just a few years ago. In other ways, digital cameras are as alien as the spaceship that crashed at Roswell back in 1947. Digital cameras—and the PCs we use to edit our photos—can do all sorts of things that were utterly fantastical just a few years ago. And the technology just keeps getting better, more powerful, and easier to use all the time.

With a digital camera, it's possible to take photos and review them instantly—while they're still stored in the camera—to see if they turned out the way you like. From there, you can transfer them to a computer and easily crop them to size, adjust color and brightness, even perform special effects on them if you want to, and then print the final result to exactly the size you like for a frame in your living room. Then you can take the same picture and e-mail it, post it to a web site, display it on a TV, or show it to friends from your handheld organizer. The beauty of digital imaging is its immediacy and versatility—just try to do those things with an old film camera.

So if you've recently bought a digital camera, congratulations—you've made the right choice. In this chapter, we'll take a quick look at your camera and digital cameras in general. And if you're shopping for a new camera, flip to the end of this chapter, where I tell you what to look for when you head off to make your purchase.

A History Lesson

When I was a kid, my dad bought a darkroom kit so he could develop his own photographs. I clearly remember that box and how it sat, untouched, on top of a hall closet. For years. Why did my dad never get around to setting up his darkroom? In a nutshell, it was just too much trouble.

Darkrooms require, well, darkness. You have to have a room that you can dedicate to the task and trust that people won't come barging in while you're developing film (or hang their wet bathing suit in there when you're not watching).

And then there are the chemicals. Film processing is all about using nasty, toxic chemicals that, if you were running a business, would get the attention of OSHA. When I worked in the space launch business, I'm sure that some of the rocket fuels we used weren't as frightening

as the chemicals that home darkroomers routinely exposed themselves to. Who wants to muck around with that stuff?

Oh, yeah—and it isn't all that easy, either. Black-and-white processing isn't really brain surgery, but working with color film is tough. It's not a hobby you can master in a few weeks, to be sure. And the whole point of having your own darkroom is so you can get better results than the corner store delivers, right?

No wonder my dad never got too far with his darkroom kit.

These days, digital photography gives you the same flexibility as those old chemical darkrooms—the ability to brighten or darken an image, crop it down to generate a better composition, and print enlargements in a variety of sizes—but without the chemicals, without the steep learning curve, and without dedicating a part of your house to nothing but photography. And that's to say nothing of all the special effects you can easily master. You can digitally change colors, create photo composites, and more. So how did we get here?

A Slow Evolution

These days, some digital cameras can compete with the best 35mm Single Lens Reflex (SLR) cameras in terms of resolution and image quality. Obviously, it hasn't always been this way.

When you consider the first digital cameras that debuted in the early 1990s, it's a miracle that anyone used them at all. The first models you could buy for under a grand included the Logitech Fotoman, Kodak DC40, Apple QuickTake 100, and the Casio QV-10. They were strictly for gear-headed early adopters that bought them just to try out the nascent field of digital photography. They certainly weren't particularly useful, since they offered poor image quality, limited resolution, and substandard optics. Early digital cameras generated low-resolution images with a mere 376×240 pixels and, soon thereafter, 640×480 pixels—not even enough to fill a computer screen when your Windows Desktop was set to the lowest resolution. And that was if you could figure out how to get the images out of the camera and into your PC.

Early digital cameras typically had low quality plastic lenses, and the light sensor that captured the image was a component called a Complementary Metal Oxide Semiconductor (CMOS) chip. CMOS chips were popular because they were cheap and required very little power, but they created horribly fuzzy pictures. Charged Coupled Devices (CCDs) cost a small fortune in comparison, so CMOS chips found their way into many of the first cameras. See Figure 1-1 for an example of the difference between an image taken with a CMOS chip (on the left) and a CCD (on the right).

NOTE *CMOS has made a comeback—the technology has improved dramatically, and new cameras with CMOS chips work as well as CCDs and cost less to boot. Indeed, some of the best professional cameras on the market now include CMOS sensors instead of CCD sensors.*

In the early days, VGA resolution (640×480 pixels) established itself as the first real standard size for digital images. Digicams came equipped with sensors capable of capturing 640×480-pixel images, which was ideal for display on a computer screen, posting on web

FIGURE 1-1 The earliest digital cameras with CMOS sensors (left) typically offered poor image quality compared to those with CCDs (right).

pages, or e-mail, but you couldn't really make a useful print from such a picture. On a typical inkjet printer, you'd get a photograph that measured just three inches across.

Then came *megapixel*. *Mega* means million, and the term simply refers to the maximum number of pixels the camera can capture. A megapixel camera can create an image with a million pixels, for example, 1000×1000 or 860×1200 or any other pixel dimension that multiplies out to about a million dots of information (see Figure 1-2 for a graphic depiction of how a picture is composed of pixels). The first megapixel cameras raised the bar for everyone. Like owning last year's laptop with a slow processor, no one wanted to own a VGA camera. Then came two-megapixel cameras. Then three.

Today, go into any camera store and you'll find an array of cameras that capture anywhere from 4 to 10 megapixels. And it doesn't end there. Some high-end point-and-shoot and Digital SLR models take pictures with 12 million pixels and more. Why the fuss over pixels? Well, as I alluded to earlier, the more pixels you have, the sharper your image is, and consequently the larger it can be printed. If you'd like to print a digital photo at 8×10 or larger, for instance, a VGA or 1-megapixel camera simply won't cut it—each pixel would be the size of a postage stamp. Take a look at Figure 1-3. On the right is a detail from a picture taken at 640×480 pixels. On the left is the same detail, but it's cropped from a 3.3-megapixel image. As you can see, the smaller image has fewer pixels to work with, and that's why it looks so grainy. Obviously, you need lots of pixels to print pictures at a large size, and that's why each year we see ever larger-resolution digital cameras hitting store shelves.

Resolution: 16 × 14 = 244 pixels

| FIGURE 1-2 | The resolution of a digital camera, usually measured in megapixels, is just the total number of pixels in the photos it is capable of taking, like this hypothetically low-res 244-pixel camera. |

| FIGURE 1-3 | More megapixels means more resolution, which is handy for changing the composition of your picture through cropping, as well as for making good-quality prints. |

The Future of Digital Cameras

Camera manufacturers will probably always try to pack a few more megapixels into their cameras. Of course, that doesn't mean you always need to be on the lookout for a new camera with more resolution. Quite the contrary; if you rarely make 8×10-inch prints from your digital photos, you're probably all set with a 4- or 6-megapixel camera.

But for those folks who definitely want larger pictures—like 11×17 or 13×19 (well within the ability of some consumer-priced wide-format inkjet printers)—you need more pixels to keep those huge images sharp. Camera manufacturers are responding with cameras that snap 8-, 10-, and even 12-megapixel pictures.

And cameras are getting smaller, too. So small, in fact, that camera phones are now commonplace. This is kinda cool, since you can always take a picture if you have your phone handy. But camera phones have some serious limitations. Like the early days of digital cameras, most camera phones still take lousy pictures with low resolution, bad contrast, and washed out colors. Of course, they'll get better. In Japan, camera phones have as much resolution as some of the best digital cameras and take really good pictures. But that day is arriving slowly here in the United States. Most camera phones have VGA-quality or 1-megapixel resolution. A few models are springing up with better, 2-megapixel cameras built in, but you really need to look for them. There's another important trend in digital photography: Digital SLRs. For years, the most common kind of digicam was the point-and-shoot model, like the Canon PowerShot G7 in Figure 1-4. They look like 35mm point-and-shoot models and automate most of the features needed to take pictures.

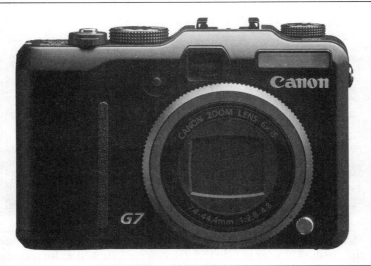

FIGURE 1-4 Point-and-shoot digicams like this Canon PowerShot G7 promise great results without a lot of effort or expense.

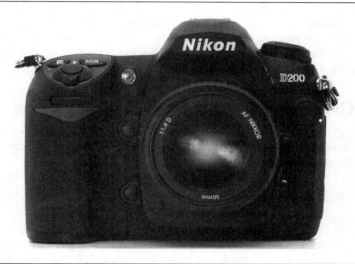

SLR-style digital cameras offer lot of resolution plus plenty of advanced photographic control.

But SLR digital cameras are getting hugely popular. These cameras, like the Canon Digital Rebel and the Nikon D200 (in Figure 1-5), don't cost a lot more than top-of-the-line point-and-shoot cameras did just a few years ago, but they feature interchangeable lenses, powerful flash units, and a wealth of manual and programmed controls. Their superior optics and larger image sensors help you take better photos. And they behave just like SLRs from the film world. Photographers who love their old 35mm SLRs finally have a digital alternative.

If you have a trusty old SLR and want a digital camera that's just like it, this is a good time to be getting into digital. Only a few years ago, the price of these pro-oriented cameras were $5000 and beyond. Right now, you can find inexpensive Digital SLRs from Canon and Nikon for under a thousand dollars! For more details on Digital SLRs, see the next chapter.

Be prepared for even more dramatic price drops in the future. In fact, this table shows how digital camera prices, on average, have plummeted in the past few years:

	Under 1 Megapixel	1–2 Megapixel	2–3 Megapixel	3–4 Megapixel	4–5 Megapixel	5–6 Megapixel
1999	$663	$839				
2001	$141	$377	$532	$815	$1733	
2002	$85	$264	$345	$556	$805	$1982
2004	Built in to phones	$150	$230	$375	$650	$750
2006	Built in to phones	Built in to phones			$150	$200

Where were the 3- and 4-megapixel cameras in 2006? Pretty much gone. Most of the cameras introduced that year were 6-megapixel or more, with "high end" cameras topping 10 and even 12 megapixels. In 2006, a typical 10-megapixel camera cost $400. That would have bought you a 2-megapixel camera in 2001! In the next edition of this book, I'll have to add new columns for 10- and perhaps 16-megapixel cameras.

Choose Your Own Digital Camera

If you haven't yet made your digital camera purchase—or if you are planning to upgrade—you're in luck. The field has never been more crowded with excellent choices, and technology advances keep making these cameras better each year.

Even though the camera field is evolving all the time, the basics really don't change. The next few sections cover the most important elements to consider when shopping for a camera.

Resolution

First and foremost, figure out how much resolution you need. This should be the very first decision you make, since it determines what cameras you will be evaluating. Use this handy little guide to decide what megapixel range you need:

Megapixels	Print Size
2 (camera phones)	4×6-inch prints
3	8×10-inch prints
6 or more	13×19-inch prints; 8×10-inch prints from a crop of a larger image

Remember that even if you choose a camera with lots of resolution, like a 10-megapixel camera, you can set it to capture lower-resolution images—perhaps even a mere 640×480 pixels—making your camera quite versatile. Why would you do that? Well, suppose you are on vacation and your camera's memory card is almost full. In that case, you might want to shoot at a lower resolution so you can hold more pictures than you would normally be able to do at full resolution.

All that said, I don't think resolution should be a major concern when shopping for a camera. Choose your camera based on features, optics, quality, and convenience—all the other things in this list. Chances are, any modern camera will have enough pixels to satisfy you.

Optics

It is a camera, after all—not a computer. The optics are important. Your camera's optics should be made of glass, not plastic, and multiple "elements" help keep everything in sharp focus through the camera's entire zoom range.

Consider what kind of pictures you want to take. Having a camera that has a fairly wide angle lens is good for landscapes, indoor shots, and general-purpose photography. If you want to take portraits or wildlife shots, a longer reach is important. But take a look at the specs for

a digital camera—what the heck is a 9.3mm lens? Is that wide angle? Telephoto? Who knows? That's why most digital cameras also advertise their focal length in "35mm equivalents"—in other words, if this digital camera were a 35mm camera, its 9.3mm lens would give you the same picture as a 50mm camera, for instance. Many photographers know that 20–35mm is considered wide angle, while 50–90mm is thought to be "normal"—great, for portraits, for instance. Anything over 100mm is thought to be "telephoto," good for pulling in distant scenes. 200mm or more is considered a powerful telephoto.

Be sure to check the 35mm equivalent numbers for an indication of the camera's real value. And remember that digital cameras generally have an abundance of "reach"—it's pretty easy for manufacturers to make digital cameras with long zoom lenses. What's harder is making wide angle lenses, so you might find it more difficult to locate cameras with a wide bottom end on the zoom range. And trust me: you will probably want to go wide more often than you'll want to go long, especially for indoor photography.

Choose a Zoom

A zoom lens lets you change the focal length of the camera. In simple terms, it lets you choose how much the camera magnifies the image, and zoom lenses let you zoom in and out of a scene for the perfect composition. In general, the greater the zoom, the better. You'll commonly see 2x, 3x, and perhaps even 5x zooms on digital cameras. With some simple finger pressure, you can use your camera to go from a normal or wide-angle view to telephoto. The effect of a 4x zoom is apparent in Figure 1-6, taken at both ends of a camera's zoom range.

FIGURE 1-6 Zoom lenses are popular because of their flexibility when composing pictures.

Beware, though, of a camera's *digital zoom*. While optical zooms move the lenses around to actually magnify the image, a digital zoom simply grabs a block of pixels in the middle of the scene and processes them to make the image look bigger. Since the result is grainy and blurry, I suggest that you ignore digital zoom ratings when evaluating a camera and just look at the optical zoom ratings.

Memory

The more memory your camera holds, the more pictures you can take. It sounds simple, and it really is. In general, it really doesn't matter whether your camera uses CompactFlash, Memory Stick, Secure Digital, or xD memory—you'll simply want to buy a couple of memory cards in the correct format so you can shoot lots of pictures when you're away from home.

Flash

Almost all digital cameras come with a built-in flash. The real issue is how well the flash works. Check to see what the maximum range of the flash is and if it works when the camera is in macro, or close focus, mode. You might also want a flash with special features like these:

- **Red eye reduction** This mode preflashes the subject to try to minimize reflected light from the pupil known as *red eye*.
- **Force/fill** Force or fill flash reduces shadows outdoors or in otherwise adequate lighting when the flash might not fire.
- **Rear curtain flash** This mode fires at the end of a long exposure. It comes in handy at night so that light trails precede the main subject, illuminated by the flash.

Some cameras also come with sync ports or hot shoes that allow you to connect more powerful, external flash units.

Special Effects

Since digital cameras are part computer, they can be programmed to do some neat tricks that were inconceivable with traditional film cameras. Few of these effects are necessary; in fact, I'd choose a camera based on solid features like the zoom, lens quality, and overall handling before you look too hard at whether the camera includes a video mode or sepia tint. Nonetheless, these are some of the effects you may see:

- **Movie mode** Some cameras can capture short, low-resolution video clips as well as still images. Don't confuse this with real high-quality digital video, though—they'll look jagged and low-res on a large television. And not all cameras can capture sound with video, so watch the fine print when shopping for a camera.

- **Tint modes** With special settings, you can take black-and-white or sepia-tinted stills. Remember, though, that you can achieve the same effect in an image editor on the PC after the picture is taken, so you aren't losing anything if your camera lacks this feature. In fact, it's usually better to start with a full-color image; that way you can do whatever you like to it later and always have the high-quality original to fall back on.

- **Color replacement** Some cameras let you swap out colors in a scene—you can make your photo into a black and white, or turn a blue rug red.

Transfer Pictures

Getting images out of your camera is just as important as taking the pictures to begin with.

Of course, most digital cameras use a USB cable to transfer images to the computer. USB is a common, standard cable that connects most external gadgets to computers. But some cameras include even more convenient solutions, like docking stations that "sync" the pictures as soon as you place the camera on the desk.

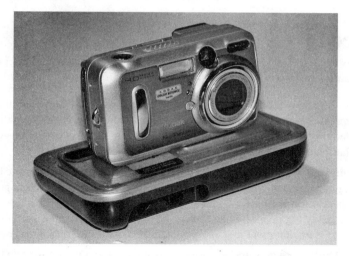

If you like to view your freshly shot images on a television or want to record them, slide show style, directly to a VCR, then you should definitely consider a camera with a video-out port. Using an ordinary RCA-style composite video cable, you can connect the camera to a TV, VCR, or some other video display unit.

Other cameras include adapters that accept the removable media card and connect to the computer directly. The advantage with these devices is that you can transfer images without draining the camera batteries, and transfers are often easier to do, since you drag and drop images from a folder on your desktop. Even if your camera doesn't include one of these gadgets, you can add one later. Memory card readers, like the one in the following illustration, let you pop the memory card from your camera into your PC and copy the pictures as if they were stored

on a floppy disk. Any computer or office supply store should have a wide array of removable memory card readers to choose from, and they all tend to cost under $30 or so.

Gear You'll Need

Every hobby has its accessories. Here's a short shopping list of things you might consider buying as you become a more avid photographer:

- ■ **A camera** It goes without saying that you will want a digital camera, but don't rush into the purchase. You can even use a film camera to begin with and scan the images into the PC for editing and printing. If you've read the previous sections of this chapter and decided what features are important to you, you can shop like a pro.

- ■ **An adequate PC** Crunching data to process digital images takes a bit more horsepower than you might be used to when working with Word or Excel. These days, a good digital camera rig includes at least a 1.5-GHz processor and no less than 1GB of RAM. If you want to work with really big images—like 8-megapixel pictures—then consider 2GB. You might be surprised to learn that more memory is generally more useful than a faster processor.

- ■ **Batteries** Digital cameras are power hogs. If your camera uses AA-style batteries, I highly recommend buying two sets of rechargeable batteries, since they'll pay for themselves before you can say "alkaline." If your camera didn't come with an AC adapter, I suggest that you buy one from the camera vendor's accessories store so you can power the camera when you're transferring images to the PC or displaying images on a TV. No matter what kind of battery your camera takes, have at least one spare that can be fully charged all the time.

- ■ **Memory** Buy the biggest memory card you can afford, or a combination of two cards each with reasonable capacity. The measly 16MB memory card that came with your camera won't last a day when you're on vacation, so having a 512MB, 1GB, or even a 2GB card is almost essential. A spare card, if it's in the budget, can keep you going when

you fill up your main card far away from your PC. (And if you're on a budget, remember that two 1GB cards are usually cheaper than a single 2GB card.)

- **Image editing software** Your camera probably came with some rudimentary image editor, but it may not be up to the task. Try a few out, and buy the image editor that you like the best. I like Paint Shop Pro (from www.jasc.com), Adobe Photoshop Elements (www.adobe.com), and Digital Image Suite (www.microsoft.com).

- **Tripod** If you want to extend your photography into the world of close-ups or long-range telephoto images, a tripod is a necessity. It needn't be large or heavy, since most digital cameras are significantly lighter than their film camera counterparts.

- **Camera bag** Choose a bag that lets you arrange your camera and accessories so that they're protected from theft and damage but easy to use when the time comes to shoot a picture. Look for bags that don't really look like they're holding camera gear—that might make them less of a target by thieves.

How to ... Choose a Digital Camera

When you're shopping for a digital camera, make a checklist of features and capabilities you want based on these criteria:

- **Resolution** Decide how large your finished images need to be, and look for cameras that can take pictures in the appropriate megapixel range. Remember, though, that you can never have too many pixels, so there's nothing wrong with a 12-megapixel camera even if you are only printing 8×10s.

- **Zoom** The bigger the zoom, the more you can enlarge the image. But pay attention to the lowest number of the zoom range, which indicates the wide angle rating, and the biggest number, which is the telephoto setting. And ignore the digital zoom rating, which is more of a marketing gimmick than a useful photo feature.

- **Flash** Consider the flash range and special features like red eye reduction. For serious flash photography, look for cameras that accept external flash units.

- **Batteries** Does the camera take standard AA batteries or special Lithium Ion batteries? Does it come with a wall adapter or a battery charger?

- **Memory** Does the camera also have special internal memory, so you can take a few pictures even if you forget the memory card at home?

- **Picture transfers** One last issue to consider is how the camera transfers images to the PC—this is a convenience issue. Does it use a standard USB cable? A docking cradle? Does the camera come with a removable memory card reader?

Features, Gadgets, and Goodies

No two digital cameras are the same. Each camera maker is known to some greater or lesser extent for implement-specific kinds of features—like interchangeable lenses, bodies that swivel around the lens, or movie recording features. If you cut through all those goodies, though, you'll find that most cameras share many of the same fundamentals. Let's start at the top and cover your camera's fundamentals.

The Optics

At the heart of every camera, no matter how it stores its images, is an optical system, as you can see in Figure 1-7.

Most digital cameras have two distinct viewfinders—an optical one and a digital one. In most cases, the optical viewfinder is composed of a lens that shows you your subject directly—it's just a plain window that lets you see through the camera to the other side. The digital viewfinder is a large LCD display that reproduces what the camera's image sensor is actually seeing.

Which one should you use? Whichever one you like. You'll get better results, though, if you understand the difference between the two. With a majority of cameras, you do not actually see exactly what the camera sees when you look through the optical viewfinder.

Here's why: When taking pictures from a distance, the optical viewfinder and lens see essentially the same thing. Close up to your subject, though, they clearly see two different things (as you can see from Figure 1-8).

The digital viewfinder, on the other hand, shows you exactly what the camera sees, and thus is the most accurate gauge of your potential photograph. You won't want to use your digital viewfinder all the time, though. For starters, it uses a lot of power, and you can get more mileage out of your camera's batteries by using the optical viewfinder instead. In addition, the LCD display can be very difficult to see in certain lighting conditions, like outside in midafternoon.

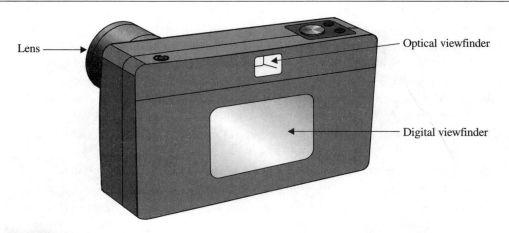

Lens

Optical viewfinder

Digital viewfinder

FIGURE 1-7 Almost all digital cameras rely on an optical system that includes both a viewfinder and an LCD display.

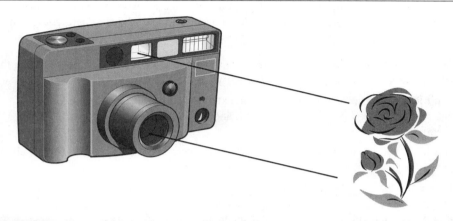

FIGURE 1-8 The optical viewfinder and the camera's lens don't always see exactly the same thing, especially when close up to the subject.

NOTE *Some cameras allow you to turn off the LCD display to conserve power. Leave the display off most of the time to get more battery life.*

Power Systems

Your digital camera, of course, takes batteries. While some digital cameras rely on a standard set of AA batteries or their rechargeable equivalents, it's a lot more common to design cameras around special Lithium Ion battery packs. The advantage is that these batteries are much smaller than a foursome of AAs, so the camera itself can be much smaller. You can see the size difference here between the battery compartments of a camera that uses AA batteries and a model that features a tiny Lithium Ion battery:

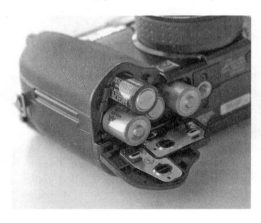
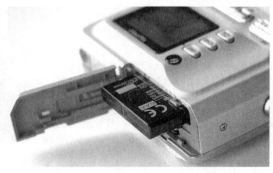

On the downside, you can't just pop in ubiquitous AA batteries when the cells run dry, which means you need to keep one or more spares on hand. Here's a little advice to help you get the most mileage from your batteries:

- Insert batteries according to the diagram on the camera body—make sure you align the battery's positive and negative ends correctly (so they work at all!).

- Don't leave batteries in the camera for an extended period of time. Some kinds of batteries may leak when fully discharged, and if that happens, your camera can be ruined.

- Don't mix and match fresh and used batteries or batteries of different kinds (like alkaline and rechargeables).

- If your camera takes NiMH batteries, it's a good idea to run them all the way down before recharging them. If you have Li-Ion batteries, though, do just the opposite: charge them more frequently before they have a chance to fully discharge.

- When you can, run your camera using AC power (a wall outlet) to conserve your batteries for when you really need them.

Some digital cameras come with their own AC adapters, while for others it's an optional accessory. Check the camera body for an AC adapter connector. If you can connect the camera to a wall outlet, especially during image transfers to the PC, you can significantly extend the length of your battery's life.

Take Care of Batteries

Digital cameras are battery hogs, plain and simple. You shouldn't expect the batteries in a digital camera to last very long since they are responsible for running a number of key functions within the camera:

- The imaging system, including the exposure controls and the zoom lens motor
- The LCD display
- The flash
- Picture storage

That's a lot to expect from a set of batteries, and, in fact, they don't last long—you might typically expect to get between 100 and 200 shots from a set of batteries, depending upon how aggressively you use features like the zoom and LCD display.

Rechargeable versus Alkaline If your camera uses typical AA-style batteries, you should avoid alkaline batteries. Instead, invest in one or two sets of NiMH rechargeable batteries. Yes, they're initially more expensive. But they quickly pay for themselves, since you can use rechargeables several hundred times before they stop holding a useful charge. Do the math: Let's say that you

Batteries Don't Last Forever

Rechargeable batteries lose a teeny tiny little bit of their life every time you charge them. You can extend the life of these batteries by only recharging them when they're actually run down; "topping them off" is like a regular recharge in that it heats the chemicals in the battery casing, which slowly reduces the battery's life.

use your camera every weekend for a year, and you have to replace the batteries about once a month. Here's how the cost stacks up over the course of a year:

AA Alkaline (Like Energizer "Titanium" High-Performance Batteries)	NiMH Rechargeables (Charger and One Set of Batteries)
12×$8 = $96	$20

The more you use your camera, the more obvious the cost savings become. Once you buy your first set of rechargeable batteries, additional sets are less expensive (usually under $10) because you don't have to buy another charger. So you can see how useful rechargeables actually are.

Get the Most out of Your Batteries With so many demands on your camera batteries, it's not all that surprising that they don't last very long. But there are certainly things you can do to extend the life of your batteries, making them last longer between charges or replacements. Just follow some of these commonsense tips:

- **Use the optical viewfinder** If your camera lets you, turn off the LCD display and look through the optical finder instead. The LCD screen is one of the biggest energy hogs on your camera, and you can significantly extend the value of your batteries by not using it.

- **Don't review your pictures** Likewise, avoid gawking at your pictures on the camera's LCD display. Of course, feel free to review them briefly. But save the slow, careful replays for your computer screen.

- **Disable the flash when you don't need it** Sure, there are excellent reasons to use it, even outdoors, but if you are shooting subjects that are 40 feet away and the flash can't possibly help, turn it off. Your batteries will thank you.

- **Leave the camera on** If you're taking a lot of pictures in a brief time, don't turn the camera off after each and every picture. You might think that you're conserving battery life, but in fact you're burning energy every time the camera has to power on. That's especially true if your camera has to retract the zoom lens every time it powers down and extend the lens when you turn it on again.

How Many Pictures Memory Cards Can Hold

How many images can you fit on a memory card? This handy chart can give you some indication of what size memory card—or how many memory cards—to take on your next family vacation. This chart is just approximate, because the exact number of pictures you can fit on a memory card depends upon how much compression your camera applies to each picture:

	256MB	512MB	1GB	2GB
3-megapixel	145	290	580	1160
6-megapixel	72	145	290	580
12-megapixel	36	72	145	290

TIP

If your batteries die in the middle of a shoot and you don't have any spares, here's a trick you can try that might give you a few extra shots: turn the camera off, wait a minute, and then turn it back on. Often you can sneak in a few more pictures before the batteries are completely exhausted.

Memory Storage

Memory cards store your digital images for you. The more memory your camera has, the more images it can store. Most cameras include a memory card with some memory capacity (such as 32MB, 256MB, or GB) that, when inserted in the camera, stores images. When it's full, you can remove this card and insert another card for additional storage. Of course, most manufacturers include a pretty small card in the box with the camera, expecting that you will buy one or more additional memory cards for your camera. Some cameras also come with a little internal memory so they can snap a few photos even if the memory card is full or missing. Keep in mind, though, that that internal memory is usually just a failsafe and is only good for a handful of images.

You can use the connection cable that came with your camera to transfer images to the PC, or use a memory card reader to directly insert a memory card (see Figure 1-9) into your PC as if it were a floppy disk.

There are four major kinds of memory cards in use today:

- CompactFlash
- Memory Stick (and its big brother, Memory Stick Pro)

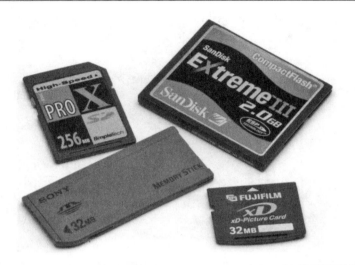

FIGURE 1-9 There are four main kinds of memory cards in use today, and your digital camera accommodates at least one of them. Card readers can read your memory card like a floppy disk, eliminating the need for cables.

■ Secure Digital (commonly abbreviated SD, along with its little brother, MMC)

■ xD

NOTE *How many images you can fit on a memory card has nothing to do with the type of memory card—all that matters is the resolution of the images and the memory card's total capacity, measured in megabytes or gigabytes.*

Camera Controls

Perhaps the most subjective of digital camera features, the controls are also among the most important because they account for how you interact with your camera. The controls should be comfortable, logical, and convenient. Of course, I can't really tell you which is best; you need to experiment with a few cameras to see which you like the best. Try handling cameras in the store whenever you can. Make sure you can reach all of the important buttons and try to pick a camera that isn't littered with so many buttons that you'll never remember how they all work.

Digital cameras typically feature two distinct control systems: on-body buttons and dials, plus onscreen menus. Figure 1-10 shows some body controls, such as a diopter dial (for adjusting the eyepiece to your personal eyesight), shutter release button, and zoom controls. The onscreen menu (seen in Figure 1-11) is commonly used to adjust less frequently used controls, like

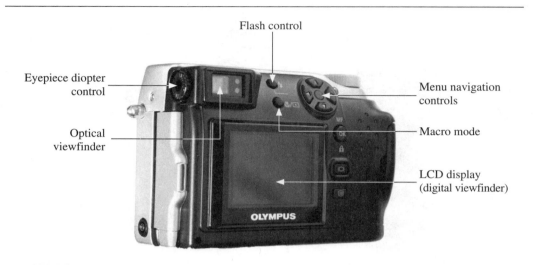

Flash control

Eyepiece diopter control

Optical viewfinder

Menu navigation controls

Macro mode

LCD display (digital viewfinder)

FIGURE 1-10 Most of these controls are common to all digital cameras.

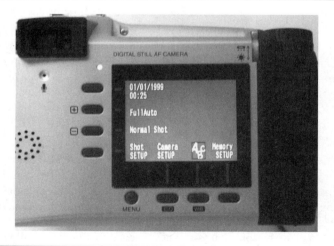

FIGURE 1-11 Digital cameras use a series of menus in the LCD display to operate the more advanced or less frequently used features.

Did you know?

The Truth about the Upgrade Race

Do you need to get a new camera next year just because the megapixel bar has been raised—or some other cool new features have surfaced?

No, you don't. Just like your desktop computer, a digital camera isn't obsolete just because a new model came out with more. It's only obsolete when it no longer does what you want it to do. Find a camera you like and stick with it.

resolution settings, exposure compensation, and special effects filters. That's not always the case, though, as you can see in Figure 1-12. This camera uses a button—the one with the star—to change the resolution without resorting to a menu system.

And don't forget that the best camera in the world is the one you actually have with you. That means that small is usually better than big; even if a somewhat bulky camera seems to have a great assortment of features, a smaller, sleeker model that actually fits in a purse or pocket might be a better bet.

You need to take the time to review your camera manual to find out how to operate all your camera controls. Without knowing how your camera works, you can't really learn to take great pictures.

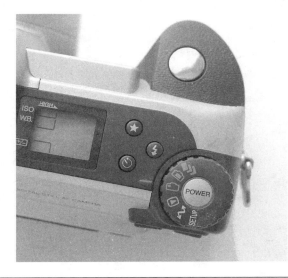

FIGURE 1-12 The star symbol is sometimes used to indicate resolution.

Chapter 2

Work with Digital SLRs

How to...

- Amaze your friends with D-SLR trivia
- Use your D-SLR
- Shop for interchangeable lenses
- Take care of your interchangeable lenses
- Clean your camera sensor

One of my earliest experiences with a digital camera was pretty atypical, as far as most photographers go. My editor at a photography magazine called me up and asked if I wanted to review the Kodak DCS520. "You'll like it," I remember him telling me. "It's an SLR."

Keep in mind that this was 1998, which was years and years before Canon and Nikon would make Digital SLRs commonplace. It was delivered in a large padded case—the kind of thing you expect that they ship nuclear reactor parts in—and it was indeed a rather bulky Digital SLR. It took 2-megapixel photos and supported FireWire only—no USB—for transferring the images to the PC. How much did this digital wonder cost? Well, perhaps you should sit down before I tell you: $15,000.

That's right, it cost about the same as the car I used to drive around town looking for things to photograph with the DCS520. And, as I lamented in my review of the camera, "For a whopping $15,000, you don't actually get a whole lot—Kodak doesn't include any lenses, batteries, memory cards, or software. They don't even provide a loaner if your camera fails under warranty. You get just a camera body with a sensor that costs $7,500 per megapixel."

Times have changed. Digital SLRs are commonplace today; in fact, camera manufacturers were caught off guard by their popularity. Nikon and Canon together offer almost a dozen different model D-SLRs in a wide range of prices and capabilities, and there are SLRs available from a number of other manufacturers as well, such as Sony, Olympus, Sigma, and Pentax.

What Is a D-SLR?

Before we go much further, it's probably a good idea to explain what an SLR actually is. SLR is short for "single lens reflex," and it refers to a class of cameras that rely on a mirror in the camera body to determine where the light goes, to the viewfinder or to the image sensor.

SLRs address one of the most serious shortcomings of point-and-shoot cameras: the fact that light can't generally go to two places at once, so as the light goes through the lens and on to the sensor, the optical viewfinder is out of the loop. As a result, the optical viewfinder in most digital cameras can't show you the exact image that the camera is about to photograph (though the LCD display on the back of the camera gets its image from the sensor, so it does reflect the image you're about to capture).

So, as you can see in Figure 2-1, the mirror in a D-SLR reflects the light from the lens to the viewfinder using a collection of mirrors. But when you press the shutter release, the mirror flips up and out of the way, allowing the light to travel straight back to the sensor. After the image is exposed, the mirror moves back into its original position, so you can see through the viewfinder again.

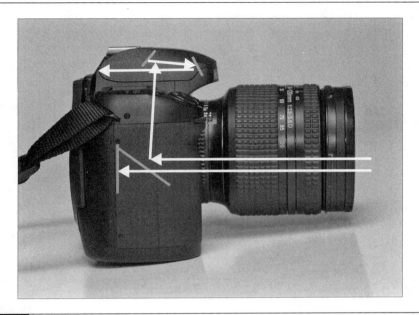

FIGURE 2-1 An SLR has a mirror that determines whether light goes to the viewfinder or the sensor.

Of course, because the mirror blocks the light from reaching the sensor before you take the picture, it means you can't preview a picture in the LCD display on the back of the camera before you take the photo. D-SLR users must use the optical viewfinder to compose a photo, while point-and-shoot users can choose to use either one.

It's also worth pointing out that even this seeming immovable law of photography—that the LCD can't be used to compose photos when using a D-SLR—is changing. Some new cameras (like the Olympus E-330) are using clever technology, like a mirror assembly that reflects some light to the sensor and some to the viewfinder, allowing you to use the LCD all the time. Time will tell if this kind of thing catches on.

Walk around a D-SLR

Obviously no two D-SLRs are quite the same, but for the most part, they all share enough in common that you can take a tour of a common Digital SLR and learn about the kinds of features and capabilities you should expect to see in many models.

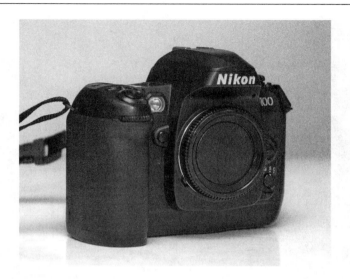

FIGURE 2-2 A typical Digital SLR

The Body

When you buy a D-SLR, you're probably just buying the body (see Figure 2-2). Sure, many deals include what's called a *kit lens*—a general purpose zoom that comes with the camera—but the deal is really just about the body, since it's interchangeable with many other lenses.

The Lens Mount

The lens mount (which you can see in Figure 2-3) is where all the action takes place. It varies from one manufacturer to another, but in general, all Canon lenses are compatible with all Canon cameras, Nikon with Nikon, and so on. There are exceptions, of course, and sometimes you need to read the fine print or talk to a salesperson.

To add and remove lenses, get familiar with the procedure so you can do it quickly without having to study the lens and camera in detail each time you want to swap. When you swap lenses, you're exposing the sensor to the environment, so you'll want to replace the lens as quickly as practical. The longer you leave the camera body open, the more opportunity there is for dust to collect on the sensor. I'll talk about how to clean the sensor later in this chapter.

Also, don't forget that your camera comes with a body cap—don't throw it away! If you ever need to handle or store the camera with the lens removed for more than just a few minutes, you should insert the body cap. If you lose it, don't worry, just go to any camera shop and ask for a spare that matches your camera manufacturer. Like lenses, they're all completely interchangeable.

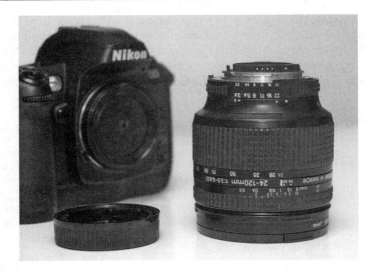

FIGURE 2-3 A Nikon D-SLR and a lens with its mount exposed

Interchangeable Lenses

It's the allure of the lenses that makes me a D-SLR fan. Whenever I use a point-and-shoot camera, I always wish I had more focal length options at my disposal—the array of lenses in Figure 2-4 are impossible to get on any single point-and-shoot camera. So if you have or are planning to get a D-SLR, what kind of lenses should you consider?

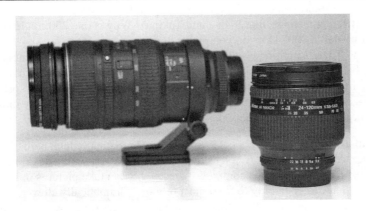

FIGURE 2-4 A typical, general-purpose "kit" lens in the foreground (24–120mm) and an 80–400mm extreme telephoto in the background

Many folks are reasonably satisfied with a kit lens that's often included with the camera purchase. These lenses vary, but frequently they're zoom lenses with a range like 80–200mm. That's not a bad range for what many photographers refer to as a "walking-around lens." What it's missing, though, is wide angle—and believe it or not, you'll need a wide lens a lot more often than you need telephoto. After all, think about the kinds of pictures you frequently take. I bet you do a lot indoors. If so, then 80–200 will be close to useless. Here's what's in my personal camera bag:

Lens	What It's Good For
12–24mm	Very wide angle photography. Good for tight corners indoors, capturing lots of people in a crowded room, and special effects in which the photo's perspective is a little skewed, since 12mm is so wide that it looks a bit unnatural.
18–200mm	Several manufacturers sell an 18–200mm lens now, and it's possibly the most perfect walking-around lens ever made. It covers all the most common focal lengths you need day-to-day and while on vacation, so it could easily be the only lens you own.
100mm macro	If you like macro photography, a macro lens in the 100mm range is ideal for a lot of common close-ups, and it's long enough to get small insects like bees and butterflies without getting so close that you bother them. When you're not shooting close-ups, this lens is a handy short telephoto.
80–400mm	Granted, this is a massive zoom, but I've used it for years to pull in distant wildlife as if it were in my backyard. If you do wildlife or sports photography, you'll want a big zoom that goes well beyond 200mm.

How to Buy a Lens

After you'd had your D-SLR a while, you might want to get an extra lens (or two) to complement the kit lens that came with your camera. And when that happens, you probably have some questions. Should you buy a Canon lens for your Canon camera, or perhaps from third-party lenses (from companies like Sigma and Tokina)? Why is one 200mm lens $300 but a seemingly similar model $2000? How do you pick a lens?

First things first. There's nothing wrong with buying a third-party lens, in principle. Many lenses that have a badge other than Canon or Nikon (or whatever camera you own) are great lenses. Often they're less expensive, and that's why they're popular. As to how to pick a lens and what separates a $300 lens from a $3000 hunk of glass, there are a few really important characteristics to consider when lens shopping:

■ **Maximum aperture** This affects the price more dramatically than perhaps any other lens feature. A fast lens—that is, a lens that can open way up with a large maximum aperture like f/2—is a valuable commodity because it can take pictures in low light. A similar lens that can open only to f/5.6 must rely on a dramatically slower shutter speed to capture the same picture. (If all this aperture and shutter speed stuff is confusing,

check out Chapter 3, where you'll learn about how they affect exposure.) Engineering a lens with a large maximum aperture is hard, though, and requires a great deal of precisely shaped glass. That makes lenses that open all the way to f/2 (or more) quite a bit more expensive than their peers. If you're serious about photography, it's worth spending more money to get a fast lens. If you're more casual about your photo hobby, you can save a bundle by getting a cheaper lens that has a slower maximum aperture.

NOTE *Many zoom lenses have a different maximum aperture at opposite ends of the zoom range, as you can see in Figure 2-5. A typical zoom, like a Nikon 18-200mm, is an f/3.5 at wide angle but a much slower f/5.6 at the telephoto end. A zoom that is a constant f/4 (or faster) through the whole zoom range is priced beyond the budget of most photographers.*

■ **Image quality** When we talk about the quality a lens can capture, we're discussing the lens's sharpness, to be sure. But we're also discussing seemingly technical stuff like contrast, chromatic aberration, color fidelity, and vingetting. And it gets worse: all of these values, including overall sharpness, vary through the zoom range for a zoom lens at each f/stop. Most modern lenses are somewhat sharper when stopped down a bit from the lens's maximum aperture. And there are a lot of factors that contribute to image quality. One example: lenses with more "blades" in the diaphragm (the mechanism that controls the size of the aperture) tend to create a smoother, more pleasing blurred background

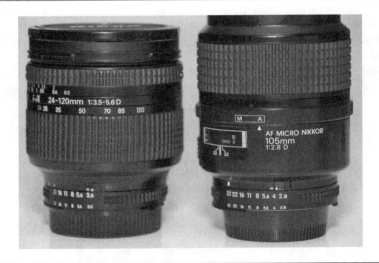

FIGURE 2-5 The lens on the left has a slower maximum aperture at the telephone end of its zoom range, while the lens on the right has one best aperture.

in photos with a shallow depth of field. It's almost impossible to judge these kinds of factors yourself. As a result, I recommend that you read lens reviews on the Web. Here are some sites I highly recommend:

- http://www.bobatkins.com/
- http://www.photo.net/canon/
- http://www.slrgear.com/reviews/
- http://www.the-digital-picture.com/Canon-Lenses/
- http://www.photozone.de/8Reviews/
- http://www.photo.net/

■ **Zoom control** If you're shopping for a zoom lens, be sure to handle it yourself (either in a store or borrowing one from a friend) before you pay for it. Why? The control needs to feel comfortable and natural. Some cheaply made lenses use a zoom control that you have to push and pull in order to change the focal length. Ugh. It's hard to do and almost impossible to quickly lock in the right magnification. Instead, look for zooms with controls that turn around the lens barrel. It should be smooth and easy, not hard and jerky. Another consideration: some zooms have a completely internal mechanism, so the lens does not change size as you zoom. Other lenses get longer or shorter as you zoom.

■ **Image stabilization** Nikon calls its image stabilized lenses "VR." Canon uses the term "IS." Either way, these lenses contain small gyroscopes and motors that minimize the sort of blur caused by handholding a lens. Image stabilization can be found on many telephoto lenses, and manufacturers claim that using a stabilized lens allows you to shoot pictures as much as three stops slower than you normally could without blurring your photo. Now, don't get me wrong: you should use a tripod for the best results, but image stabilization really does work well and is nothing short of astonishing. If you can afford to get an IS or VR lens, definitely go for it. As you can see in the following illustration, most image stabilized lenses have a control on the lens that lets you turn the effect on or off.

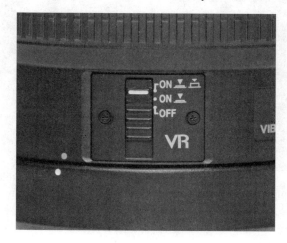

The Difference Between Zoom and Prime

A prime lens is a lens that has one (and only one) focal length. 35mm. 200mm. 500mm. Whatever. A zoom, of course, is a lens that you can use at any one of a range of focal lengths: 18–200mm, 80–200mm, 28–50mm. Both have advantages and disadvantages.

Purists like prime lenses because they're smaller, lighter, and generally sharper than zooms. They can be made with fewer compromises (trying to get a single set of optical elements to produce images at a wide variety of focal lengths is fraught with compromise), so you can get a high quality prime lens with a superb maximum aperture for relatively little money.

On the other hand, it's pretty inconvenient to carry a bag full of prime lenses around, and swapping lenses to suit the moment is not fun. One or two good zooms can replace a dozen prime lenses, and that's why most photographers rely on zooms today. Of course, zooms are the exact opposite of primes—they're bigger, heavier, sacrifice image quality at various points in the zoom range, and often have a slower maximum aperture than their prime counterparts.

Care for Your D-SLR

Everything gets dusty and dirty. I know this to be one of the fundamental, immutable laws of physics because I own a house, and every once in a while I look in places I shouldn't. And when I look, I see a thick layer of dust everywhere, which is surprising, because my family has a firm policy of dusting once every presidential election cycle.

In the same way that your household stuff gets dusty, your digital camera can collect dust as well. There are two places dust can collect that can adversely affect your photos: the lens and the image sensor. All cameras sometimes suffer from grime on the lens, but only D-SLR users have to worry about muck getting on the sensor (because point-and-shoot users can't remove their lens, exposing the sensor to the environment).

Clean Your Lens

There's no way to avoid dust sticking to the front of your lens. You can prevent grime from affixing itself directly to the front of your expensive lens by always keeping a filter such as a Skylight filter attached. Many camera shops will suggest that you get a filter along with the initial lens purchase, in fact. My opinion? I'd rather clean my lens occasionally than add an inexpensive plate of glass to the front of my camera that will dilute the quality of my lens. But your mileage may vary—if you prefer to use a filter to protect your lens, by all means do it. Even if you use a filter to protect your lens, you'll still want to clean that occasionally.

So what do you need? Make sure your camera bag includes a blower, the kind you squeeze with your hand to force air through a tube, not compressed air in a can. You should also have a microfiber cloth and some lens cleaning fluid. My favorite blower is the awesome Giotto Rocket Blower, which you can see in the following illustration:

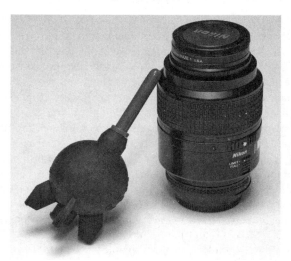

Always start by blasting the dust off the lens with your blower. Harder-to-remove gunk, like fingerprints, can be removed by wiping the lens in a circular motion with a microfiber cloth. If necessary, add a couple of drops of the cleaning fluid to the cloth first.

 CAUTION *Never apply the fluid directly to the lens. Always put it on the cloth first.*

Clean Your Sensor

Since dust can also find its way onto the sensor when you change lenses, let's investigate how to remove dust that builds up inside your D-SLR. Before we get too far, you should know that cleaning the image sensor is a delicate operation. If you are not careful, you can damage the sensor, which effectively ruins your expensive digital camera. If you don't feel up to the task, you can let your local camera shop do this for you. In reality, though, cleaning your sensor is not difficult, it just sounds scary. Some prep work, the right tools, and common sense are all you need.

Detect Dust

Before you worry about the logistics of getting dust out of your camera, it's helpful to know if you really have a problem. Simply put, you know you have dust when you can see the same dark spots in a variety of your photos. You can scan your existing photos for telltale dust bunnies or do it more methodically. Here's how to do that.

Start by setting your camera to its lowest ISO, manual focus mode, and your lens's smallest aperture setting, such as f/22. Point it at a light-colored surface, such as a white wall or a large white poster board and focus the camera. Since you're shooting with a very small aperture, the shutter speed might be several seconds. If it is, you might want to mount the camera on a tripod. Take a shot. Then reorient the camera. If you took your first picture in landscape mode, for instance, take a second shot in portrait.

Now compare the photos, looking at them on your computer screen at 100 percent magnification. Rotate the second picture so it is oriented the same as the first. If you see spots in exactly the same place in both shots, congratulations, you're the proud owner of dust on the sensor. Check out two photos of my own camera's sensor in Figure 2-6. Can you spot the dust spots? I've circled them.

Tools of the Trade

To do the cleaning, you need to get some sensor cleaning gear from your local camera shop. You'll need a blower—again, the kind you squeeze with your hand, never a can of compressed air. In addition, be sure the blower does not have any sort of brush or bristles on the end (you can use my recommended Rocket blower for this job too). You should also get specialized sensor-cleaning swabs, which you'll use to actually sweep the dust off your sensor. There are a number of popular brushes available, though I am fond of the Sensor Sweep II (www.copperhillimages .com). Another popular option is VisibleDust (www.visibledust.com). Delkin also sells the

FIGURE 2-6 Dust on a sensor is easily spotted if you take two pictures and compare them.

SensorScope (www.delkin.com), an all-in-one package that contains a bunch of sensor cleaning swabs, as well as a little vacuum and even an illuminated magnifying glass you can put on the camera's lens mount to more easily see dirt on the sensor. You can see the sensor over the lens mount, ready to help you find dust in Figure 2-7.

Roll Up Your Sleeves...

Cleaning your sensor is an understandably scary proposition. If anything goes wrong, you can end up damaging the most sensitive and expensive component of your camera, requiring a trip to the equivalent of the camera emergency room: the manufacturer's repair center. But as long as you're diligent, careful, and use common sense, cleaning the sensor is little more than a routine maintenance operation.

Start by removing the lens and using the blower to blast any loose particles out of the mirror chamber. Keep the camera pointed down so gravity will help get the dust out. Be sure that the blower doesn't come in direct contact with the mirror.

Next, get the mirror out of the way. You'll need to refer to your camera's user guide for details on how to do this. Many Canon cameras, for example, have a sensor cleaning mode in the menu, while some Nikon cameras have a mirror-up control that reveals the sensor, as you can see in the following illustration. To be on the safe side, do this with your cameras connected to

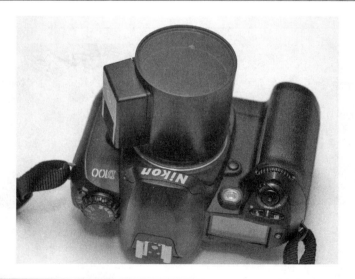

FIGURE 2-7 The Delkin SensorScope is an all-in-one package that helps you keep your sensor clean.

AC power, because if your camera turns off because of a low battery, the mirror can snap back in place with no warning, trapping the brush in an ugly disaster.

Now you'll want to use the blower to remove loose dirt, like you just did for the mirror. It's a good idea to do this while holding the camera upside down so gravity will help dust get blown out of the camera, instead of just moving it around in the sensor chamber. Use the sensor swab (with one or two drops of sensor cleaning fluid) to gently wipe away the more stubborn dirt particles. Check the directions that came with the swab. You can see a typical sensor swab in Figure 2-8.

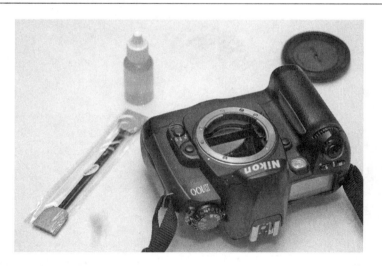

FIGURE 2-8 Cleaning your camera sensor might seem intimidating, but it's easy to do if you follow the directions, use common sense, and work gently (so you don't scratch the sensor).

That's all there is to it. Follow your camera manual's instructions to disengage the mirror lockup, and then take a couple of new test shots. Inspect them for signs of dust and, if necessary, clean the sensor again. As long as you are careful about not leaving your sensor exposed to the environment for long while you change lenses, you should only need to clean your sensor once every six months or more.

TIP *Some Digital SLRs now come with a "self cleaning sensor." These cameras vibrate the sensor to shake dust loose. That's a great feature, but it doesn't completely eliminate the need to clean the sensor by hand occasionally, since this automatic cleaning cycle only shakes the dust around inside the chamber—and the electrostatic nature of the sensor will eventually just attract the dust all over again.*

Chapter 3

Understand Exposure

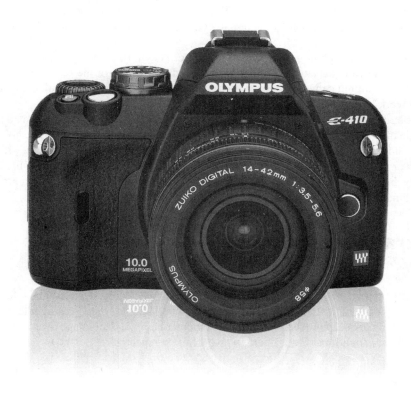

How to . . .

- Tell the difference between analog and digital camera operation
- Distinguish between slide and negative photography
- Select ISO settings for digital and film cameras
- Match aperture and shutter speed settings for correct exposure
- Use the Sunny 16 Rule
- Modify the Sunny 16 Rule based on ISO and lighting conditions
- Adjust exposure manually
- Tweak exposure with your camera's EV settings
- Choose metering modes for better pictures
- Use exposure lock to optimize exposure
- Tell when to ignore the camera and make your own exposure decisions

Some people think that photography is akin to magic. They turn on the camera, snap a picture, and a day or two later they've got a mystical re-creation of the scene they saw in the viewfinder. With a digital camera, it's even more magical—the pictures are available instantly! How does it work? Who knows?

The problem with the Abe Simpson approach to photography (which I've so named based on an episode of *The Simpsons,* in which someone took a picture of old Abe and he shouted feebly, "You stole my soul!") is that you can never really improve if you don't know what your camera does or why, nor how you can influence the camera to improve your shots. This chapter, consequently, is all about the ABCs of exposure. Here you'll learn what constitutes a proper exposure and how to get one yourself—even on cameras that are mostly automatic.

How Cameras Take Pictures

The best place to start is often right at the beginning—how on earth does a camera take a picture, anyway?

All cameras, regardless of type, work more or less the same way, as depicted in the following illustration. They open their shutter for a brief time, allowing light to enter. That light then interacts with a sensitive photo-receptor (such as film or a computer chip), and an image is recorded. Let's start by looking at a traditional film camera to give a little perspective.

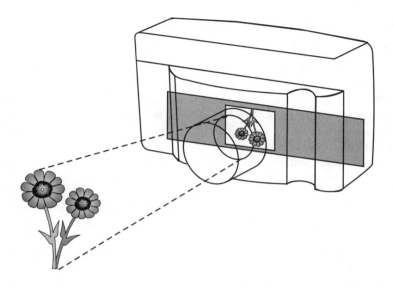

Inside a 35mm Camera

Traditional cameras rely on good old-fashioned film. But what is film, really? It's just a strip of plastic that has been coated with a light-sensitive chemical. The chemical soup on the film is loaded with grains of silver halide. The silver halide reacts when exposed to light, and that is the essence of photography. The longer the film is exposed to light, the more the silver is affected.

Did you know?

What Happens at the Moment of Exposure

Depending on the kind of camera, the events that take place at the moment of exposure can be quite complicated. In a modern SLR, for instance, microprocessor-controlled sensors determine the exact amount of light needed to expose a picture at the moment you press the shutter release. The lens automatically adjusts the size of its opening to admit the correct amount of light, and the mirror mechanism that usually lets you look through the viewfinder flips up and out of the way, allowing light to reach the film. Finally, the aperture opens, and the shutter slides open for the programmed amount of time. Point-and-shoot cameras, in contrast, don't use mirror mechanisms to let you see through the lens before the shot, so there are fewer moving parts at the moment of exposure—but the trade-off is that you don't see the picture you're about to take as accurately with a point-and-shoot.

Go to the corner photo store, and you'll find two kinds of film: negative film and slide film. They work a little differently, but the end result is similar. When you use color negative film, also referred to as reversal film, the film itself becomes a negative image of the scene you photographed. After processing, which includes letting the film sit in a chemical bath that coaxes the grains of silver to visually materialize on the film, the negative is used to create positive prints of the scene. It's a two-step process and one that is highly subjective. When creating prints from negatives, photo-finishers often tweak the picture to improve its appearance. Of course, what the local camera store considers an improvement may not be what you were trying to achieve, and that explains why your pictures never seem to benefit from filters, exposure changes, or any of the other common corrections you try to make when taking pictures.

But I digress. The other kind of film, slide (or reversal) film, uses a color positive development process: after fixing the slide film in its chemical bath, the film becomes slides that can be held up to the light to display images. Because of their far simpler development process, slides can't be tweaked by the guy processing the film. What you and your camera do determines how they turn out—and in that way, slide photography is much more like digital photography.

No matter what kind of film you have, it eventually needs to be exposed to light. When you take a picture, you obviously press the shutter release. The shutter release instructs the camera to open the shutter blades for a brief period of time and then close them again. If all goes well, that is just long enough to properly expose the film.

TIP *If you want to shoot with 35mm film, scan the results, and then edit and print the results on your PC, you might want to work with slide film. Slides are more exacting—they require you to nail the exposure fairly precisely, but they'll better represent what you actually photographed than will the local photo shop's vision of what you photographed.*

The ABCs of Film Speed

As you no doubt know by shopping for film, not all canisters of 35mm film are alike. Film is differentiated principally by its speed, or ISO number.

A film's ISO number refers to how sensitive it is to light. The lower the number is, the less sensitive it is—requiring longer exposures or very bright scenes.

What ISO Means

ISO stands for International Organization for Standardization, and that's the group that helped establish how the film numbering scheme works. Film around the world uses ISO numbers, so you can buy it anywhere and it'll all work the same. In the United States, photographers used to call this system ASA, which stood for the American Standards Association. That term was essentially abandoned about 20 years ago, so if you want to be considered a grizzled old geezer, you can refer to ISO numbers as "ASA."

A fairly typical ISO number for ordinary daylight photography is ISO 100. Increasing the ISO to 200 doubles the sensitivity of the film, meaning it only takes an exposure half as long to capture the same picture; dropping back to an ISO of 50 halves the sensitivity of the film, requiring an exposure twice as long as an ISO of 100.

The ISO number has a tangible effect on the mechanics of photography. To see why, look at Figure 3-1. This diagram shows a typical camera body as a picture is taken. The lens is equipped with a diaphragm—called an *aperture*—that has a certain diameter and consequently is designed to allow a specific amount of light through to the film. With ISO 100 film in specific lighting conditions (say, at midday) the shutter might need to open for a 250th of a second (1/250) to adequately expose the picture.

But what happens if you instead try to take the same picture with ISO 200 film? The film is exactly twice as sensitive to light as the previous roll of film. And that means, all other things being equal, that you need to leave the shutter open for only half as long (a 500th of a second, or 1/500) to take the same picture.

That's not all. Suppose you're trying to take a picture in late afternoon, when there isn't as much light available? You might need to leave the shutter open for 1/30 in that situation to gather enough light with ISO 100 film. That shutter speed is a bit on the slow side, though. Not only might you jiggle the camera as you're taking the picture (it's hard to hold a camera steady for 1/30), but your subject might move as well, causing a blurry picture. You can probably guess what the solution is—stepping up to ISO 200 film will enable you to grab that picture at a much more reasonable 1/60, and ISO 400 halves the shutter speed yet again, to a crisp 1/125.

The F/stop Ballet

So far so good—but there's one other aspect to consider, and that's the fact that camera lenses can change the diameter of their aperture, thus letting in more or less light as needed.

The size of a camera's aperture at any given moment is called the *f/stop,* also sometimes referred to as the *f/number* of the lens. F/stops are represented by numbers that start with "f/"—such as f/2, f/5.6, and f/11. The larger the number, the smaller the opening, so an f/22 is very, very small (not much light gets through to the film), while a lens set to f/1.2 is a huge opening that floods the film with light. Changing the camera setting by a whole f/stop, such as from f/5.6

FIGURE 3-1 Every camera—no matter what it uses for film—controls the exposure with some sort of aperture and shutter settings.

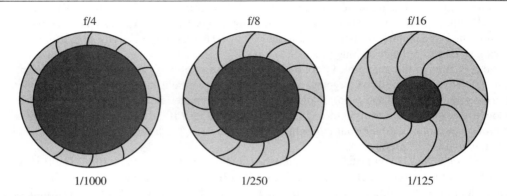

f/4	f/8	f/16
1/1000	1/250	1/125

FIGURE 3-2 Each of these combinations results in the same amount of light reaching the film.

to f/8 or f/11 to f/16, doubles or halves the available light, depending upon which way you're going. If you adjust a lens from f/8 to f/11, for instance, you've reduced the light by half.

We'll talk about this in more detail in Chapter 4 (it's really important, yet really simple), but for the moment take a look at Figure 3-2. This diagram shows the relationship between the f/stop and the shutter speed. If you reduce the shutter speed, you need to increase the diameter of the aperture in order to have enough light to take a properly exposed picture.

This concept—that there are many equivalent exposure possibilities by varying the shutter speed and aperture—is illustrated in Figure 3-3. Here's how it works: If you know that any given combination adds up to a good exposure (let's say f/5.6 at 1/60 second), then you can find an equivalent exposure setting by traveling along a diagonal line. In this example, f/4.0 at 1/125 second will yield the exact same exposure.

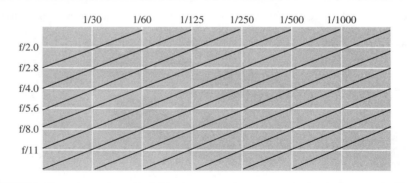

FIGURE 3-3 You can see how shutter speeds and aperture settings relate to each other in an Exposure Equivalency chart.

Of course, there's a relationship between aperture, shutter speed, and your film's ISO rating as well. Look at Figure 3-4. At any given film speed, you can take a picture with a specific aperture/ shutter combination. If you double the film speed without changing the lighting conditions, though, you have to adjust either the aperture or the shutter speed so that you still get a properly exposed picture.

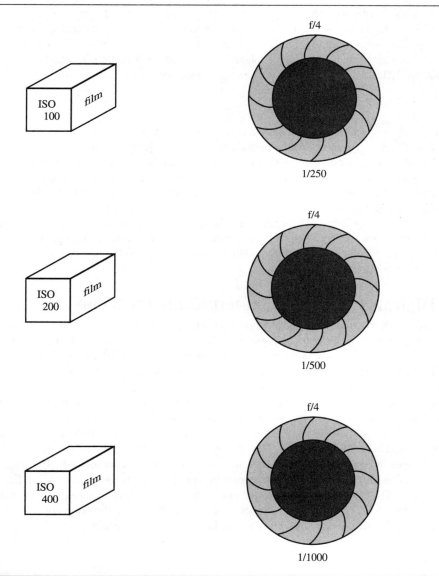

FIGURE 3-4 Film speed, known as the ISO number, also affects shutter speed and aperture.

About F/stops

You probably don't need to know this, but it might come in handy during a trivia game some day. Mathematically, f/stops are the ratio of the focal length of the lens divided by the diameter of the opening of the diaphragm. Thus, when you divide the focal length of the lens by a very small opening, you get a large number, while dividing the focal length by a comparatively large diameter gives you a smaller number.

So let's apply all this newfound knowledge. Suppose you want to take a picture of lions frolicking at the zoo near dusk. Your camera's aperture is wide open at f/2—it won't open any farther. Nonetheless, your camera needs to use the relatively slow shutter speed of 1/15 second to take the shot. You know the image will be a blurry mess at that sluggish shutter speed, so what is there to do? Take a look at your film speed. It's ISO 100. Well, you might be in luck. If you're using a film camera and willing to pop the film out and replace it with film that's two f/stops (often just called "stops") faster, you can keep the aperture at f/2 and change the shutter speed to 1/60. That's probably good enough to get the shot. Just do it quickly—it isn't getting any brighter out, and if you dally, you might find you need to increase the speed by three stops by the time you get the film loaded and ready to go.

How Digicams Are Different but Kinda the Same

All that talk about f/stops, shutter speed, and ISO settings may seem irrelevant to your digital camera, but it's not—all cameras use these same basic concepts. The main difference between a digital camera and a film camera, of course, is the fact that digicams don't use film. That means you never load anything that has a specific ISO value into the camera. So how does the camera actually work?

Simple. When light enters the camera at the moment of exposure, it doesn't hit light-sensitive silver halides that are fixed in a chemical broth. Instead, the light hits a computer chip that acts as a sensor and is usually called a CCD (though some cameras use a CMOS sensor instead, both of which I talked about in Chapter 1). The sensor is light sensitive, and each of its many pixels register changes in light just like the film's many grains of silver react individually to light. In Figure 3-5, for example, you can see each point in a photo is really just a color pixel. Each pixel is defined by a set of numbers that represents its color in the RGB (red, green, blue) spectrum. A white pixel is 255, 255, 255, while a black pixel is 0, 0, 0. And all the colors of the rainbow fall in between. In other words, the silver grains in film and the pixels in a digital sensor are

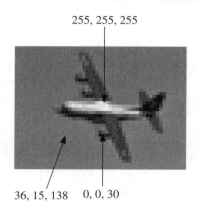

255, 255, 255

36, 15, 138 0, 0, 30

FIGURE 3-5 A digital camera creates pictures by interpreting a dense grid of light-sensitive pixels instead of chemically reactive grains of silver.

essentially the same thing. They contribute to your picture in the same way, and both are the smallest components that make up your picture.

The sensor makes a picture by noting the variation in light rays that travel through the camera lens. The CCD or CMOS sensor passes this information on to the camera's microprocessor in the form of varying electrical charges. The image is transformed into digital bits and stored on a memory card.

Your camera's image sensor functions like the film in a 35mm camera, except that it differs in one important way: you can't swap the CCD out of your camera and insert one with more light sensitivity for low-light photography. The sensor is a permanent part of the camera. Camera makers understand that you might need to change the camera's light sensitivity on occasion, though, and that's why most cameras can have their ISO rating "adjusted" on the fly, whenever you want. In essence, what this does is allow you to turn up or turn down your camera's sensitivity to light by adjusting the gain of the circuit reading the sensor voltage.

Use ISO for Exposure Control

You can use the ISO control built into your digital camera to vary its sensitivity to light and thus mimic the effect of using different grades of 35mm film. This can come in handy in a number of situations, such as when you're shooting in particularly high- or low-light situations. Remember a few key facts about your digital camera's ISO ratings, though:

■ It's not a real ISO adjustment, in the sense that your camera doesn't have real film. Each camera maker has a somewhat different way of implementing this feature, but they all use ISO numbers since that's the same as the ISO numbers used by 35mm film.

■ Don't leave your camera set at the highest ISO all the time. Some folks think that by setting their cameras to the highest sensitivity, they'll be prepared for anything and won't have to muck with the camera menu when they're on the go, trying to take pictures. In reality, boosting your camera's sensitivity to light also increases the amount of digital noise you're capturing. More ISO means more fringing, artifacts, and digital detritus, as in the image shown in the following illustration. Sometimes that's unavoidable, but stick with the lowest ISO value you can get away with most of the time. To do that, set your camera's ISO control to its lowest setting.

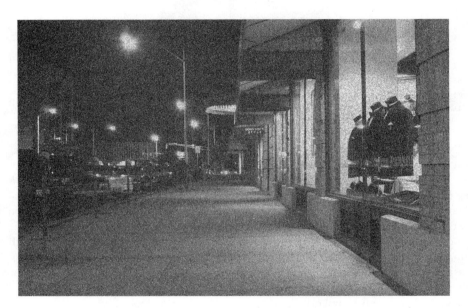

Change the ISO Setting

If you find yourself in a situation in which the lighting isn't quite right for your picture, it's time to bump up the camera's ISO value. Remember that most, but not all, cameras come with ISO adjustments, so review your user manual to see if this applies to your particular model. You can see a typical ISO adjustment in the following illustration; you'll probably find it in the onscreen menu system, displayed in the liquid crystal display (LCD) screen on the back of your camera.

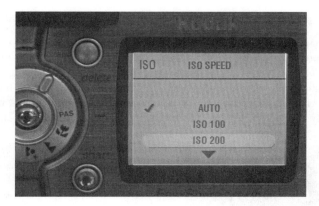

Here are some situations in which you might need to increase the ISO:

■ You're shooting in a low-light situation, such as early evening or indoors. Natural-light photos have a certain appeal, and by increasing the light sensitivity of your camera you may be able to shoot a picture without using the flash at all. Using natural light can eliminate harsh shadows and produce more natural colors.

■ Your subject is too far away for the flash to have any effect. During the day you might be outdoors and want to take a picture of something, but there's not quite enough light—such as in winter or during very overcast conditions. Your camera wants to use a flash, but your subject is just too far away. As you'll see in Chapter 5, the flash on your digital camera has a very limited range; so to properly expose your picture, you need to use "faster film"—that is, increase the camera's ISO setting.

■ You're shooting at night. Most digital cameras have limited ability to take pictures at night or in near total darkness. As a result, if you want to capture anything at all with a night shot, you may need to increase the camera's light sensitivity to the maximum.

TIP *If night photography interests you, investigate what I refer to as "performance" digital cameras—cameras that include manually adjustable shutter speeds and apertures. Using more full-featured cameras lets you perform long exposures for light trails, glowing illuminated signage, and other special effects.*

Perfect Shots with Aperture and Shutter

Let's return to the idea of aperture and shutter speed for a moment. As I observed earlier in this chapter, they're essential ingredients to creating good pictures. Of course, with most digital cameras, you rarely have to worry about setting shutter speed and aperture size at all for typical photography.

How Cameras Choose Aperture and Shutter Speed

Here's what usually happens: when you apply pressure to the camera's shutter release, the camera's microcomputer samples the scene in front of the lens and determines how much light is needed to adequately expose the scene. With most digicams, the camera selects a shutter speed and aperture combination that is sufficient to get the job done. But, you might be wondering, how does it choose? After all, there are a lot of shutter speed/aperture pairs that will work. To take the same properly exposed picture at ISO 100, any of these combinations should produce exactly the same result:

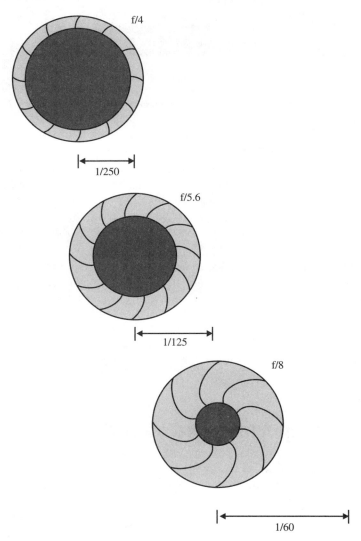

Usually, the camera uses the following logic:

The photographer wants to take a picture using the fastest available shutter speed to minimize camera shake and motion blur from objects moving inside the picture.

Though there are exceptions, most cameras tend to choose the combination that allows for the highest available shutter speed, limited only by how small they can make the aperture given the current lighting conditions and ISO setting.

This isn't always what you want your camera to do, though, and in fact you might sometimes want to choose a slower shutter speed, overexpose the image, underexpose it, or perhaps base the exposure on a completely different part of the picture. That's why you might want to investigate your camera and look for controls that let you tweak the shutter speed and aperture.

Did you know?

The Truth About Shutters

Though I talk quite a lot about shutter speed in this book, the reality is some digital cameras don't have a real mechanical shutter in the same sense that 35mm cameras have shutters. 35mm cameras usually have a physical barrier that blocks light from entering the chamber where the film is stored. This mechanism—the shutter blade—moves lightning fast, able to deliver shutter speeds as fast as 1/8000 of a second. That's fast.

Some digital cameras, in comparison, don't have real, physical shutters. You can test your own camera yourself with a simple experiment: when you press the shutter release on a 35mm camera, you can hear the quick, metallic click of the shutter blade opening and closing. Try that with your camera and listen carefully—it might not make any noise at all. Or it might make an obviously fake "click" sound through the camera's speaker. When I got my first digital camera many years ago, I actually had to look at the LCD display on the back of the camera to see if the picture was captured or if, for some mysterious reason, the camera was still waiting to grab the shot.

So if there's no shutter blade, how is the picture actually taken? If there's no mechanical shutter, the CCD is simply turned on long enough to expose the picture. Since the CCD is an electronic component that acts as the camera's film, it can be controlled electronically for whatever exposure time is needed. In addition, the camera's aperture may close completely to keep light from reaching the CCD—prolonged exposure to sunlight can damage this sensitive part of the camera; but the aperture needn't spring open and closed as quickly as the shutter blade in a 35mm camera, so the sound it makes isn't as dramatic. You'll hardly notice it at all.

Adjust Exposure Manually

The most basic manual exposure control you can exert over your camera involves setting both the aperture and shutter speed. Some digital cameras allow you to set these controls as if you had a fully automatic 35mm SLR. There are two kinds of cameras you may run into with this capability:

- **Point-and-shoot** Most point-and-shoot digicams that include manual settings for aperture and shutter speed require you to use the LCD display to make onscreen menu changes. The camera shown in the following illustration, for instance, uses a pair of buttons on the right side of the LCD display to adjust shutter speed and another set of buttons on the bottom of the screen to change the aperture settings. It isn't hard to do, but you need to remember to first set the camera to its Manual Exposure mode, and then remember which buttons do what for fine-tuning the exposure.

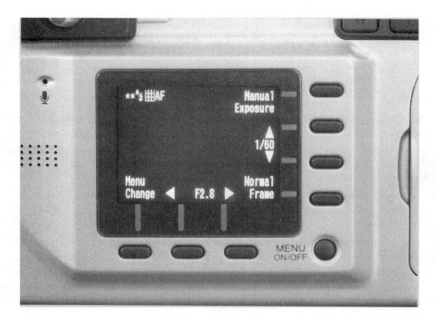

- **D-SLR** Some digital cameras—Digital SLRs, mainly—use traditional SLR-style controls for making manual adjustments to exposure. Specifically, you can turn the aperture ring on the lens to change the f/stop or use a control on the camera to accomplish the same thing, as shown in the following illustration. Shutter speed is likewise affected with a dial on the camera body, and you can look through the viewfinder to keep tabs on the setting.

 To set exposure manually, you must choose a shutter speed and aperture combination that will properly expose your scene at a given ISO. This is a great exercise for new photographers who are serious about learning photography theory.

Use the Sunny 16 Rule

At an ISO of 100, which many digital cameras use for general-purpose photography, you might want to rely on the traditional *Sunny 16 Rule* for a starting point. The Sunny 16 Rule is very old—it dates back to the earliest days of analog photography—and it suggests that when shooting outdoors in bright sunlight, you should choose an aperture of f/16 and a shutter speed that's equivalent to your film speed. Since few cameras offer the ability to choose 1/100, most photographers who rely on this rule use 1/60 or 1/125 when shooting with ISO 100 film. Here is a chart that identifies other acceptable combinations. (All of these add up to the same overall exposure.)

Shutter Speed	Aperture
1/1000	f/4
1/500	f/5.6
1/250	f/8
1/125	f/11
1/60	f/16
1/30	f/22

Keep in mind that these recommendations are just a starting point. Here are some tips that can help you zero in on your ideal exposure:

- Your camera will often recommend an ideal exposure, which you can accept or reject. If the camera considers your setting out of bounds, it may flash a warning in your viewfinder.

- Adjust your exposure based on the ISO setting. If your camera is set to an equivalent of ISO 200, for instance, the Sunny 16 Rule would call for a shutter speed of f/16 and a shutter speed of 1/250.

- Make adjustments for brighter or darker scenes. If you're shooting in a dark room, for instance, the Sunny 16 Rule doesn't really apply—but it's a good starting point. Open the aperture or lengthen the shutter speed to account for reduced light; close the aperture or shorten the shutter speed to account for increased light.

Use Shutter or Aperture Priority Adjustments

Instead of relying on an all-automatic or all-manual exposure system, you can compromise and use your camera's shutter or aperture bias, if it has one. The idea with these controls is that you select either an aperture or a shutter speed, and the camera automatically selects the other half of the exposure for you.

Aperture and shutter priority modes are discussed in more detail in the section "Use Your Camera's Various Exposure Modes." These settings are usually used to find the right balance between freezing (or blurring) motion in a picture and focusing attention on the subject by sharpening (or blurring) the background of an image.

Tricky Lighting Situations

Not all lighting situations are easy to shoot; that's why photography is both an art and a science. Specifically, it's fairly easy for real-life scenes to trick your camera's exposure sensor and consequently under- or overexpose a picture. You can fix that tendency to some degree on the PC afterwards (and we'll talk about how to do that in Chapter 13), but it's much better to expose the picture correctly to begin with. That's because an over- or underexposed image is missing information about colors, texture, and detail that can never be restored afterwards; only at the moment of exposure can you ensure that all the information will be in your image.

What are some examples of tricky photos? There are many, but a few problems tend to surface most frequently. If you or the camera bases the exposure on the darkest part of a scene, the rest of the picture might end up overexposed. Pointing the camera at the lightest parts, on the other hand, can result in overall underexposure.

How to ... Live with Dynamic Range

While digital cameras are just about the equal of film cameras in most respects these days, one area in which they lag behind is dynamic range. Simply put, a digital camera doesn't have the ability to capture the broad range of light and dark elements in a picture.

Most of the time, that's not a serious problem. But in particularly challenging photographic situations, you'll find that your digital camera lacks detail in extremely dark or bright parts of a scene. A common situation is taking pictures in snow—in your final pictures, you may find that the snow is a uniform white, with no subtle color variations. Or in scenes with both shadow and sunlight, the sunlit parts will look very, very bright even if it isn't all that bright in real life. In photographic terms, these areas are said to be "blown out." Likewise, digital cameras are far more likely to blow out a photo when overexposed than a film camera would, so you need to be careful not to overexpose your photographs.

There are a few techniques for dealing with dynamic range issues. You can bracket your photos (something I talk about later in this chapter) or capture multiple versions of the same image, then combine them afterwards on the PC. This is a cool technique that gives you the ability to display a dynamic range even beyond the range of what film cameras can do. See Chapter 8 for details on how to capture stunningly colorful, high dynamic range photos.

There are several solutions to these kinds of problems, and you can experiment to see which works best for you in various situations. Here are some ways you can correct your exposures when you see a problem in the viewfinder:

- **Use exposure compensation** Use the exposure compensation control, sometimes abbreviated as "EV" or labeled with a +/– symbol, to intentionally under- or overexpose your pictures beyond what the camera's exposure sensor recommends.

- **Switch metering modes** Use a different kind of exposure meter to account for high-contrast images.

- **Use exposure lock** Lock your exposure on a different part of the image, and then recompose the picture and shoot.

To see how to use each of these exposure techniques, keep reading.

Use Exposure Compensation

Most digital cameras come equipped with an exposure compensation control, usually referred to as the Exposure Value (EV) adjustment. The EV control, which typically looks like a +/– symbol

like in the following illustration, allows you to use the camera's recommended automatic exposure setting but then adjust that value up or down based on factors that you're aware of but that the camera may not be smart enough to see.

Beware of the flash compensation control, which looks very similar to the camera's exposure compensation but with the addition of a nearby lightning bolt. Adjusting the flash compensation only affects how much light the flash emits, so it won't have any effect on your typical daylight picture. I've seen many folks flummoxed by the fact that the EV control doesn't appear to do anything at all, when in fact they're fiddling with the flash compensation by mistake.

Each Exposure Value corresponds to changing the exposure by one stop, such as going from 1/60 to 1/30 (this is a change of +1 EV since it doubles the exposure) or 1/15 to 1/30 (this is −1 EV since it reduces the exposure by half).

Take Figure 3-6, for example. In the original picture (on the left), the dark stuffed penguin has confused the camera, making it think the scene was properly exposed when, in fact, it is horribly overexposed. The background and the other animal are nearly invisible as a result. When the camera is set to underexpose the scene by one EV (one stop), however, the scene is much better exposed. The image was saved, as you can see on the right side of Figure 3-6.

To use the EV control on your camera, do this:

1. Size up the scene you want to shoot. Decide if it calls for over- or underexposure.

2. If you need to add light to a scene to properly expose it, add exposure by setting the EV control to +1 (some cameras also let you vary the exposure by a fraction of a stop,

FIGURE 3-6 The EV control lets you use your own judgment about exposure values instead of relying exclusively on the camera's meter.

such as .3 or .7). If instead you need to underexpose the scene, set the EV control to –1. Of course, since you can see the results right away in the camera's digital viewfinder, feel free to add or remove EVs until the picture looks about right. Here's a typical digicam display set to EV +2:

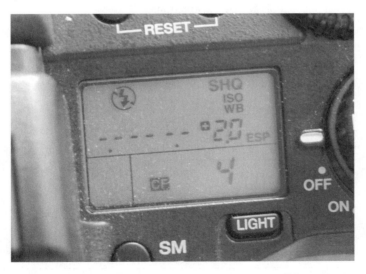

3. Take the picture and review the picture in the LCD display. If you don't like the result, adjust the EV and shoot it again.

Most cameras allow you to adjust exposure by up to three EVs, either positive (overexposed) or negative (underexposed).

You have a digital camera at your disposal, so frame your picture and take the shot. If you don't like the results, you can take it again with different settings!

Switch Metering Modes

As I mentioned earlier, it's really the camera's exposure sensor—known as an *exposure meter*—that does the majority of the work when figuring out how to shoot your picture. It decides how much light is needed to adequately expose your picture. So it should come as no surprise to learn that cameras distinguish themselves by the kind of meter they use. Some meters are better than others at metering a scene and applying the right exposure.

Center-Weighted Meters

In the old days, most cameras came with a simple center-weighted light meter. This meter measures the light throughout the image but applies more weight, or importance, to the central part of the scene in the viewfinder. The assumption—often a good one—is that you are most interested in the stuff in the front of the picture, so the camera tries to get that part of the scene exposed properly. You can see a center-weighted light meter in Figure 3-7. A number of digital cameras still rely exclusively on this kind of meter for ordinary picture taking, and if your camera includes it as an option, it's a useful backup exposure mode if the multisegment metering doesn't work well for an unusual photographic situation.

FIGURE 3-7 Many digital cameras use a center-weighted meter like this one.

Multisegment Meters

Better than center-weighted metering for routine photo situations, *matrix* or *multisegment metering* is shown in Figure 3-8. A camera that uses this kind of metering is usually better at exposing tricky scenes by balancing the lighting needs of several discrete regions within a picture. Instead of concentrating primarily on the middle, matrix meters gauge the light in many parts of the scene at once. If your camera has a matrix meter mode, you should use it most of the time, since it generally delivers outstanding results under a broad range of conditions.

Spot Meters

The last major kind of light meter is a *spot*. The spot meter is never the only kind of meter in a camera; instead, it's an option that you can switch to if the center-weighted or matrix meter fails you. As you can see in Figure 3-9, the spot meter measures light exclusively in one tiny portion of the screen, ignoring the rest of the frame completely. That can come in handy on occasion, but a meter that only measures the light in the central 1 percent of the frame will typically take very poor pictures—either highly under- or overexposed, depending on the situation.

Many cameras use multiple focus points in the viewfinder and let you specify one of the focus points as the spot meter location. The advantage? Say you want to take a picture of a subject that's not in the center of the screen. You can lock in focus using one of the alternate focusing zones and measure the exposure based on that same point as well. Be sure to read your camera manual to see how this feature works on your camera.

So when should you use the spot meter? Any time you are trying to photograph a scene in which a small subject must be exposed properly for the picture to work and its lighting is

FIGURE 3-8 Cameras with a multisegment meter are usually more accurate because they accumulate exposure information from several distinct regions of the frame (like the five regions shown here) and then use a sophisticated algorithm to decide the final exposure for the picture.

FIGURE 3-9 The spot meter is a great tool for reading the proper exposure in one precise point of the image.

different enough from the rest of the scene that you're worried it won't come out right otherwise. Imagine, for instance, that you are trying to photograph someone who is standing in front of a brightly lit window. If you let the camera decide the exposure, the bright light from the window will radically underexpose the subject. So switch on the spot meter and expose the picture based on the subject. Yes, the window light will be overexposed, but that's okay—the important part of the picture is the person.

Varying the metering mode—especially the spot meter—is best used in conjunction with the third technique, exposure lock.

Use Exposure Lock

Not all cameras offer exposure lock, but those that do are a godsend. Exposure lock is usually achieved by applying slight pressure to the shutter release—not enough to activate the shutter and take the picture, but enough that you feel the button move and the camera itself respond. Here's what happens when you take a picture:

1. Apply slight pressure to the shutter release button.

2. As you feel it depress slightly, the camera's autofocus lens locks the current subject into sharp focus.

3. At the same time, the camera's exposure meter measures the light and locks in an exposure.

4. Apply more pressure to the shutter release to press it in all the way. The camera then takes the picture and saves it to memory.

Some cameras use a separate button to lock the exposure. Refer to your camera's manual to see if it has exposure lock and how to use it.

The magic of exposure lock is that as long as you continue applying pressure to the exposure lock control, the camera will use that locked-in exposure information regardless of where you later point the camera. You can lock in exposure information for the sky and then point the camera at your feet and snap the shutter release all the way. You'll take a picture of your feet using the sky's exposure data. You probably wouldn't want to do that since the result will be totally underexposed, but it gives you an idea of the potential.

Some digital cameras have a separate focus lock and exposure lock control; you should check your camera's manual for details. In such cameras, there's a separate button somewhere on the camera (usually where your thumb would fall on the right side of the camera body), possibly labeled AEL (short for *auto-exposure lock*). To use it, point the camera where you want to lock exposure settings and press firmly down on the AEL button. Continue to hold the button down while you recompose the photo, and then take the picture by pressing the shutter release.

Exposure lock is a great tool for telling the camera that you'd like to take a picture with the exposure data from one specific part of the scene.

Instead of taking a picture that averages all the light values to give you an average picture, here's what you should do, step by step:

1. Frame the scene in your viewfinder so you know what you want to photograph.

2. Before actually taking the picture, point the camera up into the sky. Include the brightest part of the sky that doesn't also include the sun—that might be overkill. Sounds like guesswork? It is, a little. This is art, not science. You can take the picture, see if you like the result, and reshoot as necessary.

3. Press the shutter release partway to lock in the exposure information. You should sense that the camera has also locked the focus at the same time.

4. Recompose your picture. When you're happy with the scene in the viewfinder, press the shutter release all the way to take the picture.

Obviously, you could also choose the spot meter (if your camera has one) and lock the exposure with that instead of the default center-weighted or matrix meter in that you used in steps 2 and 3. It's up to you. Take a look at Figure 3-10. This is a real challenge for most cameras, since the subject is a wolf sunning itself in an isolated patch of light. A center-weighted camera would probably average the light in the darker surrounding areas and determine that it needed to select a fairly wide-open aperture to add light to the scene. But that would wash out the poor little wolf. Instead, the best solution is to select the spot meter, frame the wolf carefully, and press the shutter release partially to lock in exposure on the bright subject. Then reframe the picture and shoot.

As you become more confident with your ability to visualize compositions and exposures, you can try different things to get the desired effect.

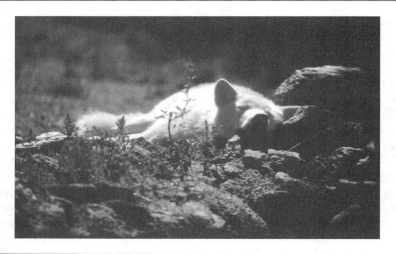

FIGURE 3-10 This wolf is lit very differently than the rest of the scene, so a spot meter is the easiest way to accurately expose the wolf's fur.

How to ... Bracket for Success

A common photographic technique that you might occasionally want to try is called *bracketing*. Bracketing your photos is simply the process of taking several pictures, each with a slightly different exposure, so at least one of them will look the way you want. When you're done, review all the bracketed pictures on your PC and discard the ones you don't like.

Suppose you're trying to take a silhouette, for instance (something I'll talk about in more detail in Chapter 5). You need to make sure the subject is sufficiently underexposed that it appears totally dark, with no detail. How can you do that? There are two common methods for bracketing:

- **Use your camera's auto-bracketing feature** Many digital cameras have something called auto-bracketing—turn it on, and it'll take three pictures in quick succession when you press the shutter release. One will be the "proper" exposure, but it'll also capture slightly over- and underexposed images for insurance.

- **Use exposure compensation** Take one picture normally, and then take additional photos after changing the EV dial to under- and overexpose. You should start with exposure variations of a half-stop or full-stop (1/2 or 1 on the display), since more than a full stop of exposure compensation can be dramatic.

When to Take Control

As I mentioned at the outset, you may often be perfectly satisfied with the results you can get from the automatic exposure controls in your camera. But there will be times when you can do better on your own. Keep your eyes peeled for situations like those described next.

Very Bright Sunlight

Very bright sun can overwhelm your camera, especially if the scene is filled with brightly colored clothing, reflective surfaces, or other tricky subjects. You can reduce the exposure for better exposure. Underexpose the scene by EV −1 for starters and see if that helps.

Backlit Subjects

If you are taking a picture of someone or something and the sun is behind the subject, you're usually in trouble—the bright background will cause the camera to underexpose the scene. That means the subject itself will look like it's in shadow. You'll get this if you follow the old (and very wrong) rule to put the sun behind the person you're photographing. The best way to shoot an outdoor portrait is to put the sun over your shoulder. Nonetheless, if you find the sun behind your subject, overexpose the scene, such as with an EV +1. Of course, this may overexpose the background, but that's probably okay—your priority is properly exposing the subject in the foreground.

TIP *Try wearing white clothing—it'll essentially turn your entire body into a giant reflector, sometimes allowing you to put the subject between yourself and the sun.*

Low Light

In low light, such as at night, indoors, or under thick cloud cover, you can often get better results by overexposing the scene slightly, such as with an EV +1. Vary the EV level depending on how dark the scene actually is.

Use Your Camera's Various Exposure Modes

Almost every digital camera on the market makes it easy to take quick-and-dirty snapshots using an automatic exposure mode. Automatic exposure is great much of the time, but I hope that you will sometimes want to get a little more creative. And when that happens, you may need to adjust the exposure of your photographs.

Not all cameras offer the same exposure controls, but here's a rundown of the most common ones, and when you would want to use them:

- **Automatic** In this mode, both shutter speed and aperture settings are selected by the camera to match the current lighting. Some digital camera automatic modes try to select the fastest shutter speed possible in order to minimize camera shake when you take a picture, while most choose something in the middle, a compromise between

How to ... Consider Exposure When Taking a Picture

Most of the time, you can just compose your shot and press the shutter release. But don't forget to adjust the exposure when necessary. Use this decision process:

1. Do I need to adjust the depth of field—that is, make the background more or less sharp compared to the foreground? If yes, then adjust the aperture/shutter or use the aperture priority mode, discussed in detail in the next section.

2. Do I need to change the shutter speed to depict motion in the picture? If yes, then again try to adjust the aperture/shutter, or instead use the shutter priority mode, discussed in detail in the next section.

3. Is the scene significantly brighter or darker than the camera is designed for? If it is, under- or overexpose the scene.

4. Is the subject backlit, such as with the sun behind? If so, overexpose the scene.

5. Is the subject especially bright, such as on fresh, bright snow? Try underexposing.

6. Do I want to expose the scene based on the lighting in a specific part of the scene? If so, use a spot meter or just lock in the exposure for that part of the picture and recompose the scene.

speed and depth of field. There's generally nothing you can do to change the settings that the camera chooses when set to fully automatic, except for adjusting the exposure compensation (EV) dial to over- or underexpose the scene.

■ **Program** The program mode (usually indicated by the letter *P* on your camera's dial or LCD display) is similar to an automatic mode. Although the camera selects both the aperture and shutter, you can generally modify the camera's selection by turning a dial or pressing a button. The effect: you can increase or decrease the shutter speed, and the camera will adjust the aperture to match. This is a good compromise between fully automatic operation and manual selection. Use this mode if you don't want to worry about devising your own exposure values but still want some say over the shutter speed or aperture.

TIP *The program exposure mode is often the best all-around setting for your camera. In this mode, the camera chooses a good exposure setting, but you can turn a dial to tweak the shutter speed. The camera will instantly compensate by changing the aperture setting, keeping the overall exposure the same.*

■ **Scene** Many digital cameras come with a handful of scene modes with names like Night, Portrait, Sand & Snow, Sports, and Landscape. Select the scene name that best represents the kind of picture you're trying to take, and the camera will automatically set the depth of field, exposure, and other factors to give you a good picture. Sports mode sets the shutter speed very high, for instance, while Sand & Snow compensates for the very bright background, which would otherwise underexpose your photo. When used appropriately, these scene modes work great and let you properly expose a wide variety of settings with little effort. Cameras with just a few scene selections may place the icons on the body (such as on a control dial; see the following illustration), while cameras with many scene selections tend to place them in the onscreen menu.

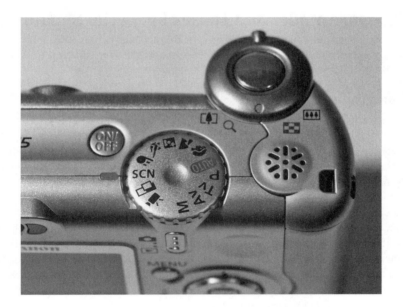

■ **Shutter priority** This setting is usually indicated by the letter *S* on your camera's mode dial or LCD display. Using this mode, you can dial in whatever shutter speed you like, and the camera accommodates by setting the appropriate aperture to match. This mode is ideal for locking in a speed fast enough to freeze action scenes, or slow enough to intentionally blur motion. If you are trying to freeze a fast-moving subject, you might find that you can't select a really fast shutter speed. That's probably because there's insufficient light. To fix that, increase the camera's ISO setting, which will make the sensor more sensitive to light and let you shoot with a fast setting. Remember to return the ISO to its default setting when you're done.

■ **Aperture priority** This setting is usually indicated by the letter *A* on your mode dial or LCD display. Using this mode, you can dial in the aperture setting you like, and the camera accommodates by setting the appropriate shutter speed. Use this mode if you are trying to achieve a particular depth of field and you don't care about the shutter speed.

■ **Manual** The manual mode (typically indicated with an *M*) is like an old-style noncomputerized camera. In manual mode, you select the aperture and shutter speed on your own, sometimes with the help of the camera's recommendation. This mode is best used for long exposures or other special situations when the camera's meter is not reliable.

Choose Exposure Modes and Lenses in Special Situations

Now that you know what your camera's various exposure modes are for, you can think about using them when you encounter unique photographic situations. Every situation is a little bit different, but here are a few general guidelines that can get you started.

Portrait Photography

Taking pictures of people can be fun but intimidating. It's hard to get a natural pose from people when they know they are being photographed. The best way to capture good portraits is to work with your subjects so they are a little more at ease. If you're trying to capture spontaneous, candid moments, then back off and try to blend in with the background. If you're trying to capture a fairly formal-looking portrait, you have a little more work cut out for you. It's up to you as the photographer to put your subjects at ease. Talk to your subjects and get them to respond. If you can get them to loosen up, they'll exhibit more natural responses and look better on film. Take pictures periodically as you pose your subjects to get them used to the shutter going off, even if it isn't a picture you intend to keep.

Digital cameras have a cool advantage for portraiture that film SLRs don't: the LCD display lets you put your subject more at ease. Try framing your picture using the LCD display, keeping the camera some distance away from your face. That leaves you free to interact with your subject without having an intimidating camera obscuring your head.

The best way to capture portraits is typically with the medium telephoto lens: in the 35mm world, that would be about 100mm. For a typical digital camera, that's near the maximum magnification for your zoom lens. You can see such a portrait in the image on the left in Figure 3-11. The version on the right, which has a fish-eye appearance, is what happens when you take a portrait too close, with the lens set to its wider position. It's also a good idea to work in aperture priority mode if possible. Aperture priority will allow you to change the depth of field quickly and easily as you frame your images. Specifically, good portraits have very shallow depth of field. You want to draw attention to the subject of your picture and leave the background an indistinct blur.

FIGURE 3-11 Portraits tend to work best with a moderate telephoto magnification and low f/numbers.

> **TIP** *You can't see the effect of aperture on depth of field in the optical viewfinder, but the LCD display can show you the depth of field. To see it, press the shutter release halfway down. That locks in the focus and triggers the aperture to close to the proper position for the impending picture. It's now—with the shutter halfway depressed—that you can see the depth of field in your picture. Even so, depth of field can be a hard thing to see, especially on an LCD display in bright daylight.*

Action Photography

Action photography is often considered the most exciting kind of photography, but it's also the most demanding for both your technique and your equipment. As in all kinds of photography, you can no doubt take some great pictures with anything from a wide-angle lens all the way up to the photographic equivalent of the Hubble telescope. And wide-angle lenses do, in fact, have a role in action photography. But the essence of many action shots is a highly magnified immediacy—something you can only get with the telephoto lens.

The shutter priority setting on your digital camera was born for action photography. To freeze action, you'll need to use a fairly fast shutter speed. Luckily, this higher shutter speed works to

your advantage by opening up the aperture and diminishing the depth of field; this focuses the viewer's attention specifically on your subject. On the downside, of course, focusing is more critical since the depth of field is more shallow.

Nature and Landscapes

Unlike action photography and portraiture that rely on telephoto lenses to compress the action into an intimate experience, landscapes typically work best with wide-angle lenses that allow you to include huge, expansive swaths of land, air, and sea in a single frame. Zoom out for best results most of the time, and adjust the camera's exposure in aperture priority mode (if possible) to get deep or shallow depth of field, depending upon what works best for the picture in question.

Chapter 4

Composition Essentials

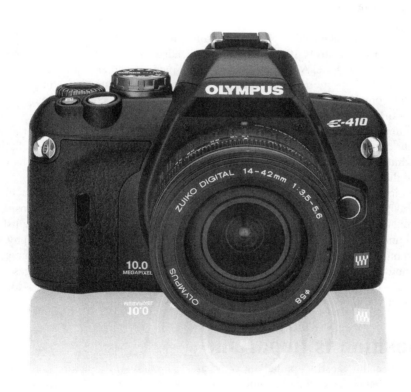

How to...

- ■ Use the rules of composition to take compelling photos
- ■ Take less cluttered snapshots by emphasizing a focal point
- ■ Take interesting photos with the rule of thirds
- ■ Avoid cropping out important pixels by filling the frame
- ■ Use lines and symmetry for artistic images
- ■ Break the rules for more engaging photos
- ■ Understand the relationships among shutter, aperture, and depth of field
- ■ Employ depth of field for pictures that emphasize the subject
- ■ Zoom a lens to achieve the right field of view
- ■ Apply rules of composition to common photographic situations

What does it take to take a good picture? Certainly, it requires more than a mastery of your camera's various controls. If that were all you needed, anyone who knew how to read a camera manual could be Ansel Adams. No, taking good pictures demands a little creativity and a touch of artistry. Perhaps more importantly, though, it takes a solid understanding of the rules of photographic composition and some knowledge—which you can acquire as you get better at photography—of when it's okay to break those rules.

Composition is all about how you arrange the subjects in a picture and how you translate what is in your mind's eye—or even right in front of you—into a photograph. After all, the camera sees things very differently than you do, and in order to take great photographs you have to understand that and learn how to see the world the way your camera sees it.

Taking a picture with a digital camera is really no different than taking a picture with a 35mm camera. That's why in this chapter we will be talking about the rules of composition: what they are, how to use them, and how to break them. If you are already an accomplished photographer and you're reading this book to make the transition to digital photography, you may not need most of what I offer in this chapter. But if you're not an expert, I encourage you to study this chapter. It is only through an understanding of composition that your images will go from snapshots—the ones that bring comments like "What a nice picture of a cat!"—to potential works of art that you'll be proud to frame in your dining room.

Why Composition Is Important

Have you ever been on vacation, pulled out your camera upon seeing a picturesque view, but later been somewhat underwhelmed with the final results? If so, you just learned the first rule of photography: reality, as seen by your camera, is quite different from what you see with your own eyes. If you frame all of your pictures without taking that into account, you will always be disappointed.

There are a few reasons why what your camera sees is different from what you see. First of all, your eyes aren't little optical machines that function in a vacuum. Instead, all that you see is supplemented, enhanced, and interpreted by your brain. In a sense, when you see a majestic landscape while hiking through the backwoods of Kauai, some of the splendor of the scene is actually being added by your mind. Lift the camera to that same view, and you get a totally objective representation of the scene, without any intelligent enhancements.

And then there's the fact that a camera has a much more limited range of focus, exposure, and composition than you do. When you look at a scene like the Hawaiian landscape I just mentioned, you might think you're seeing a fairly static scene with your eyes. But that's not really the case. In fact, as your eyes dart around, you are constantly recomposing the scene, since you can dynamically change the visual "frame" in which you are viewing the scene. To make matters a bit more complex, the aperture of your eyes, called the pupil, changes size constantly in response to changing lighting conditions and where you're looking. The result? You don't realize it, but your eyes, working in conjunction with your brain, are creating a visual feast that is difficult, if not impossible, to reproduce on paper or your computer screen.

In comparison, it's amazing that we can get good pictures at all with a camera. Film—and by film I mean both 35mm and digital—has a much narrower exposure range than your eyes because the aperture freezes a single instant in time with a fixed set of lighting conditions. And unlike the magical pictures in the *Harry Potter* books, real photographs cannot change their composition or framing on the fly. What you see in the viewfinder is, unfortunately, what you are stuck with forever.

What We See

Look around. What do you see? If you look carefully, you'll notice that your field of vision is a rectangle with rounded corners—almost a wide ellipse. In other words, we see the world panoramically. While there are techniques for creating panoramic photographs (which we'll cover in Chapter 14), most of the time this is not the kind of shot we take.

Nope—our job as photographers is to take the panorama that we see with our own eyes and translate it into an attractive photograph using the laws of photographic composition. As you can see in Figure 4-1, there's often more than one way to frame a picture; it's really your job to decide which works best for the kind of photograph you are trying to achieve. In this situation I had an extremely rare opportunity to photograph endangered monk seals, so I shot many different compositions.

Rules of Composition

For a few pages now I have been alluding to the rules of composition. I hope that you're curious about what they might be. In truth, the rules of composition are no more rigid than rules of etiquette or the rules of web page design. Certainly, those rules can be important, but they're simply guidelines to help us get the job done. If you violate any of these rules, nothing awful

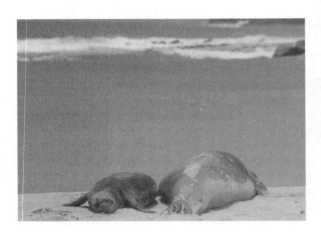
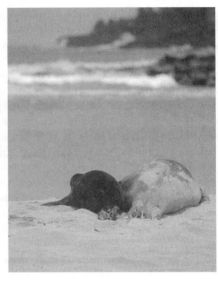

FIGURE 4-1 Changing the composition of a picture by turning the camera 90 degrees can completely change the effect a photograph has on its viewer.

happens (unless you're still living at home when you break the rules of etiquette). And that's why you'll be able to break these rules later on. To begin with, however, you need to learn the rules and apply them.

Isolate the Focal Point

I know what you're wondering: what is the focal point? The *focal point* is the main subject of your picture, such as a building or perhaps a person. In other words, the focal point is the main point of interest that the viewer's eye is drawn to when looking at your picture.

You should always strive to consider what the focal point of your picture is and then plan your photos accordingly. In my experience, the single biggest problem with photographs taken by new photographers is that they fail to consider what their subject actually is. When you don't know what you're taking a picture of, it's hard to emphasize that element in the final composition. That leads to muddy, confused arrangements in which there is nothing specific for the viewer to look at. Take a look at Figure 4-2, for instance. In the image on the left, there is no real focal point, and thus there is nothing for the viewer to concentrate on. The photographer should have decided what the subject was and then rearranged the image to emphasize that. Indeed, all I would ask of this picture is, "Why did the photographer take it?" Contrast that with the image on the right, which has a specific subject to draw your eye.

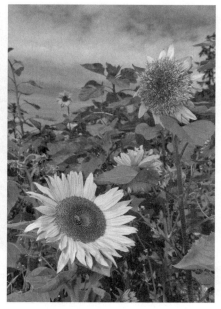

FIGURE 4-2 Without a focal point, your eyes wander the picture aimlessly, looking for something of interest. Choose a subject and compose your picture accordingly.

When your subject is simply too expansive to be considered a focal point in and of itself, try to contrive a focal point that adds some relief for your viewer. You might try such an approach when you are photographing a mountainous landscape, for instance. In fact, landscapes really benefit from this approach. A tractor, a mountain cabin, or a gaggle of hikers near the horizon allow the viewer's eyes to rest on something familiar, even though the real subject fills up most of the frame. Technically, this is called a secondary focal point. You can see how I used this technique in Figure 4-3 to give the viewer a visual resting spot when looking at the backdrop of mountains. Remember: photography is subjective, and I did not intend for the cabin to be the photo's subject. Instead, the mountains were the subject, but by themselves they would make a terrible photograph.

TIP *As a general rule, you want only a single focal point in your photograph. More than one main subject is distracting, and viewers won't really know where to look. If I show you a photograph in which several objects have equal visual weight, you probably won't like it, even though you may not be sure why. It is certainly possible to include multiple focal points in an image, but you should do it with care, and only after you have mastered the basics.*

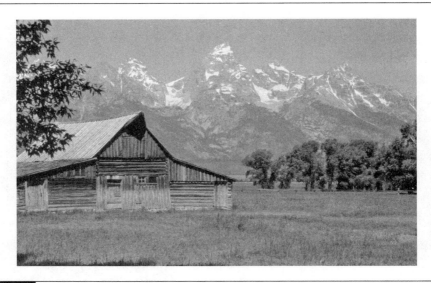

FIGURE 4-3 Secondary focal points add interest to landscapes (and many other sorts of pictures).

Use the Rule of Thirds

Many snapshot photographers don't really think much about the organization of what they see through the viewfinder, so the *rule of thirds* helps restore some balance to their photographs. And though this is the second rule I'm going to talk about, in many ways I think the rule of thirds is the single most important rule of photography that you can learn and apply.

Here's what you should do: in your mind, draw two horizontal and two vertical lines through your viewfinder so that you have divided it into thirds. In other words, your image should be broken into nine zones with four interior corners where the lines intersect. (See Figure 4-4 for an example of this technique.) It is these corners that constitute the "sweet spots" in your picture. If you place something—typically the focal point—in any of these intersections, you'll usually end up with an interesting composition.

This really, really is the golden rule of photography. Thumb through a magazine. Open a photography book. Watch a movie. No matter where you look, you will find that professional photographers follow the rule of thirds about 75 percent of the time. And while the rule of thirds is very easy to follow, you may find it somewhat counterintuitive. Many people try to put the focal point of their picture dead smack in the middle of the frame. And trust me—there are few things in life more boring than looking at a picture in which the subject is always right in the middle. Compare the two images in Figure 4-5. I think you'll agree that the one on the right, in which the subject is not in the center, is the more interesting photograph.

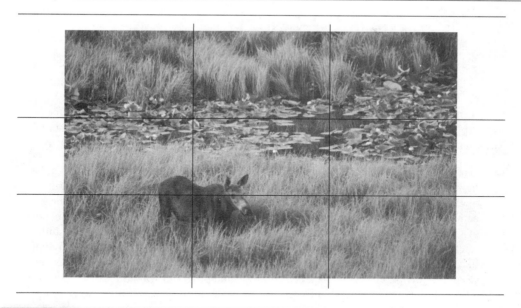

FIGURE 4-4 Every picture has four "sweet spots" to which the eye is naturally drawn.

FIGURE 4-5 As a general rule, avoid putting your focal point in the dead center of the photograph.

How to ... Focus Off-Center

Rules like "have a clear, definite focal point" and "use the rule of thirds" should indicate that being able to focus on a subject that isn't smack in the middle of the frame is really important. It's so important, in fact, that cameras have several ways of making sure you can focus sharply on an object that's somewhere other than the center of the viewfinder. There are two main techniques photographers use to focus, and you should practice both of them:

- **Use focus lock** Virtually all digital cameras have a two-step shutter release—press lightly on the button (so it only goes half-way down), and you set in motion a series of events in which the camera prepares to take the picture. Most importantly, the camera measures the distance to the subject in the autofocus zone (usually the center of the viewfinder) and locks focus. As long as you keep some pressure on the shutter release, you're now free to reposition the camera and compose the shot any way you like. When the scene is composed to your liking, just press down the rest of the way to capture the photo. Focus lock is a common and powerful way to lock the focus on a person, then recompose slightly to put him or her in the rule of thirds sweet spot.

- **Use focus zones** Many cameras—especially models with multisegment metering (see Chapter 3 for an explanation of that)—let you control what part of the viewfinder is used as the focusing zone. Instead of focusing from the center and using focus lock to recompose the shot, you can use a control on the back of the camera to tell the camera to focus using a zone on the right, left, top, or bottom of the viewfinder, like the ones depicted in the following viewfinder illustration. That way, you never need to focus lock and recompose. Just set the active focus zone over the subject and take the shot. With practice, you can change focus zones using your thumb without ever looking away from the scene in the viewfinder.

Why use a focus zone instead of focus lock? Good question. For some people, it's just a personal preference. For others, it can be a question of focus accuracy. Imagine you focus on something in the middle of the scene, and then twist your body slightly to recompose the shot. As you can see in the following illustration, the camera is now set to focus at a closer distance than the true distance to the subject. In some focusing situations, it can make the difference between "almost sharp" and "tack sharp." As a result, focusing using zones is usually better than using focus lock and then moving the camera.

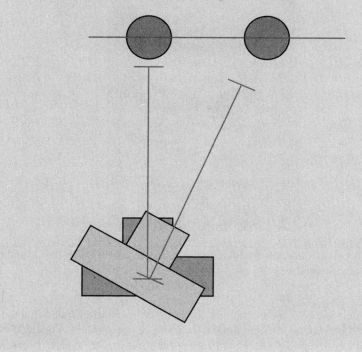

Fill the Frame

Don't forget to get the most mileage you can out of the frame in which you're working. What the heck does that mean? Essentially, all I am saying is that you should minimize the amount of dead space in a photograph. Once you decide what the focal point of your image is (remember the golden rule of photography!), there's no reason to relegate it to a small portion of the picture. Get close. Zoom in. Walk over to it. Whatever you need to do, do it in order to keep your focal point from being a small part of the overall image. Take a look at Figure 4-6, for instance.

FIGURE 4-6 This shot is uncomfortably close—thanks to a long zoom lens—and that's why it is so captivating.

When I visited London and took pictures of the changing of the guard, I found that the common wide-angle shots of the event resulted in rather unimpressive photographs. I decided that the real star of the show was the guard's face, so I zoomed in for a very tight shot. Certainly, all of your photographs don't need to be this close. Getting a tight shot of your subject is not always a natural or intuitive thing to do; so you should go out of your way to try this technique whenever you think of it.

The "fill the frame" rule certainly applies in the world of film photography, but it is true in digital photography as well. If you are using a 3-megapixel digital camera, for instance, the best you can hope to do is print your photograph at 8×10 or perhaps, if you're lucky, at 11×17 inches before the pixels start to become obvious. (See Chapter 17 for details on printing.) That's probably enough resolution for most practical applications, but imagine what would happen if you cropped your image because the subject was too small in the original composition. If you crop out half of the pixels in the photo, you end up with not 3 megapixels, but only about 1.5 megapixels in the final photo—and you'll have a really hard time getting a good-looking 8×10-inch photograph with the resulting crop.

Move the Horizon

This rule is closely related to the rule of thirds. If you follow the rule of thirds to the letter, you probably won't make this mistake anyway, but it is important enough to mention explicitly.

No doubt you have seen photographs in which the photographer chose to place the horizon right in the middle of the photograph. Actually, the photographer probably did not make a conscious decision to do this—if he or she had, then the horizon probably would have ended up somewhere else.

Running the horizon right through the middle of a photograph is akin to putting the subject smack dab in the middle. It's boring because it violates the rule of thirds. Instead, try putting the horizon along a rule of thirds line. As you can well imagine, that actually gives you two choices for where to put the horizon in any given picture. You can put the horizon in the top third or the bottom third of your composition. How do you decide which? It's easy: if you want to emphasize the distant landscape and sky, put the horizon on the bottom third line. If you are taking a seascape where you want to emphasize the foreground, such as in Figure 4-7, the horizon belongs in the upper third of the picture. Of course, these are guidelines. Digital film is cheap—in fact, it's basically free. Experiment.

FIGURE 4-7 The horizon usually works best well above or below the center of the picture.

Use Lines, Symmetry, and Patterns

Photographs are two-dimensional representations of three-dimensional scenes. The question, then, is how best to lead viewers through a picture so they get a sense of the real depth that the image is trying to depict.

The answer to that question is simpler than you might think. When you compose an image in the viewfinder, look for natural or artificial lines that might lead the viewer's eyes through the photo. These lines can create a sense of depth and perspective that is often lost in the two-dimensional photograph. Lines can be formed in almost any situation: you might see a row of trees, the shape of a skyscraper from the ground, or the route of the backyard fence. Personally, I enjoy using the natural flow of a stream or road to lead the eye from one end of the picture to the other. Figure 4-8 has two examples of this technique.

While lines like these can fit in with any kind of lens or composition, you may find that this works best when seen through wide-angle lenses. That's because telephoto lenses compress your scene and make it harder to see long, sweeping lines.

Another trick of the trade is to look for repetition and patterns and incorporate those into your image, like the image on the right in Figure 4-8. Patterns, like those that you see in nature or manmade objects, can create interesting effects. Like lines, they can add a sense of depth to your images. Try combining these patterns with a sense of symmetry. When you employ symmetry, you are balancing both sides of the photograph. That can also help lead the eye through your image.

FIGURE 4-8 A long, straight road is a powerful tool for creating a sense of implied motion in a photograph. Alternately, look for patterns to accentuate your photos, like the shapes formed by the field on the right.

Keep the Horizon Straight

This may seem obvious, but how many times have you seen a photo in which the horizon was a little cockeyed? Vertically oriented pictures can get by with a slightly off-kilter horizon, but if you take a horizontally oriented image and the horizon is not straight, it affects the feel of the photograph. Try to be as careful as possible while photographing an expansive horizon. But if you goof, remember that it's a digital photo. You can always correct for an angled horizon on the computer (see Chapter 13). Any time you rotate or otherwise perform a "correction" on a photograph on your PC, though, you degrade the image ever so slightly. That's something to keep in mind if you want to preserve very high quality.

Use Foreground to Balance the Background

If you're trying to photograph a distant subject—a landscape or cityscape, for example—a common trick is to place something of interest in the foreground to provide a sense of balance. When done well, the viewer's eyes are drawn immediately to the foreground object, and then they'll wander to the background. This is a very effective technique for adding a sense of depth and perspective to a photograph, as well as giving the foreground a sense of scale. Figure 4-9, for instance, demonstrates this technique.

Every Picture Tells a Story

Throughout this chapter, and in fact throughout the book, you'll notice references to "leading the viewer through a picture." What do I mean by that? Well, when you've done your job as a photographer, you've created an image with depth, motion, and some sort of story. When you look at a good photograph or painting, your eyes naturally start in one place and move to another. That's in sharp contrast to a typical snapshot that has no particular story to tell; the focal point is haphazardly placed, and it's cluttered enough that there's no obvious path for the eye to take. Good artists can use techniques like lines, symmetry, patterns, and multiple focal points to lead the viewer in a specific way through an image. If you can create an image like that, consider it a success.

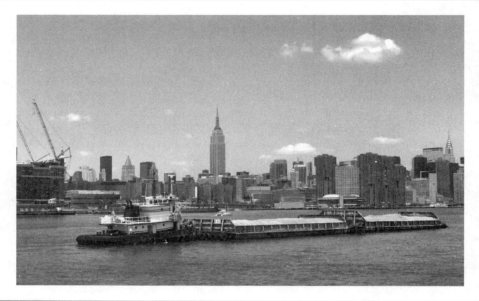

FIGURE 4-9 The barge in the foreground is the anchor that gives the New York skyline a sense of perspective.

Know When to Break the Rules

Now that I've spent the last few pages telling you what the rules of composition actually are, we can talk a little about how to ignore them.

Don't get me wrong—I love the rules of composition, and I think you should follow them. After you become comfortable with concepts like the rule of thirds and filling the frame with the focal point, however, you'll find that you can take even better pictures by bending or breaking those same rules. This is an area of photography that is best experimented with and learned on your own, but here are a few pointers to help you get started:

- **Change your perspective** Technically, we're not breaking any rules of composition here, but this is something that few people think about, yet it can have a profound impact on the quality of your photos. Simply put, experiment with different ways to view the same scene. Try taking your picture by holding the camera horizontally, and then see how you might frame the picture by turning the camera vertically. Take a look at the picture in Figure 4-10. I originally took this picture as you see it on the left. Afterwards, I found that I liked the picture better when I cropped it for a horizontal orientation. As it turns out, most people prefer the original framing, but that's okay: experiment and

FIGURE 4-10 Experiment with taking your pictures from many different angles, orientations, and perspectives. After all, you're not paying for the film anymore!

don't be afraid to try something even if no one else thinks it's a good idea. Get low to the ground or stand up on a chair or table to get a higher perspective on the same scene. You have a lot of options: try them.

- **Ignore symmetry** Sure, symmetry is great. But just as often as symmetry works well in a photograph, I have found you can get an even better image if you intentionally skew the photo to strip out the symmetry. When the viewer expects symmetry and doesn't get it, you have introduced tension and drama into an image. And that's not bad, especially if all you've done is photograph some road, train track, or river.

- **Surprise the viewer** If you've seen one landscape or sunset, you've seen them all. That's not really true, but it can sometimes seem that way. Go for the unusual by framing your picture in a totally unexpected way. One of my favorite tricks is shooting landscapes through the side view mirror of a car—you can see it in Figure 4-11.

- **Use several focal points** While most pictures rely on just one or two focal points, sometimes you need even more, especially when you're shooting a picture like a family portrait. If you're taking a picture with several people in it, you can often overcome a cluttered look by arranging the subjects into a geometric pattern. If the subjects' heads form a triangle shape, for instance, you have introduced order into the photo despite the fact that there are a lot of people in it.

FIGURE 4-11 Successful pictures are often a matter of surprising the viewer.

Use Depth of Field

The last important frontier that you need to understand for proper composition is called *depth of field*. Depth of field refers to the region of proper focus that is available to you in any photographic image. When you focus your camera, you don't get a paper-thin region of proper focus in an image; instead, there's some distance in front and behind your subject that will also be in focus. This entire region of sharp focus is called the depth of field, or sometimes the depth of focus.

What determines depth of field? There are three factors that contribute to the depth of field that is available to you for any picture you plan to take. Let's look at these factors one at a time and then combine them.

■ **Aperture** The aperture of your lens is the first major factor that influences depth of field. We talked about aperture back in Chapter 3—it's the size of the lens opening that determines how much light reaches your camera's imaging sensor. Aperture is measured in f/stops, where lower f/numbers represent bigger openings and higher f/numbers

represent smaller openings. In addition, the smaller the aperture's actual opening (in other words, the higher the f/number), the greater the depth of field will be. As you can see here, the aperture of your lens directly influences how deep the depth of field is in any given picture:

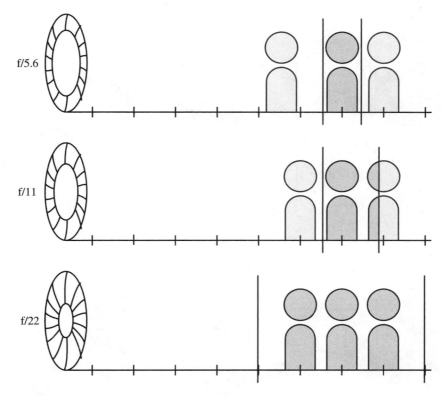

■ **Focal length** As we will discuss in the upcoming section "Get the Most Out of Your Zoom Lens," focal length is just a measure of your lens's ability to magnify a scene. And while most people focus on a lens's magnification, depth of field plays an important role here as well. In simple terms, the more you magnify your subject, the less depth of field you have available. When shooting with a normal or wide-angle lens, you have a lot of depth of field. If you zoom in to a telephoto magnification, your depth of field drops dramatically. Likewise, macro photography (also known as close-up photography) has

very little depth of field, since you are greatly magnifying a small object. See Chapter 6 for details on macro photography. This illustration graphically demonstrates the effect of focal length on depth of field:

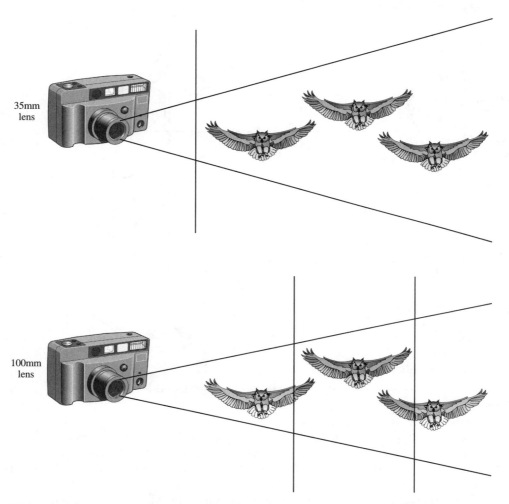

■ **Subject distance** Last but not least, your distance from the subject determines how much depth of field you can get in your scene. If you photograph a subject that is far away, the depth of field will be much greater than it is for a subject that is close to the camera. In practical terms, that means the region of sharp focus for a macro shot, where the subject is only a few inches from the camera, is extremely narrow, and you need

to focus very, very precisely. If you're photographing something very far away, like a distant horizon, a vast region in front of and behind the image will be in sharp focus. Here is what this looks like graphically:

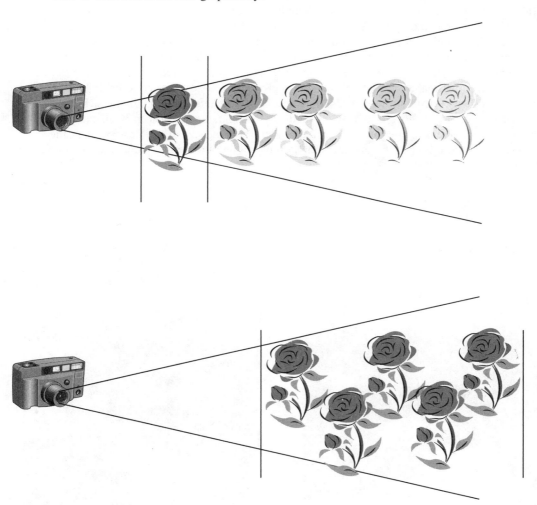

Apply Depth of Field to Your Pictures

As you can imagine, these three factors—aperture, depth of field, and subject distance—work together in any shooting situation.

Specifically, suppose you try to take a picture with an aperture of f/5.6. At a given distance from your subject, and at a given focal length, that f/stop will yield a certain depth of field. But what happens if you change the other two factors? If you get closer to the subject, such as if you walk toward it, or if you increase the focal length by zooming in, the depth of field decreases.

So what is the point of all this? Why do you care about depth of field at all? The answer is that depth of field is an extremely important element in the overall composition of your photographs. Using depth of field, you can isolate your subject by making sure it is the only sharply focused person or object in the frame. Alternately, you can increase the depth of field to make the entire image—from foreground to background—as sharp as possible. Figure 4-12 shows the effect of depth of field on a simple portrait; on the left, the child in the background is in sharp focus thanks to a deep depth of field. On the right, nothing has changed except the f/stop. By decreasing the f/number (and thus increasing the size of the lens opening), the background child is now blurry and indistinct. I think either of these two pictures would make a great album cover for some psychedelic band. But I digress.

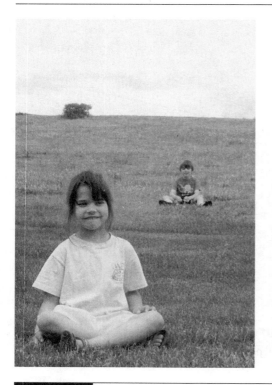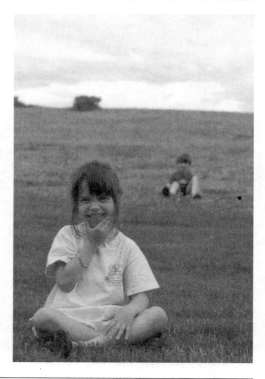

FIGURE 4-12 Varying the aperture changes the depth of field

How to ... **Take a Zoomed Picture**

Not all special effects need to be done inside a computer. The *zoomed* picture, like the one following, is a good example of a special effect that you can do "in the lens" of your camera without doing any processing on the computer whatsoever. Unfortunately, there are very few digital cameras that will let you achieve this effect. To take a zoomed picture, you need a digital camera that allows you to change the zoom setting during the exposure; generally, only professional SLR-style digital cameras are capable of this feat.

If you do have a camera like the Olympus e20n or the Nikon D100, however, here's how to do it. Start by choosing a scene that you want to zoom through. You'll get the best results with a brightly colored subject and a simple background that won't be too busy. Mount your camera on a tripod to minimize camera shake. If you have very steady hands, you might want to try holding the camera yourself.

Set your shutter speed for about 1/4 second. You'll need that much time to slide the zoom lens during exposure. Then, just as you press the shutter release, start zooming with a firm, steady, and consistent motion. Just as in golf, be sure that you follow through the zoom motion even after the shutter releases. That way, you won't stop moving the zoom in the middle of the exposure. You may need to practice this a few times to get the shot right; remember, electronic film is free.

Get the Most Out of Your Zoom Lens

As I mentioned in Chapters 1 and 2, your digital camera probably comes with a zoom lens that allows you to vary the focal length from a wide-angle or normal perspective all the way through some moderate telephoto length.

As you probably recall, focal length is just a measure of the magnification the lens provides. A larger focal length produces greater magnification; hence long focal length lenses are great for capturing fast action or enlarging objects that are moderately far away. You can see the effect of a zoom lens on magnification in Figure 4-13.

A key fact to remember, however, is that the focal length of the given lens also affects the camera's angle of view. Because a telephoto lens magnifies distant objects, it has a very narrow angle of view. As you reduce the magnification and zoom out toward smaller focal lengths, the angle of view likewise increases. You can see this graphically in Figure 4-14.

At the extreme end of the scale—specifically, wide-angle lenses—the image is shrunk with respect to what the human eye can see. The angle of view becomes extreme, sometimes even greater than 180 degrees. This kind of wide-angle lens is known as a *fish-eye lens* due to the peculiar effect of the angle of view.

The focal length of your lens has one other important characteristic. Depending on whether you have your lens set to wide angle, normal, or telephoto, you'll get a very different depth of field. As you saw previously in this chapter, a telephoto setting yields minimal depth of field, while a wide-angle setting generates a lot of focusing depth.

TIP *The telephoto end of your zoom lens is great for capturing distant subjects, but the additional magnification can create blurry pictures. Especially if you are photographing in low light, where your camera might choose a slow shutter speed, I highly recommend that you take telephoto images with a tripod.*

FIGURE 4-13 These three views, all taken from the same position, show the effect of a zoom lens on the magnification of the subject.

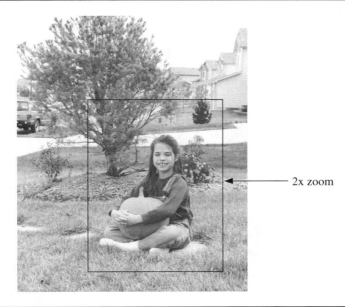

2x zoom

FIGURE 4-14 The longer the focal length, the narrower the region that a lens can see.

How to ... **Maximize Depth of Field**

There are three ways to maximize the depth of field in your image:

- Use a lens with a short focal length, such as the normal or wide-angle setting on your camera's zoom.

- Focus on a distant subject. If you're trying to get both a nearby tree and a more distant house in focus simultaneously, for instance, focusing on the house, rather than the tree, is more likely to deliver both subjects in focus.

- Use the smallest aperture you can, such as f/11 or f/16. This is often the easiest element of your picture to control and the reason that many digital cameras have an *aperture priority* mode for dialing in an aperture setting for your photos.

Not surprisingly, you can minimize the depth of field in a picture by doing exactly the opposite of these things.

Chapter 5

Flash and Lighting

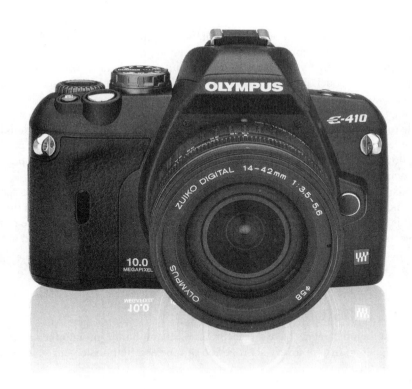

How to...

- Use your flash for primary lighting
- Fill in shadows with your flash
- Keep from underexposing close-ups
- Use the various flash settings on your camera
- Optimize lighting outdoors
- Optimize lighting indoors
- Avoid red eye in low-light photos
- Balance your scenes based on the kind of lighting around you
- Use a reflector to fill in shadows
- Take interesting photos at night

Photography is all about light. In previous chapters, I talked about how to work with the existing light in a scene to control aspects of your photograph such as depth of field. Sometimes using the light that you already have isn't quite enough, however. That's why photographers spend so much time with flash units, strobes, reflector units, and other gadgets that help enhance or supplement natural light.

In this chapter, we'll talk a fair bit about using the electronic flash. Pretty much every digital camera made today comes with a built-in flash unit. The flash is a way to bring extra light with you and brighten many kinds of pictures. On the other hand, I have found that most people don't really know how to take advantage of the flash built into their camera, so in this chapter I discuss techniques such as fill flash, red eye reduction, and bounce flash.

Lighting isn't just about using the built-in flash, either. You can use a reflector to spread light around for a more pleasing effect. For better lighting control, you can also play with the white balance built into your camera. And let's not forget about night photography. It's one of my favorite subjects, and in the next few pages I will explain how you can try your hand at this as well. Taking pictures at night can yield some of the most artistic and beautiful images you'll ever see.

The Basics of Flash Photography

These days, most digital cameras have an electronic flash unit built right into the camera body. The flash is designed to fire for a very short period of time and illuminate your scene in one of two ways:

- As the main source of light indoors or in the dark
- As a secondary source of light to fill in shadows when you're shooting in bright light, such as outdoors

In general, your flash will probably know when to fire and can illuminate most pictures without your direct intervention. When your camera is set to the fully automatic exposure mode, the flash will probably come on as needed and not fire when it is not needed. On the other hand, for better results, you can often figure out when you need a flash more effectively than your camera can. For example, there will be situations when you may want your flash to fire when it would probably stay off, and vice versa. That's why your camera has several flash modes to choose from. We'll talk about those a little later, in the section "Master Your Flash Modes."

Stay Within the Range of Your Flash

How far will the light from your flash travel? That's something you need to know if you expect to get the most out of your flash. The flash built into most digital cameras is not extremely powerful; at best, you can expect to get a range of about 20 feet. To find the range of your camera's flash, refer to the owner's manual that came with your camera. You can almost always find the flash range listed in the specifications section of the manual. If you cannot find the range of your flash listed there, assume it is no more than about 15 feet.

If you're used to the great range you would get from an external flash unit mounted on top of an SLR camera, you might be disappointed by the range from a digital camera flash. It stands to reason, though, that the small flash built into a digital camera could not have the same power as the large flash head, powered by several AA batteries, mounted on an SLR.

That means you'll have to be aware of how far you're trying to get the flash to throw light, especially at night or in very dark conditions. If your subject is very far away, such as 25 feet or more, it is unlikely that the built-in flash will have any effect at all on your photograph. In Figure 5-1, you can see that the flash is less effective at increased distances from the subject. In fact, some digital cameras disable the flash automatically when they sense that the lens is focused on infinity or when it is set to a "landscape" scene mode, which focuses on infinity anyway. You might want to check your camera manual or experiment to see if that applies to you.

Getting Too Close

Believe it or not, it's possible to get too close to your subject as well. Some digital camera flash units overexpose the subject when you are within a foot or two of the subject. Since you know about the light-reducing properties of a telephoto lens, you might expect that you can get closer when you zoom in than if you are zoomed out. And you'd be right; with a typical camera, you cannot shoot any closer than about 3 feet when set on normal zoom, but you can shoot to within a single foot if you are zoomed in to telephoto.

As you can see from Figure 5-2, close-up photos are easy to overexpose if you leave the flash turned on. There are a few ways to work around this problem, depending on what your flash unit is capable of doing:

- Turn the flash off completely and shoot with natural light.
- Bounce the flash off a plain white reflector, such as the ceiling or a reflector card. You'll probably need an external flash unit to bounce, though.

FIGURE 5-1 These snapshots demonstrate the falloff in light intensity as you back away from your subject at night.

FIGURE 5-2 Your flash may overexpose close-ups if you get too close; natural light was used for the image on the left, but the flash was enabled for the image on the right.

■ Reduce the flash's power setting to 50 or 25 percent—most cameras have a setting in the menu that lets you do this.

■ Cover the flash with a tissue or gel (available at any camera shop) to reduce its intensity.

For many digital cameras, there's an optimum range for your flash photographs. Try to stay between about 5 and 14 feet from your subject. Avoid using the flash in situations where the subject is more than about 15 feet away or closer than 3 feet.

Master Your Flash Modes

In this digital age, choosing between "on" and "off" is just too easy. Instead, your camera's flash has three or more modes, each intended for a specific photographic situation. Here's the rundown of your options. Your camera may not include all of these features, so you might want to check out your camera manual before you get your heart set on trying all of them out. Your camera should have some, if not all, of these modes:

 Off This one is easy. When you set your camera to this mode, no matter how strongly your camera believes that you need extra light, the flash will not fire. This is handy for situations where you are not allowed to fire a flash, such as in a church or a museum, or when you're too close to the subject and think you might overexpose it. You may also want to turn off the flash in many night photography situations. I'll talk about that later in the chapter.

 Auto This is the standard mode that you'll probably want to leave your flash set to most of the time. When set to auto, the flash determines whether it needs to fire based on the amount of light in the scene. This is a good mode to use when you don't want to think about whether the flash needs to fire. For typical snapshot photography, just set your flash to auto.

 Forced This mode goes by many different names depending upon the camera you are using. Sometimes called "forced flash," "fill flash," or just "on," forced flash is probably the most appropriate name. When you set your camera's flash to this mode, it will fire regardless of how much light is available. Why would you want to use this mode? It's most useful as a fill flash: when you're shooting outdoors in natural light, the fill flash can erase shadows that would appear based on the way the sun hits your subject. Fill flash, or forced flash, is great for portraits.

Red eye Red eye reduction mode has become extremely popular in all sorts of cameras, both digital and analog. By preflashing the camera flash several times quickly right before the picture is taken, the red eye reduction mode forces your subject's pupils to close down to a smaller size, thus decreasing the chances that the retinas will reflect the light of the flash. When you use this mode, remember that it will take a fraction of a second longer for the picture to be taken; don't pull the camera away as soon as you press the shutter release, or you'll blur the picture. If you're photographing people in

a dark room, it is probably worth the extra time it takes using red eye mode. You do not need to use red eye reduction outdoors or in bright light. If the red eye mode isn't completely effective, or if you forget to turn it on, you can eliminate red eye on the PC in an image-editing program—see Chapter 13.

Taking pictures at the tavern? The red eye mode can also help reduce the red eye effect in people who have been drinking.

Low ⚡ **Low power** Some digital cameras let you control the power output of the flash. You might be able to reduce the intensity of the flash by 50 percent or more. You can use this mode when you are using the flash to fill in shadows or when you are taking a close-up and a full flash burst would overexpose your subject.

Slow ⚡ **Slow** This slow setting might be referred to as a *rear curtain flash* or *slow sync*. Of course, neither of those names may not help you understand what the slow (or rear) setting does. When you set the camera to this mode, it fires the flash at the tail end of the exposure. This setting is used most often at night, when the exposure is long (such as a second or more), as in Figure 5-3. What does it do? Suppose you were trying to take a picture of a car driving down the street. With an ordinary flash exposure, the flash fires right away, thus freezing the car at the start of the frame. In a long exposure, you will then see headlights cut through the car and out of the frame. The slow mode, however, saves the flash for the end. In a picture taken with this mode, you will see headlights that travel through the frame and then meet up with the rear of a flash-frozen car. The car is leaving the picture at the end of the exposure, just like it should. As you can see, you won't want to use this mode all the time, but it is indispensable when you need to get a certain kind of long-exposure photograph.

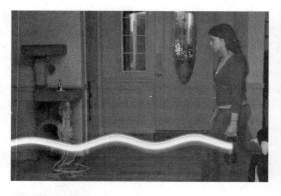 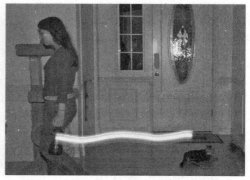

FIGURE 5-3 The normal flash mode on the left looks odd in a long exposure at night. But the slow sync shot on the right looks much more natural.

Add an External Flash

Many digital cameras are compatible with external flash units. Your camera can accept a flash if it has a flash shoe on the top of the camera body, which looks like this:

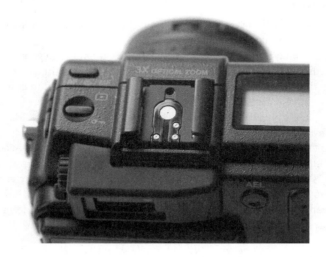

If your camera does have such a mount, check out the camera manufacturer's web site or your local camera store for information on compatible flash units you can attach to your camera. External flashes have these major advantages:

- Greater range for better flash photography in a wider range of environments.

- The ability, with some flash units, to pivot, swivel, and tilt the flash head. By angling the flash, for instance, you can use it to bounce light off of walls and ceilings, which adds up to softer lighting effects.

- You can get the flash off the lens axis. Many flash units, with the right bracket adapter, can be held away from the camera. In addition to giving you more creative control over the direction the light is coming from, these lens brackets let you eliminate red eye effects because the flash isn't right in line with the lens.

- Better battery life. Since an external flash has its own batteries, it can last longer and not wear down the camera's own batteries at the same time.

Be aware, though, that all flash units are not the same, nor are they all compatible with all cameras. In theory, pretty much any digital camera should be able to fire pretty much any flash designed for a 35mm film camera, but the advanced, automatic exposure features probably won't

work—you'll have to shoot in manual mode, which isn't much fun. It's also possible that an incompatible flash can damage your camera. That's why you should check to see what flash unit is made for your model by your camera's manufacturer.

Add a Slave Flash

It's possible to easily add a flash to your camera even if it doesn't have a built-in flash shoe—by adding a slave flash to your digital camera accessories.

A slave flash might sound like a complex piece of professional photo gear, but it's not. A slave looks like a traditional external flash unit, but thanks to a built-in light sensor, it fires at the same time as your digital camera's built-in flash unit. There's no need to connect cables, and you don't even need to have a digital camera with an external flash "hot shoe" connection. Just turn on the slave flash, and it automatically fires when you take a picture (as long as your digital camera's own flash fires, of course).

Personally, I love the convenience of a slave flash. You can position it anywhere you like—on the camera's hot shoe, on a separate flash bracket, mounted on top of a tripod, or even on a nearby tabletop—and as long as it's pointed at your subject, you'll get good results. In fact, you can use a slave flash to enhance your photos by creatively positioning the flash. Light from the side is less likely to cause red eye in your people photos, for instance, and side light can really enhance otherwise flat scenes.

TIP *You can use a slave flash in any situation in which a fill flash or reflector would come in handy—like those described throughout the rest of this chapter.*

Most digital camera shop should be able to show you a slave flash, or you can look on the Web. Even better, some Digital SLRs have flash units that automatically act as a slave in conjunction with other flash units or the built-in flash on the camera.

Improve Your Outdoor Photographs

In my experience, people are more disappointed with their outdoor photographs than any other kinds of images. They complain about the washed-out sky—it was very blue when they took the picture—as well as ugly shadows on people's faces, bad exposure, highly contrasting, and harsh shadows that go through their pictures.

Why do all these problems occur? At the most basic level, it's because your digital camera works very differently from the way your eyes do. When you look around outside, your pupils—the apertures of your eyes—change diameter constantly to adjust to varying light conditions throughout the scene. When you look toward the sky, your pupils close so you see rich, blue colors. Look under a tree, and your pupils immediately open to help you see in the deep shadows that are down there. And then there's the fact that your eyes have a much wider

range of exposure values than a camera does. When you press the shutter release on your camera, it has to choose a single exposure level and try to depict the entire scene with that one reading—regardless of how dramatically the light changes throughout the picture. As I've mentioned, it is a miracle that we can get good pictures at all. That said, there are many strategies we can employ to get great pictures outdoors.

Beware of the Sun

When you take pictures outdoors, always check your watch. By that I mean that there are better and worse times during the day to take pictures. Perhaps the worst time of all is midday, when the sun is directly overhead. The noon sun creates extremely harsh shadows and casts unflattering light for almost any kind of photographic project. People look their worst when you photograph them between about 10:00 in the morning and 2:00 in the afternoon, when the extremely bright, overhead light (particularly in the summertime) can tend to overwhelm a digital camera. If you're shooting on a cloudy or overcast day, though, even midday is fair game since there's no direct sunlight to interfere with your photos.

The alternative? Shoot early or late in the day. Photographers traditionally like the warm colors created by the sun in the late afternoon, but the morning is almost as good. If you are traveling on vacation, for instance, and want to get really great pictures, plan your photo exploits for the early morning hours and then again for late in the day. Heck, it's too hot in the middle of the day to pay too much attention to photography anyway.

If you make a conscious effort to take your best pictures before or after the high noon sun, you're halfway there. You also need to think about the position of the sun in the sky.

In the old days, new photographers were taught to take pictures with the sun to their back. The reason was simple: the sun would best illuminate the subject. Unfortunately, if you were photographing people, the sun would blast that light in their faces, causing them to squint. That made for some mighty ugly pictures. A much better solution is to position the sun over your left or right shoulder. But no matter where you put the sun, don't shoot into it unless you are intentionally trying to photograph a sunset or a silhouette.

Add Fill Flash

While most people think of their camera's flash as something to use at night or in the dark, it's also a great way to improve the look of your photographs in the daytime. Set your camera's flash to its forced flash (also called fill flash) mode, and use it to shoot portraits and other outdoor photographs. You'll find that the flash fills in shadows nicely, dramatically improving the quality of your images. You'll be surprised, in fact, at how much fill flash can do to improve photos that you thought were pretty good to begin with. Check out Figure 5-4, for instance. Here you can see two portraits—one with a fill flash, and one without. Remember, you'll need to be fairly close for this to work. Stay within 10 to 15 feet of your subject.

FIGURE 5-4 A little fill flash can go a long way.

Reflect Some Light

A second source of light is just the ticket to eliminate shadows, reduce contrast, and even out the lighting in your pictures. Sometimes you can do that with fill flash, and sometimes a small reflector will do the job.

A reflector is often better than a flash because the light from a reflector is softer, and that typically makes better pictures. In other words, it's always better to use natural light, which includes reflecting it, than to use an electronic flash.

There are two ways to get into reflectors: the cheap way and the expensive way. Believe it or not, you don't need an expensive reflector from your local photo shop in order to move light around—you can have a lot of success using a glossy white sheet of poster board. Purchase a sheet of poster board from your local art supply store for a dollar or two to try it out. The problem with poster board, of course, is that it is often difficult to carry around. For a more compact reflector solution, pick up a photo reflector at your local camera store. Personally, I really like PhotoFlex Litediscs. These clever little reflectors fold up so small that you can almost put them in your pocket. Take them out of the bag, however, and they pop open to a variety of handy sizes. I use a Litedisc that measures about 24 inches in diameter (see it in Figure 5-5), and I find that's a great size for most of the things that I want to photograph.

How to ... Shoot Silhouettes

It's easy to photograph a silhouette—in fact, new photographers do it all the time. They just don't always do it on purpose.

The easiest way to photograph a silhouette is simply to position yourself so that the subject you would like to silhouette is arranged against a bright background, such as the sky. Point the camera directly into the sky and slightly depress your camera's shutter release—that locks in the exposure based on the bright sky. (If your camera has a separate exposure lock button, press that instead.) Then recompose your picture and shoot. What you'll probably get is an inky-black subject, since the exposure was based on the brighter sky, as in the following image. If your subject isn't quite silhouetted, you can underexpose the image even more using the exposure compensation (EV) control on your camera. You might also want to use your camera's spot meter (discussed in Chapter 3) to lock the exposure on a bright piece of sky.

You may find that the subject is out of focus because the camera locked its focus on infinity when you pointed it at the sky. If that's the case, check to see if your camera has a separate exposure lock button, and use it. If not, you may need to set the exposure manually (or use the EV control) or focus the camera manually instead. One way or the other, if your subject is too close to focus at infinity, you need to find a way to separate the exposure and focusing aspects of your camera.

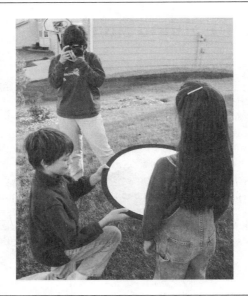

FIGURE 5-5 Instead of using a flash, try asking someone to hold a reflector near your subject. By holding it level with the ground, you can reflect light up into the subject's face.

Or, try a piece of paper—it's free and extremely portable. You can make a reflector for your flash from an 8.5×11-inch sheet of paper and affix it to your flash using a rubber band. Use this template to cut out your reflector:

You might be dubious about a flash reflector cut out of a piece of paper, but trust me: the results are stunning. When I shoot flash photography indoors, I use this paper reflector almost all the time—you can see my setup in Figure 5-6. This home-brewed reflector delivers wonderfully soft, attractive lighting that's especially great for portraits. You can also experiment with your flash by spinning it around so the reflector is in front, diffusing some of the light, and the flash fires backward, behind the camera.

Want to learn more? I was first turned onto this idea from a short how-to video on the Web. You can watch it yourself at www.abetterbouncecard.com.

When you're ready to take a picture with your reflector, you'll probably need some help. It's fiendishly difficult to hold a reflector and take a picture at the same time. So instead of trying some feat of photographic gymnastics, ask an assistant to hold the reflector such that light reflects from the sky onto your subject. Try to hold the reflector to minimize shadows or illuminate the dark side of your subject.

All that said, reflectors can serve a second important purpose as well. When you're out in the field trying to take a picture, the wind can sometimes get in the way. You'll notice this most often when you're trying to take a close-up of something like a flower. As I talk about in Chapter 6,

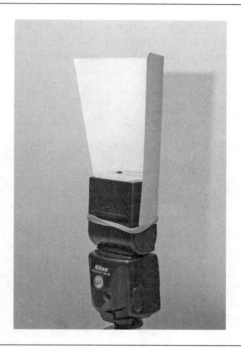

FIGURE 5-6 A paper reflector is as good—or perhaps even better—than many bounce cards and reflectors for sale in stores.

How to ... Bounce Your Light for a Softer Effect

If your digital camera has a hot shoe (a rectangular connection on the top of your camera for attaching a flash unit) or an input for a flash synch cable, you can attach external flash units for additional light and control over your images. I love using external flash units because the flash head tilts. That means you can tilt the flash so that it reflects light off the ceiling or a wall, thus diffusing the light and creating a softer effect. Be sure that you're not reflecting light off of colored walls, though, or the reflected light might paint your subject some horrible shade of yellow. You may also want to disable the built-in flash in your camera if you use an external flash. Check the camera's menu system for flash controls. Try it both ways, though, since some pictures can benefit from dual flash units arriving on the scene from different directions.

just a little breeze can create an out-of-focus and blurry macro photo. The solution? Compose your picture so that you can use the reflector not only to add light to the scene, but also to serve as a wind break. That's right, reflectors can block the breeze and give you a more stable picture. See Figure 5-7 for a look at how you can use a reflector this way.

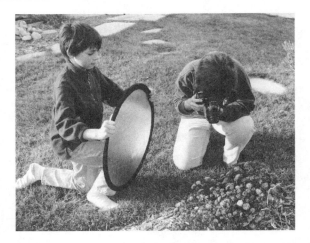

FIGURE 5-7 Reflectors can block the wind as well as reflect light.

NOTE *A common way to use a reflector is to hold it roughly parallel to the ground, just under a person's face. That throws light upward, into the shadowy areas of the face, giving you softer, more even illumination.*

Improve Your Indoor Photographs

Indoors, we are often much less concerned about harsh sunlight than we are about having enough light and light of the proper color. The evil red eye is also the nemesis of many indoor photographs. For common snapshots, there's probably nothing wrong with simply using your flash and leaving the camera in its fully automatic mode. But if you want to get really good at indoor photos, there are a few things you can do to shift the odds in your favor.

Use Window Light

The best light is natural light. Whenever possible, position your subject near a window so that you can take advantage of the natural light pouring into your house. If you want to try the window technique, here are a few tips:

- Avoid using windows where the light streams in directly and thus creates harsh shadows. Instead, pick a window in which you get more diffused, indirect light.

- Position yourself with your back to the window and turn your subject to face mostly head-on into the window, with some light spilling over to the side of the subject's face.

- If necessary, fill in the side of the subject's face with a reflector to eliminate shadows. You can also use your camera's flash as a fill flash.

Avoid Red Eye

As I mentioned earlier in the chapter, the dreaded red eye is the effect that happens when the flash reflects off your subject's pupils. You can get this effect with any living subject—although, if you've all seen the *Omen* movies, it looks particularly creepy on dogs. Red eye happens most frequently indoors and outdoors at night because everyone's pupils are wide open to see better in dim indoor light.

Once you understand what causes red eye, it's easy to prevent. Here are the most common ways to avoid red eye:

- **Use the red eye reduction mode on your digital camera** This is the easiest solution most of the time. When you turn on the red eye reduction mode, your camera triggers the flash several times rapidly right before the picture is taken. When you use this mode, remember the delay between when you press the shutter release and when the picture is

actually taken—often, about a second. That doesn't sound like much, but it's enough to make you move the camera and ruin the picture if you're not paying attention.

- ■ **Use an external flash off-camera** If you have a digital camera with a hot shoe for an external flash, or one that includes a flash synch cable port, you can connect external flash units. The cool thing about using a separate flash is that you can hold it away from the camera. The farther you get the flash away from the camera lens (to the left or right of the camera), the less susceptible your picture will be to red eye, since the light won't reflect directly back to the camera.

- ■ **Photograph people outdoors, or near windows** If you can arrange your subjects near a bright source of natural light, you can avoid the red eye problem entirely because their pupils will already be closed due to the strong light source.

Correct the Color Balance

The color of artificial light is dramatically different from natural outdoor light. In fact, every kind of artificial light has its own unique properties. And that means that different kinds of artificial light have subtly different colors.

It is because of these variations in color that many indoor photographs simply don't look natural. Your camera has a way to adjust for these different light sources. Called *white balance,* it will help you to make sure that you get natural colors in your pictures regardless of what kind of artificial light you use. If you find that the automatic white balance setting in your camera gives you unpredictable results, then be sure to read the next section and manually adjust your camera's white balance before every indoor photographic session.

Correct Images with White Balance

As I mentioned, you can adjust your digital camera's white balance. White balance is important because different light sources have different *color temperatures,* meaning that a scene will appear to have a slightly different color tone depending on how it is illuminated.

You have probably noticed this yourself without really even paying attention. You may have seen, for instance, that ordinary light bulbs appear more yellow than the light that streams in from outdoors. And other sources—like candlelight and fluorescent lighting—are certainly a very different color than sunlight.

Photographers and scientists have gone to the trouble of cataloging the different color temperatures exhibited by various light sources. Lower temperatures appear warm, or slightly reddish, while warmer light sources tend to add a blue tone to your pictures. It's not at all unlike the way a flame has different colors at its outside and center. Why? Because those different parts of the flame are different temperatures.

As a point of comparison, this chart shows the approximate color temperatures of several common light sources:

Source	Color Temperature (Degrees Kelvin)
Candlelight	2,000
Sunset	2,000–3,000
Incandescent	3,000
Tungsten light	3,200
Fluorescent light	4,500
Daylight	5,500
Camera flash	5,600–6,000
Overcast sky	6,000–7,000

If your camera is balanced for one kind of light source (daylight, for instance) and you photograph a scene that has been illuminated by a very different temperature of light (such as tungsten), the resulting image won't reflect the true colors in the scene. What should be white will turn out looking somewhat reddish. Ordinarily, we don't notice this ourselves because, as I've said before, the human brain is very good at interpreting what the eyes see. Our brains adjust for different color temperatures so that white almost always looks white, no matter what color light we're seeing it in. Of course, cameras aren't quite that smart. And that's why we need a white balance adjustment.

The white balance setting on your camera allows you to specify exactly what the color temperature of the scene is. In many cases, your camera can automatically adjust to conditions—but your camera often guesses wrong and gets the improper white balance fairly often. If need be, you can do it yourself. You'll know that you need to adjust the white balance if your pictures routinely come out shifted to the blue or red end of the spectrum. If your whites are not white—in other words, your camera doesn't do a good job of correcting the white balance—then you need to do it yourself.

TIP *If you get in the habit of manually adjusting the white balance, remember to reset the white balance to auto when you are done with each shoot. Otherwise, you might forget that your camera is balanced for fluorescent light when you shoot outdoors, and you'll get very funky results.*

Adjust White Balance Presets

Most digital cameras let you choose from a small collection of white balance presets. In addition to automatic white balance selection, your camera probably includes white balance settings for conditions such as incandescent lights, fluorescent lights, an external flash unit, and cloudy or overcast days.

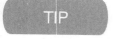 *If you shoot in your camera's RAW mode, the white balance setting is not "baked into" the photo when it's taken. Instead, you can easily change the white balance afterwards on your PC in your photo editing software with no ill effects whatsoever.*

Choose a White Balance Preset

Changing your white balance setting varies from camera to camera, but the process is typically fairly simple. For the specifics on your camera model, check your camera's user guide. In general though, this is the process:

- Turn your camera on and set it to its normal record mode. If your camera has a separate record mode specifically for manual photography, you'll probably need this one instead.
- Press the menu button on your camera so that you see a set of menus in the LCD display.
- Find the option for white balance.
- Scroll through the white balance options until you find the lighting conditions that best represent your scene.
- Press the menu button again to turn off the menus. You can now take your picture.

Measure White Balance Yourself

Sometimes these white balance presets just don't get the job done. If you are in a tricky lighting situation, such as a room that has both incandescent light and candlelight, you may need to set the white balance manually based on the actual lighting conditions in the room.

One of the hardest lighting situations on Planet Earth is a school gymnasium. Because of the way gyms are lit, no white balance preset ever seems to work properly. For best results—and to avoid the inevitable yellow cast in your photos—try to arrive early and manually set the white balance with the help of a white or gray card.

This may sound complicated, but it's really not that hard. Before you start, you'll simply need one additional item: a white surface that the camera can use to set the white balance. Typically, you can get by with a small square of white poster board or typing paper. For better and more consistent results, though, I recommend that you purchase an 18-percent gray card from your local photo shop. Professional photographers use these small gray cards to judge exposure all the time, since the exposure meters in most cameras assume that images average out to about 18-percent gray overall. You can get a gray card for just a few dollars, and you'll be surprised at how handy it is for setting white balance.

So, here is how to set the white balance yourself:

1. Ask your subject or an assistant to hold the gray card with the gray side facing you. Make sure the card is where you're actually going to take the picture, so you are measuring the actual light as it will be in your scene.

2. Turn on your camera and set it to the record mode.

3. Activate the menu system on your LCD display.

4. Find the white balance controls in the menu system.

5. Scroll through the white balance until you find the option to record it yourself. Select this option.

6. You should now see something on the LCD display directing you to photograph a white object. Compose your scene so that the gray card—or whatever you are using to set the white balance—fills the frame.

7. Take the picture and exit the menu system.

The camera will now expose any pictures you take using this new white balance value. Be sure to reset the white balance back to automatic when you're done taking these pictures; otherwise, you may try taking pictures a day or two later in very different lighting conditions and get bizarre results because the white balance is completely askew.

TIP *If you have a Digital SLR, you can use a cool device called the ExpoDisc (www .expodisc.com) to quickly and easily set the white balance. It's essentially a gray card in the form of a filter that fits over the lens. Snap it in place, take a white balance reading, and remove it—the whole process only takes about 30 seconds.*

Experiment with White Balance

Don't think that white balance is only used to get perfectly white whites in your pictures. Certainly, that is the reason most people use this mode. On the other hand, photography is an art, not a science. By changing the white balance values of your camera, you can get some creative results that you might like better than if the white balance were set properly. As one example, I sometimes like the warmer colors I can get by misadjusting the white balance when shooting portraits. By making my subject's face a bit redder, I think the photo looks richer and more lifelike. Try it yourself and remember that photography is all about trying new things.

NOTE *Many cameras set white balance in the way described in this section, but your camera may do it slightly differently. Refer to your camera's user manual for exact details.*

Try Your Hand at Night Photography

Taking pictures at night is a rewarding, exciting activity; unfortunately, digital cameras don't always make it easy to do. On the plus side, taking pictures with a digital camera is essentially free, since you're not buying film. So you can experiment to your heart's content without wasting any film.

Not every camera is cut out for night photography. Low-light photography requires long exposure times; if your digital camera is not capable of shutter speeds of one second or more, you will probably have some trouble getting decent night shots. In fact, your camera should have a manual exposure mode so you can dial in the shutter speed by hand. Automatic exposure settings may not give you anything even remotely interesting. If you're shopping for a camera and are specifically interested in night shots, try to get a camera with a bulb setting—that's photography lingo for a shutter that stays open for as long as you hold the shutter release down—or at least a maximum shutter speed of 8 seconds. Not all night exposures are measured in seconds, though. I captured this image with a tripod and only about a one-second exposure, something virtually any digital camera should be able to do:

A camera with a wireless remote control can also be handy for night photography because you can activate the shutter without shaking the camera. If you don't have a remote, then you might want to trigger the camera with the self-timer feature.

If your camera does not let you manually choose the shutter speed and aperture, try using its EV adjustment to overexpose your picture by one, two, or even three stops. For example, set your camera to EV –3, focus the camera on the darkest part of the scene, and then shoot.

After you've taken a batch of night shots, you can compare your pictures side by side and see the effect of increasing exposure time. As you can see from Figure 5-8, there is no such thing as the "one perfect exposure" in a night photograph. Increasing the exposure means longer light trails and brighter points of light. Eventually, too much exposure time will lead to obviously overexposed images and perhaps digital noise (which I discuss in the next section). But for the most part, the exposure you choose is a matter of personal taste.

How to ... Take Your First Night Shots

So, you're ready to take your first pictures at night. I recommend that you choose an interesting locale to begin with. Go downtown, where there are lots of neon store lights and cars with headlights on. Alternately, try a local carnival or fairground. The idea is to find a location that has lots of interesting lights and motion.

To take your first night pictures, do this:

1. Mount your camera on a tripod. Your exposure times will be a half second or longer; there is absolutely no way you can hold the camera for that amount of time without introducing an incredible amount of blur.

2. Switch your camera to its manual exposure mode, if it has one. Set the aperture to a medium setting, such as f/5.6. Set the shutter speed to 1/2.

3. Point the camera at something interesting. If this is the first time you are trying night photography, I suggest you go to a fairly busy intersection downtown and frame the street and a store or two in your viewfinder.

4. When a car is about to enter your viewfinder, take the picture. You should be able to get fairly instant feedback on how your picture came out by looking at it in the camera's LCD display. No matter how good or bad the picture came out, do not delete it.

5. Now double the shutter speed. Try an exposure of 1 second, and shoot the same scene again.

6. Take more pictures, varying the shutter speed so you can get a feel for what kind of results your camera gives at night at various shutter speeds. You will very likely find that your camera won't expose a picture for more than a few seconds; many cameras limit the shutter speed to 5 or 10 seconds. That's OK—just work your way up until you hit your camera's maximum shutter speed.

7. If your camera automatically records exposure information for each picture, great. If not, write down all of your exposure information so you'll remember what you did later and learn from your efforts.

Sensors and Noise

Night photography is a little trickier with a digital camera than with a film SLR. Don't get me wrong—film has its own problems. *Reciprocity failure,* for instance, is a phenomenon that affects 35mm film. What it means is that film reacts somewhat unpredictably during very long exposures, such as at night. Film is designed to be exposed to light for a fraction of a second; so if you leave the shutter open for 10 seconds, the reliable relationship between the aperture

FIGURE 5-8 Longer exposure times lead to longer light trails and brighter points of light.

size and shutter speed begins to fail. That makes night photography for 35mm photographers something of a guessing game.

Don't trust your camera's exposure meter at night. You might want to start with whatever your camera's meter suggests, but you can almost always get more interesting pictures by doubling or tripling the shutter speed that's suggested by the camera.

For digital photography, we have a completely different problem to contend with. When you expose a digital sensor to light, it gets hot. This heat manifests itself in the form of noise in your final picture. After all, light and heat are forms of energy, and the heat energy collecting on the sensor has a negative effect on the picture. For short exposures, this is rarely, if ever, an issue. You might see some noise in your picture if you set the camera's ISO value to a very high number when you're shooting in bright light, but usually the shutter speed is so short that there is little time for the sensor to generate noise in the final image. When you are measuring the exposure in seconds, however, noise can build up quickly. Take a look at Figure 5-9. Here you can see how digital noise affects a picture when the shutter speed is more than a few seconds long.

Some cameras are designed to minimize this noise that occurs with long exposures. The sensor is built directly onto a heat sink to carry excess energy away during long exposures. Other digital cameras don't have such a feature, however. Instead, there are three ways to minimize this effect:

- Keep the shutter speed as short as possible.

- If it has one, turn on your camera's noise reduction feature—it can do wonders for minimizing digital noise.

- As a last resort, run a noise reduction filter on your picture in an image editor after you transfer it to the computer.

FIGURE 5-9 Sensors are not always optimized to take long exposures at night.

Cool Things to Photograph at Night

There are all kinds of things to photograph when the sun goes down, and each one requires a somewhat different technique. Here are some suggestions to get you started:

- **The moon** When shooting the moon, remember that it is a very bright object. The Sunny 16 Rule (discussed in Chapter 3) may work for you in this situation, but I've found that many cameras get confused by the dramatic variation in brightness with shots like this, so you may need to experiment a bit. If you can get enough magnification out of your lens so that the moon fills up at least half of the frame, you'll need to shoot at fairly fast shutter speed or even set the exposure compensation control to underexpose the frame. And be sure to use a tripod. For more details on photographing the moon, see Chapter 8.

- **Sunset** The sky is full of rich, gorgeous colors around sunset. Base your exposure on the sky itself, not on your subject or anything on the ground. And take a few extra pictures, bracketing your exposure (see Chapter 3 for details) to make sure you get the shot.

- **Dusk** I have found that photographing lighted buildings and headlight trails works particularly well when you can get the rich blue colors of dusk in the sky at the same time.

- **High dynamic range** For even cooler early evening or night photos, try taking a series at varying exposures and combining them into a high dynamic range image. See Chapter 15 for details.

Chapter 6

Take Close-Ups

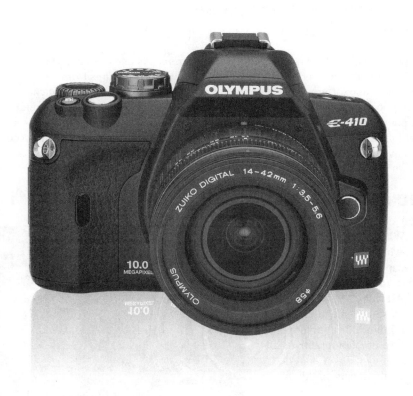

How to...

- ■ Set your camera to its close-focus mode
- ■ Close-focus a manual-focus camera
- ■ Ensure proper focus when shooting very close up
- ■ Use the correction marks in the optical viewfinder
- ■ Use optional close-focus lenses
- ■ Interpret diopter numbers
- ■ Configure a tripod for semisteady macro shots
- ■ Blur the background
- ■ Maximize your depth of field for sharper pictures
- ■ Eliminate reflections from glass display cases
- ■ Build your own light tent for indoor macro photography

Close-up photography, also known as *macro photography,* is one of the most exciting ways to experiment with your digital camera. We're used to seeing things from 5 or 6 feet off the ground, but it's a whole different world down there when you get within a few inches of your subject. When you're within an inch or so of your subject and it's magnified to several times its normal size, photography suddenly seems like magic.

You might think I'm exaggerating, but macro photography really is a lot of fun. And just because you have a digital camera, don't think that you can't play along.

Capture the Microscopic World

First of all, let's talk about some terminology. When we discuss close-up photography, what we really mean is macro photography. We're not talking about close-ups in the portraiture sense— there are no "All right, Mr. DeMille, I'm ready for my close-up" situations in this chapter. I hope I didn't disappoint you.

Instead, close-up photography is all about photographing the world around us to capture small objects, highly magnified. That usually means getting pretty close to the subject—like within a few inches, as in this shot:

Using 35mm SLR equipment or even larger gear, such as medium- and large-format cameras, you can get incredibly magnified views of small subjects. You can magnify the eyes of a fly to fill up an 8×10-inch print, for instance. In digital photography, we typically can't get quite as close as that, but we can take impressive close-ups nonetheless. If you would be happy with getting the fly itself blown up to 8×10 inches, then keep reading.

Coax a Digital Camera to Take Close-Ups

Virtually every digital camera on the market has some sort of close-focus mode. Such a mode exists because the camera lens typically can't focus properly when you get very close—within inches—of a subject. The optics must be rearranged to accommodate such close focusing.

Point-and-Shoot Cameras

If you have a point-and-shoot digital camera, you probably need to enter close-focus mode (also called *macro* mode) by pressing a button on the camera body. A tulip shape typically represents close-focus; you should see a button somewhere on your camera with such a symbol. Can't find it? On a few cameras, the macro mode is buried in the onscreen menu on the LCD.

You can see a typical close-focus button control in Figure 6-1. Often, camera buttons perform more than one function. You might need to press the button several times to cycle through the various modes before the macro mode is actually enabled, or you might need to hold the button down while turning a selector dial. When you're in macro mode, it's usually indicated by a tulip somewhere on the camera's LCD display. That tulip is a reminder that you are in close-focus mode, and you will get sharp focus when shooting very close to the subject. (Often, the effective macro range is in a range such as 8 to 30 inches, though some cameras can focus to within an inch or so of the subject.) In addition, some digital cameras require your zoom lens to be within a certain macro range—zoom in too far, and the camera won't be able to focus properly. If in doubt, check your camera's manual.

FIGURE 6-1 Follow the tulip on your camera to find the close-focus or "macro" mode.

Digital SLRs

If you have a Digital SLR, things are a bit simpler. Instead of entering macro mode by looking for the tulip, you simply need a macro lens. (So instead of a built-in button, you might need to buy a new accessory. You can't win them all.)

There are a wide variety of macro lenses available for most Digital SLRs. You can find relatively wide macro lenses (as low as 50mm) to somewhat telephoto versions (200mm). There are two reasons macro lenses come in such a variety of focal lengths:

- You can also use them as general purpose lenses, so a 100mm macro lens is also great for portrait photography.

- The longer the lens, the longer the "working distance." In other words, a longer macro lens allows you to shoot from farther away and still get the same magnification as a shorter macro lens. 100mm is considered fairly "normal" for a macro lens, but if you have a hankering to photograph insects, a longer lens might work better for you. Shooting stamps, coins, or the inside of a wristwatch? Consider a 50mm or 60mm macro lens.

As I mentioned, there are no special settings to set for macro photography with an SLR. These lenses are designed to focus continuously from close-up distances to "normal" photographic distances. If you have a D-SLR, you have a few other options for shooting close-ups as well:

- **Extension tubes** An extension tube goes between the camera body and the lens. It has no glass—its only purpose is to put more distance between the lens and the sensor. That decreases the working distance, allowing you to get more magnification. Downsides: With the extension tube attached, your lens will not be able to focus at infinity. Also, you'll lose some light, so you'll have to increase the exposure.

- **Reversing ring** Like an extension tube, this goes between the camera and the lens. But unlike the extension tube, the reversing ring does have glass in it—and a special connection that lets you mount the lens backward, so the rear element faces out at the world. This turns almost any standard lens into a macro lens. It's an inexpensive alternative to a custom macro lens, but the image quality might not be as high.

 When you're done shooting in macro mode, be certain to return your point-and-shoot camera to its ordinary focusing mode or you'll end up with a memory card full of out-of-focus images!

Close-Up Enemy No. 1: Parallax

Most digital cameras—especially the point-and-shoot variety—don't show you an accurate representation of the actual scene in the optical viewfinder. Instead, using the viewfinder is like looking through one window in your house while someone else looks through a nearby window. You both see essentially the same scene, though they are not identical. If the two of you look to

How to ...

Ensure Good Focus in Close-Up Mode

Close-focus photography is a bit temperamental. For starters, the acceptable focusing distance for macro lenses is much shorter than in the normal photo world. You should check your camera manual to discover what the minimum and maximum focus distances are for your camera's lens. Typically, you might be able to get as close as 5 inches or as far away as 3 feet. These numbers vary, though.

Here's what you should do when you're trying to take a close-up photo:

1. Verify the close-focusing range of your camera or your macro lens.

2. Press the macro button on your camera (if you're using a point-and-shoot model) to enter the close-focus mode.

3. Position your camera in front of the subject somewhere inside the range. The closer you get, the higher your magnification will be until you reach the closest point in the lens's working distance. Anything closer than that will be blurry. For best results, set the camera on a tripod.

4. Press the shutter release down halfway to lock in the focus. Look for the camera's visual focus indicator. (Most cameras use a light near the viewfinder to indicate that the image is in focus.)

5. If you're having trouble getting the image in focus, point the camera at an edge or some sharply defined region of the subject (without changing the distance to the subject). This may help the camera lock onto the subject. Or you can carry a small card with sharply defined black-and-white stripes on it (a business card and a magic marker is all you need). If you're having trouble getting good focus, hold the card right next to the subject and get the camera to focus-lock on that instead. Also, some digital cameras have trouble focusing in low light; you might want to carry an inexpensive light that you can use to illuminate the subject when focusing. Don't forget that you might be too close to or too far from the subject to lock the focus—experiment by moving the camera until you can successfully get a sharp image.

6. When you're ready, take the picture by pressing the rest of the way down on the shutter release.

That's it in a nutshell—the point is that you need to be very sensitive to focus when shooting close-ups, and you may need to reorient the camera slightly to get a good, solid focus lock. Also, when you do get a lock, make sure that you're focused on the right subject. The depth of field is quite shallow at this close distance to your subject, and it's easy to get an out-of-focus image.

How to ... Solve the Parallax Problem

There are a few solutions to avoiding parallax when taking macro photos:

- **Use the LCD viewfinder** Though the optical viewfinder of most point-and-shoot digital cameras shows a skewed image at close range, the LCD display always shows you exactly the same scene as what the sensor sees, so it should match the final image.

- **Use the optical viewfinder's correction marks** See the section called "Frame a Close-Up" for details.

- **Use a Digital SLR** Because a mirror reflects the image that passes through the lens to the optical viewfinder, D-SLRs don't suffer from parallax problems.

the horizon, for instance, the two scenes are virtually indistinguishable. If you're both looking at a person walking toward the house, though, as the person gets closer and closer, your two views become increasingly different.

And that is what it is like when you look through the optical viewfinder and the camera uses the nearby lens to take the photograph. Digital SLRs don't have this problem, because the optical viewfinder actually looks through the lens right up until the moment of exposure.

The problem, as you have probably guessed, manifests itself when you try to take a close-up with point-and-shoot digital camera. Since your subject is only a few inches away, the difference in view between the viewfinder and the lens means that you're not even looking at what the lens is about to take a picture of. That's why most digital cameras have indicators in the optical viewfinder. Called *close-focus marks, parallax marks,* or *correction marks,* these lines show you how to line up the photograph when you are shooting a close-up. See Figure 6-2, for instance. Here, you can see the effect of parallax on a photo. The image on the left represents what I saw in the viewfinder; the image on the right represents what the lens actually photographed.

Frame a Close-Up

So, now you understand the principle behind parallax and close-up photography. Let's apply this so you can see how to take a close-up photo.

Look through your camera's optical viewfinder. Hopefully, you can see some correction marks. If the lens is located to the right of the optical viewfinder (as it is in most cameras), you should see correction marks on the left side of the viewfinder. Why is that? Well, these marks represent the left edge of the photo when shooting at close distances. Since the lens is off to the right of the viewfinder, you will need to point the camera slightly to the left in order to take the

FIGURE 6-2 You can't trust your window-style viewfinder when taking close-ups because it sees a slightly different scene than your lens does.

picture you desire. In actual operation, just recompose the scene so the correction marks help frame the left edge of your picture.

You might have correction marks at the top or bottom of the viewfinder as well. If the lens is below the optical viewfinder (as it often is), correction marks at the top of the frame show you how to reorient the camera slightly higher than you would otherwise.

If all this is just a little confusing, take a look at Figure 6-3. Here, you can see how I have oriented my camera to use the correction marks at close distance.

Correction marks indicate left edge of photo when close

FIGURE 6-3 The correction marks help you overcome composition errors caused by parallax.

Correction marks are a guide to help you frame macro photographs. But there are some very important things to remember about correction marks:

- **Correction marks are only approximate** They help you adjust for parallax error, but they are not perfect. This should be obvious when you realize that parallax varies depending on your distance from the subject.

- **Correction marks work only at close range** Parallax, by definition, diminishes with distance from the subject. At ordinary distances, you don't need to worry about the marks at all. In fact, if you use them when shooting a subject that is 10 feet away, they will simply introduce composition error in exactly the opposite direction. Remember though, that they are important when using your macro mode.

- **You can avoid using correction marks entirely** Instead of relying on the optical viewfinder when shooting close-ups, use the camera's LCD display instead. The LCD display shows you almost exactly what the lens sees, and therefore there's no parallax at all when using it.

> TIP *Whenever possible, frame your macro shots with the LCD viewfinder. Unfortunately, this can be hard in very bright sunlight, when the LCD is too difficult to see. Try shading the LCD display—Delkin (www.delkin.com) sells Pop-Up Shades that attach the back of your camera and help shield the LCD display from direct sunlight.*

Use Add-On Lenses

The macro mode built into your point-and-shoot digital camera is certainly a nice start for taking close-up pictures, and you can get some pretty good results with it. But if you yearn for greater magnification than your camera is capable of providing, there is an answer: add-on lenses.

Many cameras are designed to accommodate additional lenses and filters. Of course, SLR-style digital cameras with interchangeable lenses spring directly to mind. Cameras such as the Nikon D50 accept all of the traditional 35mm lenses in the Nikon family, and Canon D-SLRs work with a whole slew of Canon lenses. Many of these lenses have macro modes that allow you to get excellent magnification.

But what if you're not using a camera like that? Actually, many point-and-shoot cameras accept add-on lenses as well. These are lenses that snap or screw on to the front of your camera's built-in lens. Sometimes, the manufacturer sells add-on lenses for its own models, such as the camera in Figure 6-4. In other cases, your camera may have standard threads on the front of the lens, in which case you can visit your local camera shop or search online for filters and lenses that fit.

> TIP *You can look online for data on lenses for your camera. First, check out the camera manufacturer's web site for compatible accessories, including lenses. Also visit Tiffen (www.tiffen.com) and Raynox (www.digitaletc.com). Tiffen is the largest manufacturer of add-on lenses for digital cameras, and it's likely to have something for your camera; Raynox has a variety of macro lenses as well. Last, but not least, camera-depot.com has a great selection of common lenses and filters in stock, and they ship promptly.*

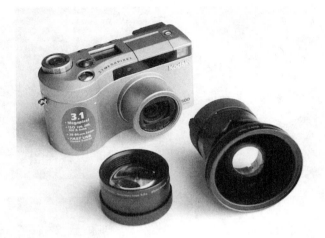

FIGURE 6-4 Many cameras are compatible with snap-on or screw-on lenses that provide telephoto, wide-angle, and macro capabilities.

The most common close-up lenses for digital cameras look like the ones shown in Figure 6-5. The macro filters in Figure 6-5 have 62mm threads and sell for about $40 as a set of four. Such filters are usually made from a single element of glass and are threaded to screw onto the front of the camera lens, an adapter, or even each other. Of course, the specific close-up filters you get will depend on the size of the lens on your digital camera.

Keep in mind that you can combine close-up lenses by threading them together. Adding a +1 lens to a +2 lens, for instance, yields an impressive +3 magnification. For that reason, I suggest getting close-up lenses as a set instead of one at a time. That way, you can combine them however

FIGURE 6-5 A typical set of close-up lenses

FIGURE 6-6 These images show the differing magnification effect of varying intensities of screw-on macro filters.

you see fit to get the magnification you need for a given picture. Check out Figure 6-6. This picture shows the effect of four different magnifications: the camera's built-in macro capability, in addition to various combinations of +1, +2, and +4 filters.

NOTE *If you add too many close-up lenses, you can start to get a vignette effect—that's when the lens and filters get in the way and cut off the corners of your picture. You can see an example of vignetting in Chapter 8.*

TIP *When combining close-up lenses, put the highest magnification on first, closest to the camera lens. That way, you can remove the lenses in smaller increments to achieve just the right magnification. Also, you may find that some lens combinations cause your images to curve unnaturally, thanks to something called "barrel distortion."*

Did you
know?

Understand the Lingo of Macro Lenses

With rare exception, close-up lenses are not described in terms of focal length, as are other lenses. That's because they're essentially just magnifying glasses that go in front of the camera's normal lens. Instead, close-focus lenses are described using the term *diopter.*

A diopter is an indirect measure of focal length. It tells you both how close you can get to the subject and what relative magnification the lens provides. Specifically, the diopter number indicates how close your camera lens can focus with the lens set to infinity and the close-up lens attached, in fractions of a meter. A +2 rating will let your camera focus 1/2 meter away, while a +3 rating focuses at 1/3 meter away, and so on. Believe it or not, these diopter numbers hold true no matter what the focal length of your camera lens. Close-up lenses typically come in a variety of strengths, from +1 to +10.

Close-Up Techniques

As I've already mentioned, taking close-up pictures is a very different experience from taking images at ordinary focal lengths. Though it's not particularly difficult to get really good macro photos, it does take a little more care and a slightly different approach.

First of all, you'll find that your subjects are slightly different in macro photography. Obviously, you won't be taking a lot of people pictures from 2 inches away. There are numerous choices, however. I suggest that you start by taking pictures of things that don't move, such as in the example shown here:

Once you have coins and stamps pretty well in hand, you can move on to photographing insects, flowers, and other mobile or semimobile subjects.

In fact, lots of subjects look radically different at close range and magnified than they appear from a human perspective. Some subjects can even take on an almost fractal appearance—that is, their underlying structure can seem to have a nearly infinite amount of complexity, as you can see from these ice crystals on a tree branch, captured on a chilly April morning:

That's why I think macro photos make for some very exciting images. Here are a few subjects you might want to consider trying your hand at:

- Hobby subjects such as stamps, coins, and models
- Wildlife such as plants, flowers, leaves, insects, and butterflies
- Found objects such as rubber bands, paper clips, and fabric
- Snow, ice, and water

A Steady Base

Without a doubt, you should invest in a tripod if you plan to take many close-up photographs. Although you can get away with holding the camera in your hands most of the time, the extreme magnification provided by close-up lenses tends to make even the most subtle shake ruin your picture. In close-up photography, I highly recommend planting your camera securely on the floor or ground with a tripod. For some information on choosing a tripod, see Chapter 9.

TIP *Even if you have a lightweight digital camera, the outdoors can be unkind to your photos. If you're shooting in the wind, a heavier tripod will hold your camera steadier than a comparatively lighter tripod. If you have a light tripod, you can hang something heavy from the center of it to help stabilize it. Of course, in a strong wind, it'll also be hard to keep your subject still unless you have some means to block the wind.*

FIGURE 6-7 A loose tripod head comes in handy when you're taking pictures of moving insects.

When you set your camera up on the tripod, you can leave the head unit somewhat loose. That helps you move the camera around and position it with minimal fuss. This is really up to you—try leaving the head a little loose, and if you can consistently get sharp images, work this way. If you find that your images are always a bit blurry and you think it's because you're leaving the head unit loose, then tighten everything up before you take your picture.

Here's a perfect example: In Figure 6-7, you see a bee that I photographed hovering around a columbine. If I had tightened down every knob and lever on my tripod, there's no way I could have caught the little guy as it flitted around somewhat randomly. Instead, the tripod gave me the support I needed, and I left the head unit loose so I could move the camera around to catch the bee at just the right moment.

Keep the Subject Sharp

In Chapter 3, I spent a lot of time talking about depth of field. If there was ever a time when depth of field was important, this is it. The reason? At high magnification in very short focusing distances, depth of field becomes vanishingly small. In fact, it's not unusual to find that the total

Did you know?

You Can Use Beanbags as Camera Supports

I heartily recommend getting a tripod. The problem with tripods, though, is that they're bulky and are a pain to carry around, and heavier ones always tend to work better than lighter ones. What's one to do?

Well, you can carry a beanbag instead. I'm not suggesting beanbags as the ultimate, full-time replacement for tripods, but I have run into situations when they can steady your camera in a pinch. If you have something you'd like to lean the camera on top of, such as a fence post, a boulder, or even the ground, try putting a beanbag under the camera. It'll conform to the shape of the camera as well as to the shape of whatever you're placing the camera on, and the dense clump of beans in the bag will help steady the camera as you press the shutter release.

And if you don't have a beanbag, improvise. As a scuba diver, for instance, I always have bags of soft weights when I go on dive trips. They're filled with small beads of lead shot, and aside from being a lot heavier, they act a lot like beanbags.

Finally, if you want a beanbag that has been designed especially for photographers, check out The Pod, a beanbag-style camera support with a tripod bolt sticking out of the top, which you can see in action below. It's available for about $15 from www.thepod.ca.

depth of field in a close-up photograph is only about half an inch. In Figure 6-8, for instance, you can see that only part of the flower is in sharp focus, while most of the image is blurred. Even parts of the flower are out of sharp focus. Or go back and check out the photo series in Figure 6-6. As you move from picture to picture, the magnification gets greater, and you can actually see the depth of field get smaller and smaller in each image.

FIGURE 6-8 It's easy to blur the background in a close-up; the hard part is getting everything you want to be in focus actually in focus.

That said, the focusing range of your camera is always at a premium in close-up photography. Even if you want your background to be out of focus, you often want the most depth of field you can possibly get your hands on, since the background will almost certainly be out of focus anyway.

Here are a few things you should keep in mind to help you control the depth of field in your photograph:

- **Distance** Remember that the closer you get to your subject, the less depth of field you will have available. So to regain depth of field, back away from your subject. To do that, you may have to remove a close-up lens from the front of your camera if you're using one or more add-on lenses.

- **Aperture** Another way to increase depth of field is to close the aperture as much as possible. You may need to enter your camera's aperture priority or manual exposure mode to control this.

- **Light** The more light available, the more you can close the aperture. You can use the camera's built-in flash or an external flash if your camera allows it, or just shoot in situations where there is a lot of natural light.

CAUTION *Be careful when you compose your picture so that the subject is parallel to the lens, not perpendicular. If your subject has depth with respect to the axis of your lens, part of it will be in focus and part of it will not. When you can, turn the subject or the camera so that the entire length of the object is in sharp focus.*

Mind the Background

The background is an important part of your photograph. In general, you probably want your background to be fairly indistinct. As luck would have it, that is not too hard to do in a close-up photograph. After all, there's precious little depth of field to begin with, so the background will probably be blurry. Here are a few tips for tweaking the background of your photograph:

- **Turn it black** If you use your flash, you'll throw so much light onto the primary subject that the background—especially if it is more than a few inches away from the subject—will be black. This is a good effect in certain situations, but it doesn't look particularly natural. That's why many professional macro photographers avoid using flash units when shooting flowers in the field.

- **Use a plain background** You can insert a prepared background—a piece of poster board, for example—between the main subject and a distracting background. If the poster board is far enough away, it'll be out of focus and give you a plain, diffused look. I sometimes use big slabs of colored foam board from the local hobby and craft store for this purpose.

- **Blur it out of existence** As I have already mentioned, depth of field is perhaps your most powerful tool when taking close-ups. You can check how much depth of field you currently have by half-depressing the shutter release. The camera's LCD display will show you the image with the aperture closed to the appropriate level, and that will give you your final depth of field. (Digital SLRs often have a depth of field preview button near the lens—press it to "stop down" the lens to see what the final photo will look like.) If you need more or less depth of field, let go of the shutter release and tweak the camera settings. Just check your depth of field over and over in the camera's display until you are happy with the result. I took the image shown in Figure 6-9 with a very wide aperture to blur the background while keeping the monk's head flower quite sharp.

Beware of the Flash

You might start to get the impression that I am not a big fan of the electronic flash unit built into many digital cameras. Flashes that have limited range can make your pictures look artificial and can sometimes create harsh shadows. Nonetheless, flash units are admittedly an essential tool, and I don't hesitate to use them when needed.

FIGURE 6-9 This image was taken with a very wide aperture and no flash.

On the other hand, you should be aware of two key limitations that may be inherent in your camera's flash unit when used in close-up photography:

■ **Overexposure** Unfortunately, some digital camera flash units are not designed for very close range. When you're taking a close-up (and you're within, say, a few inches of your subject), most camera flash units won't fire at all (they're disabled in macro mode) or they'll overexpose the subject. Most flash units expect the subject to be several feet away and don't react well when the subject is much closer. You can find out very easily if your camera suffers from this problem. Just take a test picture or two and evaluate the results. Of course, there are workarounds to this problem. You can try underexposing the picture using the EV controls on your camera (even better: use the camera's flash compensation control to throttle down the flash effect, if the camera has such a control), or try a low-tech solution: lay a piece of thin tissue or some photo gel (available at any camera shop) in front of the flash to diffuse the light.

How to ... Secure the Subject

Need a way to keep the subject perfectly still? If you're shooting something that's not ambulatory (stamps, coins, flowers, and die-cast models will work, but insects won't) then you need to get one or two *plamps* (www.tripodhead.com). A plamp is a lightweight plastic clamp with a long, flexible arm that you can use to precisely position subjects in front of the camera. Clip one end to your tripod, for example, and use the other end to securely and precisely position your subject. You can use a plamp to hold a flower still so it doesn't blow around in the wind, for example. Here's a pair of plamps in action, ready to secure a subject:

■ **Blockage** Some flash units are positioned so that the lens itself blocks some of the light when the subject is too close to the camera. In my book (and hey! This *is* my book!), this is a camera design deficiency, plain and simple. Nonetheless, if your camera is affected by this particular glitch, it's easy to see for yourself. As in Figure 6-10, there will be a huge shadow in part of the picture where the lens got in the way of the flash. Ordinarily, your camera may not suffer from this problem, but it may become prone to light blockage if you add snap-on lenses (like macro filters, for example).

FIGURE 6-10 Some cameras block the flash when the subject is too close; if yours does this, use only natural light to illuminate your subject.

Keep in mind, though, that there are special flash solutions designed especially for macro photography, especially if you have a Digital SLR. Ring lights attach to the end of the flash and evenly illuminate the scene in front of the camera.

Shoot through Glass

Sometimes you might want to take a close-up of something that is under a sheet of glass—jewelry in a display case, for example. There's a common problem with this kind of subject, though: light from the sun or overhead lamps can reflect off the glass and cause unwanted glare in your picture. Not only is glare like this ugly, it can actually make it difficult to see what it is you were trying to photograph under the glass. The solution? Use a polarizing filter. A polarizer does a few nifty things for your photograph, but the most important one is that it eliminates reflections caused by glass and water by blocking polarized light.

Polarizing filters are sold in many sizes and for many digital cameras. It's not a bad idea to carry one in your camera bag for those occasions when it might come in handy. Polarizers are usually two-piece devices that rotate on the end of your camera—you turn the outer layer until the reflections are minimized.

CAUTION *You want a circular polarizing filter. You probably won't have trouble on that count, since most photographers today buy circular polarizers. But a less-common linear polarizer simply won't work right for you because it confuses the camera's light sensors.*

That may sound complicated, but it's actually pretty easy. The LCD display on your camera gives you immediate feedback on the effect of the filter. If you can see a reflection in the display, continue turning the polarizer until the reflection is gone (or at least minimized). Keep in mind

that a polarizer is most effective when you photograph at a 34-degree angle from the reflective surface, as demonstrated in this illustration:

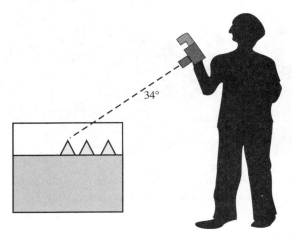

Not sure what 34 degrees works out to be? Just experiment a bit and you'll quickly find the right position. If you use your polarizer properly, you can reduce glare significantly—sometimes completely. In Figure 6-11, for instance, you can see the effect of a polarizing filter. The image on the left is uncorrected; it's what you would get without a polarizer. The image on the right has had its reflections stripped away using a polarizing filter.

FIGURE 6-11 By turning a polarizing filter on the end of your lens, you can minimize the reflections caused by light and glass.

Your Own Macro Studio

It's not always easy to get perfect results from close-up photography. There are so many elements to worry about: wind, lighting, the narrow focusing range, and limited depth of field. Lighting is especially tricky, in fact, because certain subjects look pretty bad when you hit them with an electronic flash. Lots of people try to photograph reflective items such as coins and jewelry, for instance, to sell on ebay.com or post on a web site, and they're disappointed with the reflections from the flash.

If you are excited about macro photography and expect to do a lot of it, you might consider setting up your own macro photography studio. What's that? Also called a light tent or a light box, it's just a small structure in which you place whatever you want to photograph and surround it with lights, reflectors, and, most importantly, some material to diffuse the light. There are numerous light tents of various sorts available for purchase—here are a few examples:

- **Cloud Dome** This clever little gadget is a plastic dome (it looks like an upside-down salad bowl) that covers your subject and has a hole at the top for mounting your camera. The dome itself diffuses light from the outside, illuminating the macro subject evenly and professionally. You can find it at www.clouddome.com.

- **EZcube** Available in various sizes from 12 inches to a massive 55 inches on each side, the EZcube looks a lot like the sort of tent you'd go camping in; it's made of a translucent fabric that diffuses outside lights quite nicely. It also includes a zippered flap on top so you can arrange your scene without disturbing your camera that's positioned in front. Check it out at www.ezcube.com.

- **Samigon** A light box like the Samigon Internet Photo Studio Lighting Set comes with its own lights and can be adjusted for large and small subjects. You can add your own backdrops—colored poster board does the trick. Learn more at http://www.adorama.com/VRLBIPS.html.

In addition to commercial light tents like these, you can build your own. It's really not hard, and you can make something yourself for very little money that's as good (or better) than a store-bought light tent.

Just to demonstrate how easily you can build a simple light tent, consider that you can make an incredibly simple setup by surrounding a tripod-mounted camera with a diffusing material, like tissue, paper towel, sheets, or a pillowcase, and pointing a desk lamp at the subject from the other side of the diffuser. (There's no "correct" diffusing material—people I know have used all sorts of stuff, from white muslin fabric to drafting paper to old white T-shirts. Experiment!) You don't need any structure to hold it all together. Just drape the material over the top of the camera.

A more elaborate light tent can be made from a large cardboard box or interconnected PVC pipes. The idea here is to create an open area in which you can position the camera and windows on all the other sides on which you can attach some diffusing material to soften lights.

So, what kind of lights should you use? Any sort will do in a pinch. You can position desk lamps or a lamp from your living room outside the light tent, though you might have better results with 250W "photo" bulbs, available at most camera stores.

Chapter 7

Sports, Action, and Active Kids

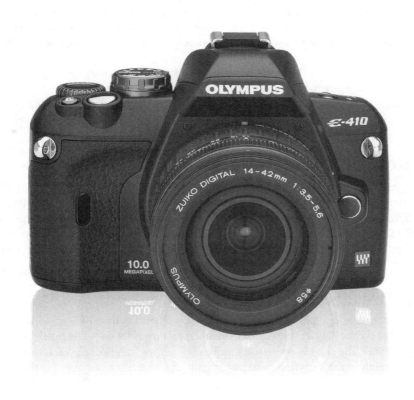

How to...

- Catch fast-moving subjects despite shutter lag
- Stop the action with shutter and sports modes
- Pan for action
- Freeze kids at sporting events
- Take beautiful waterfall pictures
- Capture wildlife at the zoo and in the woods
- Shoot photos of colorful fireworks
- Take photos from an airplane window

Everybody likes motion—even our vocabulary makes that clear. We love movers and shakers. We're always on the go. We describe fun friends as having animated personalities; the good stuff is always up and coming. Slowpokes, like sloths and snails, on the other hand, have a somewhat less glowing reputation. So, if motion is such a good thing, perhaps we should put a little in our photographs.

But you already know that. Action photography—like shooting sporting events and kids, well, pretty much doing anything—are some of the most common photographic subjects. So you know just how tricky it can be to catch a picture of your kid running around the bases of a softball game. In this chapter, you'll see how to capture sports, action, and kid photography.

Action Photography Essentials

Action photography is often considered the most exciting kind of photography, but it's also the most demanding. The problem—obviously—is that you're taking pictures of things that are moving. And that means not only do you need a shutter speed fast enough to "stop the action," but you might also have to contend with the slight delay between when you press the shutter speed and when the picture gets taken—this is called *shutter lag,* and it's common to many digital cameras. Let's talk lag first.

Avoid the Dreaded Lag

Often, the most common complaint I hear about digital cameras is this: "There's a long pause between when I press the shutter release and when the picture is taken." The result: when trying to take an action shot, the subject sometimes moves before you can take the picture. You may see the picture on the left in the viewfinder, but what you get on your memory card is the picture on the right:

Indeed, while some cameras are better than others, that pause is responsible for more frustration than all of the world's child-safe medicine bottles combined. Older digital cameras had a "shutter lag" that lasted a whole second or more, but even many of the newest digital cameras have some lag—and that's a real problem whether you're trying to freeze a NASCAR rounding the corner or catch your grandson hugging the dog.

How to ... Capture the Moment

Most digital cameras have a two-step shutter release. Knowing how to use it is key to taking great pictures.

When you put a little pressure on the shutter release button, the camera springs into action—it locks in the focus. If you continue to hold down the shutter button, the focus won't change; you can then recompose the picture and, when it meets your approval, press the shutter release all the way to take the picture.

You might want to use the focus/exposure lock step without pressing the button all the way down for a lot of reasons:

■ Focus lock takes a little time—a fraction of a second, but time nonetheless. If you're taking an action shot in which you want to precisely control the instant of exposure, lock the exposure and focus first; then wait with your finger on the shutter until you are absolutely ready to take the picture. Then, all it takes is a hair more pressure to capture the scene more or less instantly.

■ If you want something that's off to the side of your picture to be in sharp focus—and this commonly is the case if you follow the rule of thirds—then point the camera at your off-center subject and lock the focus. Then recompose the shot to put the subject off to the side, and snap the picture.

Shutter lag happens because—invisible to you—digital cameras have a veritable checklist of tasks to perform when you press the shutter release. Not only does the camera need to measure the distance to the subject and lock in the proper focus, but it also has to measure the light, figure out how to balance the colors so whites look white and blue looks blue, calculate the best exposure, and lock in an aperture setting and shutter speed. The camera also has some obscure computer-like "housekeeping" chores to perform, like initializing the sensor chip and flushing buffers that hold data about your picture. You don't have to know what any of that means, just know that your camera is busy doing stuff as you start to take a picture.

If your camera's lag doesn't bother you, fine. You might have a camera with a short lag and, if that's the case, consider yourself lucky. But, if your camera has a noticeable amount of lag and you want to minimize it, you can do a few things:

- The single biggest time-waster is using your camera's auto focus. If you prefocus your picture, you can save valuable milliseconds of lag.

- If you're more adventurous, you can also try presetting the camera's white balance based on the kind of scene you're shooting. If the white balance is set on auto, it'll have to adjust the colors in the image every time you take a picture, and that takes a little bit of time each time you press the shutter release. Instead, you can use the camera's menu to set the white balance for whatever lighting conditions you're shooting in, such as daylight, night, florescent, or incandescent lighting. Just remember to change the white balance for every new lighting situation you find yourself in.

- If you try those things and still find lag a problem, you may need to shoot *predictively*— and by that I mean to press the shutter release a heartbeat before you want to capture the photo. Measure the amount of lag your camera has—a half second? A second?—and start pressing the shutter release that far in advance.

- Some digital cameras try to get around the lag problem by offering a Continuous Fire or "Burst mode." When set to that position, you'll capture a series of pictures in quick succession, usually about 1/3 second apart. The presumption is that you'll get lucky and at least one of them will look good. Experiment with that mode and see if it helps you get better action shots.

- Finally, you can try panning at the same time to better freeze your subject. See the section "Pan for Action" later in this chapter.

Stop the Action

If your digital camera is an "all auto" point-and-shoot model, there's not a whole lot you can do to change your camera settings to help freeze the action—your camera is already programmed to try to use the fastest shutter speed it can most of the time. But you definitely can try your hand at panning, as I explain in the section "Pan for Action."

But, if your camera has a shutter priority setting—and many do—you're in luck: Shutter Priority mode was born for action photography. To freeze the action, you'll usually want to use

the fastest shutter speed you can get your hands on—and Shutter Priority mode makes that easy to do. This is what Shutter Priority mode typically looks like—either an *A* or a Tv symbol:

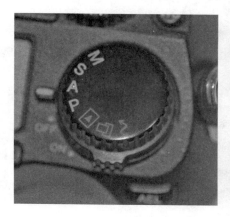 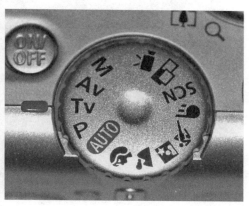

In general, I recommend that you use the fastest shutter speed available to capture action. To do that, set your camera to Shutter Priority mode, and then use the controls on your camera to set it to the fastest, or close to the fastest, shutter speed available. Good speeds for freezing action include 1/125, 1/250, 1/500 second, or even faster, if your camera allows. But if the shutter speed is really slow—like 1/60, 1/30, or, heaven forbid, 1/15 or slower, then it's pretty likely your picture will be blurry—although those shutter speeds are great for panning, which we'll talk about shortly.

What if you know that your camera has faster shutter speeds, but, probably because of the available lighting, you can't get the shutter speed to go high enough to freeze the action? Bump up your camera's ISO, which we first talked about back in Chapter 2. Many cameras have an adjustable ISO level, which, like the film speed rating it's named after, lets you change the sensitivity of the camera to light. Increase the ISO level to enable you to shoot with a higher shutter speed.

Pan for Action

Another really cool action photography technique called *panning* captures the subject in good, sharp focus, while "holding" the background as a motion blur. See Figure 7-1 for an example of panning used to freeze a child's wild ride at a Renaissance festival. This is a great technique to try for a couple of reasons:

- It gives the picture a great sense of motion. Freezing everything can make the picture look too static; panning lets you see that the subject is really ripping through the picture.

- It works well at slower shutter speeds. So, while your camera might usually blur an action shot in a bad way, panning lets you blur it in a good way.

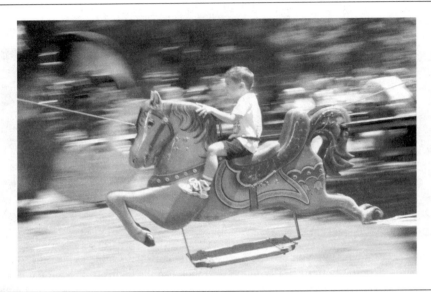

FIGURE 7-1 Panning freezes the subject while blurring the background.

Learning to pan takes a little practice. To create a good pan, you need to twist your body in synch with the motion of the subject as you press the shutter release. Here's how:

1. Position yourself where you can twist your body to follow the motion of the moving subject, without having the camera's line of sight blocked by something else.

2. If you can, set the camera's shutter speed for about 1/30. Feel free to experiment with this, but if you set the shutter speed too slow, you can't capture the subject effectively—it blurs. And, if the shutter is too fast, you won't get the contrasting blur in the background.

3. Twist your body with the motion of the subject and track it for a few seconds through the camera's viewfinder or on the LCD display. Keep the subject centered in the viewfinder, and then press the shutter release and continue tracking the subject for a few moments, even after you hear the picture get recorded. Just like in baseball or golf, ensure that you follow through the motion even after the shutter releases. That way, you don't stop panning in the middle of the exposure. You may need to practice this a few times to get the shot right, but your digital camera gives you the opportunity to practice till perfect for free!

There's another way to show action—hold the camera rigidly in place and let the action scream through the viewfinder as you take the picture, capturing *its* motion, instead of the background's motion. If you're shooting in broad daylight with a reasonably fast shutter speed, you can hand-hold the camera for this kind of shot. If you're shooting with a slow shutter speed

in a dark location, though, you might get better results mounting the camera on a tripod. Here's an example of capturing motion in a New York subway station at about 1/15 second:

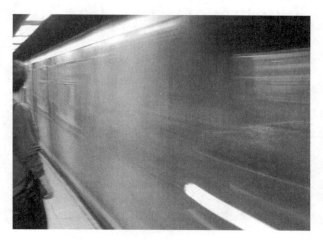

Compose Action Shots

As in all kinds of photography, you can no doubt take some great pictures with your camera's zoom lens set on anything from its wide-angle position all the way up to the photographic equivalent of the Hubble telescope. And your camera's wide-angle setting can, in fact, have a role in action photography. But the essence of many action shots is a highly magnified immediacy—something you can only get with the lens zoomed all the way in to the telephoto position. Try zooming in tight for action shots—check out the difference between these pictures, and decide for yourself which ones are more exciting:

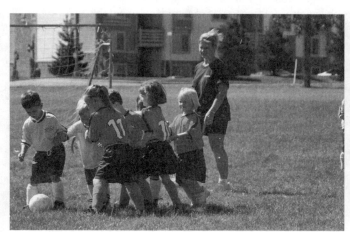

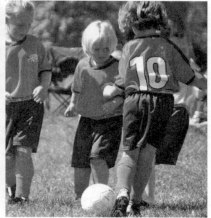

How to ... **Experiment with Action Mode**

Your camera might have something called Action or Sports mode, like the one on the following dial (it looks like a running person).

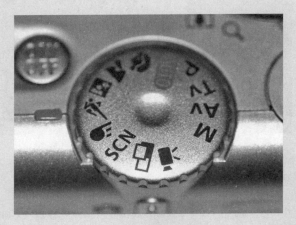

If that's the case, consider using it to take these kinds of pictures. Action mode is usually designed to use the highest possible shutter speed available with no additional effort on your part. And that's great.

But, beware—not all Action modes work the same way. I have found that some cameras, when set to Action mode, disable focus locking. Most digital cameras lock in the focus the moment that you apply slight pressure to the shutter release, and I recommend using that technique to help reduce the inevitable shutter lag when taking pictures in fast-changing situations. With some models of camera, though, the lens will continue to autofocus continuously, right up to the moment of exposure, even if you try applying some pressure to the shutter release. How does your camera work? You'll have to experiment with your camera to see. The easiest way is to put a little pressure on your shutter release button and move the camera around, so it has to change focus from a nearby to a distant object. If the focus changes as you move, then give some thought to using Shutter Priority instead for hectic shooting, like at a soccer game.

Photograph Kids at Sporting Events

So, you're at a soccer game and trying to get some great pictures of your kid and the team. Here are a few pointers for getting great shots:

- **Stay close to the action** If you can get close to the sidelines, you won't have to shoot over or between other spectators. Get right on the sidelines whenever possible. Getting closer also means that you don't have to zoom in all the way just to get something interesting in the frame—so your pictures won't be as shaky.

- **Get down to their level** If you have little ones, get on your knees or on your belly, so you're taking pictures from their perspective. Often, they'll be a lot more interesting than photos that look down from 5 feet in the air, which is a towering height to a toddler.

- **Keep the sun out of your eyes** If the sun is anywhere in your field of view, your pictures will be badly underexposed. Scout out a good spot before the game starts, so that you can keep the sun behind one of your shoulders. If you want to know the basics of exposure, check out Chapter 3.

- **Whenever possible, try to frame the action as tightly as you can, meaning that only a few players are in the frame at once** If you're including the whole field in your shot, the scene will lack impact and it will be less interesting.

Photograph Animals

Animal photography—whether it's your family pet or a pack of wolves at the zoo—works best when you have a lot of zoom, a fast shutter speed, and a tripod. Try to fill the frame as much as possible, and expect the unexpected—like your subject suddenly darting out of your frame just when you get ready to snap the picture. Figure 7-2, for instance, shows a pair of wolves frolicking that would have been impossible to shoot without a fast shutter and a lens with a long reach.

FIGURE 7-2 Wildlife photography requires many of the same shooting skills as action photography.

Photograph Waterfalls

Have you ever seen those cool running-water shots in nature books and wished you could get the same sort of thing on your next vacation? Well, you can—it's easy to get images like this one:

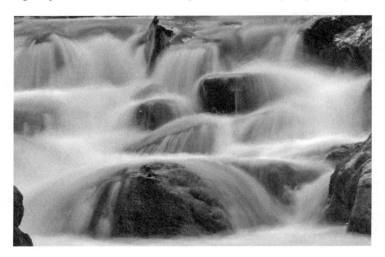

Here's how:

- You need to ensure that your camera will give you a long exposure—at least half second, and longer if possible. The best way to do this is to show up at the waterfall or running stream early in the morning or late in the afternoon, when there's not much light available.

- Be sure that your camera's ISO setting is as low as it'll go, such as 100.

- Set your camera on a tripod (the long exposure absolutely requires a steady support—but you can use a very small, lightweight tripod).

- If the camera has a shutter priority mode, use it to set the camera's shutter speed to half second or slower.

- Compose the image and take the shot.

- If your camera allows it, take several pictures, each with a different shutter speed. The longer the shutter is open, the "smoother" the water will look. Compare the two images in Figure 7-3. The version on the left was shot in just 1/30 second; the one on the right had a far more leisurely shutter speed of 1/2 second.

Finally, you don't encounter waterfalls every day—so it pays to be prepared when you find one out in the real world. Practice at home! You can simulate a waterfall in your own kitchen. Check out the following pictures, shot in a kitchen sink. The first one was taken with the camera in Automatic mode. Then I set the camera to Shutter Priority and dialed the shutter speed to 1/30 second.

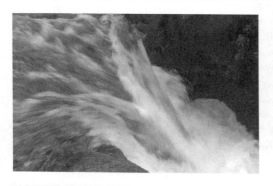
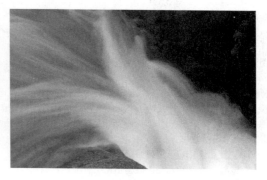

FIGURE 7-3 Varying the shutter speed can have a dramatic effect on the look of a photo with lots of motion, like a waterfall.

Notice the picturesque way that the water rolls off my dirty dishes. Take a few of these sorts of images, and you'll be ready for a real waterfall!

Photograph Fireworks

When I think about the summers of my youth, I remember the long, hot, humid days of Jersey City. There were fire hydrants opened up to serve as water sprinklers, touch football games in the street, and the Italian ice truck that rumbled down the street every day at three. I don't know if those traditions have changed in the last 30 years, but one thing that never goes out of style is summer fireworks.

It doesn't take much to get some pretty amazing fireworks photos. Almost any digital camera will do; you just need the ability to adjust the exposure (so an all-automatic camera won't give you very good results) and a tripod. Yep, you're going to need to use a tripod—any photo of fireworks will require an exposure of 1 second or more, and you can't hold the camera steady for that long.

One other goodie will improve your fireworks shots: a wireless remote for your camera. Keep in mind that this is far from essential. If your camera comes with one, you should use it. But if you don't have one, don't sweat it. The goal is to avoid touching the camera when the exposure starts, so that you don't jiggle it and blur the photo. But as long as you're gentle and don't continue to touch or lean on the camera after the exposure starts, you're probably going to be just fine. I love those little infrared remotes though (Olympus, in particular, tends to include them with their models) for totally hands-free operation. If you have a Digital SLR, you can probably get a remote cord that plugs into the camera.

Set the Focus

Usually, when you take pictures, you don't need to worry much about the focus, since your camera auto-focuses automatically at the moment of exposure. Fireworks are different, though, because you're shooting in almost total darkness. Because it's so dark, your camera can waste time trying to find the right focus at the moment that you take the picture. If you've ever tried taking a picture in the dark and heard the lens straining to find the right focus to your subject, you know what I'm talking about.

The solution? If your camera has a manual focus mode, switch to that, and manually focus at infinity. If not, your camera probably has a landscape mode (symbolized by a small mountain range). Switch your camera to landscape, and it'll automatically focus at infinity for you. Infinity, incidentally, will always be the right focusing distance when shooting fireworks. Unless you're incredibly close to the detonating fireworks, that is, in which case focusing your camera should not be your top priority.

Zoom In on the Action

So, you're almost ready. You've got your camera mounted on a tripod, it is set to infinity, and you're waiting for the fireworks to start. While you might be tempted to zoom way in to get close-ups of the action, I recommend that you zoom out a bit. If you keep the camera set at the wide angle end of your zoom range, you'll be able to capture more fireworks in a given frame. Of course, you can experiment and change your zoom range throughout the evening, but start zoomed out far enough that when you begin the exposure, you can catch the fireworks rising up into the air and then exploding, all in the same frame. This way, you're guaranteed to get better pictures right from the start. If you zoom in more tightly, it can be difficult to know exactly when and where the fireworks are going to do their thing, and you'll end up missing the action.

Find the Right Exposure

All that's left is selecting the correct exposure. Because you're photographing small moving lights against a pitch black background, you obviously want to use a timed exposure—something

longer than the typical 1/60 second your camera usually uses. You'll probably get your best results when you use an exposure time between 1 and 4 seconds. If you can control your aperture setting, try starting at f/8. After you take your first couple of pictures, review them on the back of your camera, and check to see if you're getting realistic color. If the bright blue, orange, and red fireworks all look kind of white, you should use the same exposure time but close the aperture a bit and try again. That means changing your f/8 setting to f/11 or perhaps f/16. If you don't have any control over the camera's aperture setting, then you'll have to shorten the exposure time instead.

Take Photos through an Airplane Window

It seems that no matter where you go on vacation, there's always some sort of airplane or helicopter tour available to let you get a better view. Even on an ordinary airline trip, there are some cool sights to be seen out the tiny little window, like the following image, which I captured on final approach to one of the Bay Islands near Honduras while shooting out the window of a typical passenger plane.

The next time you find yourself boarding a plane, snap a few shots. Here are some things to keep in mind:

- Hopefully this goes without saying, but turn off your camera's flash—if the flash fires, it will reflect off the window and ruin your shot. Unless you own a flash powerful enough to illuminate the ground 10,000 feet below you, there's no reason to use one. Rely on the natural lighting outside the plane.

- If you're on a sightseeing trip, let the crew know you have a camera and would like a seat that is closer to one of the large windows. That's not always possible—in a helicopter, for example, they often arrange passengers by weight—but it doesn't hurt to ask.

■ If you're on a sightseeing flight, ask the pilot before you take off if you can open any of the windows. Sometimes regulations prohibit to open windows, but getting rid of the glass can dramatically improve your shots.

■ If you're stuck shooting through glass, ask if you can clean the windows beforehand. Once, I was positioned in front of an especially dirty window. When I mentioned that I had a camera and asked if I could clean the window, an aircrew member was dispatched to do it for me.

■ If any of the windows are actually open, you'll have a lot of cold wind. Make sure everything you are carrying is securely clipped to your body or otherwise secured. As an aside, it'll be cold in the cabin, so dress accordingly.

■ Be sure not to lean any part of the camera or lens against the airplane (such as the window), because the vibration from the engine will ruin your photos.

■ Set your camera's focus on "infinity," since you'll be shooting at subjects that are very far away. If your camera doesn't have a manual focus control, then it almost certainly has a Landscape exposure mode (often one of the "scene" settings). One of the things that Landscape does is set your camera to focus at infinity, so that's a good substitute.

Chapter 8

Push Your Camera to Its Limits

How to...

- Take pictures in special color modes like black and white or sepia
- Decide when to use special color modes on the camera or wait and process images on the PC
- Shoot a series of panoramic photos
- Add wide-angle and telephoto lenses to your camera
- Avoid vignetting when using add-on lenses
- Correct for distortion caused by wide-angle lenses
- Interpret lens magnification numbers
- Take a series of time-lapse photos
- Turn time-lapse photos into a movie
- Extend the life of your camera's batteries

These days, cameras are no longer just cameras. Take a look at the most common cameras in the local computer or camera shop, and you'll find that many models are designed to record movies, take panoramic photographs, record sound, and do a host of other things as well. It seems that camera manufacturers think that if you like a camera, you'll like a camera that washes your dishes and plays music even better.

Most of this book concentrates on how to use your camera to take good pictures. A lot of the extra features that you find on cameras are, in my opinion, usually just gimmicks. On the other hand, every once in a while you may find a useful, creative application for one of the gizmos built into your camera. And that's where this chapter comes in: look here for information about some of the other cool things your camera can do.

And that's not all. This chapter is about pushing your camera to its limits. That means we'll talk about how to do unusual things with your camera, such as use it to perform time-lapse photography.

Get Creative

Your camera probably comes with a couple of photo modes besides the ones that we have already discussed. The most common features you'll encounter in digital cameras are additional color modes. By setting your camera to the appropriate mode, you might be able to take pictures in black and white, for instance, or perhaps with a sepia tone.

TIP *If your camera does not come with one of these special effects modes, you can always convert your images to black and white or sepia on a computer after you've taken them—all photo editing programs let you convert photos to black and white or other color schemes.*

Using the black-and-white or sepia mode on your camera allows you to capture images that have a somewhat old-fashioned look. That's because very old photographs have a brownish tint that is called sepia that comes from the dyes that were used to print them.

Black-and-white images also make a strong artistic statement, so people use this mode to be creative.

The downside? If you decide that you want to use the photos in color as well, it's simply not possible to put the color back in later. If you're not sure how your images might be used, I recommend that you avoid these special color modes on your camera and instead just save ordinary color photos. Later, you can easily convert the images to black and white in a photo editing program if necessary.

The Old-Fashioned Look

If you want an authentic-looking old-time photograph, you can get a pretty authentic imitation with your camera's sepia mode. People instantly recognize the brownish hue of the sepia-toned image as something that is quite old—or at least something that's supposed to look that way. But in addition to just using a little sepia color, there are other things you can do to ensure that the image looks more authentic. Try these tips:

- Pay attention to costumes and props. If your goal is to take a picture that is set in a specific period, it will look more authentic with the right garb, regardless of whether it is colored sepia or not.

- Use natural light. Avoid using an electronic flash, which can get in the way of the picture's look.

- After you take the picture, fine-tune it with an image-processing program. In Chapter 14, you'll see how you can make the picture look more authentically aged.

Make a Panorama

Panoramic photographs have been around for a long time. Before digital photography came along, there were two ways to make a panorama. Special cameras—loaded with special, extra-wide film—were capable of taking photos that were much wider than they were tall.

The other traditional way to make a panorama is to take a series of photographs and connect them, sort of like a collage. This collage technique allows you to make very, very wide panoramas. Unfortunately, you can usually see the seams between each photograph, since each print is simply layered, one on top of the other.

Digital photography allows us to make panoramas in an entirely new way. Using a still camera, it is a piece of cake to take a high-resolution photograph that spans your entire field of view from left to right, including your peripheral vision—like the ones in Figure 8-1 that I took from a Circle Line tour boat in New York harbor. Heck, you can keep going around and take a 360-degree photograph. I can't easily show such a picture on the pages of this book, though, because to squeeze a very long image onto the page, it would become so narrow that you

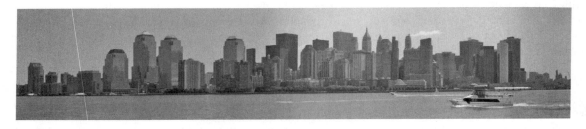

FIGURE 8-1 Panoramic images allow you to see a picture more or less the same way your eyes see the real world.

wouldn't be able to see what was in the picture. Nonetheless, you can read more about them in Chapter 14.

Some cameras boast right on the box that they have panoramic capability. Some cameras don't. Either way, you can make a panorama; so don't despair if it appears that your camera does not have a panorama mode. Creating a panorama on the PC is actually pretty similar to making a collage of prints. The software simply takes a series of photographs and stitches them together digitally so that the seams are essentially invisible.

Before we get there, though, you need to take the initial batch of pictures. Believe it or not, you can get some very nice panoramic photographs even if you are a bit sloppy when you take the original images. For best results, however, you should be as careful as possible when you take your pictures. Just like the old computer axiom "garbage in, garbage out," the better your original images are, the better the final panorama will be.

Did you know?

The Best Reasons to Shoot Panoramas

People sometimes ask me why they should bother with panoramas. There are two excellent reasons:

- **Fit more in the frame** "I can just use a wide-angle setting on my camera's zoom to take the same picture," people tell me. That's simply not always possible, though. Often you can't back up far enough to fit everything in the frame. And when that happens, your only choice to capture it all is to take the picture in sections and stitch it together afterwards. Hence, a panorama.

- **Get more resolution** You might want to print your picture at a giant poster size like 20×30 inches, but your camera takes 5-megapixel pictures, so you're worried about having enough resolution to make a sharp print. No worries; shoot the picture in sections. When each 5-megapixel square of the photo is stitched together, it might be 10 or even 20 megapixels. At that point, you have enough resolution to print a billboard!

Did you know?

Have the Right Hardware

You can take a series of panoramic photographs by just holding the camera up to your eye. I've done that myself. In England a few years ago, I made a panoramic photo in front of Abbey Road Studios, where the Beatles recorded virtually all of their music. This was something of a religious experience for me, and I was distressed that I didn't have a tripod with me to make the shot perfect. But I made do with what I had—essentially, my body and a 2-megapixel digital camera—and the results were fine.

For the best results, though, it pays to travel with the right gear. To take a good panoramic shot, each image should be taken level with the ground. Remember that there are two different axes to keep under control. The lens needs to be parallel to the ground, and the horizon needs to stay level in each picture. That's not easy to do when you're holding the camera in your hand.

For better results, mount the camera on a tripod. You can keep the head of the tripod slightly loosened so you can spin the camera slightly for each picture. See Chapter 9 for advice on tripods.

Get the Right Overlap

The single most important step in making a panorama is getting the correct overlap between each photo so the software on your PC will know how to combine each image into the finished panorama. To do this, you should try to get about 30–40 percent of the scene to overlap between each pair of pictures. If you make sure that some of the scene that you photographed in the first image also appears in the second image, the stitching software on your PC will be able to match them and combine them into one wide picture—see Chapter 14 for details.

How do you ensure the right amount of overlap? That's where your camera comes in. Some digital cameras have a panorama mode built-in that helps you line up each picture using a series of guide marks.

Switch your camera to panorama mode and look in the LCD display. You should see a set of guide marks like the ones shown here. As you take each picture in your panorama, the guide marks help you keep part of the previous shot in the next picture you are about to take.

TIP *If your camera does not have a panorama mode to help you compose each shot, just use your eyes to estimate distance. It's actually quite easy.*

How to ... Take a Panoramic Series

Ready? It's time to actually take your panoramic series. Here's what you should do:

1. Set up your camera on a tripod in front of the scene that you want to photograph. Make sure that the camera is level with respect to the horizon.

2. Turn on your camera and frame the rightmost edge of your panorama and take the picture.

3. Spin your camera on the tripod slightly so that it is framing the next part of the scene. Make sure, however, that 30 percent of the first image now also appears in the second image. It is this overlap that will allow your computer to line up the image into one seamless panorama.

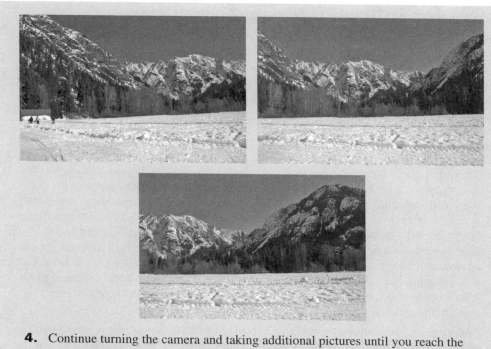

4. Continue turning the camera and taking additional pictures until you reach the opposite edge of your panorama. Or if you are taking a 360-degree panorama, continue taking pictures until you go all the way around and reach your starting point with a suitable overlap.

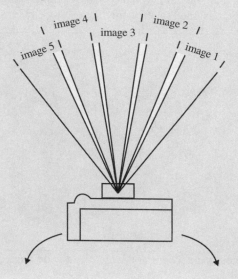

Add Lenses for Different Perspectives

As you've already seen, you can attach additional lenses to many digital cameras to enhance your photographic options. In Chapter 6, for instance, you saw how to add close-up lenses to shoot macro photographs.

Your options don't end there. There are add-on lenses that cover the spectrum of photographic possibilities. Even if your camera only comes with a 2X zoom, you can probably enhance that with a set of telephoto, wide-angle, and close-up lenses.

The first thing you'll need to know is how you will be attaching additional lenses to your camera. Typically, there are three ways of doing this:

- **Threads** Some digital camera lenses are threaded at the end. If your lens has screw threads, you can probably screw additional lenses directly onto the end. Even so, you may need something called a step-up ring. This is a device that screws onto the end of your lens and provides a different diameter for screwing on the additional lenses. Lens manufacturers typically only make lenses in a few sizes, such as 37mm and 43mm. If your camera has a different thread size, you will need the step-up ring. You can get such an animal at your local camera shop, from a filter company like Tiffen (www.tiffen.com), or a web store like B&H (www.bhphotovideo.com). Your camera's manufacturer may sell a step-up ring specifically for your camera as well. No matter where you buy it, a step-up ring shouldn't cost more than about $10–15.

- **Adapters** Some cameras do not have a threaded lens but instead allow you to snap additional lenses onto the end of the camera using an adapter. Usually, you'll snap or clip the adapter onto the end of the camera lens and then screw the add-on lenses onto the end of the adapter. Figure 8-2, for instance, shows a Kodak camera with its lens adapter in place. The camera manufacturer typically makes adapters like these since they are such specialized devices, designed to affix only to specific cameras.

FIGURE 8-2 Lens adapters are a common way to add wide-angle and telephoto lenses to your camera.

■ **Jury-rigged** Unfortunately, not all camera manufacturers include a way to add new lenses. That may sound like the end of the line, but it is possible to affix additional lenses to your camera using homemade adapters, in some cases with an adapter for a different camera, some tubing, or a judicious amount of tape. Sounds like something a fourth grader might do? Well, even professionals resort to this method on occasion, so if you try it, you are in good company. Personally, I've taken pictures just by holding a filter in front of a digital camera lens, and I'm sure many other experimenters have done so as well.

Choose Lenses

Be sure to visit your camera manufacturer's web site or your local camera shop to see what kinds of lenses are available for your camera. Even if your camera manufacturer does not sell lenses for your specific model, you can probably get a suitable substitute from a company like Tiffen (www.tiffen.com), which sells a wide variety of lenses and probably has something that would work for you.

Lenses are typically identified by their X power. In other words, the lens will be marked as something like .5X, 2X, or 3X. This designation tells you what the new focal length will be once the lens is attached to your camera. If it is a 2X lens, for instance, the lens will double the focal length of your camera. Obviously, a 2X lens is a telephoto, and attaching it to a typical digital camera should yield a focal length in the vicinity of 200mm.

If you are looking for a wide-angle lens, shoot for one that has an X power of less than 1. Suppose you purchase a .6X lens. When you attach it to your digital camera, it will reduce the focal length by 40 percent. Zoomed out at a focal length of 40mm, your camera will actually provide a focal length of 24mm, which is rather wide. If you zoom in to your camera's telephoto position, the add-on lens will still work. Now, your usual 100mm will only be 60mm.

You can sometimes purchase add-on lenses in a complete set, such as the one in Figure 8-3.

FIGURE 8-3 A collection of add-on lenses that all fit common digital cameras

Add-On Lens Precautions

While add-on lenses are a powerful tool for expanding your photographic options, you need to take some care to avoid an effect known as vignetting. *Vignetting* is what happens when the lens barrel itself gets into the picture, causing the frame to lose its square shape. Subtle vignetting might simply cause the corners of your pictures to be dark, blurry, or rounded off. Extreme vignetting (like the example in Figure 8-4) can feature a perfectly round vignette; in this case the edge of the lens itself is included in the photo.

You can avoid unwanted vignetting by keeping an eye on the camera's LCD display. If your add-on lens is prone to vignetting effects, zooming farther into the telephoto range will usually eliminate the problem. You can also crop the darkened corners out of your picture or paint over the edges with nearby bits of the picture using your photo editor's Clone Brush. See Chapter 14 for tips on how to do that.

Distortion is another potential effect of adding lenses to your camera. All lenses have some small amount of distortion; after all, no piece of glass or group of optical elements is perfect. But you'll rarely notice any distortion from your camera's principal lens by itself. When you add the equivalent of a big magnifying glass on the front, though, you can start to see some effects. Most of the time, it'll be either pincushion or barrel distortion—vertical lines will bend in or out of the frame instead of being perfectly straight.

FIGURE 8-4 This image suffers from a particularly extreme case of vignetting, thanks to an add-on telephoto lens. Reducing the zoom setting to a wider angle view will reduce the effect.

Reduce Vignetting and Distortion on the PC

The magic of digital photography is that you can correct all sorts of problems on the PC in a photo editing program. Obviously, if you can clearly detect aberrations like vignetting or distortion in your photos when using an add-on lens, you may want to avoid using that lens. On the other hand, it's possible to remove this sort of thing from your pictures afterwards.

In Photoshop Elements, for example, you can use the Correct Camera Distortion control to remove unwanted effects like barrel distortion and even brighten the corners of your photo to counteract vignetting effects. To do that, open a photo in Photoshop Elements and then choose Filter | Correct Camera Distortion. You'll see a window that looks like this:

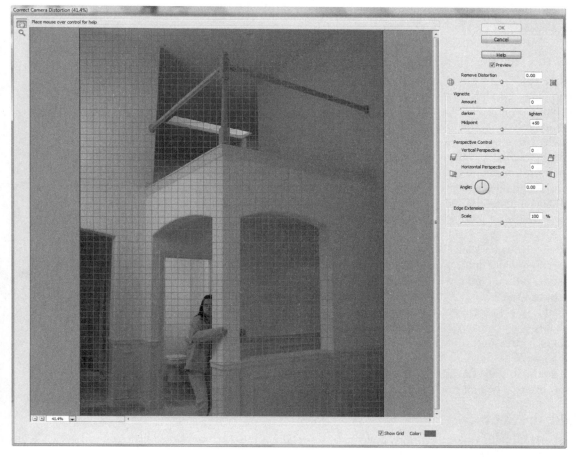

Adjust the sliders until the photo looks about right and then click OK.

Infrared Photography

Just for fun, you might want to try shooting some pictures in a completely different part of the color spectrum: infrared.

Infrared light is off at the south end of the spectrum, just below the "red" in the ROY G BIV color spread that you no doubt learned in high school. Humans can't see infrared, but photographs exposed to infrared light can look dramatically different, as if you're seeing the world through the eyes of a bat or one of those aliens from the movie *Predator*. Trees and plants can glow a bright, luminous white, while the sky is often much more visually turbulent. Indeed, different plants and trees respond differently to infrared, so you can get a spread of infrared effects shooting flora outdoors. Indeed, infrared photography is often like peeking into another world. Best of all, for our purposes, you never really know what you're going to get before you press the shutter release. It's like a photographic grab bag.

Get the Gear

Before you can try your hand with infrared, you need to learn if your digital camera is capable of seeing in infrared. Not all cameras can; some include a component called a "hot mirror," which is explicitly designed to block infrared light.

Go grab an infrared remote control, like the one that operates your television or stereo. Point it toward your camera's lens, turn on your camera, and look at the camera's LCD display (not the optical viewfinder). When you press a button on the remote, can you see a light at the end of the remote? If you can, the camera is sensitive to infrared and you're ready to go. If you don't see the remote light up, then your camera has a hot mirror and you can't shoot infrared, sorry. (If you really want to do infrared photography, check out www.lifepixel.com, where you can learn how to remove the hot mirror from your camera.)

As you have probably guessed, you need some way to prevent noninfrared, visible light from entering the camera lens when you shoot in infrared. What you need is a filter. Infrared filters are designed to block most or all of the visible light in a scene. All that reaches your camera's image sensor is infrared light, which is what your camera will use to take the picture.

Here's the bad news: infrared filters are a specialty photographic items and typically aren't available at your local photo store. You may be able to special order an infrared filter, but it's probably cheaper from an online photo store like Adorama (www.adorama.com) or B&H (www .bhphotovideo.com). Either way, an infrared filter will set you back around $50–75. They come in a variety of strengths, but I've found that pretty much any one will do. Just be sure to order one that will fit the thread size on the front of your digital camera; if your camera doesn't have screw threads, you may be able to order an adapter.

Take the Shot

The early morning or late afternoon hours are the best times to shoot infrared photos. You can't shoot at night, of course, because there's little or no infrared light available to expose your picture. You'll find out very quickly that infrared photography is dramatically different than visible light photography. The most important difference, of course, is that an infrared filter blocks nearly all of the visible light coming into the camera.

The lack of visible light means that exposure times are much longer than usual. You might find your camera exposing a picture for half second or more in broad daylight—which means that a tripod is essential.

There's so little light that you may run into another problem: it's hard to see through the lens. As a result, the camera's LCD display is very nearly useless for framing your shot. If your digital camera has a window-style optical viewfinder that doesn't get its information from the lens, you can use it to frame the scene instead. Alternatively, you can line up your scene with no filter in place and then screw the filter onto the lens and take the picture. Obviously, you'll need to use a tripod.

Edit Your Pictures

When you get the images back to the computer, you may find that the infrared shots have a relatively narrow dynamic range. Load your images into a photo editor such as Photoshop Elements and use the Levels control (which I explain how to use in Chapter 13) to fix the image. After you tweak the image, you can leave the red tint or (more commonly) convert it to a grayscale image.

Essential Add-on Lenses

Granted, this is a matter of opinion, but there are a few add-ons that I highly recommend keeping in your camera bag. I suggest that you carry these lenses if you like to experiment with different perspectives and focal lengths (if you have a Digital SLR, check out Chapter 2 for more specific SLR-related recommendations):

- **UV or skylight filter** If your camera has screw threads on the front of the lens, you might want to add a filter to protect the lens from bumps, bangs, dust, dirt, and over-aggressive cleaning. A $25 filter can protect your expensive camera investment for quite a long time, making it one of your smartest investments. You can throw it away and replace it any time it gets scratched or otherwise damaged.

- **Telephoto** A 2X telephoto can dramatically increase the "reach" of your digital camera.

- **Wide angle** If you can get a .5 or .6X wide-angle lens for your digital camera, it becomes much easier to get indoor photos, especially ones with a lot of people.

- **A set of close-focus (macro) lenses**

- **Circular polarizer** Discussed in Chapter 6, this add-on filter lets you cut reflections from glass and water.

■ **Neutral density filter** This is a translucent piece of glass that fits over the lens. It's designed to reduce the light entering the camera by one or two stops, thus letting you slow the shutter to add more "blur" in action shots (such as the one shown here) or increase the depth of field on a bright day. I use a ND filter to allow for slower shutter speeds when photographing waterfalls in the middle of the day.

Connect Your Camera to a Telescope

Folks with 35mm SLR cameras can easily connect their camera to a telescope to take extreme-telephoto pictures or even photograph the heavens. If you want to try that with a digital camera, you're in luck—companies such as LensPlus (www.lensadapter.com) sell just the sort of adapter you need. LensPlus, for instance, sells a gadget called the LE-Adapter, which acts as a docking port between your digital camera or digital camcorder and other optical gadgets such as telescopes, binoculars, spotting scopes, and microscopes. It works with a wide variety of digital cameras—all you need is a set of threads on the front of your camera's lens to screw on the LE-Adapter.

The adapter comes ready to screw onto cameras with either 37mm- or 52mm-diameter threads. If your camera has a different diameter lens, you can buy a step ring that goes from your camera's threads (the size is usually inscribed right on the front of the lens) to either 37mm or 52mm.

If you go shopping for a step ring, be sure to get the right size. If your camera's lens is larger than 52mm, you'll want a step-down ring. A step-up ring will have threads that go the wrong way, so the distinction is important.

Once you screw the LE-Adapter onto your camera, you bolt the other end of the adapter onto your telescope, binoculars, or other optical system, and start taking pictures. In most cases, your digital camera should be able to autofocus right through the new optics.

The LE-Adapter works pretty well, as long as you understand that the optics won't necessarily be as bright and as sharp as you're used to with your ordinary lens. A set of binoculars, for instance, may give you a lot of magnification, but the optics aren't designed to take professional-caliber photos. Personally, I've had a blast photographing the moon through my 6-inch reflector telescope, though, and it's a way to capture photos that are otherwise absolutely impossible with your digital camera:

Your results will also vary depending on what camera you own. The preceding shot of the moon was taken with an Olympus e10, which you can see in position here:

Take Time-Lapse Photos

If you've ever been impressed by a time-lapse movie of a flower opening or traffic moving on a busy highway, you might want to try it yourself. It's not hard to do, though it's certainly easier if your camera supports time-lapse operations to begin with.

First, a little theory: time-lapse photography is just the process of shooting the same subject over and over with a certain time interval between each shot, so that when you play the images back later in sequence, it's like a movie in which events happen faster than normal time. It's the same principle behind stop-motion photography used to animate spaceships, monsters, and other special effects in movies.

If your camera has a time-lapse feature, this is a piece of cake. All you need to do is configure the camera's "interval time," which is the interval between photos.

If your camera doesn't have a time-lapse control, you can still take a series of photos, but you'll have to shoulder more of the work. Specifically, you'll have to turn the camera on, take a shot, and wait the appropriate time period to repeat the process. When you use automatic time-lapse photography, the camera does all that on its own.

If you want to try your hand at time-lapse photography, here are a few pointers to keep in mind:

- **Use a tripod** This is probably obvious, but I once saw someone trying to take a time-lapse movie by hand, and—trust me—that just doesn't work. The effect is ruined if each and every image isn't framed exactly the same way.

- **Choose a subject** Most of the time, a time-lapse photo series looks its best when you find a single subject that is going to change over time and make it the focal point of your photos. If too much changes take place in the frame, the image loses its impact. In simple terms, it looks like a mess.

- **Find the right interval** This may take some experimentation. Choose an interval between shots that best highlights the changes in your subject. Cinema relies on 24 frames per second, but TV uses 30. On your PC, you can get by with fewer frames than that. Specifically, plan on shooting about 8 or 10 frames per second—so something in the neighborhood of 100 frames for a 10-second movie.

- **Start fresh** Make sure that you have plenty of room on your memory card to take your series. You might want to start with a blank card and reduce the resolution of each image to a manageable 640×480 pixels. If you plan to take a lot of pictures, be sure the camera batteries are fresh (so you don't run out of gas halfway through the series).

- **Use automatic exposure** Most of the time, make sure the camera is set to automatic exposure. That way, it can react to changing light conditions throughout the day. The exception: if you're taking a series of night shots, configure the camera for the desired manual settings, such as f/5.6 for 8 seconds each.

Make Movies

Now that you've finished shooting your film, and your camera is filled with perhaps 100 photos, it's time to take your raw footage and assemble it into an actual film. There are a lot of programs you can use for this sort of thing. Any video editing program (like Adobe Premiere Elements, for example) should work, but you can also do it for free using Movie Maker, which comes with Windows XP and Windows Vista. Here's how:

1. Open Movie Maker and start a new project by choosing File | New Project.

2. Import your photos into this project. To do that, choose File | Import Media Items. Navigate to the folder that has your images, and select them. (If you're using Windows XP, choose File | Import into Collections.)

3. Now you should see the hundred or so photos from your stop-motion project. Before you go any further, it's time to configure Movie Maker so each photo appears onscreen for about an eighth of a second. Choose Tools | Options from the menu, and then click the Advanced tab. You'll see that the Picture Duration is currently set to a large number—probably about five seconds. Throttle that down to .125 and then click OK.

4. Believe it or not, you're almost done. Select all of your photos. The easiest way to do that is to click one of them and then press CTRL+A on your keyboard. Then just drag the whole slew of photos down to the storyboard at the bottom of the screen.

5. At this point, if you want to see your movie, click the play button and watch your creation.

6. You can save your film and share it with friends. Choose File | Publish Movie and choose E-mail. (If you're using Windows XP, choose File | Save Movie, and then choose E-mail.)

Did you know?

Movies on Your Camera

These days, most digital cameras come with some sort of movie mode. Thus, instead of simply snapping stills, you can record a short video that can be played back on the camera or on a PC.

While the movie mode is easy to operate, not all cameras treat movies the same. Some digital cameras have no microphone, for instance, so they can't capture sound. Likewise, some cameras set a fixed length for your movies—say, 15 or 60 seconds—while other cameras will record any length, right up till the point you run out of memory on your storage card. Depending on what kind of camera you have, the movie will either be recorded in MPG, AVI (also known as Video for Windows), or MOV (QuickTime) format. No matter which format your camera records, it should be playable on any PC with the appropriate viewer application.

Finally, when you make a movie, remember that you can often choose the video's resolution—but even the biggest movie will still be fairly small on the computer screen.

Take Care of Batteries

Digital cameras are battery hogs, plain and simple. You shouldn't expect the batteries in a digital camera to last very long since they are responsible for running a number of key functions within the camera, including the following:

- The imaging system, including the exposure system and the zoom
- The LCD display
- The flash
- The image storage system

That's a lot to expect from a set of batteries, and, in fact, they don't last long—you should expect to get between 100 and 300 shots from a set of batteries, depending on how aggressively you use features like the zoom and LCD display.

Rechargeable versus Alkaline

If your camera uses typical AA-style batteries, I recommend that you avoid alkaline batteries. Instead, invest in one or two sets of NiMH or Lithium rechargeable batteries. Yes, they're more expensive. But they quickly pay for themselves, since you can use rechargeables over a hundred times, on average. Do the math: Let's say that you use your camera every weekend for a year, and you have to replace the batteries about once a month. Here's how the cost stacks up over the course of a year:

AA Alkaline (Energizer "Titanium" High-Performance Batteries)	NiMH Rechargeables (Charger and One Set of Batteries)
12 × $8 = $96	$20

The more you use your camera, the more obvious the cost savings become. Once you buy your first set of rechargeable batteries, additional sets are less expensive (usually under $10) because you don't have to buy another charger, so I think you can see how useful rechargeables actually are.

Get the Most out of Your Batteries

With so many demands on your camera batteries, it's not all that surprising that they don't last very long. But there are certainly things you can do to extend the life of your batteries, making them last longer between charges or replacements. Just follow some of these commonsense tips:

- **Use the optical viewfinder** If your camera lets you, turn off the LCD display and look through the optical finder instead. The LCD screen is one of the biggest energy hogs on your camera, and you can significantly extend the value of your batteries by not using it.

Did you know?

Batteries Wear Out

Rechargeable batteries lose a teeny little bit of their life every time you charge them. Most types of rechargeables last for about 1,000 charges, after which they stop holding a meaningful charge and you need to throw them away. You can extend the life of these batteries by recharging only them when they're actually run down; "topping them off" is like a regular recharge in that it heats the chemicals in the battery casing, which slowly reduces the battery's life. In fact, it's best to recharge most modern batteries somewhere in the middle of their useful life. Don't top off a fresh battery. Nor should you wait until a battery is completely exhausted, since that can affect its performance as well.

- **Don't spend all your time reviewing pictures in the camera** Avoid gawking at your pictures on the camera's LCD display. Review them briefly if you need to select images for deletion (to free some room on the camera's memory card) or to see if you need to reshoot a particular picture. But save the slow, careful replays for your computer screen.

- **Disable the flash when you don't need it** Sure, there are excellent reasons to use it, even outdoors (we talked about fill flash to improve portraits in Chapter 5), but if you are shooting subjects that are 40 feet away and the flash can't possibly help, turn it off. Your batteries will thank you.

- **Leave the camera on** If you're taking a lot of pictures in a brief time, don't turn the camera off after each and every picture. You might think that you're conserving battery life, but in fact you're burning energy every time the camera has to power on. That's especially true if your camera has to retract the zoom lens every time it powers down and extend the lens when you turn it on again. If the LCD display is off, many cameras use hardly much more power when turned on than when turned off.

- **Use AC power when it's available** When you're transferring images to the PC, don't rely on battery power. You should have an AC adapter to power the camera when you're working at your desk near electrical power. If your camera didn't come with an AC adapter, it's probably wise to invest in one for exactly this reason. The AC adapter might also come in handy if you're shooting a lot of pictures inside a house from a somewhat stationary position. You can save battery life for when you really need it by tethering yourself to an AC outlet.

TIP *If your batteries die in the middle of a shoot and you don't have any spares, here's a trick you can try that might give you a few extra shots: turn the camera off, wait a minute, and then turn it back on. Often you can sneak in a few more pictures before the batteries are completely exhausted.*

Did you know?

Carry Spares

I never go anywhere without a spare set of batteries in my camera case. I don't need to tell you how frustrating it can be to run out of energy in the middle of Yellowstone National Park. If you can fit it, I also suggest bringing a charger with you so you can charge your batteries as needed. For AA batteries, I am particularly fond of slim-line chargers like the one shown here, since it takes up so little space and can be used to hold a second set of batteries without consuming any more precious space in your camera bag:

Use Batteries in the Cold

You may want to run outside in the dead of winter to photograph snowmen, snowball fights, and freshly fallen snow clinging to the trees. But because they're electronic devices, digital cameras don't function as well in cold conditions as in the heat of summer.

You can prevent most problems, though, just by keeping your camera batteries warm. If the batteries get too cold, the chemical reactions that generate power are inhibited, and they'll simply stop working. Here's what I suggest: carry a spare set of batteries in your pocket, where your body heat can keep them warm. If the current in the first set of batteries drops off due to the cold, swap them out with the ones warmed by your body, and then continue shooting. Since the first set of batteries will recover some of their charge when you stick them in your warm pocket, you can swap back and forth a few times—unless you're shooting in the Arctic where the ambient temperature is 50 below zero.

Chapter 9

Your Camera On the Go

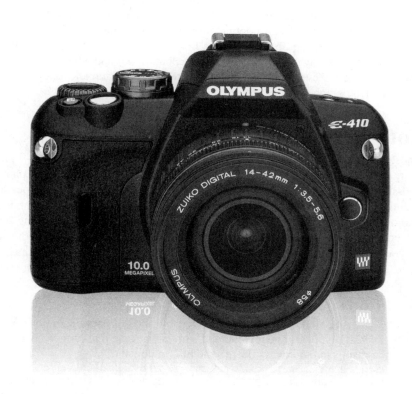

How to...

- Use a tripod or a monopod
- Choose a head for your tripod
- Use unusual gadgets to secure your camera
- Protect your camera from rain moisture
- Protect your camera from bumps and bruises
- Care for your camera and lenses
- Use remote triggers
- Know where you took your photos with geotagging

If you and your camera never leave the house, you might not need to avail yourself of this chapter. Taking pictures in your living room or around the dining room table might be fun for a while, but if you ever want to try your hand at shooting outdoors in the elements, then you might want to invest in some ways to better equip your camera. In this chapter, we'll talk about some of the essentials for digital photography on the go. I'm talking about tripods and other stabilizing gadgets, rain and water protection, and even stuff like geotagging techniques that mark your photos with the locations they were photographed.

Stabilize Your Camera

One of the most common complaints that people have with their photos is fuzziness—a lack of overall sharpness. In previous chapters, I've explained strategies for making your photos as sharp as possible—like increasing the shutter speed—but that sort of thing only goes so far if you're holding the camera in your shaky little hands. If you're shooting in low light, using a long telephoto zoom lens, capturing motion with a slow shutter speed, or scrambling across rough terrain, you really should consider bracing the camera with a tripod or some other support. Indeed, once you master the basics of holding your camera steady and using your camera's exposure modes, no other single thing can have as big of an effect on improving your photos.

Support Options

When it comes to steadying your camera, there really are all sorts of possible options. While a tripod is usually the *best* support for your camera, it's not always the most convenient, and you can get very similar results in other ways. Here's the full rundown:

- **Full size tripod** Sure, I like tripods. They're sturdy and rigid, which makes them great for steadying a camera in the wind and helping to dampen little vibrations like the ones caused when you press the shutter release. **Disadvantage:** Mainly, the schlepping factor. Tripods tend to be big and heavy, and few people enjoy carrying them around.

■ **Tabletop tripod** What's not to like? It's a tripod, but one seemingly made for a Twilight Zone world of tiny people. Tabletop tripods, like the one shown next, are designed to hold lightweight point-and-shoot cameras in position on a table, desk, windowsill, or some other flat surface. They're also inexpensive—you can get them for just a few dollars at the local camera store, and they're often given away for free with other photo purchases. **Disadvantage:** They're way too light and rarely sturdy enough to support larger digital cameras, especially Digital SLRs.

■ **Monopod** Start with a tripod and remove two of its legs. You're left with a monopod— it won't stand up on its own, but that's okay. It's great for completely stopping up/down movement so you can concentrate on steadying the side-to-side and front-to-back motion. Some are designed to double as walking sticks when there's no camera mounted on top—ideal for hiking. **Disadvantage:** They're not good for freezing the action when you use long shutter speeds.

■ **Beanbag support** Instead of carrying a long tripod or monopod, you might instead consider propping the camera on top of a beanbag. Beanbags are handy because they can conform to the shape of the camera as well as to the shape of whatever you're placing the camera on. As I mentioned in Chapter 6, if you don't have a beanbag, improvise. As a scuba diver, for instance, I always have bags of soft weights when I go on dive trips. They're filled with small beads of lead shot, and aside from being a lot heavier, they act a lot like beanbags. You can buy custom camera-ready beanbags with tripod mounts built in, like The Pod (www.thepod.ca, shown below), or get adapters that help you set

your camera more securely on a standard beanbag, such as ones sold by Wimberley (www.tripodhead.com). **Disadvantage:** Beanbag supports typically force you to put your camera on top of a table, on a fencepost, or on the ground—they don't give you a lot of flexibility to shoot anywhere, at any height.

Choose a Tripod

If you're interested in using a tripod, you can probably make do with almost any model. Often, camera stores include inexpensive tripods as part of a package deal when you buy a digital camera. And thankfully, tripods are essentially interchangeable, since they all use a quarter-inch bolt to mount to the underside of the camera. That said, there are many variations among tripods, so it's helpful to consider your options. If you've never spent much time looking at tripods in camera shops before, you might be surprised to learn that you can buy your tripod in components—the legs and the head can be bought separately and assembled into your dream tripod. Of course, many inexpensive tripods are sold as a single piece. Either way, it helps to think about elements like the legs and the head separately to choose the tripod that's best for you.

The Legs

Here is a cheat sheet of things to look for when you go tripod shopping:

■ **Height** Some tripods reach taller than others; depending upon whether you're a racing jockey or a basketball player, you'll have different needs for the height of your tripod. Be sure to extend the legs and test any tripod you plan to buy. Some tripods get extra height by using an extra leg segment (such as three or four extendable sections), while others are only tall enough if you extend the center column. My advice: Go for a tripod that gets sufficient height from the legs alone, since the taller you make the center post, the more wobbly your camera becomes.

■ **Weight** My philosophy about tripods: the lighter it is, the more likely I'll bring it along. Many times I've put a monster tripod in the trunk of my car, and when we get to the start of a hike, I leave it there, opting just to carry the camera pack. That was in the old days. Now, I use a tripod that's made of carbon fiber, which is pretty much the state of the art in tripods today and you-have-to-try-it-to-believe-it light. Of course, carbon fiber is also kind of expensive (they can run several hundred dollars), so you might opt for aluminum instead. You can also find tripods made of plastic and even wood (wood is preferred by some pros because it tends to dampen vibrations instead of transmitting every tremor directly to the camera, like metal), but lightweight aluminum is a good bet for most folks.

■ **Locking mechanism** When I think back on my time with my tripods, I probably spent most of my time carrying it or taking pictures. But that's not what it *seems* like. It seems like I spent most of my time extending and retracting those darned legs. As a result, the locking method is really important to consider, simply because it determines how convenient your tripod is. Some of the least expensive tripods rely on clunky latches to secure the legs in place. I'm not saying that latches are bad; some excellent tripods use latches. Just be sure you can operate the locking mechanism quickly and efficiently, and that it feels solid and secure. Personally, I love the twist lock mechanism used in my Gitzo tripod—see it and a less convenient set of latches in Figure 9-1.

FIGURE 9-1 Leg locks are a matter of personal taste, but I find locking collars (left) easier and faster than latches (right).

As for the overall weight, some people will tell you that you need a heavy tripod in order to securely hold your camera in place. It's true that the heavier your tripod, the better it will dampen vibration and resist wind. But there are ways around carrying a 10-pound tripod. Many tripods include a hook in the center post, for example. That's there so you can hang weights (rocks, beanbags, whatever you have) to better secure the camera when conditions warrant extra weight. In a pinch, you can even hang your camera bag from the bottom of the tripod (provided that there's something heavy in it).

The Head

After you've hung out in the camera shop for a while, extending and retracting legs and standing beside fully deployed tripods to assess the height, it's time to think about the head. Folks new to photography don't think much about tripod heads and tend to end up with what's called a pan head, in which you adjust each of the axes independently. You can see a typical pan head in Figure 9-2. To frame your photo, you need to loosen two or even three controls (up/down, or elevation, side-to-side, or azimuth, and leveling).

Pan heads are really indented for video production, though, and are generally poorly suited to most kinds of still photography. After you bring home a tripod with a pan head, one of two things tend to happen:

■ You use it for a while, get frustrated with it, and stop using your tripod—or at the very least, use it very infrequently.

■ You use it for a while, get frustrated, and replace it with a ball head.

FIGURE 9-2 A pan head's three controls make it difficult to quickly frame a photo when the action is happening fast and furious around you.

FIGURE 9-3 Most people find that ball heads are faster and easier to use—I highly recommend getting one if you plan to use a tripod.

There are not many "I loved it!" success stories involving digital photographers and pan head tripods.

A ball head, like the one in Figure 9-3, is far easier to control because in general, there's only one control that affects the orientation of the camera. The camera is mounted on a ball that sits in a socket; when you loosen the head, the ball can move in any direction. To lock the head in a particular position, just give a single control a slight twist, and you're done.

Some ball heads have other conveniences, like a pretensioner. If you pretension the head properly, you can move the camera around, but the ball will be tight enough that it'll stay where you put it even without clamping down on the main control. That's kind of handy.

Quick Release

Almost done! I'd be remiss if I didn't mention another cool timesaver: the quick release.

Not all tripods have a quick release assembly. Less expensive models require you to methodically screw the camera into the tripod each and every time you want to use the tripod. A better solution is to get a tripod (or a head) that has a quick release mount. To use it, attach a plate to the bottom of your camera, where you should pretty much just leave it there all the time. The plate locks into place on the tripod head, which you can connect and disconnect with a quick flick of your finger.

If you have a Digital SLR with one or more telephoto lenses, you might actually need more than one plate. Mount it on your camera body as well as any lenses that are long and heavy enough to warrant their own tripod mounting holes. That way, you never have to fiddle with your tripod threads again—it takes but a moment to get your camera in position.

 When the camera is mounted on your tripod, never try to carry the entire assembly by holding just the camera or just the tripod. Release the camera and carry them separately, or carefully carry the combination by holding the camera with one hand and supporting the tripod with your other.

Unusual Supports

Tripods and monopods are the usual fare for supporting your camera, but you can find all sorts of interesting alternatives around if you look for them.

Take the Quik Pod (www.quikpod.com/home.asp), for example (Figure 9-4)—it looks like a monopod, but it has a ball head on the top so the camera is easy to point in any direction. The goal of the Quik Pod is to take self-portraits—hold the Quik Pod in front of you to put the camera at more than twice arm's length—set the self-timer, and you can shoot yourself or a couple of people without need for a tripod.

You might also want to secure not the camera itself but your subject. In that case, look no further than *plamps* (www.tripodhead.com). A plamp is a lightweight plastic clamp with a long, flexible arm that you can use to precisely position subjects in front of the camera. Clip one end

FIGURE 9-4 The Quik Pod is a camera support designed mainly for taking pictures in which you get to include yourself in the shot.

FIGURE 9-5 Plamps are incredibly useful for securing your subject for precise positioning, or to hold it still in the wind.

to your tripod, for example, and use the other end to securely and precisely position your subject. They're especially handy for macro and close-up photography; attach one end to your tripod and the other end to whatever you want to take a picture of. You can use a plamp to hold a flower still so it doesn't blow around in the wind, for example. You can see a plamp in action in Figure 9-5.

Protect Your Camera from the Elements

Back when disposable cardboard cameras were a popular vacation accessory, an unexpected disaster might have meant losing a $15 investment in film and processing. These days, a digital camera mishap can set you back hundreds of dollars—not to mention all the photos locked on your precious memory card. Equipped properly, though, you can take your camera out in the rain, over treacherous terrain, and even under water. Whatever your lifestyle, there's a way to protect your camera that will let you snap photos with peace of mind.

Protect the Lens from Scratches

One of the two most vulnerable parts of your digital camera is the lens—a big, highly polished hunk of glass that is essential to taking sharp, clear photos. Scratch or scuff your lens, and your photos will suffer no matter how well you care for the rest of your camera.

When it comes to the lens, the best medicine truly is prevention: leave the lens cap on your camera whenever you're not actively taking pictures. If you have a point-and-shoot camera that slides a motorized cover in place when the camera is turned off, it's a good idea to power down the camera whenever you don't expect to take pictures for more than a few minutes. Constantly turning the camera on and off can actually drain your battery faster than just leaving it on for a long period of time, but the risk is scratching the lens if something goes awry.

Another solution for cameras that have screw threads on the front of the lens: many photographers add a protective "Skylight" filter, available at any photography store, to the front of their camera. If you accidentally ding the front of the lens, you can just replace the filter—it's a lot cheaper than buying a new lens. Not all digital cameras lenses accept screw-on filters, but all interchangeable lenses for Digital SLRs do. That said, I'll admit that I don't use protective filters on my lenses. I don't like the idea of bolting a cheap piece of glass on front of my expensive lens, so I accept the risk and try to be extra careful.

Protect Your LCD Display

Your camera's other key danger zone? The LCD display. Granted, you have to try a little harder to damage your LCD display, but it can happen. I've found that Delkin's Pop-Up Shade (see Figure 9-6) can protect the LCD from accidental damage. It is a protective cover that encloses your camera's display, preventing damage that can break the screen. In addition, it pops up, offering shade from direct sunlight. That makes the screen much easier to see, even in harsh sunlight. The Pop-Up Shades come in a variety of sizes, customized for many popular camera models.

FIGURE 9-6 The Delkin Pop-Up Shade can protect your LCD from accidental dings and scratches.

Whether you're cleaning the lens or the LCD display, never apply any kind of cleaning fluid directly to the camera. Pouring or squirting lens fluid directly on the lens can cause the fluid to enter the delicate seals and get into the optical interior of the camera, for example. Similar problems arise if you apply liquid to the LCD. Always spray a small amount of lens fluid on the lens cleaning cloth and use the slightly damp cloth to clean the lens or LCD.

Protect Your Entire Camera Body

Why stop at the LCD? If you ever put your camera in harm's way—such as on mountainous hiking trips—then consider encasing your entire camera in a protective skin.

I've found two products that can give you an extra level of confidence when you're using your camera out of the house:

- Camera Armor (www.camerarmor.com) completely envelops select camera models (including Canon and Nikon Digital SLRs) in a thin but rugged, rubberized, shock-absorbing covering. Camera Armor also includes an LCD shield and a flexible, elastomeric lens hood. It looks like military-grade protective gear but is really quite affordable (priced between $50 and $80, depending upon camera model). Check out the Canon Digital Rebel XTi version in Figure 9-7.

- If there isn't a Camera Armor for your camera, try a Snug-It camera skin (www.delkin.com). Designed mainly with point-and-shoot cameras in mind, Snug-Its protect the camera body as well the lens, both when it's extended from the camera body and when it's retracted into the camera body.

FIGURE 9-7 Camera Armor adds a thin layer of rubber-like protection to your camera.

Digital cameras don't like temperature extremes—especially on the toasty side of the spectrum. Be sure never to leave your camera locked in your car during the summer, when temperatures inside the vehicle can exceed 140 degrees. You can damage the batteries and possibly even electronic components like the image sensor. In winter, cold weather won't hurt your camera, but taking it indoors too rapidly can cause moisture damage when condensation forms. To avoid that, seal your camera in a zip-lock bag before going indoors and only open it after the camera has had several hours for the temperature to equalize.

Keep the Water Away

Digital cameras and water just don't get along. If you're trekking outdoors and want to be able to shoot in any weather, consider dressing your camera in a rain cape. A company called Ewa-marine (www.ewa-marine.com), for instance, offers a variety of capes in sizes for large and small cameras—they protect the body, but leave the lens exposed.

A rain cape will keep a drizzle away, but it won't help you if you're kayaking or snorkeling. If you are planning to submerge your camera, be sure to get a watertight enclosure. Traditional watertight camera housings cost hundreds or even thousands of dollars, but you can get an inexpensive flexible plastic bag case that's safe up to about 10 feet under water from Aquapac (www.aquapac.net) or Ewa-marine, like this one:

If going deep really is your plan, such as if you're into scuba diving, then be sure to investigate your options from the top housing manufacturers:

- **Sea & Sea** www.seaandsea.com
- **Ikelite** www.ikelite.com
- **Light & Motion** www.uwimaging.com
- **Olympus** http://tinyurl.com/2wgbqr
- **Subal** http://subal.com/index_en.php

Keep in mind that while if you're careful and maintain your housing well it should never leak, a flooded housing can destroy your camera. That's why some photographers dedicate a separate camera just for underwater use. But on the other hand, underwater housings are expensive. Really expensive. So expensive that the camera itself costs less than the housing. So if you think of it that way, the camera itself is a minor financial component in your underwater photography system.

Remote Triggers

Sometimes known as cable releases, remote triggers let you take a picture without actually touching the camera. That's great for times when you want to minimize any possibility of vibration or shake, such as when you're shooting a long shutter speed in daylight. I always use a remote trigger when I take photos of waterfalls, for example. Can you remotely trigger your camera? Probably. There are three main ways to do this, depending upon your specific camera:

- ■ **Self-timer** This is the if-all-else-fails remote triggering solution. If your camera isn't compatible with either of the other options, just set it on self-timer (the usual symbol resembles a clock, like in the following illustration), prepare to take your shot, and press the shutter release. Then step away from the camera, so you're not physically touching it. Ten or fifteen seconds later, the camera will automatically take the picture.

- ■ **Wireless remote** This is my favorite option, because it's high tech and doesn't involve any wires. Many digital cameras are compatible with credit card-sized remote controls (see the following illustration) that trigger the camera via infrared. Some cameras come

with such a remote, but usually you'll have to buy it as an optional accessory. Check your camera's web site to see if there's a wireless remote available, or visit your local camera store.

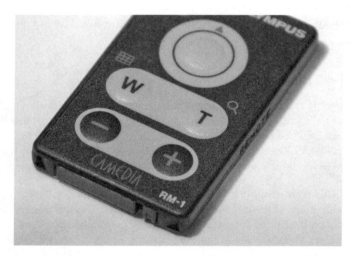

■ **Cable release** This is a wired remote trigger that plugs into some port or connection on your camera and tethers the camera to a gadget with a shutter release button via a short cable. In the old days of 35mm film cameras, the cable release usually screwed directly into the camera's shutter release button and activated the shutter mechanically with a little metal "plunger." These days, in the age of electric cars and robotic vacuum cleaners, remote triggers, like the one in the following image, are electronic.

Geotag Your Photos

I remember showing the results of my photo trek through Grand Cayman to a friend a few years ago. "Where were these taken?" she asked me about a particular set of photos. "Hmm," I replied, "I don't remember. The East End, I think. I took so many photos, I can't keep track." At the time, I wished there was some automatic way to "tag" my photos with location information, so they'd be able to tell me where they were taken. Yet another thing I'd never have to remember ever again!

Well, my wish has come true: geotagging is here. *Geotagging* is the term for adding location information to your photo files so they automatically know exactly where they were taken. And I think that it's one of the coolest things ever to happen to digital photography.

There are a number of ways to geotag your photos, from the simple to the complex, and from the fully automatic to the manual do-it-yourself:

Do It By Hand

The most low-tech way to do it (if anything with a digital camera can be described as low tech) is to manually tell each photo where it was taken. If you know where you were standing when you took a photo, you can just do it yourself, usually by clicking on a map and letting some program enter the latitude and longitude values in the photo's metadata. Photo sharing sites such as Zooomr.com, Fotki.com, and Flickr.com all have this kind of feature built in. It's okay if you have no better alternatives, but it's kinda slow and relies on your own memory—and geotagging is supposed to be all about doing this part of the job for you. In Figure 9-8, you can see the interface that Flickr uses to let you assign photos to a location on the map: first click the link that says "place this photo on a map," and then just drag the photo into the map at the desired location.

Connect a GPS Receiver

A much more efficient and accurate solution is to rely on a GPS receiver. GPS, the constellation of navigational satellites that a lot of people now take for granted to navigate around in their cars, is also a nifty way to geotag your photos with latitude, longitude, and altitude information that can be translated directly to a precise position on a map.

In a perfect world, a GPS chip would be built into every digital camera. Already, there are a couple of cameras available with built-in GPS. Photos taken with the Ricoh 500SE, for example (see Figure 9-9), automatically embed position information in the file thanks to a built-in (but detachable) GPS receiver.

But right now, cameras like the Ricoh are clearly in the minority (though I have no doubt that in a few years, *many* cameras will have GPS built right in). For now, we need to somehow marry GPS and photography to make geotagging work.

FIGURE 9-8a Many photo sharing sites have a feature that lets you assign your photos to places on a map—a very manual form of geotagging.

FIGURE 9-8b Many photo sharing sites have a feature that lets you assign your photos to places on a map—a very manual form of geotagging. (*Continued*)

The Ricoh 500SE is an example of a digital camera with a built-in GPS system for geotagging photos.

The easiest solutions tend to connect a GPS receiver directly to the camera in some way, so the position information is encoded into each photo as it's taken. Several digital cameras, notably Digital SLRs, have this ability. To find out if your camera is compatible, check the camera manufacturer's web site or your local camera store.

One example of a compatible camera is the Nikon D200. The camera can receive GPS information from the same port that is also used to connect a remote trigger. Nikon sells a GPS attachment that plugs into this connection, but a company called Blue Hen has a wireless alternative that's even better. The Blue2Can (www.redhensystems.com) is a tiny gadget about the size of your thumb. It communicates wirelessly with any Bluetooth GPS receiver (like the kind that comes with inexpensive navigation programs and is designed to sit on your car's dashboard). You can see it attached to a D200 (left) and set beside an inexpensive Dell Bluetooth GPS receiver (right) in Figure 9-10.

GPS solutions like the Blue2Can automatically tag your photos as you take them with GPS data (latitude, longitude, and altitude), and that info is automatically readable by mapping software. If you were to take a few pictures and upload them to your Flickr page, for example, Flickr would add a "map" link to each picture—click the link to see exactly where the photo was taken. Even cooler: you can view all your photos as pushpins on a map, so you can go on a virtual walking tour of that Grand Cayman vacation you took last year. You can see Flickr's position-aware mapping feature in Figure 9-11.

 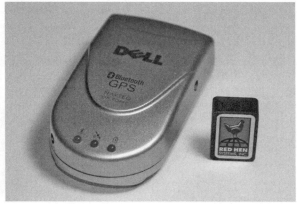

FIGURE 9-10 The Blue2Can is an elegant way to connect Nikon cameras like the D200, D2X, D2Xs, or D2Hs to a Bluetooth GPS receiver.

GPS Not on Board

All that is pretty cool, but the fact remains that unless you own one of a small handful of digital cameras that can connect to a GPS receiver, and thus add position data as the photos are taken, you need a different plan.

Specifically, you need to somehow add location info to your photos after the fact. And believe it or not, you can do that without a whole lot of trouble. To do that, you can carry a GPS receiver with you while you shoot, and then use a program on your PC to "synchronize" the GPS data with your photos after you get home again.

There are several programs that do this sort of thing, including:

■ **RoboGEO** www.robogeo.com

■ **Quakemap** www.earthquakemap.com

■ **Gpicsync** code.google.com/p/gpicsync

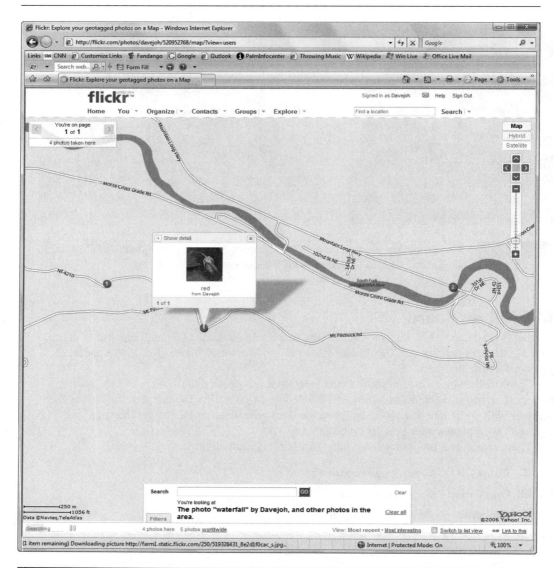

FIGURE 9-11 If you upload photos that are already marked with position data, some photo sharing sites can display them in the context of a map.

Part II

Transferring Images

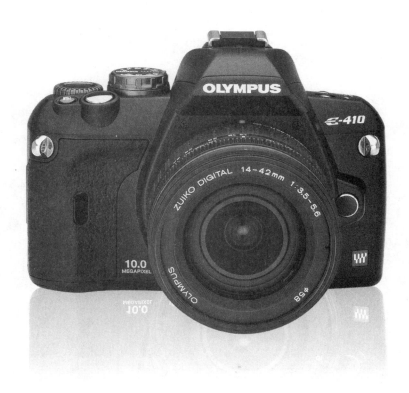

Chapter 10

Conquer File Formats

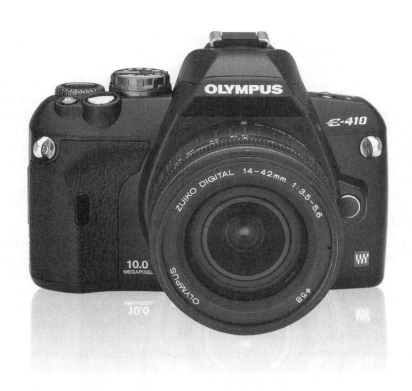

How to...

- Use image file formats
- Distinguish among formats such as JPG, TIF, GIF, and BMP
- Recognize file extensions on the PC
- View file extensions in Windows
- Understand the value of JPG compression settings on the camera
- Select the best image compression on a camera
- Determine when to use the TIF format to capture pictures on your camera
- Know when to save images in various file formats
- Batch-save a large number of images in a different format automatically
- Choose the best JPG compression level on the PC

Like it or not, working with a digital camera means that you are going to have to learn some of the nuances of your PC. That can be a bad news. After all, computers can be a pain in the neck. Nonetheless, the pictures stored in your digital camera are not terribly useful to you unless you understand how to work with them. Your images are stored in individual files not unlike the document files you'll find on the computer itself—such as word processing files, music files, or the saved game files created by a computer game. In this chapter, we will look in some detail at the image files created by your digital camera. We will talk about file formats, image quality, and what you need to know about all of this to get the best results with your camera. Don't worry, though: this is not a computer class, and we won't go into any more detail than you will actually need to manage your pictures.

What Are File Formats and Why Do I Care?

When you take a picture with your digital camera, the camera's imaging sensor interprets the scene and records a representation of it on the camera's memory card. The scene is essentially a grid, or matrix, of pixels. How many pixels are there depends on the resolution of the camera.

If you were taking a 1-megapixel picture, for instance, the image's resolution would be about 1280 pixels across (the X dimension, or width) by 960 pixels down (the Y dimension, or height). It would look something like Figure 10-1, in which you can see each individual pixel that makes up the image, assuming you can zoom in far enough. The picture is a sort of paint-by-numbers grid—just add the right color to each of the pixels in Figure 10-1, and you'll end up with a picture of something.

So far, so good. The problem comes in when the camera tries to save all this data to the memory card. How does it do it? Essentially, the camera needs to save the data in some standardized format so the information will be understandable to software and devices other than the digital camera itself.

FIGURE 10-1 A digital image is little more than a grid of colored pixels.

In the old days of computing, every word processing program stored its documents in a unique file format that was understandable only to that program—a real hassle if you needed to open a document on someone else's PC using a strange word processing program. Likewise, if your camera stored information about the color value of each one of those pixels however it felt like it, odds were good that only the camera would ever be able to understand that information again.

And that is a somewhat long-winded explanation of why we have file formats. By writing the information about each of those pixels in a standard and predictable way, each picture that the digital camera saves can be read by your computer's software, even if the software didn't come from the same company that made the camera.

That said, you'll find that digital cameras and computer programs use more than one file format—many more. In fact, there are well over a hundred file formats in use by image software on computers today. Only about a half dozen are particularly popular—most are really just historical curiosities used by very few programs—but even that small number can be confusing. Why are there so many file formats? Good question. It's not just to confuse everyone. Instead, different file formats exist because some are better at certain tasks than others. Some file formats compress well—in other words, a large picture will only take up a small amount of space on the memory card or hard disk. Other file formats more accurately represent the original image, are

optimized for the Web, or are designed to work well on both Windows and Macintosh computers. And most importantly, they were all invented at different times, by different people, under unique circumstances, for certain kinds of tasks, and many formats tend to hang on because some folks still use them.

The Most Common File Formats

As I said earlier, there are really just a few file formats that most people use most of the time. So while you may occasionally hear about a file format such as IFF, IMG, or KDC, rest assured they're all historical curiosities. You typically need to pay attention to just a very few.

By the same token, you might want to get to know the most common file formats and know when it's appropriate to use them. Here is a quick overview, ranked in terms of importance and popularity, of the most common formats and what they are used for.

The Main Formats

- **JPG** Short for Joint Photographic Experts Group (pronounced "jay peg"), this is far and away the single most common file format for digital photos. Almost every digital camera on the planet saves your pictures as JPGs by default. Though it's ubiquitous, this file format is *lossy*. That means that when you save an image in this format, some of the data is lost. That's because JPG files are compressed to save storage space. Why do people put up with a file format that sacrifices image quality? The answer is that, in ordinary use, the JPG format does an outstanding job of preserving virtually all the visual information that the human eye can generally see in a picture. When you save a picture in the JPG format, you'll typically have to zoom in quite a bit to see any artifacts or digital noise caused by the format.

- **TIF** Short for Tagged Image File format, this format is also quite popular, but for exactly the opposite reason that JPG is popular. TIF files can be saved in two different ways: with a small amount of compression or without compression. Either way, TIF files are absolutely *lossless*—they preserve 100 percent of the information about every pixel in the original image. Many digital cameras offer a mode in which they save your photos in TIF format instead of JPG. People who don't want to sacrifice any image quality sometimes choose this option.

- **RAW** This is a wacky category because the term RAW refers not to a single file format, but to a bunch of file formats. Every camera manufacturer has its own version of the RAW format—Nikon's RAW format is called NEF, while Canon, for example, calls its latest RAW format CR2. Whatever it's called, though, RAW files do a bunch of cool things. First, like TIF, they are completely lossless, but they also hold more color information than JPG and TIF files. In addition, a RAW file stores not just totally uncompressed data, but also preserves the "raw" image file before the camera has

had a chance to do anything to it. You get the unprocessed, uninterpreted data—and consequently, it doesn't include the camera's white balance settings, image sharpening, noise reduction, or anything else the camera typically does to JPG and TIF images as they're saved. More on this later in the chapter.

Other Common Formats

That's the big three. You could probably live out the rest of your days only knowing those three formats, but here are three others you might occasionally run into:

- **JPEG2000** JPEG2000 uses the same basic compression technology as its older cousin JPG, but it offers better image quality while keeping roughly the same file size. JPEG2000 has some fans, and it's supported by most image-editing programs. On the other hand, digital cameras still use the JPG format—so to use JPEG2000, you'll have to convert the images from TIF, JPG, or RAW to JPEG2000 format on the PC, which is honestly a lot of work. Personally, I think this format is not worth your time or trouble.

- **BMP** This is the old standard "bitmapped" file format created by Microsoft for Windows. It can be used for general-purpose storage, for image editing, and as the wallpaper on your Windows desktop, but it isn't generally readable by Macintosh computers, nor is it used on the Internet, or, well, pretty much anywhere else anymore. The biggest problem: BMP files tend to be quite large because the format makes no effort to compress the data at all. In general, the only reason you would ever use this file format anymore is if you want to display a digital image as the wallpaper on the desktop using an old version of Windows. These days, though, Windows let you use JPG images for wallpaper—relegating the BMP format to the "where are they now" file for most users.

- **GIF** Short for Graphics Interchange Format (pronounced either "giff" or "jiff," depending on who is doing the talking), this format was originally developed by the online service CompuServe and is semicommonly used on the Web, along with the more-popular JPG format. Because you can make the background of GIF images transparent, they're handy for displaying graphics (like line art and some kinds of computer-generated images), but JPG files display photos more efficiently. Like BMP, there's little reason to mess with GIF anymore.

- **HD Photo** The very newest file format on the block is Microsoft's HD Photo, which has all sorts of features that make it a promising future alternative to existing formats like JPG and RAW. HD Photo supports a broader color range than JPG, which means it has the potential to capture and store a far greater dynamic range than existing cameras. (To see why this is so important, check out the High Dynamic Range section in Chapter 15.) It also offers better compression quality than JPG (as well as a lossless compression mode), and HD Photo images can be mind-blowingly immense: up to 262 million pixels on an edge, or 68.6 terapixels in total.

How to ... Understand File Extensions

The many file formats used on computers today are generally referred to by the letters that make up their three-letter extension (some file extensions have four letters, but those are less common). Computer files are generally named using a standardized system that looks like this:

filename.ext

The *filename* can generally be almost anything—a random collection of numbers and letters or a word or two that describe the contents of the file. The three-letter *ext*ension tells the computer what kind of data is within the file. Here are a few common file extensions:

- **.doc** Word processing document (usually created by Microsoft Word)
- **.xls** Spreadsheet document (usually created by Microsoft Excel)
- **.mp3** Digital music file, commonly downloaded from the Internet
- **.htm** Web page document

In other words, you and I, as users, control the first half of the filename. The file extension—the part that comes after the period—is determined by the program that made the file or the file format that the data corresponds to. If you open a folder on your computer and find a bunch of image files, you can immediately tell what format they are in by looking at their extension, as in the illustration below. For example, *ant.jpg* is saved in JPG format, while *bee2final.tif* is saved in the TIF format.

Windows may not be configured to show you the complete filename including the extension. To turn on the extension view in Windows, follow these steps:

1. Open a folder on the Windows desktop.

2. If you are using Windows XP, choose Tools | Folder Options from the folder's menu. If you are using Windows Vista, choose Organize | Folder and Search Options.

3. Click the View tab so that you can see the Advanced settings in the bottom half of the window.

4. Find the entry Hide Extensions For Known File Types (it's about halfway down the list), and remove the check mark from this selection.

5. Click OK to save this change.

Use File Formats

Now that you understand file formats, you are probably wondering which one you should use on your own system. As in all things, it depends on how you're going to use your images. Let's look at your choices, and I'll make a few recommendations about how you might want to work with and save your images.

On the Camera

Let's start with your camera. No doubt, you realize that your camera saves images in one of the file formats we've already discussed as soon as the images are taken—but which format?

JPG: The Lossy Default

Actually, this is the easy part. Most digital cameras, by default, save their images in JPG format. JPG is a pretty good compromise between quality and file size for most users and in most photographic situations. But what you may not realize is that you have a fair degree of control over how aggressively your camera compresses the JPG images, and therefore the picture quality. Take a look at your camera, and you will no doubt find that somewhere—whether it is in a menu system or controlled via a button on the camera housing itself—there is a setting for image quality. Note that image quality is quite different from resolution. *Resolution* is a measure of how many pixels are in the image; *quality* determines how much color information can be stored in each pixel and, consequently, how much image quality will be sacrificed when the image is saved.

Most cameras tend to have several quality settings, such as high, medium, and low. If you're using the JPG format, I recommend that you always stick with the highest setting for your JPG images—the lower-quality settings can make for some pretty unsatisfactory images. On the other hand, the highest image quality and resolution setting takes more space on your memory card, reducing the number of images you can keep on a card at once. Which is the bigger deal? Well, consider this: you can always buy another memory card to store extra images, and memory cards have gotten quite cheap. But once saved at a lower resolution, you can never buy back the lost image quality at any price. If you're only using your pictures for low-impact applications such as web pages and e-mail, small differences in image quality may not mean a lot to you. But if you're planning to print your pictures or keep them for posterity, even a little color fringing or digital noise can ruin your memories.

Be sure to check your camera menu for details on setting image quality and resolution because every camera is a little bit different. Some cameras make it easy to distinguish between resolution and image quality because they are set with two different controls. Other cameras offer these two controls in a single, somewhat confusing menu selection. You may be forced to work with a camera menu that gives you a choice of SHQ, HQ, and SQ (Super High Quality, High Quality, and Standard Quality), for instance, where both SHQ and HQ are the same high resolution, but with different amounts of JPG compression. In the following illustration, you can see how a FujiFilm camera on the left limits you to choosing only what resolution you can work with, while the Olympus camera on the right uses SQ and SHQ to distinguish between image quality. Inside each of those selections is the ability to choose a specific pixel resolution. The moral? Read your camera manual to see how to set the resolution and image quality.

TIP

The bottom line is that you should strongly consider saving all your photos at your camera's highest resolution and highest image quality.

Did you know?

Compression versus Reduction

In this chapter, I use the term *image compression* a lot. The loss of quality in JPG images, I contend throughout this chapter, is the fault of the file format's efforts to compress the original image.

In reality, there are two techniques used to save disk space in many file formats: compression and reduction. *Compression,* by definition, is simply removing redundant data from a file in such a way that the file can be made smaller without losing any truly unique information. Consider the number 1,000,000,000, for instance. Using data compression, I can represent that value as 1E9. It's the exact same information, but I've managed to write it in far fewer digits on the page. A compression utility like Zip or RAR, for instance, lets you compress a program or a document file so it can be e-mailed or downloaded from the Internet more quickly. Compression doesn't actually remove any data from these files—otherwise, the original program would never work again after being uncompressed!

Reduction, on the other hand, is a programming term that refers to making a file smaller by actually sacrificing some data. Small changes in color between adjacent pixels might be approximated, for instance, or numbers might be rounded off with the philosophy of "good enough." With many lossy file formats—such as JPG, MPEG, and MP3—a lot of effort goes into developing mathematical models that can sacrifice data the human brain won't notice much.

The distinction between compression and reduction is a subtle one, though, so I'll mainly use the term "compression" to refer to both techniques.

Lossless Alternatives

In addition to the default JPG format, many digital cameras have a second file format option, TIF. Remember that the TIF format, unlike JPG, can be used to ensure that the image is absolutely pristine, without any data loss at all. Many cameras have a special setting that you can use to save your images in this lossless TIF format.

You might want to use TIF if you are shooting a special photograph that you plan to crop, enlarge, and print. Professional work may call for TIF images, but even then, a high-res, high-quality JPG might be sufficient. Remember: the TIF format exacts a serious penalty: each TIF file is several times the size of the equivalent JPG photo, and using the TIF format to save your photos can seriously slow down your camera's ability to take and save images.

If you want to work in TIF format a lot, you should get the largest memory card you can afford. Consider a 1GB memory card in a typical 10-megapixel digital camera. Such a card might usually be able to store about 100 high-quality JPG images. When set to TIF format, though, the same card might only hold a dozen images. That's a pretty radical difference, so it's worth asking how significant the difference between TIF and JPG really is. Here's my take: the benefits of TIF are typically only obvious when enlarged, and even then it isn't always readily apparent. It's most noticeably important when trying to print an enlargement on a good color printer.

There's another issue with TIF: it takes a long time to save these images to memory. Since TIF files are the size of several JPG images, your camera has to spend the time to store the equivalent of several pictures each time you press the shutter release. Finally, I think that RAW has put a nail in TIF's coffin. If you're really serious about your photos, use your camera's RAW mode, if it has one. If it doesn't, think about upgrading to a camera with RAW capabilities.

> TIP
>
> *In general, I suggest that you forget about the TIF mode on your digital camera. It's not worth the sacrifice, since a high-res, high-quality JPG is more than adequate 99.9 percent of the time. Worse, it can take a long time to write a TIF file to memory. In any event, RAW is a better choice for lossless photography today.*

RAW Files

As I just mentioned, RAW is the clear winner in the lossless camp. The RAW format does TIF one better, storing not just totally uncompressed data, but also storing more *bits per channel*. Finally, it stores all that data before the camera's processor has had a chance to do anything to it.

What am I talking about? Let's take the processing question first. Consider this: your digital camera's processor does a lot to each image you snap before it gets stored on the memory card. First and foremost, each pixel of the image sensor can only capture a single color, so the camera's processor combines adjacent pixel information to interpolate the colors you finally see in your finished image. Then your camera guesses how to calibrate the colors in your photo based on ambient lighting conditions (this is called setting the white balance, discussed in Chapter 5). It might also run some sharpening and other tweaks to improve the final image. All of this happens every time you press the shutter release, and most of the time you probably have no idea how heavily processed your images really are. RAW images, in contrast, represent the unprocessed, uninterpreted data, period. In other words, the RAW file is like a digital negative

What do you want to do with your digital camera? The possibilities are almost limitless—whether you want to take portraits, capture action photos of race cars or kids (which both move at about the same speed), or dabble in close-up photography. Consider the next few pages a sort of visual menu of digital photography options. Pick something that you'd like to try, and then refer to the appropriate chapter to learn how. Enjoy!

High Dynamic Range

Take hyperrealistic photos that depict a richer range of colors, brightness, and contrast than is ordinarily possible. High dynamic range photography lets you combine several photos of varying exposure into a single, eye-popping picture. See Chapter 15 for details.

Your camera's macro mode (usually indicated by a tulip symbol) lets you take bigger-than-life photos of small objects like insects, stamps, coins, flowers, and jewelry. Remember that the depth of field is very shallow, so careful focusing is a must. Chapter 6 has more information.

Shoot the Night Life

Set your camera on a tripod, turn on your long exposure mode, and get ready to take some cool photos when the sun goes down. Read Chapter 5 to find out what you need to take night and low-light photos.

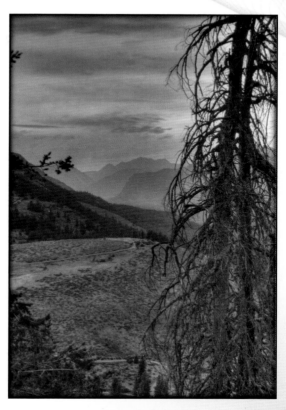

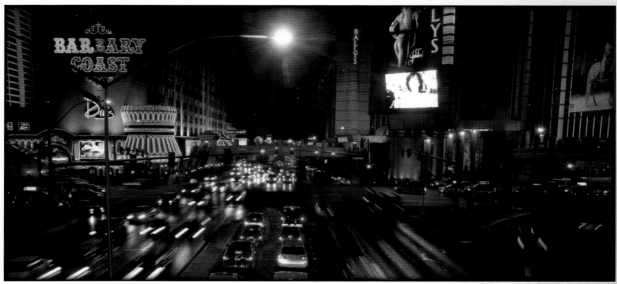

Capturing Action

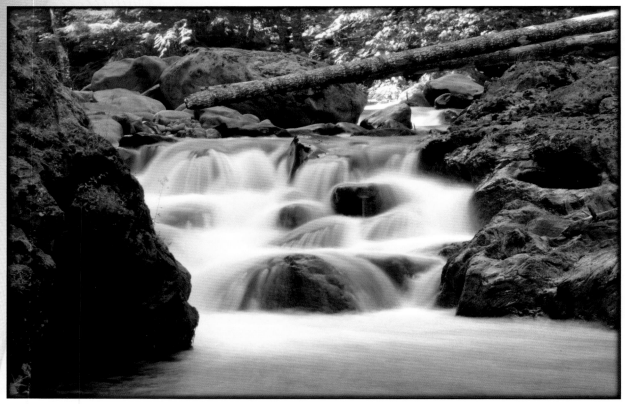

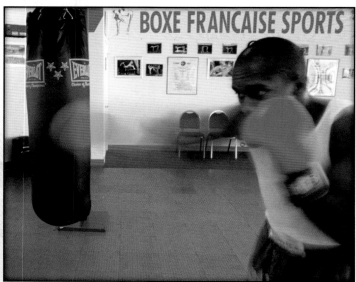

Action photography—kids, animals, waterfalls, race cars, fireworks—is one of the most exciting things you can do with a digital camera. Whether you're using a fast shutter speed to freeze the action or slowing your camera down to blur your subject, you'll get all the answers in Chapter 7.

Out of This World

Become Steven Spielberg! It's easy to doctor your own photos to create all sorts of special effects. Turn to Chapter 15 for step-by-step instructions on how to stuff someone in a mayonnaise jar, have a phaser battle, shake hands with Elvis, or replace the background in your photos.

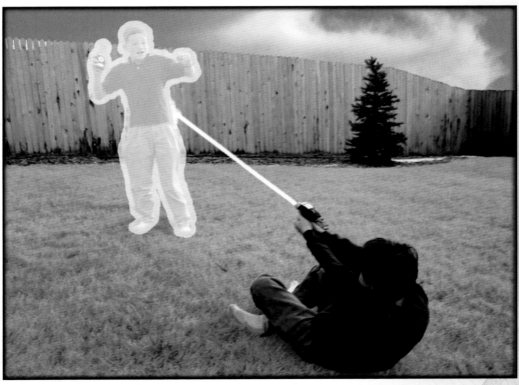

Sometimes the vista in front of your eyes is just too big and grand to capture in your camera's viewfinder. That's okay; take it in sections and "stitch" it together on your PC afterward. Find out how in Chapter 14. You can even correct the colors, as I've done here, using techniques found in Chapters 13 and 14.

*P*unch Up the Exposure

The histogram displays your photo's exposure in a graph. You can use this graphical display to see if your picture is badly under- or over-exposed and even to improve your photos after you transfer them to your computer. Learn how to do this in Chapter 14.

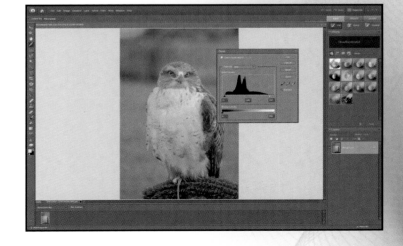

Eye on Composition

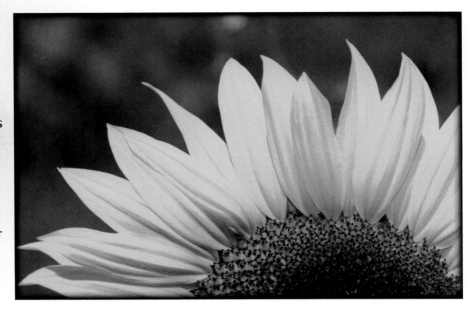

We often fall into the trap of taking the same kinds of pictures over and over. Think differently and try to capture photos with unusual subjects, perspectives, or composition. Look for unusual photos in everyday objects like signs on the street. And don't forget that framing is important—remember the rule of thirds and be sure to take advantage of depth of field to vary the focus in your scene. Learn more in Chapters 3 and 4.

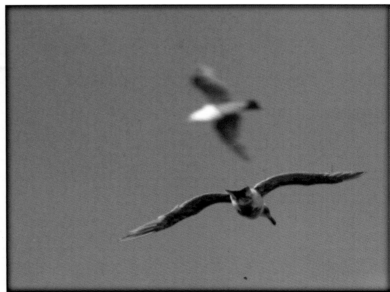

in that it is totally unprocessed, unfiltered, and untouched. (Unlike a film negative, of course, it isn't in reverse color!)

Now for the other issue: bits per pixel. JPG and TIF images pack 8 bits of color information into each of the three color channels of your photos. That means there are 256 levels of color available for the red, green, and blue components of your photo, or a total of 16 million color possibilities. RAW photos, on the other hand, store 12 bits per channel, for dramatically more color information in your photos. Unfortunately, you can't see the difference between JPG and RAW images on a computer screen. Instead, the real advantage of all those extra bits is in photo editing. If you want to tweak color, brightness, contrast, and other aspects of your photos, RAW is a great choice. If you rarely do that kind of editing, you're probably better off with JPG.

Even then, be aware that all RAW files are not the same. Nikon's NEF format is similar to—but incompatible with—Canon's RAW format, for instance. And some cameras, like a few Olympus models, disguise their RAW mode by simply calling it TIF, so it pays to read your camera's user guide to learn the details. In addition, not all cameras have a RAW mode. Check your camera's manual.

Finally, keep in mind that there's a little more work involved with RAW files. Since RAW files don't already have white balance applied, you typically need to apply white balance to correct colors on the PC. See later in this chapter for a quick tutorial on RAW workflow.

On the PC

When you transfer your images to the PC, you'll find them in the same file format that the camera used. There's no magical transformation as they go from camera to computer. But just because they arrive in JPG format, for instance, doesn't mean they have to stay that way. You can save these images in any file format you like.

NOTE
If you save a JPG picture in TIF format, you essentially "freeze" the image at its current level of detail and image quality. That way, when you edit and save it again later, you're not degrading its quality as you would by resaving it in JPG format. But remember, just saving an image in TIF cannot restore quality that wasn't there to begin with. Your image will never look any better than it did in JPG format. But at least you prevent further image loss; every time you change a JPG file and click the Save button, you're reducing the quality of the image.

Depending upon how important your photos are—and how picky you are about image quality—you might want to convert files that you plan to edit or manipulate into a lossless file format such as TIF. As I have said several times, I have nothing against JPG—it's a great format—but since it is lossy, every time you edit and resave the file, it degrades a bit more.

This is very important! Many people assume that resaving a JPG image doesn't affect the image quality, but that's not the case. Think of it this way: a JPG is nothing more than an approximation of the original that conserves disk space by reducing the total image quality slightly. Every time you save a JPG file, the JPG compression algorithm runs, reducing the image quality again. Each time you click the Save button on a JPG image in an image-editing program, you're making an approximation of an approximation. It's like making a photocopy of a photocopy.

Figure 10-2 shows the effect of opening and saving the same image a dozen times in an image-editing program like Adobe Photoshop. Notice how the eyes and whiskers don't look as smooth and well defined after it has been resaved multiple times using the JPG format.

FIGURE 10-2　Every time you click the Save button in an image editor, your JPG file degrades a little bit more—the image on the bottom is a degraded copy of the original on the top.

That said, don't be alarmed about JPGs that you don't edit and then resave. If you take a picture in JPG format, transfer it to the PC, and then only open it *to look at it,* you can leave it in JPG format because you're not saving it over and over.

How to ... **Change the File Format**

When you open a JPG image to crop it, brighten it, or perform some other minor (or major) editing job, you might want to save your changes as a new file with a .tif extension. Most image-editing programs work pretty much the same way, but I'll show you using Adobe Photoshop Elements. Here's how to do that:

1. In an image editor, choose File | Save As from the menu.

2. In the Save As dialog box, click the list arrow in the Save As Type box, and choose the option for TIF. It is sometimes spelled out as Tagged Image File.

3. Change the filename if you desire, and then click Save.

If you no longer need the original JPG file, you can delete it from your hard disk to save space. You might want to keep it, though, in case you want to go back to the original image (prior to the edits you just made).

Also, keep in mind that if you're saving your photo as a JPG, your image-editing program will offer you the ability to set the compression level of the photo. The higher the compression, the smaller the file size—and the lower the print quality.

A Simple RAW Workflow

If you're shooting your photos in JPG format, you can do something with them more or less immediately: e-mail, print, post to the Web. If you shoot in RAW format, though, you'll want to perform some minor processing on them before you share the photos. You can do this workflow in almost any photo editing software. Adobe Lightroom, for example, is designed with a RAW workflow in mind, and I really like the way it works. You can also use Photoshop Elements or pretty much any other program that has built-in RAW support for your camera.

To prepare your RAW photos, do this:

1. Open a RAW photo in your favorite program. You might be presented with a RAW interface, like this one from Photoshop Elements:

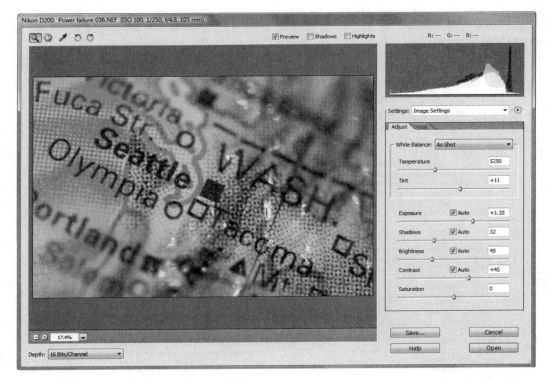

2. Set the white balance. To do this, choose the preset that most closely approximates the conditions when you took the photo. The photo should already "know" what the lighting was like, so you can choose As Shot to accept the default.

3. Make any other changes you'd like to apply to the photo. You can tweak exposure, colors, saturation, and more. See Chapters 13–15 for more information.

4. Feel free to apply some sharpening (preferably with an Unsharp Mask tool, discussed in Chapter 14). Remember that RAW photos are not sharpened in the camera.

5. When you're ready to save your work, you'll need to choose a new file format. Adobe Lightroom saves all your changes implicitly (meaning you never have to click a Save button…and you can always undo anything, at any time in the future), but most other programs require you to choose a new file format since you can't make changes to a RAW file. You can Save As JPG or TIF, for instance. Now you'll have two images: the original RAW file and the edited version in whatever format you've chosen.

Choose a File Format

The TIF format is great if you plan to print enlargements of your images or if you want to preserve an image precisely, without any compression artifacts. Digital images have lots of uses, though, and that's why there are lots of file formats. Here are a few file format tips you might want to keep in the back of your mind:

- **Web publishing** If you're publishing pictures on the Web or in a page layout program such as Adobe PageMaker, JPG is often the best choice. But GIF files can have transparent backgrounds, so text can be made to flow professionally around an irregularly shaped image, as you can see in Figure 10-3.

FIGURE 10-3 In an image editor, be sure to save your image with a transparent background. Then you can make text wrap around it in your web design or publishing program.

- **Print publishing** Creating a newsletter? If you're printing a black-and-white document, such as on a laser printer, it often pays to convert your image to grayscale before you insert it into the page layout or word processing program. There are two reasons for this. First, you can see exactly what you're going to be printing, and viewing it in shades of gray lets you determine whether the image needs brightness adjustment or other edits. Second, you're sending less information to the printer, and the software should work somewhat faster.

- **Enlargement printing** If you want to print digital images at large sizes, such as 8×10 inches or beyond, TIF or JPG is fine, but stick with TIF if you are editing and saving the file first.

- **Onscreen display** The JPG format is perfectly adequate for most onscreen applications, including e-mail, slide shows, PowerPoint presentations, web photo albums, Windows desktop wallpaper, and that sort of thing.

Tweak JPGs

The JPG file format is very flexible. Just as on the digital camera, where you can usually select from several grades of JPG image quality, desktop-based image-editing software usually lets you specify an image quality level as well.

Remember the trade-off with JPG settings: the higher the image quality, the larger the file size. In a program such as Photoshop Elements, for instance, you can find the JPG controls in the JPEG Options dialog box after you choose to Save As the picture:

You should see a slider control for increasing the compression level. Most people stick with a compression level in the range of 9 to 12. Below 8, the compression artifacts start to become quite noticeable, though the file size shrinks dramatically. Check out Figure 10-4, for instance. Here you can see a conservative compression of 12 on the left and an aggressive compression of 6 on the right. The difference is dramatic, especially in the image's background.

FIGURE 10-4 When you save JPG images, use as little compression as possible to avoid this kind of degradation.

My advice: for all my photography, I set my photo editor to the absolute lowest compression/ highest image quality and I leave it there. That way, successive changes do the very least damage to my pictures possible. Yes, the picture files are fairly large, but they're still just a fraction of what they would be as TIF files.

Did you know?

Workflow in a Nutshell

I've had a lot to say about the how, why, when, and where of which file format to use. Let me wrap it up with a recommendation for when to use the ol' Save As control in your image-editing program.

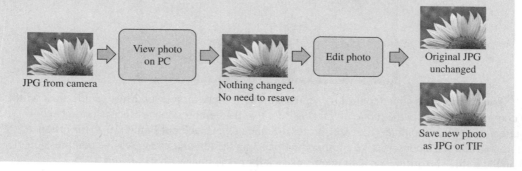

As you can see, the only time you need to save your photo is when you make changes to it in an image-editing program like Photoshop Elements—and at that point, no matter whether it started as a RAW or a JPG, you should save the changed image as a TIF, high-quality JPG, or the editing program's native file format using a different filename, and leave the original image alone. If you follow this workflow, you'll always have the original photo, and the modified photo will be of sufficient quality to print or share. There's one other step you could follow as well:

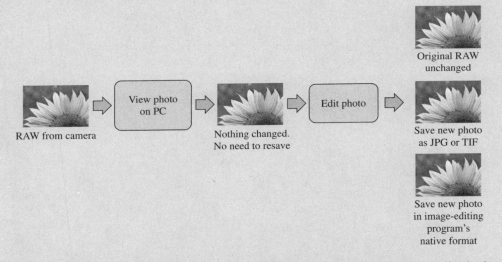

RAW from camera

View photo on PC

Nothing changed. No need to resave

Edit photo

Original RAW unchanged

Save new photo as JPG or TIF

Save new photo in image-editing program's native format

Here, you can see that I'm not just saving the edited photo as a TIF or JPG, but also in the photo editing program's native format—in the case of Photoshop Elements, for example, that would be as a Photoshop PSD file. Why? Because a native file includes layer information, which you'll learn about in Chapter 14. Preserving layers can save you a lot of time if you want to go back later and make small changes to your edited photo.

Chapter 11

Working with Digital Film

How to...

- Choose a camera based on its memory card format
- Understand the advantages and disadvantages of various kinds of memory cards
- Use a serial connection cable to copy images from the camera to the PC
- Troubleshoot serial port problems
- Correlate serial ports and COM port numbers
- Use a USB cable to copy images from the camera to the PC
- Solve USB port problems
- Delete images from your memory card
- Care for memory cards

Often, you'll hear people describe a digital camera's image sensor—be it the Charge-Coupled Device (CCD) or Complementary Metal Oxide Semiconductor (CMOS)—as the equivalent of camera film. Heck, I use that comparison myself pretty often. That's because the sensor behaves like film. It's sensitive to light and is primarily responsible for sensing the scene in the same way that the silver halide solution on chemical film records a scene. But, in just the same way that about 50 different people each stake a claim to being the Fifth Beatle, another component in your camera is also "like the film in a camera." This is your camera's removable memory, and that's the subject of this chapter.

Removable memory like SD, SmartMedia, CompactFlash, Memory Stick, and xD cards are just like film in the sense that they are where your images are stored. If you remove the memory card from your camera and hold it in your hand, you're holding your pictures. If you insert that memory card in your PC, you can transfer those pictures to your computer for editing or printing. And, because memory cards can be erased and used again, digital imaging is much more flexible and a heck of a lot cheaper in the long run than film photography. To learn how to get the most out of your computer's digital film, read this chapter.

The ABCs of Digital Film

All digital cameras have to store their images somewhere—it's the *where* that's the big question. There's no single standard way of storing images in a digital camera; several different memory "standards" are used by cameras today, so the memory card you need to use is really determined by the particular camera you happen to buy. Almost all cameras use one of the following methods of storing images.

Internal Memory

Although a few low-priced digital cameras use just a few megabytes of internal, nonremovable memory for storing images, this animal is a dying breed. In fact, it's almost extinct. Most cameras include the capability to insert some sort of removable memory. That way, you can

Did you know?

Pixel Potential

If you photograph a plain white background in JPG format, it'll take up almost no space at all on your memory card or computer hard disk. That's because the JPG format stores information about the change in color information from one pixel to another and, if the image is all white, there's little change data to record. This also explains why photos with digital noise—especially images taken at high ISOs—are larger than similar photos taken at lower ISO levels. Noise is essentially random pixels of unexpected color, and that increases the amount of color information the JPG file has to keep track of.

What about a TIF? The same picture stored as a TIF will be much larger, because the file holds a space for all 24 bits of color data in each pixel. The TIF format isn't concerned about the actual colors in the image; instead, it's preoccupied with the potential range of colors that could be in the image. Even though every pixel might be white in our hypothetical photo, the TIF format must have enough room to store any color at each and every pixel. TIF files compress quite nicely using a ZIP program, though, so you can save a file in TIF format and "zip it up" to e-mail it to someone.

insert a fresh memory card when your camera is full of pictures. With only internal memory at your disposal, you can easily run out of storage space and be unable to take more pictures unless you delete a few old images or you download your pictures to the PC—something that can be hard to do if you're shooting snapshots on vacation.

NOTE *Many cameras come with a few megabytes of internal memory in addition to a removable memory card slot. That way, if your card gets full, you might be able to snap a few more pictures with just the memory built into the camera.*

SmartMedia

SmartMedia, originally known by the somewhat cumbersome name of Solid State Floppy Disk Card (SSFDC), is the oldest of all memory formats. It's also the thinnest, weighing in at a mere .75mm thick. Because it's so thin, SmartMedia has little on board "intelligence," and it relies on its parent device (such as your digital camera) to understand how to read and write data on the card.

While this approach makes for a more streamlined memory card, it also means that some digital cameras can't read all SmartMedia cards. This is because firmware in older cameras isn't programmed to understand newer, higher capacity cards, which didn't yet exist when the camera

was manufactured. Another problem: SmartMedia cards are wafer thin, somewhat flexible, and have unprotected electrical contacts on the outside of the card. That makes SmartMedia more easily damaged than other kinds of memory.

Here's the bottom line on SmartMedia cards: They're old, frail, and virtually extinct. You might see them in older cameras and museums, but that's about it. Otherwise, they're best avoided.

CompactFlash

I often call *CompactFlash* the most versatile memory card format on the market. They're the largest of all the removable memory cards in use today, but they come in a wide range of capacities, are built like tanks, and are often the most cheaply priced cards you can find.

CompactFlash was brought to the market right about the same time as SmartMedia—together, those two formats are the great-grandparents of today's mobile storage gadgets. I think CompactFlash is a good bet for photographers who need to pack a large number of images onto each card. As you can see in the following, CompactFlash is reasonably small (it's about an eighth of an inch thick), yet it comes in a variety of capacities all the way up to 16GB—enough storage for hundreds of high-resolution photos. CompactFlash cards are ideal for high-megapixel cameras and situations in which you can't easily swap out memory cards when the first one is full (underwater photography is an excellent example).

A variation on the CompactFlash format is a small device called the *Microdrive*. Originally sold by IBM, the Microdrive is a tiny hard disk packed into the CompactFlash format. These days, they're not as popular—you can get regular flash memory-based CompactFlash cards with as much storage space quite inexpensively—but there was a time when these tiny hard drives were pretty much the only way to get a gigabyte of storage space into your camera. Today, you can get them in capacities up to about 8GB from companies like Hitachi and Seagate. I'd steer clear of these gadgets; compared to CompactFlash, they're slower, more fragile, and consume more of your camera's power.

Memory Stick

Originally manufactured exclusively by Sony for Sony products, *Memory Sticks* are increasingly popular (thanks, in large part, to the popularity of Sony cameras and other Memory Stick–enabled devices. Memory Sticks (shown in the following) come in a variety of capacities, currently up to about 8GB.

Memory Sticks are smartly engineered. They're thin and narrow, like a stick of chewing gum, and they have a "self-cleaning" set of electrical contacts on the end—that means it's hard to damage the Memory Stick, even though the contacts are visible. Thanks to the card's unique shape, you'd have to try very, very hard to insert it into your digital camera incorrectly.

The real appeal of Memory Stick–equipped digital cameras is you can remove the Memory Stick and insert it into any other Sony Memory Stick–enabled device to access your images. Memory Stick products include VAIO laptops, digital picture frames, camcorders, digital cameras, and handheld PCs.

On the other hand, if you deal with Memory Stick you have to live with the fact that Sony breeds a slew of different Memory Stick subspecies:

■ **Memory Stick** The original Memory Sticks are not of much use to anyone with a modern digital camera, since they have an upper limit of just 128MB.

- **Memory Stick Pro** This newer version of the original Memory Stick is faster and has a higher capacity (a maximum of 32GB). Most digital cameras today use this version—but don't insert a Pro card in an older camera, because it will not work.

- **Memory Stick Duo** A slightly smaller version of the Memory Stick, the Duo is about two-thirds the size, designed for smaller cameras. You can transfer photos to your PC using an adapter that lets a normal Memory Stick reader work with the Duo. There are classic and Pro versions of the Duo available.

- **Memory Stick Micro** About the size of your fingernail, Memory Stick Micro is an ultra-small version of the memory card designed for extremely compact devices. There are classic and Pro versions of the Micro, with a maximum capacity of 32GB. You can transfer photos to your PC using an adapter that lets a normal Memory Stick reader work with the Micro.

- **Memory Stick Pro-HG** The newest member of the Memory Stick family can be used in older Memory Stick Pro devices, where it behaves just like Memory Stick Pro. But when used in a new HG-compatible gadget, this latest version of the Memory Stick is dramatically faster, designed to read and write next-generation high-resolution pictures and video.

Secure Digital (SD)

A very popular kind of removable memory is called Secure Digital (and more commonly referred to by the acronym SD). *SD* offers your digital camera high memory capacities in a footprint about the size of your thumbnail. SD cards are similar to MultiMediaCard (MMC) cards—both share the same overall dimensions (though SD cards are slightly thicker than MMC cards), and most mobile devices are designed to accommodate both formats interchangeably. The principal difference is data encryption: SD cards enable vendors to deliver copyrighted data to the end user while ensuring it can't be illegally copied.

Here's the important part: SD cards, thanks to their small size and reasonable price, are pretty much the standard storage card today in point-and-shoot cameras, as well as in other kinds of devices like PDAs and some cell phones.

xD

When it became clear that the now ancient SmartMedia card was ready for the Old Memory Card Home, Olympus and Fuji collaborated on a new memory card format, which they dubbed xD. The *xD card* is SmartMedia's more modern successor, and it appears in several Olympus and FujiFilm cameras, with a maximum capacity of about 8GB. xD competes with the Memory Stick Micro for the prize for the smallest memory card format on the market, which means it can be used to power some very tiny cameras.

Did you know? **Memory Card Glitches**

Occasionally, memory cards sometimes seem to "die." If it stops working, what's the real problem?

First, remember that some memory cards are pretty delicate. SmartMedia cards, for example, are wafer-thin and have important electrical contacts exposed right on the surface. If you've damaged a card, which isn't altogether out of the question, it's now a really, really small coaster. Throw it away with the knowledge that you can replace it for just a few dollars.

Other possibilities exist as well. Using the same memory card in multiple devices can change the formatting or fill the header information on the card with gibberish, rendering it temporarily unable to store digital pictures. So it's a good idea not to use the same card in your MP3 player and digital camera. If you end up with a dead card, you can try to revive the card by using the Format command in the camera's menu system. But, if that doesn't work, you're probably out of luck.

Choose a Memory Card Format

As mentioned, memory devices vary dramatically in size. In Figure 11-1 you can see the relative sizes of the most common memory formats.

Worth noting is this: in at least a few cases, you needn't choose between different memory storage formats anymore. Some camera makers include two or more different kinds of memory slots in some of their cameras (see Figure 11-2). Not only does that mean you can pick a camera for its features and not worry about whether you like SmartMedia or CompactFlash better, but you can also insert two memory cards in the camera at once and switch from one to the other when one card fills up.

With all that said, what kind of memory card should you use? In general, I'd say choosing a specific kind of memory card isn't nearly as important as picking other camera features, like zoom, optical quality, and useful exposure modes.

Bottom line? Buy a camera based on other features, and only use the kind of memory card it has as part of your last-look criteria.

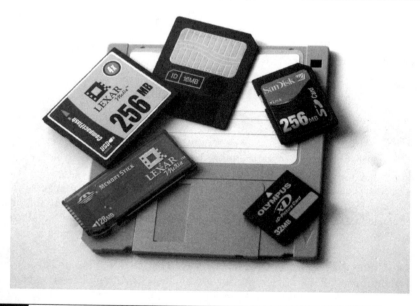

FIGURE 11-1 Relative size of various removable memory cards

FIGURE 11-2 Most cameras use just one kind of memory, though some models accept multiple memory cards, like the SmartMedia and CompactFlash cards shown here.

Transfer Images to the PC

No matter what kind of digital camera or removable media you use, eventually you need to get your pictures from the camera to a computer, where you'll be able to edit, print, and distribute them. Your digital camera might come with software for transferring images and a cable that you can use to connect the camera to your PC. My advice? Throw that disc away (though perhaps you shouldn't take that advice too literally). In my experience, photo transfer programs that come on disc with digital cameras are junk. Instead, use the photo transfer software built into Windows (especially Windows Vista) or the utilities that accompany your photo editing program, like Adobe Lightroom or Photoshop Elements.

Transfer Photos with USB

Getting photos from your camera to your computer is a snap, since virtually every camera in existence comes with a USB cable that connects to your PC. Just plug your camera into your computer, click one or two things, and all your photos will appear on your computer.

Did you know?

USB 2 versus USB 1.1

These days, almost all computers and digital cameras use a standard called USB 2, which is dramatically faster than its older cousin, USB 1.1. Instead of 12 Mbps, which is the speed of USB 1.1, *USB 2* runs at a whopping 450 Mbps. So, if it used to take 10 minutes to transfer your digital images to the PC's hard disk, USB 2 will be able to do it in about 20 seconds. Pretty cool, huh?

Of course, for USB 2 to work, you need a computer with USB 2 ports (most new PCs have them) and a digital camera that's USB 2-compliant as well (older cameras use USB 1.1, but most new ones are USB 2). If you use a USB hub to attach lots of USB devices to your PC, that must also be USB 2. If any one of those parts is USB 1.1, your image transfers will happen at the older 12 Mbps speed.

On the plus side, USB 2 is 100 percent compatible with USB 1.1—so you can mix and match gear, albeit if any piece of the puzzle is USB 1.1, all the data is transferred at the slower USB 1.1 speed. So it'll never fail completely, but rather just move over to the slow lane.

USB Glitches

USB is susceptible to a few problems that might occasionally annoy you. The main problems? A lack of power and insufficient bandwidth, both of which can rear their ugly heads when you try connecting a lot of USB devices to your computer. Consider these tips:

- **Add more ports** Have you run out of ports to plug stuff into? If you don't have anywhere to insert your digital camera's USB cable, don't unplug the mouse or the scanner or the speakers. Instead, buy a USB hub from the local computer store. A USB port can turn one USB connection into four (or more), as you can see in Figure 11-3.

- **Power the ports** While some devices can get power from the USB port itself, many USB devices require more power than the USB port can deliver. That's why it's a good idea to use a *powered hub*—that's a USB hub that you plug into AC power. If your USB devices seem to work erratically or if you get warning messages in Windows, be sure to use a powered hub and keep the hub plugged in. It's worth noting that USB 2 hubs are always powered—plugging it in is not an option.

- **Distribute your bandwidth** Each USB port on your computer has a certain amount of bandwidth to work with—for an older USB 1.1 port, for example, that's 12 Mbps. If you attach a hub to one of those ports, those four new ports in the hub still have to share the original 12 Mbps of data. If you put four data-hungry devices (like a digital camera, a video Webcam, a joystick, and a speaker set) on the same hub, they can overtax the USB hub and make it perform erratically. So, if you have a bunch of USB devices, I suggest you put a hub on each port and try to move devices around so the most power-hungry ones aren't all connected to the same port.

FIGURE 11-3 Belkin's powered USB hub is just one of many options for connecting more USB gadgets to your computer's limited array of USB ports.

How to ... Transfer Your Camera's Photos with USB

The transfer process is a piece of cake. Here's how to do it:

1. Connect the USB cable to your computer's USB port and to the camera. You needn't turn off your computer to do this, even if you have to disconnect an existing USB device to free up a port.

2. Turn on the camera and, if necessary, set it to its transfer mode. Connect the camera to AC power if possible.

3. The computer should automatically recognize the camera and start the transfer software. If you're using Windows Vista, for example, you'll first see the AutoPlay dialog box. In it, click Import Pictures using Windows.

4. Next, you'll see the Import Pictures and Videos dialog box. Click Next and your photos will automatically be copied from your camera to the Pictures folder on your computer.

5. After the transfer is complete, you can see your photos by opening the Pictures folder (choose Start | Pictures) or, even better, open Windows Photo Gallery (Start | Windows Photo Gallery).

Transfer Shortcuts: Using Memory Card Readers

Just because your camera comes with a USB cable, that doesn't mean you have to use it. *Memory card readers*, which are gadgets that let you insert a memory card and read images from it like a floppy disk, let you easily transfer images to the computer without messing with any cables at all. Using a memory card reader has several advantages:

- You can conserve camera battery power because the camera isn't used in the transfer.
- You don't have to get to the back of your computer to connect or disconnect cables.
- Transfers might be faster with a reader.
- You can avoid using transfer software because readers let you drag-and-drop images directly to a folder on your hard disk.

Use a Memory Card Reader

The kind of memory adapter you choose depends largely on the kind of removable memory your camera uses. In general, they're all more efficient than connecting your camera with a cable.

- **Desktop single format card readers** For $15 or $20, you can get a USB card reader that accepts whatever kind of memory card your digital camera uses. You can get readers for CompactFlash, SmartMedia, SD, Memory Stick, and even xD. The downside? If you ever need to read a different kind of memory card—like from a second camera or a digital music player—you'll need to buy a second card reader, which will eat up a second USB port and more desk space.

- **Desktop all-in-one readers** Just like cameras that are starting to accommodate more than one kind of memory card, readers are becoming more flexible as well. Universal readers can accommodate six or more kinds of memory cards, making it easy to read and

write to cards for your digital camera, MP3 player, and PDA—all from the same device. I use my 6-in-1 universal card reader from Dazzle all the time.

■ **Internal card readers** For the ultimate in convenience, you can find card readers that fit in one of your PC's empty drive bays. In fact, many new computers come with 7-in-1 readers that pack every kind of memory card slot imaginable into the space of a normal floppy disk drive.

Did you know?

Memory Card: Fact and Fiction

I've met people with some interesting misconceptions about digital film, so let me try to dispel some myths.

Removable memory cards are nothing more than digital storage for your camera. That means memory cards aren't designed to store images of a certain size. Some people mistakenly believe if they want to store images of a larger or smaller pixel size, they need a different memory card. Memory cards are completely standardized and interchangeable, and they don't particularly care what you store on them. In fact, you don't even have to put digital images on them at all. They'll hold sound files, text documents, and more. Your camera won't know what to do with files like that and, consequently, they'll ignore such files, but you can store anything on a memory card.

Differences exist among memory cards, though. The principal difference is speed: faster ones write data faster and are a good choice if you value speed when taking pictures. They're also good for high-megapixel cameras because large files take longer to record. On the other hand, faster cards cost more, and the speed benefits generally aren't measurable unless you have a digital SLR—many other digicams don't take advantage of the faster performance. Some of the fastest cards on the market have names like "Extreme" (as in SanDisk's Extreme IV).

Care for Your Memory Cards

After you finish transferring images from the memory card to your PC, you no longer need those images. You can delete them to make room for more pictures. You can do this in several ways: you can delete the individual photos via the PC, use the camera's controls to delete the images, or reformat the card (either on the PC or on the camera). If your memory card is inserted in the PC via some sort of memory card adapter, using the PC doesn't waste camera battery power, and that's a good reason to do it that way. If you don't have that luxury, a good idea is to plug the camera into its AC adapter, so you don't drain your camera's batteries.

To delete images from your memory card via the PC, you can usually just select the files and press the DELETE key on your keyboard. It's just like deleting any kind of file from your PC's floppy or hard disk. But, if you want to format your memory card, only do it on your camera—not on your desktop PC.

To delete images using the camera's interface, you'll have to navigate the camera's menu system. Typically, you'll have the option of either deleting a single image or all the images on the disk at once. Be careful—this operation can't be undone.

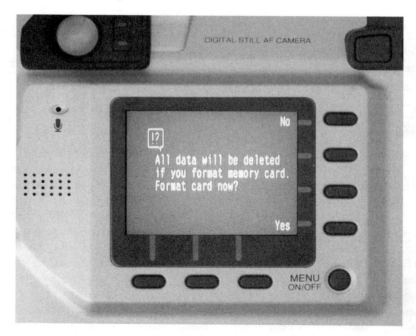

Why would you consider formatting the memory card instead of just deleting the photos? Formatting the card wipes it completely clean and gets rid of stray bits of data. Over time, just deleting photos can make the card get fragmented, which will slow down the camera when it tries to save photos. I use my camera's format option regularly, after every few photo sessions, to keep my camera and memory card working as quickly and efficiently as possible.

NOTE

If you have some important images on your memory card and you don't want them deleted, you can usually use your camera to protect them. Check your camera's menu system for a feature called "protect" or "lock." That way, you can delete all the images on your memory card, and those specially protected images will remain until you explicitly unprotect them. In general, though, I suggest moving special images to your PC where you'll be less likely to accidentally delete them.

In addition to deleting images from your memory cards, you should take other precautions to ensure your cards live a long and fruitful life. After all, memory cards can be expensive. Keep the following tips in mind:

- Avoid putting memory cards in direct sunlight or extreme heat, such as on the dashboard of your car on a sunny day.

- Don't put memory cards in your back pocket or other places where they can get bent or crushed. That's particularly true for SmartMedia cards, which can break with moderate amounts of force.

- Keep your cards empty whenever possible. All memory cards look alike, and the last thing you need is to put a memory card in your camera while you're on vacation only to discover it's still full of images you never saved to your PC from last time. Transfer images to the PC promptly, and then format or erase the card.

- Never write on memory cards or put any kind of sticker on them to track their contents. That can damage the card or the camera.

- Try to avoid dropping cards or getting them wet. That said, most memory cards are almost supernaturally indestructible. Many magazines and web sites have done extensive testing on memory cards and found that you can drive over them with your car, leave them in the washing machine, and throw them out of the window. In most cases, they'll survive all such assaults. Even so, I wouldn't recommend tempting fate.

Recover Lost Pictures

Have you ever accidentally deleted an important file, noticing it was gone an instant after you sent it irretrievably to the trash? All you can do is shout, "D'oh!"

The same thing can happen to pictures on a memory card. Thankfully, when you erase a card, the files aren't necessarily gone right away—the memory card simply "forgets" that it's holding data. If you need to get back lost images, there are several programs to choose from. All are inexpensive and work very well:

- **ImageRecall** www.flashfixers.com
- **Photorecovery** www.lc-tech.com
- **Digital PhotoRescue** www.objectrescue.com

These simple programs (you can see a screen shot of ImageRecall next) recover deleted images, movies, and other data from removable memory cards. And they all work with any kind of removable media, from SmartMedia and Compact Flash to Memory Stick and SD Cards.

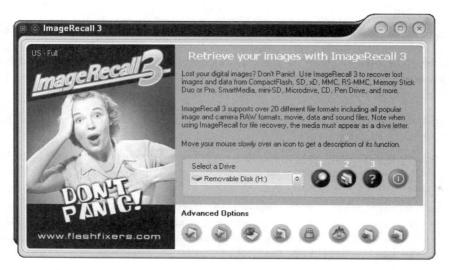

No matter which program you choose, they all scan the contents of your card, restoring lost files to a folder on your PC's hard disk. I've tried all three and they work. In fact, a friend of mine once sent me a card he believed was corrupt—after he filled it with pictures, the PC reported no images were on board. I used ImageRecall to get a batch of photos back. My friend was quite grateful.

Just remember, if you plan to run a photo recovery program on a memory card, do it before you use the card for anything else. Adding new data to your card can damage "deleted" pictures already on the card, lowering the odds that you'll get anything useful from the recovery process.

What are the odds you'll ever need one of these programs? Pretty low, I suspect. But if you do find yourself with a dead memory card or lost pictures, this might be worth a try.

Travel with Pictures

It's one thing to travel with a memory card or two and a digital camera—it's quite another thing to have so many memory cards that your pockets jangle when you walk. But if you're traveling for a while, such as on a vacation trip, how can you have enough memory space to take all the pictures you need without running out of room? Instead of taking a half-dozen 1GB memory cards, I have a better solution: take a storage device that you can use to transfer your pictures to, and then erase your card and start anew.

Several gadgets on the market store your digital images while you're on the road. These devices have memory slots to accept images from your memory cards and securely store your images until you can get home and transfer the data to your PC. Here are some you might want to consider:

- **Photo Safe (www.digitalfoci.com)** This gadget is available in a couple of sizes, but the 40GB version costs $139. It's a portable hard drive with the ability to read common memory card formats.

- **Portable Digital Image Backup (www.ezpnp.com)** This portable CD recorder accepts AC power or AA batteries. Insert your memory card and press the Record button—the contents of the card are written to a folder on the CD-R, after which you can erase the card and continue shooting pictures. I like this device because, compared to portable hard disk, a CD-R is essentially indestructible—it won't break from rough handling (though, obviously, it can be fatally scratched).

- **iPod Camera Connector** If you already take your Apple iPod with you on trips, then you already have all you might ever need. Instead of carrying yet another portable gadget, get the $20 Camera Connector (www.apple.com/ipod/accessories.html). It plugs into the bottom of your iPod and accepts your camera's USB cable. It'll automatically back up all your camera's photos, which you can transfer to your PC when you get home.

Chapter 12

Finding and Organizing Your Pictures

How to...

- Use the Pictures folder
- Organize your photos in Windows
- Transfer, rename, and categorize your pictures to reduce clutter
- Browse images visually with your favorite photo editor
- Search for images more easily using tags and keywords
- Use Windows to see pictures without opening an image-editing program
- Archive your pictures on CD-ROM
- Install a new hard disk for additional storage

In the previous chapter, we talked about how to get images from your camera or its memory card onto your PC. That's a good start, but if you're anything like me, you need some help getting it all under control. Digital images proliferate like bunnies and can be hard to organize. After just a few months, in fact, you might discover that your computer's hard disk is essentially full, and the unorganized mess within is largely a ton of poorly named, hard-to-decipher digital images that don't do anyone any good.

In this chapter, we'll talk about the essentials of getting your stockpile of digital images under control. You have a lot of things to consider: naming and arranging your images; using software to better organize and find your pictures; and taking care of your photos so you don't lose them if you have a computer problem.

Manage Your Digital Photos

Keeping your hard disk organized is essential if you hope to find your digital pictures. In a sense, then, this chapter is kind of a tutorial in managing your digital photos' lives.

I know some people who don't worry too much about organizing the photos on their computer. They just download images from their camera to some folder on their hard disk and assume they can find what they need later. The problem? The images from your camera typically have fairly obscure filenames, like pic00012.jpg or dsc0012.jpg (see Figure 12-1). It's impossible to determine the contents of an image from such an arcane filename. Imagine having hundreds or, more likely, thousands of files like this on your hard disk with meaningless names like these, and you start to get an inkling of the problem.

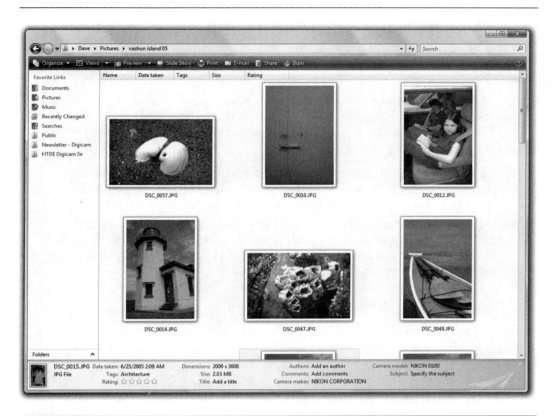

FIGURE 12-1 Your digital camera's code-like naming scheme for images is of no help when you want to find a specific picture.

Store Your Photos in the Pictures Folder

My first bit of advice is to store your photos in the folder that Windows has provided for you. Where's that? Click the Start button and then click Pictures. (If you're using Windows XP, it will be called My Pictures.) There you go! This folder is custom made to hold all of your digital images. Not only is it easy to find, but most photo software will automatically expect to find your photos here.

The Location of the Pictures Folder

If you're the sort of person who isn't satisfied knowing the Pictures folder is available from the Start menu, you might ask questions like, "Where on the hard disk is it actually stored so I can find it without the Start menu?" Well, here's your answer: It depends upon whether you use Windows XP or Windows Vista.

■ **On a Windows XP computer** The My Pictures folder is located inside the My Documents folder, along with My Music and My Videos. The formal path to the folder is: C:\Documents and Settings*username*\My Documents\My Pictures.

■ **On a Windows Vista computer** The Pictures folder, along with all the other media folders, is a peer of the Documents folder—in other words, it lives on the hard drive in the same parent folder as Documents instead of being inside it. The formal path is C:\Users*username*\Pictures.

Of course, you don't have to store all of your images in the "root" of the Pictures folder. You can create subfolders here and arrange your photos by any system you like—though the most effective organizing schemes are by naming the picture subfolders by date or by event.

Store Your Photos in Subfolders

To create subfolders in the Pictures folder to store your images, do this:

1. Open Pictures (or, if you're using Windows XP, My Pictures).

2. Right-click an empty space in the folder. You should see a menu appear.

3. Choose New | Folder from the menu. A new, empty folder should appear in the window.

4. Now it's time to rename the folder. The New Folder text under the folder is highlighted. Type a name for this folder and press ENTER. You should see the name of the folder change.

> TIP
>
> *If you click somewhere before you have a chance to rename the new folder, just right-click the folder and choose Rename from the menu. Then type the new name of the folder.*

Let Your Photo Importer Organize for You

Remember that you can store your photos anywhere on your computer's hard drive, but I think that organizing them in subfolders within the Pictures folder is a great place. It's easy to remember, accessible with a single click from the Start menu, and all of your photo programs will automatically look here for pictures.

Even so, you don't have to laboriously create subfolders for all your images. The cool thing about letting software automatically import photos for you is that you can configure it to always drop the new images in a common folder.

Windows Vista includes a program that recognizes when you connect your camera or a memory card to your PC and offers to import your photos to the Pictures folder. It stores your images in a subfolder, so each of your photo "collections" gets its own folder (see Figure 12-2 for a Pictures folder full of subfolders). For details on how to use this tool, see Chapter 11.

FIGURE 12-2 The more subfolders you use, the easier it can be to find the right image in a pinch.

You can configure the way Windows Vista imports your photos. You can fine-tune the folder it copies your images to, for instance, and the scheme it uses to name the new subfolders. To do all that, click Start | Windows Photo Gallery, and then choose File | Options. You'll find all the settings on the Import tab.

Of course, you don't have to let Windows import your photos for you (though it works so nicely, why not?). If you use Adobe Photoshop Elements, for example, you can let the Adobe importer manage your photos instead.

Use Tags to Find and Organize Your Photos

In earlier editions of this book, when digital photography was much more in its infancy, I spent a fair bit of time right here talking about how you should be a good photographer by meticulously renaming all of your photos as soon as you transfer them to your PC. My logic was infallible, of course: cameras give your photos sequential, but otherwise meaningless filenames like DSC00534 and DSC00535. Stack up a few thousand of those, and it becomes hard to find specific photos when you want them.

But I'll be honest with you: As I write this revision to the book at the end of 2007, I don't think that renaming your photos is a particularly effective solution for getting organized anymore. Heck, it never really was a great solution to begin with, but now there is a far better option. Renaming photos is slow and tedious, and when you're done, it only makes your photos marginally easier to find. I far prefer the newfangled solution of *tagging* your photos with metadata.

Here's what I'm talking about: using photo organizer software, you can assign tags (sometimes called *keywords)* to each of your photos. If you put a little thought into your tags, you can create a dozen or so general categories that reflect all the common subjects, events, and/or locations you routinely shoot: family, pets, holidays, soccer practice, Elvis sightings, and so on. It's about the same amount of work as renaming photos, but when you want to see all your holiday photos, just click that tag in your photo software and the software will filter out all the photos that don't match that tag, showing you a tight set of images that match your search. Plus, unlike file naming, you don't have to type the same tag over and over. Create a tag just once, and then just drag and drop photos to that tag to assign it.

Intrigued yet?

Tag with Windows Photo Gallery

You don't have to spend extra money to organize your photos using tags. Windows Vista includes the Windows Photo Gallery, which is a built-in way to view and organize your photos. (If you use Windows XP, you can get the same experience by installing Windows Live Photo Gallery from www.windowslive.com—it's free.) Let's see how to do the most common tagging activities with Photo Gallery, which you can see in Figure 12-3.

Organizing your photos is easy with Windows Photo Gallery, a part of Windows Vista and Windows Live.

Create a New Tag

There are two ways to create a new tag—use whichever method you prefer:

- Click a photo and then, in the Info pane on the right side of the Gallery, click Add Tags and type a tag name. Press ENTER. (If the Info pane isn't visible, first click Info in the toolbar at the top of the screen.)

- In the Navigation pane on the left side of the screen, click Create a New Tag and then type the tag name. Press ENTER.

In both cases, the new tag will appear in the list of available tags in the Navigation pane. The first method actually adds the new tag to the selected photo, while the second method creates the tag but does not apply it to any images.

Did you know?

What's Metadata

Metadata literally means "information about information." Specifically, metadata is bits of info that get attached to files on your computer (like photos) that tell you things about the files and make those files easy to find. Many kinds of files have a special place in the file to store this metadata. Digital photos, for example, can be tagged with metadata like the camera name, exposure information, and zoom lens setting used to take the photo, keywords or tags you used to describe the photo, and when the photo was taken. To see all the metadata associated with one of your photos, right-click the file icon and choose Properties. There's a surprising amount of information in the Details tab, which you can see just part of here:

Add a Tag to a Photo

If you already have a tag in the list, you can easily add it to one or more photos using drag and drop. Just select the photo (or the group of photos) that you want to tag and drag them from the main thumbnail view to the Navigation pane. If you hover, you should see a tooltip that tells you which tag you're about to apply. Drop the photos on the desired tag.

Find a Photo Using Tags

After you've tagged your photos, the real magic happens when you want to find a photo. Instead of rooting through dozens of folders in search of the right set of images and looking at filenames and thumbnails that might be close to what you need, just click the tag in the Navigation pane that reflects what you want. Instantly, the thumbnails will filter down to only images that have that tag.

Don't forget that you can also use the Search box in the Photo Gallery (shown next)—you can type the name of a tag, for example, to look for pictures with that tag. But you can do a lot more than that. Imagine that you have tagged a few hundred pictures with birthday parties, but you're looking for a picture from your dad's birthday party in 2005.

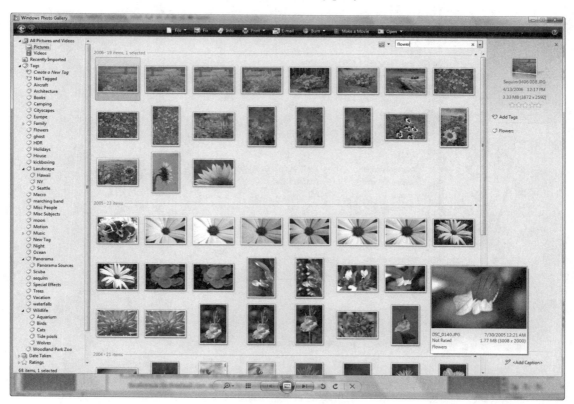

If you click the tag *birthday parties*, you'll get more results than you need, and sorting through hundreds of photos in thumbnail view might take too long. But if you know that your dad's photo has two tags (*birthday parties* and *dad*) you can type *dad* in the Search box to filter down to just the few photos that have both tags. Pretty cool, huh?

TIP *Want to open all the photos tagged with the word Beach in your favorite photo editing program? Click the Beach tag in Photo Gallery and then select all the images using* CTRL-*click. Then drag the entire set of photos from Photo Gallery to the open window of your photo editor.*

Remove Tags

Sometimes you might want to remove an unwanted tag. There are a few ways to do that:

- To remove all of the tags from a specific photo (or group of photos) all at once, drag the offending image from the thumbnail view to the Not Tagged entry in the Navigation pane.

- To remove an accidentally applied tag from a specific photo (or group of photos), select the photos in the thumbnail view, right-click the offending tag in the Info Pane, and choose Remove Tag.

- To delete a tag from your computer—and thus remove that term from the metadata of any pictures it might be applied to—right-click it in the Navigation pane and then choose Delete. You won't delete any photos, just the tag.

If You Don't Use Photo Gallery

Not everyone has Windows Vista or uses Windows Live, so it's worth pointing out what to do if you don't have Windows Photo Gallery at your disposal.

If that's the case, most of what I said about Photo Gallery also applies to other programs that use tagging or keywords to manage and organize photos. If you use Adobe Lightroom, for example, it has an integrated photo library that has Keyword Tags (apparently unable to decide between calling this metadata keywords or tags, they just stuck both words together).

Likewise, if you use Adobe Photoshop Elements or a version of Photoshop CS, they both come with an organizer that lets you tag your photos.

One thing to keep in mind is that if you switch programs, the tags or keywords won't always come with you—at least not automatically. Windows Photo Gallery puts its tags directly in the photo file, so if you later move to a program like Lightroom, Lightroom will easily read Photo Gallery's tags. Some programs, though, write tags and keywords to a special index, and those items won't go with the photos if you later change programs. At the very least, be sure to see if there's a program feature to write the metadata back to the photo files before you upgrade.

How to ... Add Tags When You Import Your Photos

In addition to tagging your photos in Photo Gallery, you can add tags when you initially transfer them to the PC. When you click Import Your Pictures Using Windows (see Chapter 11 for details), you can add an optional tag to all your photos.

Crop to just the Import dialog in the bottom right of the desktop. Unfortunately, the tag will be applied to every photo in the collection, but if your photos all have a common theme, like summer vacation or your kid's recital, then it might make sense to add a tag globally to all the incoming images. You can always fine-tune the tags (by adding new ones or removing the tag from a few images that aren't appropriate) as soon as they're opened in Photo Gallery. And a special tip: to add more than one tag during import, just separate each tag with a semicolon, like this: *kids; vacation; Hawaii.*

Rename Your Photos

All that said about tags, I understand that not everyone wants to go to the trouble of tagging—or you simply might not own the appropriate software. Or tags still seem somehow intangible, so you want to give your photos understandable names. If that sounds like you, you might want to know how to rename your photos from obscure camera-speak like DSC000023 to "Barbara at the beach."

If you do plan to rename your photos, I suggest you do it right away, when you transfer your images to the PC. Don't put it off till later! If you transfer images and opt to rename them later, you'll end up with a few batches of 50 or 100 images each that need to be renamed. The task will eventually get too daunting, and you'll have untold pictures with obscure filenames that need to be renamed. (Of course, that might be a good thing, because it'll prompt you to try tagging!)

Here's an easy strategy for renaming your images:

1. Open the folder in which your newly transferred images are stored.

2. You should see a preview of the image in the folder. If you can't, you're probably using Windows XP and need to reset the folder view. Choose View | Filmstrip or View | Thumbnails from the folder's menu. Look at the first photo and decide what you want to name it.

3. Click the photo, pause, and, after a second, click the image's name. Don't simply double-click, or the image will open. If you did this step properly, the filename should be ready to edit. Type the name of the file and press the ENTER key.

> **TIP** *If this technique doesn't work for you, right-click the photo and choose Rename from the menu.*

4. Repeat the process with the other images in the folder.

5. When you're done, you can drag images into an appropriate subfolder in the My Pictures folder and delete the empty temporary folder.

If you want a better view of a picture in the folder, you can always just double-click it. You can use the scroll wheel on your mouse to zoom in and out when in the viewer.

Faster Renaming

Ideally, you'll rename all your photos as you transfer them to your PC—that way, it's a bit easier to find them whenever you need a specific image. But let's be honest: sometimes that's just a bit too much work. If you simply want to change the name of your files from totally indecipherable, like P7281775, to something that reflects the overall theme of the batch, like Summer Vacation, then you can do that as well.

Select all the photos in the folder. You can do that by pressing CTRL-A on your keyboard.

> **TIP** *Only want to select a few images? Use the CTRL key on your keyboard to use the Control-Select method to choose only certain images. Or, select all the images, and use the CTRL key to deselect the images you don't want!*

Right-click one of the selected images—it doesn't matter which one—and choose Rename from the menu. Type a new name and press the ENTER key. Your pictures will all be given the new name, with a number in parentheses so you can tell them apart.

If you really get into organizing your photos by filename, the Windows method may start to seem kind of anemic. For beefier file naming, try a favorite program of mine: for just $10, Name Dropper (cognitial.com/namedropper) lets you create a slew of name fragments and assign them to a dozen customizable buttons. To rename photos, combine the fragments into descriptive compound names. Or try Siren (www.snapfiles.com/get/siren.html), a free program that gives you access to the metadata associated with your photos. You can combine snippets of info like your camera model, ISO, exposure data, lens information, and date taken to create truly informative filenames for your photos, automatically.

Preview Pictures with Windows

Windows comes with a built-in photo viewer that makes it easy to preview your images without opening a dedicated photo editing program. Using it couldn't be simpler: just double-click any photo icon, and the viewer starts automatically.

Of course, the viewer you get depends upon which version of Windows you're using. If you have Windows Vista or Windows Live Photo Gallery, you'll see something a lot like Figure 12-4.

If you're using Windows XP, you get the Windows Picture and Fax Viewer instead, as you can see in Figure 12-5.

Zoom in/zoom out Start slideshow Change picture Rotate picture Delete picture

FIGURE 12-4 The Photo Gallery Viewer comes with Windows Vista and Windows Live Photo Gallery.

Change picture —— Start slideshow —— Rotate picture

FIGURE 12-5 The Picture and Fax Viewer comes with Windows XP.

Photo Organizing Software

Let me be very clear: if there's one thing you should take away from this chapter, it's that you should be using some sort of photo organizer and tagging your photos for easier retrieval. Thumbing through folders in the Pictures folder for a specific image is so…primitive.

Organizers are not just places you can look at your photos. From there, you can launch your photo editor, print, burn to disc—pretty much anything you could do in a folder, you can do here. In fact, you can usually drag and drop a photo from a photo organizer into another program (like Photoshop Elements) just like you'd drag and drop from a folder.

Choose a Photo Organizer

So what program is right for you? Here's my 20-second guide to choosing the right organizer for you:

Program	Who It's For
Windows Photo Gallery	Casual photographers that have either Windows Vista or Windows XP with Windows Live Photo Gallery. Photo Gallery is easy to use, yet has surprisingly powerful tagging capabilities—including the ability to make nested, or *hierarchical* tags. And finding your tagged photos is a snap. I think this is all most users will ever need.
Adobe Lightroom	If you take a lot of RAW photos and want a single program that combines a photo organizer with a powerful editing workflow, Lightroom is hard to beat.
Adobe Photoshop Elements or Microsoft Digital Image Suite	Users that already have one of these programs and want to use the integrated organizer. Honestly, the organizers in these programs don't offer a lot of features that you won't already find in Windows Photo Gallery, but some folks like to take full advantage of the programs in a suite. My advice? Even if you're using one of these apps, I'd seriously consider just sticking with Photo Gallery.

CAUTION *No matter what program you use, it's important to note that organizers don't make a second copy of all your photos. The thumbnails in your organizer are just representations of the original photos stored in your Pictures folder. So if you start using Photo Gallery or Photoshop Organizer, for example, don't delete all the images in the Pictures folder, thinking you now store your images somewhere else. You don't. The photos in the organizer are nothing more than shortcuts that point back to your original set of photos. If you delete them, they're gone forever!*

Archive Your Photos

Eventually, your collection of digital images could grow too large for your hard disk. If that's the case, you have a few choices:

- Delete nonessential images from your hard disk.
- Archive the images on another storage device, like a CD or DVD.
- Add another hard disk for additional storage space.

Deleting images is the easiest route, but no one wants to throw away images just because the digital shoebox is filling up. You probably want to save most of your images forever, so you might not want to use deleting as a routine housekeeping option. Instead, consider archiving your

images to another device. If you have a CD-RW or DVD-R/RW drive, you can copy dozens or hundreds of images to a disc (depending on the file size) that will last more or less forever. CDs do degrade over time, but they will last for a hundred years or so—longer than the ink on many kinds of photographs. To be sure your images are protected, you can duplicate your CD or DVD every few years—or, more realistically, transfer the images to whatever technology is popular then, like nuclear bionic laser holographic kneepads. Or whatever.

A *CD-RW drive* is a kind of CD drive that can write to blank discs, while *DVD writers* come in several varieties, the most common of which is DVD-R/RW and DVD-RAM. Most of these drives come with software like Adaptec's Easy CD and DVD Creator (www.adaptec.com), seen in Figure 12-6, or perhaps Nero (www.nero.com). These programs let you simply drag-and-drop image files from the hard disk to the CD, and then "burn" the disk, a process that takes a few minutes to copy all the data to the CD. After it's done, the CD-R is playable in any computer with a CD-ROM drive.

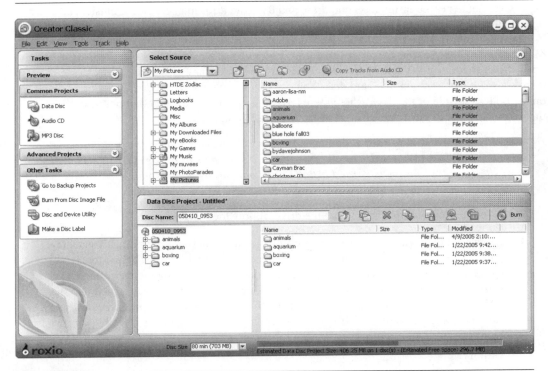

FIGURE 12-6 CD burning software makes it easy to copy blank images to a CD.

In fact, you don't even need any additional software—Windows has CD and DVD burning software built in. If you're using Windows Vista, just open the folder with your photos and select the images you want to copy to CD or DVD. Click the Burn button in the folder's toolbar and follow the directions to create a disc.

If you have Windows XP, the process is similar, though it can only burn CDs. (Windows Vista can make CDs *and* DVDs if you have the appropriate drive connected to your PC.) For Windows XP, open a folder with images and select the images you want to copy to CD. Then click Copy To CD from the Picture Tasks pane on the left side of the folder. After a few moments, you'll see a balloon in the System Tray that says, "You have files waiting to be written to the CD." Place a blank CD in your drive and open My Computer. Right-click the blank CD and choose Write These Files To CD. It's a bit more complicated than using a program like Roxio or Nero; but it's free.

Add Extra Hard Drives

One other option you might consider is adding another hard disk. Hard drives get cheaper and bigger every year, and these days 400GB drives are neither unusual nor are they particularly expensive. Some people install a second drive and dedicate it for images, video, music, and other multimedia files.

To see if your PC is a good candidate for a second hard disk, shut it down and open it up. Many computers have tool-free cases that you can open easily; other PCs require a small screwdriver to remove the side of the case. In either case, once the PC is open, check to see if there's a spare bay to mount the hard disk. You can mount it in one of the drive bays or, perhaps, on the bottom or side of the case, where there are some mounts for exactly that purpose. If there's somewhere to put a hard disk, it's easy to install yourself.

TIP *If you don't want to mess around inside your PC, you can add an external hard disk instead. These days, USB 2 and FireWire (also known as i.Link or IEEE1394) hard disks are fast, inexpensive, and install in just minutes by doing nothing more than plugging in a cable. I highly recommend these sorts of external drives.*

Once you've found somewhere to put the drive, follow these basic steps:

1. Ensure the PC is turned off and you are fully grounded before proceeding. You can purchase a static grounding mat or a strap that attaches to your wrist at any local computer shop. Alternately, you can ground yourself by touching the metal cage surrounding the computer's power supply as long as the computer is plugged into the wall outlet. If you leave the computer plugged in for grounding purposes, be absolutely sure the computer is turned off before you open it and start working.

2. Remove the new hard disk from its packaging and review the instructions that came with it.

3. Configure the hard disk depending on how you're installing it and the sort of PC you have. If your computer is new, it might use *Serial ATA,* which is a faster, smarter, more modern way to connect hard disks. You can only connect one hard drive to each long and thin SATA cable, which dramatically simplifies the installation process. These drives are

a snap to attach. If you have an older PC with a traditional, wide ATA ribbon cable, you usually need to set the hard disk's jumper on CS (cable select).

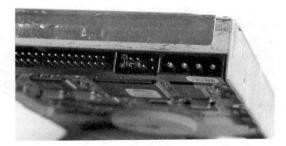

4. Mount the drive in the PC. Connect the power cable and cable to the hard disk.

5. Without closing the case, turn on the computer. When the PC starts to boot, display the BIOS screen (usually by pressing the DELETE or F1 key as your computer starts to boot) and check to see that the computer recognizes the hard disk. If it doesn't, make sure you have set the jumper properly, it's connected to the correct IDE channel, and the power cord is fully inserted in the hard disk.

6. If all is well, shut down the PC and seal the case.

7. Finally, use the software that came with your hard disk to format the drive and prepare it for operation in Windows.

Protect Your Pictures Using Backups

There's one problem with using a hard disk to store your digital photos: eventually, they all fail. No matter how new, fancy, or expensive your hard disk is, a day will inevitably come when it stops spinning. Most people tend to buy a new computer and transfer all their data to its fresh, new hard drive before that happens, but you never know.

If you keep your computer for a very long time—say, more than five years—the odds increase that your hard drive may fail while you're still using it. And when that happens, all your pictures, unless they're also backed up somewhere else, like on another hard disk or on a CD-R disc, will be lost and gone forever. That's why I'm a big advocate of using some sort of regular backup system in your computer.

Use a Backup Program

One easy solution is to get a backup program that can run routinely and automatically at a set time each day or week. I like a program called Casper, which you can download from www .fssdev.com. When you run Casper, you can tell it to automatically run once a week (say, every Friday evening at 9 PM) and back up automatically to a second hard drive on your PC. It's pretty painless.

Install RAID

Once you get past the initial setup, using a RAID drive is even easier.

What, exactly, is RAID? RAID stands for Redundant Array of Inexpensive Disks. It is a combination of two or more hard drives, controlled in such a way that they act as one virtual drive. Long used just by large businesses, RAID systems have traditionally been too expensive and complicated for normal folks like us. That has changed, though, and RAID now offers a way to painlessly and securely back up 100 percent of your data (including digital images) in real time, with absolutely no effort on your part. No more delayed backups, tape rotation schemes, archives of CD-Rs, or forgotten data files. And unlike a backup solution like Casper, the backups happen continuously, so there's no worry of not getting a backup made because the PC wasn't on during a scheduled backup. In many ways, RAID is the perfect backup solution.

There are many flavors of RAID, usually referred to as "RAID implementations" or "RAID levels." Large businesses have about a dozen RAID levels to choose from, each designed for some specific purpose. *RAID 6,* for instance, delivers "independent data disks with two independent distributed parity schemes." If you need that, you'll want to find a good book on RAID—I can't help you. I don't even know what that sentence means.

But more typical users, like you and me, can choose from three handy RAID levels. RAID 0 is called a *striped array,* and it writes alternating blocks of data across two separate hard drives. The result? Two 300GB hard disks will appear as a single 600GB hard disk in Windows, for instance. And because the data is being distributed across multiple channels, data access is much faster than if you had a single, large hard disk drive. The downside, of course, is if either drive fails, 100 percent of your data is irretrievably lost unless you maintain a separate backup solution. RAID 0 is the most dangerous way imaginable to store your data. And that's not our goal.

Instead, you want RAID 1. This *mirror array* treats two identical hard drives as a single drive and writes the same data twice, once to each physical drive. While there's no performance advantage like you get with RAID 0, there's essentially no penalty, either. That's in stark contrast to mirroring data to a second drive using backup software, which uses system resources and slows your PC in a noticeable way. If one drive ever fails with a RAID 1 array, your PC continues functioning as if nothing ever happened, and all your images are preserved. Of course, your PC also warns you if the RAID array isn't running perfectly, so you know it's time to replace the bad drive.

The final option, RAID 0+1, is the most expensive solution. Using an array of four drives, *RAID 0+1* stripes data to one pair of drives, while duplicating everything on the second pair. The result: higher overall performance, while also maintaining a real-time backup. The downside, of course, is you must purchase four identical hard drives.

To install a RAID system on your PC, you'll typically need a RAID controller card and two or perhaps even four *absolutely* identical hard disk drives—they should be the same brand and model number. Installing it isn't difficult, but if you aren't handy inside a PC, you might want to take it in to a shop for the surgery.

NOTE *If your RAID 1 hard disk is ever infected by a nasty virus or gets corrupted, both drives will be equally affected, so it isn't a bad idea to conduct periodic backups of your hard disk in addition to using RAID. What RAID does is ensure you'll never get stung by a physical failure of your hard disk—and that's very reassuring, to say the least.*

Part III

Editing Images

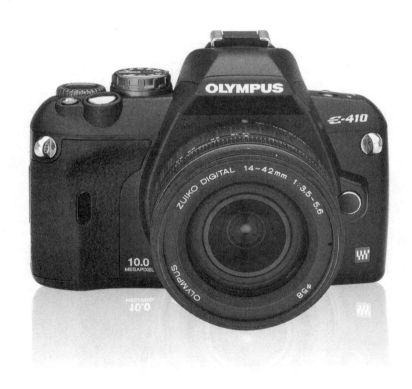

Chapter 13

Quick Changes for Your Images

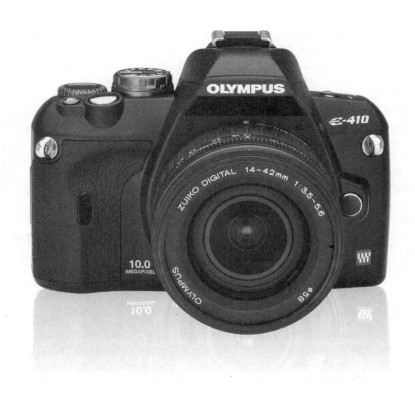

How to...

- Determine the computer requirements to edit photos
- Choose a photo editing program
- Open and edit images
- Change the resolution of digital photos for e-mail, web, and other applications
- Save an image in a different file format
- Crop photos to improve composition
- Fix the color and exposure in a photo
- Rotate images taken with the camera on its side
- Fix a crooked image

One of the most exciting advantages of using a digital camera is the power and control it gives you over tweaking and improving your images. Don't like your composition? Change it. You can crop your pictures just a little to subtly improve their appearance or radically change the look of a picture by turning its orientation from landscape to portrait. You can fix a crooked horizon, tweak the colors or brightness of an image, improve a bad exposure—it's all up to you.

These are things that, until recently, you needed a darkroom and a whole lot of practice to do right, and every attempt would cost you money in photo paper and chemicals, or in trips to the photo shop, where you'd have to explain what you wanted to someone else, who might or might not quite get what you were looking for. These days, you can experiment endlessly. It never costs you a penny until you're ready to print the final result because it's all done with pixels on a computer screen. As long as you're careful not to save over the original file, you also never have to damage or change the original image.

In this chapter, we'll learn how to do the simplest and most common kinds of photo editing. This is the place to turn to for day-to-day corrections—simple things you can do to your images without learning a whole lot about the art and science of image editing. For more sophisticated things you can do to edit your images, check out Chapters 14, 15, and 16, which get into the topic a little deeper.

How Much PC You Need

You're probably expecting me to tell you that you should have the fastest PC you can afford—a 10GHz Quad Core with a terabyte of memory sounds just about right. Aside from the fact that you can't buy a computer like that quite yet, you really don't need that much speed. To be perfectly honest, you *should* work with the fastest PC you can afford. Photo editing, especially with high-megapixel images, is a horsepower-intensive task. The more computer you have pushing pixels around, the more fun you'll have. A slow PC might frustrate you because editing operations will be sluggish, and it'll even take a while to redraw the screen. But you can make so with a lot less than the state of the art.

Here's what I think you should have, as a minimum, to do photo editing without getting an ulcer:

- **Dual core processor** Keep in mind that I used to do photo editing on a computer with a 200MHz Pentium processor back in 1997, so you can get the job done with almost any computer. But you won't enjoy it. A much better configuration: get a computer with a dual core processor, even a slow one. Dual core technology (whether you get an Intel or AMD processor, running at any speed) is dramatically and noticeably faster than older Pentium-style processors.

- **1GB of RAM** Here's where spending a little extra can really pay off. If you upgrade from 1GB to 2GB of RAM (which costs about $100, and you can install it yourself or get it preinstalled with a new PC), image editing will seem much faster, even on a slower processor. That's because high-megapixel images occupy lots of room in memory and, if they can't fit there, Windows stores parts of them on the hard disk. That can make something as simple as a screen redraw drag on forever. In general, the more memory, the better: if you have several large images open at once, your system won't slow down as it would with less memory. Upgrade if your wallet can handle it. One big caveat: 32-bit versions of Windows (the most common edition sold today) can only address about 3GB of memory, so there's no reason to get a PC with 4GB of RAM unless you have a 64-bit processor and the 64-bit edition of Windows (and 64-bit versions of Windows are not especially common, so I doubt you'll run across it too often). If in doubt, ask a salesperson.

- **500GB hard drive** Hard drives are really cheap now, so you should make sure that you have lots of room to store your images. Just like with memory, bigger is better. Most PCs come with a single hard drive, but you'll get better performance if you dedicate a second drive just to storing your photos. Many professional photographers use a smaller drive as the main Windows drive (the C:\ drive) and get a huge D:\ drive for storing photos and other data. Windows is faster and more efficient when you store your data on a separate drive, and if your C:\ drive ever fails, all your photos are located in a separate drive that you can just plug into another computer and keep on using. That's not your only option, though. Some people get a pair of matching 500GB hard drives, so they can automatically back up one drive onto the other.

- **17-inch monitor** You need a way to see your photos, and these days flat-panel (also called LCD) monitors are all the rage. Whether you get an LCD or an old-style CRT monitor, be sure it's at least 17 inches (measured diagonally to the corners). And, as you've heard me say before, bigger is always better. A 19-inch, 21-inch, or even a 24-inch display supports better resolution, which leads to sharper images onscreen and the ability to see more workspace on the screen as well. If you choose an LCD display, be sure the monitor does a good job rendering photos—some displays don't have as much dynamic range as CRT monitors, and that means those monitors can't accurately display photos. In addition, widescreen monitors, which have 16:9 or 16:10 aspect ratios, are quite popular these days. Be sure to set the right display resolution. Because the screen is wider than a normal monitor, you can't use a "typical" resolution like 1024×768 or 1280×1024. Those resolution settings, which have a 4:3 aspect ratio, will make your photos look stretched and "fat." For best results, check the user guide for the widescreen monitor's native resolution.

Choose a Photo Editor

Before you can get started editing your images, you need some sort of photo editing program. Almost any one will do, at least to begin with, when you're learning the basics. Later, you might get more comfortable with the art of photo editing and decide you'd rather have a different program. But for the most part, all photo editors give you the capability to do certain things, such as:

- Resize and crop your images
- Correct the exposure and colors in a photo
- Selectively "erase" parts of a photo
- Remove red eye from photos that were taken with a flash indoors

In addition, most photo editors also give you these additional abilities:

- Select specific regions of a picture and apply changes to just those instead of the entire image
- Apply "paint" to your image using a set of brushes and other paint tools
- Add text and other graphics
- Combine multiple images into a new composition

That's certainly a quick overview of photo editing, but the point is that there are a lot of programs around that can get the job done. Which one is for you? Well, you might want to start with a free one. If your digital camera came with a photo editor of some sort, you might want to give it a spin and see if you like the way it works.

You might find, though, that your photo editing program relies on automatic tools like one-click fixes and wizards that change your image for you without giving you a lot of control over what happens. These tools can adjust the colors and brightness in an image, remove red eye from flash photography, and perform a host of other minor miracles without any real input from you. The downside, of course, is this: the final result isn't always what you expect and, often, such automated attempts to fix your photos don't quite hit the spot. Use them with care, and always remember that you can use the Undo button to revert to the original image. Automatic features are generally aimed at novices who don't want to learn the ins and outs of an image editing program but want immediate results.

If you're reading this book, I suspect you're probably more interested in getting your hands dirty, so to speak, with a more manually operated set of editing tools. These features give you more control and power but, of course, you have to master more concepts and the mechanics of the program before you can see improvements in your images. Perhaps the most famous photo editor of all time is Adobe Photoshop, seen in Figure 13-1. Photoshop's downside is that the program has a somewhat steep learning curve. A somewhat less intimidating alternative is Photoshop Elements. I like the way Adobe has combined the best parts of Photoshop with a simpler interface that's designed for ordinary folks, not graphics professionals. Elements is a good program that combines both automatic and manual tools for the enthusiastic photo editor.

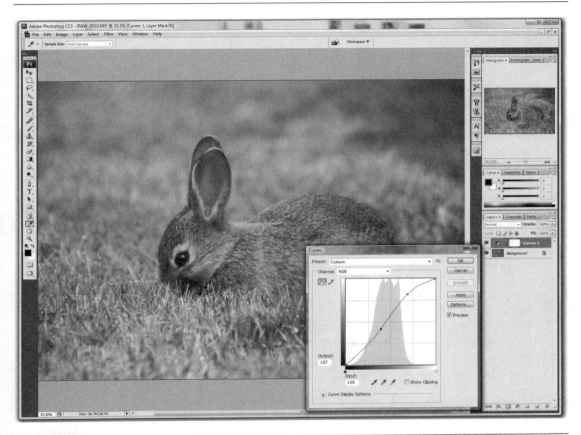

FIGURE 13-1 Photoshop is an outstanding program, but all of its features can be intimidating.

And there are other choices as well. Here's a quick look at the best of the other options:

- **Adobe Photoshop Lightroom** While Adobe considers this program a companion to Photoshop, the fact remains that it works great on its own *or* in concert with Photoshop or most any other photo editing program. The program is focused expressly on the sorts of traditional exposure and color adjustments a photographer would want to make to a digital photo. As a result, Lightroom is pretty easy to use and features a logical workflow. You won't find paint tools, text entry, projects design, or even layers. This makes this program feel lighter and easier to use than other photo editors, which are bogged down with all sorts of graphic design tools that photographers rarely need. Depending on your needs, Lightroom could easily be the only photo editor you ever use, or it could be a supplement to Photoshop, Photoshop Elements, or some other program.

- **Corel Paint Shop Pro** This program has about 75 percent of the features found in Photoshop, but at a fraction of the cost and with a much simpler interface. It's very similar to Photoshop Elements in terms of overall capabilities. The newest version includes a feature that lets you create high dynamic range photos (see Chapter 15).

- **Microsoft Digital Image Suite** Microsoft's image-editing program has a surprising amount of power, but it has a very simple interface and is really aimed at beginning photographers. The program has one notable deficiency: it lacks the ability to create true layers (though it uses its own version of layers), so you can't use the program to do a lot of the cool stuff I discuss in Chapters 13–16. In addition, Microsoft is no longer developing new versions of this program, but some folks swear by the latest (Digital Image Suite 2006 Anniversary Edition), so I've included it here anyway. This program is going to be hard to find in a year, though.

- **Ulead PhotoImpact** Ulead's photo editing program never seems to get the same amount of attention as the other programs I mention here, but it has pretty much all the same key features. Even better, it has some superb extras, like the ability to do high dynamic range photography. Personally, I find the interface less elegant, though, and most people would probably find the alternatives easier to use.

> NOTE
>
> *Throughout the rest of this book, I've used Adobe Photoshop Elements to illustrate how to perform many common editing tasks. You can perform the techniques I discuss using a different program, but the menu items and tool locations will somewhat be different. In most cases, it isn't too hard to adapt my instructions to whatever program you're using.*

Tweak the Picture's Format

Sometimes, the only thing you want to do to a photo is to resize it for e-mail, the Web, or to import it into some other documents or applications. Or perhaps you want to save a photo in a different file format—like turn a JPG into a TIF or a RAW into a JPG. In the next few sections, I'll show you how to make changes to the file itself, like resizing and changing the file format of your digital images.

Shrink Your Images

As Jebediah Springfield, founder of the animated city in *The Simpsons,* once said, "A noble spirit enbiggens the smallest man." If *The Simpsons* founder can make up a word, so can I—so this section is all about de-biggening your pictures.

Why would you want to do that? Well, high-res megapixel images are great, but they're just too big for many applications. Suppose you want to post some images to a web site, for instance. Or, say you want to e-mail some pics to friends and family. A 6-megapixel image, which measures about

How to ... **Open a Photo in an Editing Program**

Let's take a quick look at how to get your photos into your photo editing program so you can start to make some tweaks. Start your photo editor by choosing it from the Windows Start menu. After that, you can open an image in any one of four different ways. Use whichever method you find easiest.

■ **Use the Open File dialog box** Choose File | Open from the main menu and navigate your way to the image you want to open in the Open dialog box. Double-click the file, or select it and click the Open button.

■ **Use an organizer** If you are using Adobe Photoshop Elements, for example, you might know the program comes with its own organizer, called Photoshop Elements Organizer. Open the Organizer (you can click the Organizer button in Photoshop Elements), find the photo you want, and then click Editor | Full Edit.

■ **Use Windows Photo Gallery** If you use Windows Vista or have installed Windows Live Photo Gallery, I think Photo Gallery is an awesome way to organize your photos and, you might remember from Chapter 12, I recommend this approach. Here's what to do: Start Windows Photo Gallery. Click the photo thumbnail you want to edit and drag it to the photo editing window. If you can't see the program window because Photo Gallery is in the way, you can do this instead: drag the image out of Photo Gallery and hold it over the photo editing program's button in the task bar at the bottom of the Windows desktop. Don't let go of the file yet; just hold it there for a few moments. Your program will pop to the front. Finally, just move the file up to the program window and let go.

- **Use the Pictures folder** Open the folder that contains the photo on the Windows
 desktop, and then drag the image file from the folder to the program window. If you
 can't see the program because the Pictures folder is in the way, do this instead: drag
 the image out of the folder and hold it over the photo editing program's button in the
 task bar at the bottom of the Windows desktop. After a moment, your program will
 pop to the front. Finally, just move the file up to the program window and let go.

3000×2000 pixels, is too big for these kinds of applications. If you e-mail a 3.3-megapixel image to
your friends, you'll lose friends fast (unless they specifically asked for the photos in their original,
full size, that is). Files that big tend to clog e-mail pipelines and can take quite a while to download.

What you need is to de-biggen your images. In other words, shrink them to a manageable
size that others can appreciate.

NOTE *A few digital cameras have the capability to resize images even before they're transferred
to the PC. You should check your camera manual to see if there's a way to automatically
make a duplicate, e-mail-friendly copy of images you want to share. That way, you can
skip this de-biggening step when you want to e-mail or upload your pictures.*

How small is small enough? I suggest that for web-based or e-mail images, you shrink the file so its longest dimension—either length or width, depending on the orientation of the image—is no more than about 800 pixels. Here's how to do it:

1. Start Adobe Photoshop Elements and open the file you want to resize.

2. Choose Image | Resize | Image Size.

3. Make sure Constrain Proportions is checked. This will maintain the aspect ratio of the photo, so it doesn't end up squished or stretched. Also, make sure that Resample Image is checked and it's set to Bicubic (this is the ideal choice for maintaining image quality while you resize a photo).

4. Because you want to make the image a specific pixel size, make sure Pixels is selected on the right side of the dialog box. You could also change the photo based on a percentage of the original size, but you don't need that option right now.

5. Finally, enter the new dimensions for your photo. You only need to enter the height or the width and, because the aspect ratio isn't changing, Photoshop Elements will fill in the other number for you automatically. Click OK to resize the image.

6. You should see the image shrink on the screen. If you click Save now, you'll save your image over the original—destroying the original. Instead, I suggest that you save it as a new file so you retain the original's larger pixel size. Choose File | Save As and give the image a new name.

You might have noticed that you can also make images bigger using this procedure. It's usually a bad idea to increase the size of your images, though, because all you can do is stretch and multiply the pixels already in the images. The result is generally unattractive, especially if you enlarge the image too much.

Save Photos in Different File Formats

Something I commonly do is change the file format of some of my pictures—usually from JPG to TIF, or perhaps PSD (which is Photoshop's file format). Why would I do that? Usually, to preserve image quality. Every time you edit and then resave an image in JPG format, for example, it loses a little quality (depending upon how much compression is used in the resaving). TIF is immune from that kind of compression punishment, though, so if I need to edit a photo that was originally shot in JPG format, I typically save it in the TIF format before I start editing to (as they say in the zip-lock bag industry) *lock in* the image quality.

Another reason to change formats: these days, I usually take most of my photos in my camera's RAW format and then save the final, edited version as a JPG, so I can share it with friends, family, editors, or anyone else who needs a copy.

Just looking at a JPG file doesn't affect the image quality. You can open the file in an image editor, view it, and close it again without affecting quality—just don't make any changes and click the Save button. If you don't plan to edit an image, you can safely leave it in JPG format.

You might want to change image file formats on the PC for a number of reasons. Here are some of the most common reasons:

■ Convert a JPG to TIF to preserve image quality before repeated edit-and-save sessions.

■ Convert TIF or RAW to JPG to save disk space, to share the file with someone.

■ Convert an image in an unusual format to something more common so you can open it in a program or upload it to the Web.

■ Save an image with features unique to the image editor you're using, such as with masks or layers intact. Every photo editing program has its own native format that "remembers" stuff like layers. Saving your photos as PSD files in Photoshop, for example, can make it easier to finish editing later.

For a more in-depth discussion of file formats, check out Chapter 10. Saving a photo in a different file format is easy. Just follow these steps:

1. Open the photo in Adobe Photoshop Elements.

2. Choose File | Save As from the main menu.

3. In the Format drop-down menu, choose the file format you need.

4. Click OK to save the file.

5. Some formats have extra options you need to configure before the save is actually completed. For a JPG file, for example, you need to specify how much compression to use—the more compression, the smaller the file will be, but the lower the visual quality. My advice: always use the maximum quality (which, in Photoshop Elements, is 12).

After saving the file, you'll have two copies—the original file, such as myfile.jpg, for instance, and one called myfile.tif. You can keep both copies, or delete the older one, depending upon your needs. Of course, when you look at two files with the same name but different file extensions on the Windows desktop, telling them apart can be hard. If in doubt, right-click the file and choose Properties from the menu. Verify the file extension before you possibly delete the wrong file.

TIP *If you want to see file extensions all the time to more easily distinguish between photos that have the same name but different file formats, you can make file extensions visible in Windows. To do that, open a folder and click Organize | Search and Folder Options (or, on Windows XP, choose Tools | Folder Options). Click the View tab and then uncheck Hide Extensions For Known File Types.*

Fix Your Photos with a Simple Workflow

Don't get me wrong: there's nothing wrong with just taking pictures with a digital camera, and then sharing, printing, or storing the results with no intermediate editing. I do that quite often myself, when I don't feel the need to fix the exposure, crop, or otherwise mess with anything. But if you want to get the best possible results from your photos, then you should think about following some sort of *digital workflow*—simply put, what you should do with your photos, and in what order, to improve your pictures.

The concept of a digital workflow is really just a modern update on the old workflow used by the film photographers who developed their own pictures. In the digital universe, it's a good idea to do certain things in a certain order, or else your edits won't necessarily have the desired effect, or one set of edits will adversely affect something you've already done. In the next few pages, I'll outline the workflow I recommend (illustrated graphically in Figure 13-2). Try using it on your own images. Don't want to mess with every stop on the workflow train? Then skip the ones you don't care about, but try to do the ones you want in order.

Crop Exposure Color Save As

FIGURE 13-2 A good workflow for your photos: crop, fix the exposure, adjust the colors, and then use Save As to create a new version of the photo.

Recompose Your Photo with Cropping

Even if you do nothing else to your photo, you'll frequently want to do a bit of cropping. Unless you framed your picture perfectly in the viewfinder, you can probably improve it a bit using the crop tool in your photo editing program. And this is a great time to crop the image. If you later want to correct the exposure or fix the colors, cropping first lets you discard pixels that aren't in the part of the picture you really care about. That can make exposure corrections more accurate.

Here's how to crop your photo:

1. Click the Crop tool, shaped like the thick frame.

2. In the tool palette, choose an aspect ratio from the menu. You might want to use a standard print proportion, such as 8×10 or 5×7. If you don't care about printing the photo, then feel free to choose No Restriction.

3. Click in the image, and, holding down the mouse button, drag the crop tool until you've drawn a rectangular outline around the part of the image you want to keep. If you are cropping to an arbitrary aspect ratio, there will be no restrictions on the height or width of the crop. If you are cropping to a specific print proportion, on the other hand, the proportions of the crop box will be constrained by the print aspect ratio you selected.

4. To move the crop box around within the image, move the mouse inside the box, and then click-and-drag the box around the image.

5. To change the size of the crop box, hold the pointer over any edge of the box, and then click-and-drag to change the height or width of the box. Watch out for the corners, where you have the opportunity to rotate the crop box, rather than resize it.

6. If you want to change the aspect ratio of the crop from portrait to landscape (or vice-versa), click the Swap button in the tool palette. You should see the crop box change.

7. When your crop box represents the picture as you want it composed, click the check mark button in bottom right corner of the crop box. The image will be immediately cropped down to your new composition, which you can save as a new file or save to replace the older image. Compare the original and cropped versions of the same photo in Figure 13-3.

FIGURE 13-3 The original photo (left) and its cropped version (right)

If you decide not to crop the photo, click the Cancel button in the lower right corner of the crop box, or just click a different tool in the toolbar, and then click Don't Crop when Photoshop Elements asks if you want to crop the photo.

Fix the Exposure

Everyone has a stockpile of too-dark images. The flash didn't reach the subject or, perhaps, the camera underexposed the subject because of a bright background. Back in the first part of the book, I told you how to avoid those kinds of problems in the lens when you take the picture, but you can also repair some of the damage in post-processing.

Now that you've discarded the pixels you don't care about, it's easier for your photo editing program to help you improve the exposure. The most precise and powerful way of correcting the exposure in a photo is by using your photo editor's histogram control.

Understand the Histogram

Once you understand the point of a histogram, you'll find it's really easy to use. Don't worry: histograms might look intimidating (they seem to remind people of high school math class), but they actually aren't that complicated. A histogram is a graph that shows the relative amount of information stored in each color channel in your image—in other words, it displays how many pixels are dark and light in your image. The left side of the graph represents the darkest part (shadow) of the image, while the right side is the lightest (highlights). The central area of the histogram represents midtones.

Here's the most important thing to know about a histogram: you want the information distributed through the middle of the graph, not bunched up at the extreme edges. If there's a spike of pixels at the extreme left or right, it indicates the photo is underexposed (on the left) or overexposed (on the right). You can't fix a truly under- or overexposed photo, because those pixels recorded pure black or pure white when the photo was taken. Fiddling with the histogram can't extract any additional detail or color information from those pixels. All you can do is turn those pixels with varying shades of gray.

On the other hand, keep in mind that, as long you don't see deadly spikes of under- or overexposure in a photo, you can't necessarily characterize an image as "good" or "bad" (or well exposed or badly exposed) just by observing how the pixels are distributed across a histogram. If a photo has a big "hump" toward the dark end of the graph, that doesn't mean it's underexposed, for example. The picture might have a dark subject, and you might very well like it that way.

Let's take a look at some real histograms so you can see what I'm talking about. A graph like the one on the left in Figure 13-4 has good overall exposure with no clipping in the shadows or the highlights, while the overly exposed photo on the right is "blown out," and that manifests itself in the histogram by the spike on the right side of the graph. You can use that kind of information to tweak the brightness and contrast.

Now consider a photo like the one in Figure 13-5. Here, you can see that the camera's exposure setting didn't take full advantage of the available exposure range, and so we ended up with a picture that lacks contrast. See how the distribution of pixels in the histogram doesn't go all the way to the edges? This is something we can fix.

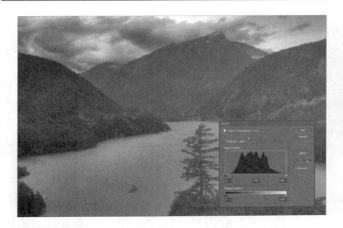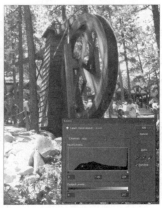

FIGURE 13-4 The picture on the left is well exposed, though the one on the right overexposed; information has been "clipped" from the highlights.

FIGURE 13-5 This photo's exposure settings didn't take advantage of the full tonal range available, and you can tell this because the graph doesn't reach both ends of the histogram display.

Adjust the Histogram with Levels

Most good photo editing programs have a handy tool for adjusting the light levels in your image using the histogram and a few sliders. No matter which program you use, this tool works more or less the same way. To use the tool, simply move the sliders under the histogram to set the white and black points, which stretches the distribution of brightness information in the image.

Suppose you have an image like the one in Figure 13-5. Here's how you would correct the image using Levels in Adobe Photoshop Elements:

1. Choose Enhance | Adjust Lighting | Levels to open the Levels dialog box.

2. Because the histogram curve drops off before reaching the right side of the graph, that tells us there are few pixels with very bright colors. Consequently, you should drag the white point slider to the left to meet the point where the graph ends. That sets this point in the image as white, and you should see the image brighten as you drag the white point slider.

3. Do the same for the black point, if necessary.

4. Now use the gamma slider, if needed, to adjust the overall brightness level in the image's midtones.

Note that you need to eyeball the photo as you adjust the sliders—the histogram in the Level control might show you how far you can stretch out the histogram before you start destroying information, but you might not want to take full advantage of that tonal range in any particular picture. You might only drag the white point slider a small distance and decide the photo looks good. It's up to you.

Correct the Colors

You've perfected your photo's composition and adjusted its overall exposure. Now the image is in good enough shape that you can judge what the colors actually look like. At this point, you can probably tell if there is some sort of color cast making the whole image look somewhat blue or reddish.

If the colors don't look "true," then the photo's white balance might be a little askew. You might recall from Chapter 5 that white balance is what adjusts the colors in your photo in response to the fact that different kinds of light have different color temperatures and therefore make colors look different, depending upon when and where they were photographed. Your camera tries to set the white balance each time you take a picture, and often (usually, in fact) it gets the balance at least a little wrong. That's okay; we can adjust the white balance afterwards on the PC.

To adjust your photo's white balance, do this:

1. Click the Quick Fix tab.

2. In the Color section of the Fixes palette, drag the Temperature slider slowly to the left or right until the colors in the photo look right—keep an eye on the whites, especially, to make sure they are really white and free of any unwanted color cast.

You have some other ways to correct the white balance as well in Photoshop Elements. Try any of these to see if they are easier for you to use:

- **Set the white point** Click Enhance | Adjust Color | Remove Color Cast and click any white or neutral (gray) color in the photo. Photoshop Elements will adjust the color balance in the photo, removing the color cast.

- **Set flesh tones** You might not have an obvious white point in your photo, but if there is a person in the shot, set the color balance by adjusting for skin tone. Choose Enhance | Adjust Color | Adjust for Skin Tone and click a point in someone's face. (I've found that this technique works pretty well regardless of the lightness or darkness of the skin tone in the photo.)

- **Do it yourself using Variations** If all else fails, choose Enhance | Adjust Color | Color Variations and selectively add or remove red, green, and blue to the photo until you're happy with the result. Truth be told, I'm not a big fan of this approach: I find it very hard to use.

Add Some Snap to Your Colors

There are a few ways to add life to washed-out, flat, or bland pictures. By tweaking the Levels control to stretch out the histogram, you've probably already made your photo a lot punchier. But what if the colors in your photo are still too bland? Then you might want to try increasing the saturation.

Saturation increases or decreases the intensity of colors in an image, much like the saturation control on your television. Too much saturation can make the picture look like it was taken on Mars, but using it in moderation can add life to an otherwise bland picture. After all, film photographers might remember that certain films—especially Fujifilm's beloved Velvia—were known for capturing more saturated colors, which made them favorite choices for nature photography. There's no reason not to bring a little of that magic to your digital photos.

 Do you have a people picture that's a little too red? This doesn't happen often, but it can occur when you take indoor pictures in artificial light. Back off on the saturation slightly to get a more natural skin tone.

In Photoshop Elements, the Saturation control is found in Enhance | Adjust Color | Hue/Saturation. Experiment with the Saturation tool—it's fun. You can bleach all the color from your picture (making an ad hoc black and white photo) by reducing the saturation to zero, for instance, or hyperactivate the colors by going in the other direction.

Save Your Improved Photo

When you're ready to save your edited photo, I suggest that you follow the digital photographer's version of Hippocrates Oath: Do no harm. By that I mean two things:

- **Don't "save over" the original.** You never know when you might want to return to the unedited version and try a different approach.

- **Save the edited photo in a format that preserves quality.** That might mean saving the photo as a highest-quality, lowest compression JPG, a TIF, or a format that's native to your photo editing program (like PSD for Photoshop Elements). It's up to you. For most people, saving it as a high quality JPG is probably fine. If you plan to use layers to do fancy editing (see the next chapters for details), you might prefer to use a native format like PSD.

Enhance Your Photo's Perspective

Beyond those essential fixes, there are other things you might want to do to your pictures to make them presentable.

How to ... **Fix Photos in Windows Vista**

If you have Windows Vista, you can perform a simple workflow—crop, fix exposure, fix colors, and even remove red eye—for free by just using Windows Photo Gallery. To do that, start Photo Gallery, choose a picture, and click Fix. Next, in the Fix pane, click Crop and recompose your photo. After that, you can click Auto Fix to automatically adjust the exposure and color in the image, or tweak those levels manually.

When you're done, Photo Gallery saves your changes automatically. I know that sounds bad, especially since I have repeatedly told you not to do that in this book. But Photo Gallery actually saves an original version of the photo, which you can get to any time (even long after you make the changes). To get back to the original version of a photo, select the image in Photo Gallery, open the Fix pane, and then click Undo at the bottom of the screen. Choose the option called Revert to Original, and your original photo will be restored.

Rotate the View

Not all your shots are going to be plain old, horizontal shots, especially if you took my advice in Chapter 3 and went nuts with camera position and perspective. If you have images from your camera that are sideways—you took the pictures sideways, so you have to turn your head to look at them on the PC—you should fix those images right away. It's a snap.

Most photo editors have one-click buttons for rotating your images to the left or right by 90 degrees. Indeed, you don't even need to open a photo editor—you can do it right from Windows itself. Here's what you need to do to fix a sideways (landscape-oriented) image using Windows Vista:

1. Find the sideways image in Windows Photo Gallery and decide which way it needs to be rotated, right (clockwise) or left (counterclockwise).

2. Click the Rotate Clockwise or Rotate Counterclockwise button in the controls at the bottom of the screen (to the right of the slideshow controls). The image immediately spins accordingly:

One-Step Photo Enhancement

Most editing programs give you easy, one-step tools for improving your images. Generally, I prefer to tweak my photos myself, since that way I can control how much exposure and color correction to provide (and I generally err on the conservative side). Sometimes, though, I'll try the quick-fix approach to see if it helps the image. If it does, great! I can save the image and get on with my day. If I don't like the results, the Undo button is just one click away.

What am I talking about? Check out Photoshop Elements, and you'll find the Enhance menu is chock-full of "auto" fixes. Auto Smart Fix, for example, tries to correct the exposure and color in a single click. Generally, it does a pretty good job, but if you try it on a photo with unusual lighting conditions, it might make the image worse. The Enhance menu also has auto fixes for contrast, color correction, and more. You can run these one at a time by choosing them from the menu under Enhance Photo, and undo them if you don't like the result. Either way, they let you quickly optimize a picture with little to no effort on your own part.

TIP *Most of the time, these kinds of rotations don't affect the image quality of the photo, so there's no need to worry about losing JPG image quality. If you have a photo that will lose quality as a result of the rotation, Windows will warn you first and give you a chance not to turn the image.*

You can also do this sort of thing in a photo editor. In Photoshop Elements, for example, just choose Image | Rotate | Left 90 Degrees or Image | Rotate | Right 90 Degrees.

Fix a Crooked Horizon

Nothing is quite as annoying as a crooked picture, especially when the horizon or some other straight line is visible in the image. A crooked shot can ruin an otherwise great picture. Even if the horizon is only off a little, it can be distracting, but you can use the principle you learned in the last section on rotating sideways images to fix this annoyance. Here's what you need to do:

1. Open the crooked image in Photoshop Elements.

2. Click the Straighten tool.

3. Find a line in the photo that should be horizontal, such as the horizon. Click the line, hold down the mouse button, and then drag the line across the screen. Release the mouse on the line.

4. Inspect the result. If you aren't satisfied, choose Edit | Undo and try again with a different angle of rotation. When you're happy, save the file.

Don't apply rotation on top of rotation, or the image quality will suffer. Undo the first rotation to get back where you started, and then apply a different rotation angle to get where you're going all at once. Any rotation effect will degrade the image slightly, but compounding rotation on top of rotation can wreck the image fairly quickly.

When you're done rotating your image, be sure to crop it down a bit because the rotation probably introduced some unwanted background color in the corners of your picture.

Chapter 14

Clean Up Your Images

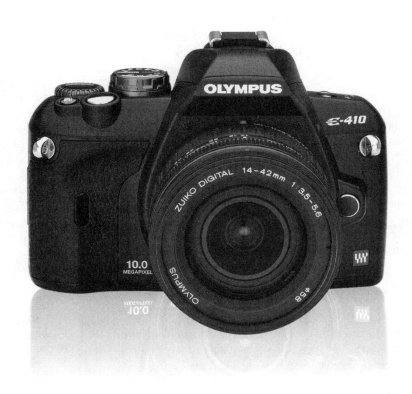

How to...

- Sharpen blurry images
- Blur the background to enhance apparent sharpness
- Use the painting tools in your image editor
- Choose foreground and background colors
- Make selections based on color, region, and by hand
- Remove ugly red eye from flash photos
- Eliminate distracting objects with airbrushing
- Repair tears and scratches on photos
- Create a panorama from a series of photos
- Use Adjustment Layers to improve your pictures
- Fix crooked buildings
- Replace the sky in your photos

In the previous chapter, we looked at easy and fast techniques you can use to gussy up your images—stuff like how to rotate or resize your images, correct bad colors, and even save them in different file formats.

But you can do much more. In this chapter, we'll go one step beyond and learn how to fix your images with techniques that actually change reality. You'll see how to remove red eye caused by flash photography, for instance, how to sharpen (or blur) a picture, and how to airbrush away distracting elements from a scene and move elements around within a picture.

This chapter is filled with techniques that sit between what I would call elementary quick changes and special effects. We're not adding Elvis to your holiday pictures, but we're certainly going beyond color correction. When you learn the techniques in Chapters 13 and 14, you'll be equipped to improve virtually any picture in your photo library. Strap in and have fun with your photos and your favorite photo editing program!

Repair the Evil Eye

Back in Chapter 5, I talked about how to avoid getting red eye into your pictures. Red eye, of course, is the phenomenon that occurs when the camera flash reflects off your subject's retina, because the pupils are wide open (usually in a dark room or outdoors at night). If you have a photo with red eye, you can correct it on the PC fairly easily.

Almost all photo editing programs have some sort of red-eye removal feature, though some work better—or have more finesse—than others. Corel Paint Shop Pro, for example, has an outstanding red-eye removal tool that lets you customize the color of the subject's eye and even lets you remove "red" eye from animals.

The red-eye removal tool in Photoshop Elements is much simpler. Here is how to use it:

1. Open a photo that includes someone with a case of evil eye.

2. Zoom in and pan around the image until you have a good view of the red eyes.

3. In the toolbar, click Red Eye Removal Tool.

4. Click in the red part of an eye. After a moment, you should see the eye turn dark.

5. Repeat the process for the other eye.

Airbrush Away Distractions

Have you ever taken a great landscape shot only to realize—far too late to reshoot the picture— that a telephone pole is in the middle of what should be serenity? Or a tourist in a loud shirt is right behind your family in a scene that you wanted to frame? Don't worry—in this section, I will show you how to eliminate those kinds of distractions with a little digital airbrushing.

The tool at the heart of this magical process is the Clone Stamp tool. This handy feature, found in most photo editors, lets you copy pixels from one region of your image to another. That means you can "airbrush" away distracting aspects of a picture—like power lines, unwanted people, credit card numbers, and so on—by duplicating a similar or nearby part of the image (see Figure 14-1). Typically, smaller and more isolated distractions are easier to airbrush away than larger ones (or objects that cut a swath through the main part of your picture); but if you're patient, you can get great results from a surprising number of photos that otherwise would be unremarkable or bound for the recycle bin.

To use the Clone Stamp in Photoshop Elements, do this:

1. Click the Clone Stamp tool in the tool palette. It looks like a rubber stamp.

2. You'll need to find a region in your image that's similar to the area you want to cover. If you want to airbrush away a power line that runs through the air, for instance, you can look for a nearby patch of sky that's similar enough so you can paint over the power line with this other section of sky.

3. Set the source for your cloning operation. To do that, position the mouse pointer over the area you're going to steal color from and then ALT-click.

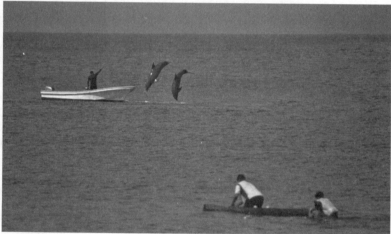

FIGURE 14-1 Paint away distractions with the Clone Stamp tool.

4. Move your mouse over to the area you want to airbrush and start painting. Don't try to cover the blemish all at once; paint a little, pick up the mouse, and paint again. This reduces the chances that a recognizable pattern will appear as a result of your painting. You can see the partially erased boat from Figure 14-1 here:

The Clone Stamp tool works best in small areas because you can start to tell something is wrong with the area you're cloning to if you paint over too large a region.

Keep in mind that the Clone Stamp tool has two different modes, each controlled by the Aligned check box in the toolbar. In one mode, when you pick up the brush and paint elsewhere, the source stays where you put it: this is called *Nonaligned* mode. If you pick up the brush and start painting elsewhere, and the source moves the same relative distance from where you first started, this is the *Aligned* mode.

You can see what I mean if you try cloning someone's face and then painting it somewhere else in the photo. If you clone it using Aligned mode, you can paint the entire face without any glitches even if you paint a few strokes, lift and move the mouse, then click and paint again. Try that in Nonaligned mode, though, and you'll restart the face from the clone source point wherever you click, making it impossible to paint a face unless you do it in a single set of strokes without lifting your finger off the mouse button.

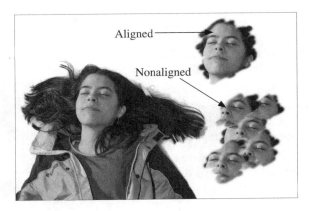

Some pictures work better with one mode or the other. Experiment to see which is best in each situation.

You can also customize your airbrushing by changing the size of your brush and the opacity of what you're painting. Generally, an opacity of about 80 percent is a good place to start, but the brush size depends entirely on the size of the photo and texture you're trying to cover—experimentation is essential.

Use Layers for Fine Control

So far, everything we've done to a photo, whether it's adjusting exposure and color in Chapter 13 or removing red eye and cloning parts of the image in this chapter, has been directly applied to the main image. You can always work in that mode if you want to, but many people prefer work using something called *layers*.

What are layers? Well, imagine that you want to edit a picture, so you make a duplicate copy of it and load that into a layer on top of the original image. Then you make your changes to that photo, such as adjusting colors, fixing the exposure, and perhaps adding a little sharpening. The original (unedited) picture is underneath, but you can't see it because the new layer is on top of it. So, to finish the picture off, you might reduce the opacity of the top layer a bit, which tends to blend the two pictures together. By controlling the level of opacity, you can tweak the intensity of the edits into the overall photo until you're happy with the results.

In addition, if you want a change to only apply to part of the picture, like the left side, you can use an eraser tool to remove the parts of the top layer you don't want. That way, the original, unedited photo shows through. When you're done, save the finished product as a new picture.

This technique allows you to find the perfect balance between your original photo and the edits you applied. In addition, you can save the photo with the layers intact (as a native file, such as a PSD file if you're using Photoshop Elements) and always have the ability to completely change (or even remove) any edits you made in the top layer.

Intrigued? Here's how to edit your photo using layers:

1. Open a picture in Photoshop Elements.

2. Choose Layer | Duplicate Layer from the menu. You should now see both layers in the Layers palette.

3. Make your changes to the top layer as if you were working on your original photo— correct the exposure using the Levels control, for example.

4. When you're ready, drag the Opacity slider in the Layers palette around to see how you can change the look of the photo by combining the original image with the edited photo on top.

5. When you're happy with the rest, save the picture. Remember that you can use this technique to improve the brightness, contrast, sharpness, or any other aspect of your picture.

How to ... **Undo a Mistake**

Photoshop Elements, like most photo editors, has an extensive undo history you can use to fix anything that goes awry. If you spend 10 minutes making edits to a photo and don't want to choose Edit | Undo 25 times in a row to get rid of it all, do this:

1. Choose Window | Undo History. You'll see a dialog box that lists all the operations you've performed, from the very first to the most recent.

2. Scroll down until you find the point at which your unwanted edits begin.

3. Click that first unwanted edit. All the stuff you did from that moment to the last edit you performed are undone instantly. If you clicked the wrong entry, that's okay—click something else, because the change is not permanent yet.

4. Right-click the entry and choose Delete. The image will revert to its earlier state, before that action took place.

Stack Corrections in Adjustment Layers

That's pretty cool, right? Well, you can take it a step further using a specialized layer feature called Adjustment Layers. Adjustment Layers are layers custom designed for each of the major kinds of changes you might want to make to your photo. You can apply multiple Adjustment Layers to your photo and change the opacity of each one independently.

To see it in action, choose Layer | New Adjustment Layer and check out all the options in the submenu:

Just choose an Adjustment Layer—Levels, for instance—and make your changes. Then add a new Adjustment Layer, and so on, until you've fixed the photo to your satisfaction. Be sure to tweak the opacity of each layer if you want to emphasize more or less of the original, unedited layer at the bottom.

Sharpen Blurry Pictures

After reading this headline, I know what you're thinking: Wow! I can sharpen my blurry pictures! Technology is great!

Well, let me begin by saying that as great as digital imaging is, you can never really add detail or information into a picture that wasn't there to begin with. That's why I'm always amused when I see a movie in which the spy takes a surveillance videotape and enlarges the image enough to read the phone number on a piece of paper across the room, or zooms into a satellite photo to identify someone's face from a photo taken in space. No matter how much they enlarge images in the movies, those Hollywood computers always seem to sharpen the focus perfectly.

Though that kind of photo editing is science fiction, there is some hope for your *slightly* soft or blurry images. You can sharpen an image in two ways: directly, using the Sharpen tool in your image-editing program, or indirectly, which amounts to blurring the background so your subject doesn't look quite so bad. I'll show you how to do both.

TIP *As you might have guessed, you can combine the two sharpening techniques. But keep in mind that sharpening can also increase the digital "noise" in a photo and degrade the overall look of the photo.*

Use Unsharp Mask to Enhance Your Picture

The most straightforward way to sharpen a photo is with a tool called Unsharp Mask. Yes, it has kind of a weird name, but it's quite effective. To understand what it does, it helps to know that sharpening tools typically do their magic by increasing the contrast between pixels. The human eye is easily fooled into thinking that more contrast actually means more sharpness, so running a sharpening filter on photos that are a bit "soft" in the focus department can add a lot of "punch" to your images.

Simple sharpening tools increase the contrast of every pixel in a photo. That can get the job done, but it's kind of wasteful; you don't really need to increase contrast everywhere to give the impression of better focus, you only need to increase the contrast around edges and lines in a photo. And increasing the contrast everywhere can make a photo look worse.

That's where Unsharp Mask comes in. This tool adjusts the contrast of pixels at the edges of a photo, as well as a region around the edges. This is the most common sharpening filter used in photo editing programs today and, in fact, it's pretty standard practice for photographers to run the Unsharp Mask tool on photos that they plan to print (see Figure 14-2).

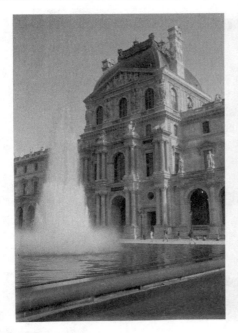

FIGURE 14-2 A little sharpening can add an almost subliminal "punch" to your digital
images—especially ones destined for print.

TIP *Sometimes, adding a little noise to a slightly blurry picture can make it look sharper—
and, indeed, your photo editor's Noise tool has roughly the same effect as the basic
sharpen tool—but keep in mind that Noise tends to happen everywhere in the picture,
while Unsharp Mask tries to be more selective by only working around edges within
the scene.*

To sharpen your photo in Photoshop Elements, choose Enhance | Unsharp Mask from the menu.
At this point, you might need to tweak the settings a little. Here are your controls:

■ **Amount** This is the intensity of the sharpening effect. You should get good results if
you start with about 200 percent.

■ **Radius** This determines how many pixels around the edges are affected by the filter.
Start with a value of 1 or 2. The higher the number, the more pixels around the edge get
sharpened.

■ **Threshold** This determines how different the pixels need to be before they're
considered an edge. A value of zero adds sharpening to every pixel in the photos and is
generally far too harsh. Try values between 2 and 20 for better results.

How to ... **Make Selections in a Photo**

Some of the time, you'll want to change a part of a photo—just the sky, for example, or only someone's face. Photo editing software makes that kind of effect possible in a number of ways, with the most common being selections. Using a selection tool, you can isolate one part of a photo from the rest of the image, and any effects you add only affect the selected region.

Photoshop Elements puts several selection tools at your disposal: the Lasso, Magnetic Lasso, and Polygonal Lasso. They all bunk together in the sixth cubby from the top of the toolbar. There's a fourth selection tool nearby: the Magic Wand.

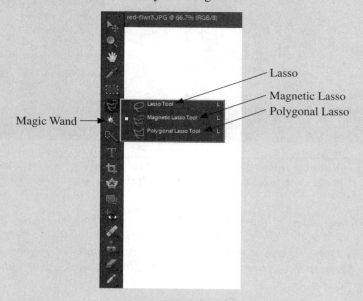

■ **Lasso** This is the most straightforward of the selection tools—just click in the photo and draw a shape. The lasso creates a selection and automatically "closes" the selection when you lift your finger off the mouse. It's completely freehand, though, so for good results, you need to zoom in for a good view and work slowly.

■ **Magnetic Lasso** I use this tool most of the time. The "magnetic" refers to the fact that this tool automatically seeks out edges, so if you're trying to select a person in a photo, for example, the tool automatically tries to stick with the edges of the subject's body and clothing. There's no need to click the mouse, because as you move the pointer, it automatically locks onto the closest edge. That said, you can force the tool to draw a point by clicking. To undo points, you can press the BACKSPACE key. When your selection is complete, close the selection by double-clicking.

- **Polygonal Lasso** If you need to select something using lots of straight lines, try this tool. Each time you click, it draws a straight line to the next place you position the mouse. Like the Magnetic Lasso, you can remove points from the polygonal selection using the BACKSPACE key. When you're done, double-click to close the selection.

- **Magic Wand** Unlike the other tools that do their thing by forcing you to manually outline the selection area, the Magic Wand tool automatically creates a selection area by selecting parts of the photo that have similar colors. This is a great way to select the sky in a photo, for instance, because it's all mostly blue. Use it anytime the edges are poorly defined but the colors are similar. You can control the tool's tolerance—how similar the colors need to be in order for them to be selected in a single click—using the Tolerance setting in the Options palette.

Newcomers to selections often get frustrated with the tools—it can be hard to get a good selection in a single pass, so they try over and over again. But here's a secret: it doesn't have to be that way. You can easily "build up" a selection in multiple passes, which takes the pressure off getting it right the first time. In the Options palette, you can choose any of four selection modes:

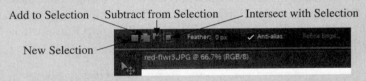

- **New Selection** This is the default way to create a selection. Whenever you start a new selection, it cancels any other selection you might have in the photo.

- **Add to Selection** When you are selecting a complex area in a photo, such as when you're outlining a person, this mode is extremely handy. Any selections you make get added to selections already in the photo. This lets you select someone's face, then scroll down to see more of the photo and add that existing selection to a new selection of the neck and chest. Or, you can select two different parts of the photo—selections don't have to be connected in any way. (You can switch to the Add to Selection mode by holding the SHIFT key while you draw with the selection tool.)

- **Subtract from Selection** If you ever want to select a donut but not the donut hole, you'll like this mode, which lets you selectively remove or correct an existing selection. If the magnetic lasso jumped off the line you were tracing and selected too much photo, don't start over—switch to this mode and surgically delete the part of the selection you don't want. Hold the ALT key while you draw switches to this mode.

- **Intersect with Selection** This mode is kind of cool because it only selects selections that overlap. What do I mean? Check it out for yourself: using the Elliptical Marquee tool, draw a circle. Then draw another circle that intersects the first one. You'll find that only the parts of the two shapes that intersect remain. That said, I find this the least useful selection mode for day-to-day use.

Blur to Sharpen

Using Unsharp Mask is the most common way to make your image look sharper, but there's another, more subtle, and potentially more "artistic" way to enhance the apparent sharpness of your image: blur the background. This process works best when you're photographing a subject that's quite distinct from the background, like in a portrait.

Here's the digest version: To blur the background of your image, you'll need to isolate the subject so the blurring only happens in the rest of the picture (see "Make Selections in a Photo" for the scoop on selection tools). Once your subject is selected, you need to "invert" your selection so the Blur filter happens to everything *except* the subject. Finally, you can run the Blur filter on your image. Once you've blurred your background, turn off the selection and save your image.

That's the quick overview. Here's how to pull off this feat of digital trickery:

1. Open a slightly blurry portrait that you'd like to sharpen into Photoshop Elements.

2. Select the Magnetic Lasso tool and set the Feather value to about 5—that way the transition from the subject to the background won't be abrupt.

3. Trace the outline of the subject's face or body, being careful to stay along the edge. If it helps, "build up" your selection using the Add to Selection mode. (You can even switch tools from Magnetic Lasso to the plain Lasso or Polygonal Lasso without losing any of your selection.)

4. When you have completely selected the subject, choose Enhance | Unsharp Mask to sharpen the subject, but not affect the background. Experiment with the settings until the image preview looks sharp.

5. Next, choose Select | Inverse from the menu. This "flips" the selection so the subject isn't selected but everything else is.

6. Choose Filter | Blur | Gaussian Blur. The amount of blur you should choose depends upon the resolution of the photo, but try starting with a radius of 3.0 and see if that is sufficient. You should see the background blur slightly. If you're not happy with the result, blur it again. In fact, you can repeatedly use the blur effect until the background is blurred to your liking.

7. Finally, when the image is complete, choose Select | Deselect.

Hopefully, the subject now looks better, especially in comparison to the background. Compare the two images in Figure 14-3 for a look at this effect in action.

Simulate a Shallow Depth of Field

Suppose you want to take a picture with a sharp foreground and a shallow background, but your automatic camera settings didn't cooperate. Well, it's easy to simulate the out-of-focus effect that a wide-open aperture gives your background by using the select-invert-blur technique we used to give the subject more apparent sharpness. You'll need to heap on liberal amounts of blur for this technique to work, though. You can run the Blur filter several times until you get the effect you like.

FIGURE 14-3 Blurring the background can simulate a shallow depth of field—great for portraits—while also giving the impression of a sharper subject.

Clean Up Old, Damaged, or Dirty Pictures

An unexpected benefit of digital imaging and editing has been the capability to restore old pictures—heirlooms and keepsakes you might have written off as too badly damaged to be of much value anymore. Some of the techniques I've already mentioned can be used to fix these old prints on your PC. First, of course, you'll need to scan these images into the PC at the highest resolution you have available. That'll make it easier to print them later and will preserve the most detail possible from those old images. From there, it's just a matter of applying digital editing techniques to repair them.

Remove Picture Scratches

After a particularly bad moving experience a few years ago, one of my wedding pictures got a few nasty scratches because of the way the glass broke and slid down the print. The image was essentially irreplaceable, so I turned to digital editing to make a repaired duplicate. You can take several approaches to fixing scratches, depending on where they are in the image, how prominent the scratches are, and their relative size with respect to the rest of the image:

■ In some cases, you can select and copy an undamaged area of the picture that's similar in color and overall texture to the damaged portion, and then paste it over the damaged area with a liberal amount of feathering to smooth the edges. This is particularly effective in fairly uniform backgrounds, such as the sky.

- Another alternative—and the more common solution—is to use the Clone Stamp tool (see the earlier section on airbrushing for more details). Select the Clone Stamp tool and use a nearby, similar, but undamaged, section of the image to paint over the mar. Remember to use short, dabbing motions to paint, or you'll introduce an undesirable pattern into the image.

- Finally, you can use the automated scratch remover found in many photo editors. Photoshop Element's Healing and Spot Healing tools let you remove scratches, tears, and other small problems by painting over the scratch with nearby colors automatically, kind of like the Clone Stamp tool. This technique doesn't work well for wide scratches or scratches that curve or bend—it's off to the Clone Stamp tool for those.

Remove Dust, Dirt, and Digital Noise

Your photos might be filled with little specks that come from grainy, high-speed 35mm film, from bad scans, or from using a digital camera in low light or at a high ISO. What does digital noise look like? Dots, speckles, and smudges of random, unwanted color. Noise is easiest to see in regions of regular color. You can see it in skin tones or on the wall in the background, for instance. In the following first example, you might not notice a lot of noise. But check out the second example, which is a small detail of the original image—you'll see a lot of noise in the girl's face:

Whatever the reason you get specks on your image, most photo editors have a noise reduction tool. In Photoshop Elements, you can find a couple of tools at Filter | Noise. Try both Despeckle and Reduce Noise.

Use a Noise Reduction Program

The Reduce Noise tool in Photoshop Elements does a good job on photos with a little speckling of noise, but for bigger jobs, you're better off trying a program that's custom designed for noise reduction.

In my opinion, two excellent choices are Noiseware and Noise Ninja. You can find Noiseware at www.imagenomic.com/download.aspx. There's a free version called Noiseware Community Edition, which is handy for getting your feet wet, but I don't recommend it as your main weapon against digital noise because the program limits you to saving your finished pictures at a JPEG quality level of 90 percent. It seems to me that this defeats the whole purpose of using the program to begin with, since you can't resave the image at the highest quality. Instead, you can purchase the commercial version of Noiseware for about $50.

Truth be told, I like Noise Ninja even better. You can get a "home license" for $35 or the pro version for $80 at www.picturecode.com/download.htm. What's great about Noise Ninja is that you can create a custom noise profile for your own digital camera and use it to accurately remove unwanted noise while doing the least damage to the good parts of your photo. That might sound intimidating, but it's really pretty simple. What you need to do is display the "profiling chart" on your computer screen (it's a colored grid available from Noise Ninja's File menu). Then take a series of pictures of the chart while it's displayed on your computer screen. Take a photo at each of your camera's various ISO settings, leaving the picture slightly out of focus while you do so (it will help to switch your camera to manual focus mode for this). Also, use a slow shutter speed so you don't accidentally capture any dark bands on the computer's screen.

That's the hard part; next, load the photos into Noise Ninja and click the Profile chart button. Finally, click the button marked Edit Profile Annotations and click Autofill. Then save the profiles. Don't worry: Noise Ninja comes with complete instructions on setting up your profiles. Once that's done, the program will automatically load the right profile whenever you open a photo. Want to see the kind of results you can get? Well, remember the picture of the girl in the previous illustration? Here it is again, after being run through Noise Ninja:

Make a Panoramic Photo

A *panorama* is an image that's wider than the ordinary images produced by your camera, such as the one in Figure 14-4.

Panoramas are typically used to take landscape photos because they provide the wide, sweeping vistas that look so impressive. You can take a panorama of anything, though—a school play, a tall monument, the inside of your home, or some other scene. The key to making something into a panorama with a digital camera, though, is that you'll need to take two or more images and "stitch" them together on your PC. That means the scene shouldn't change much between photographs (like waiting so long that different people wander in front of the subject from one picture to the next, or trying to combine daylight and nighttime versions of the picture), or you won't be able to match them. So, if you're taking a landscape, for instance, the same cars, people, and other objects shouldn't move as you rotate your camera and take successive shots.

I first talked about panoramas back in Chapter 8. In that chapter, I explained how you can use your camera to take the panorama's raw ingredients—the individual shots. In this chapter, we'll pick up where we left off and talk about how to stitch those together on the PC.

As mentioned in Chapter 8, taking a panorama involves two steps: photographing the scene and stitching the images together afterward. When shooting the pictures, keep these tips in mind:

- You need to take a series of pictures that overlap. Try to get 30 percent to 50 percent of each image to overlap into the next picture to make it easier to stitch them together. Scenes with lots of movement are a poor candidate for panoramas because the computer needs to look for similar regions in common from one picture to another. A little movement is fine, but the scene should be essentially static.

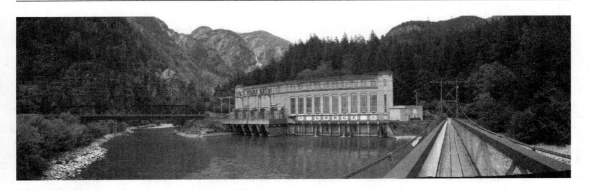

FIGURE 14-4 You can connect a number of images to make a wide (or tall) panoramic shot.

■ To keep each image's perspective identical, you'll need to keep the camera's rotational axis the same. In plain English, that means you need to take all the pictures from the same location. Don't drift a few feet from side to side as you photograph, and take the shots on a tripod if possible (though you can get superb results just holding the camera in your hand).

■ Avoid using a wide-angle lens because this can distort the images and make it difficult to line up edges.

Now it's time to make the panorama. While it's sometimes technically possible to combine pictures into panoramas by hand, it's really hard and it won't always work very well. Instead, you really should purchase a panorama program that automates the entire process for you. That's okay, though: there are many inexpensive programs around that can do the stitching for you. If you're interested, check out any of these:

■ Windows Live Photo Gallery (**www.live.com**)

■ Adobe Photoshop Elements (**www.adobe.com**)

■ Jasc Paint Shop Photo Album (**www.jasc.com**)

■ Ulead Cool 360 (**www.ulead.com**)

■ ArcSoft Panorama Maker (**www.arcsoft.com**)

Using any of these programs, all you need to do is drag and drop the individual images into the panorama canvas, and the software does the rest (see Figure 14-5). These programs are designed to match the edges between the pictures automatically, and they typically do a good job even with wide-angle lenses and other technical difficulties.

To create a panorama in Photoshop Elements, just do this:

1. Choose New | Photomerge Panorama.

2. In the Photomerge dialog box, click Browse and locate all the images you want to combine into the panoramic scene, and then click OK.

3. Photoshop Elements will take a few moments to arrange the images. There are some advanced tools for tweaking your panorama, but generally you just need to click OK to open your new panorama in the Photoshop Elements editor.

4. Finish the photo by cropping away any rough edges.

The Resolution Advantage

Not all panoramas are photographed just to take wide, scenic landscapes. Sometimes, you might want to photograph a subject in sections so you can get more pixels for a high-res print.

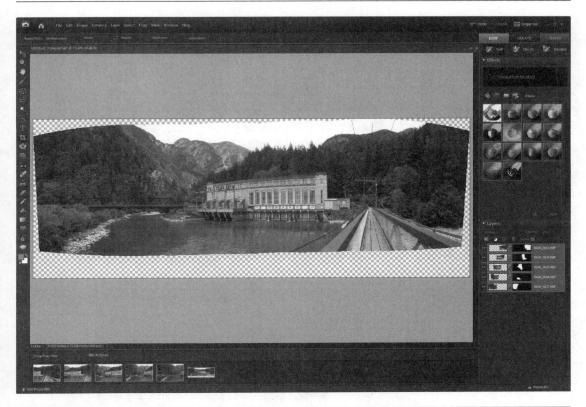

FIGURE 14-5 Automatic panorama software is a convenient way to stitch images together into impressive panoramas.

What am I talking about? Consider a situation in which you want to make a 20×30-inch poster-sized print, but your cropped 6-megapixel photo doesn't have enough resolution to make a large picture. You can still get the shot, as long as you're trying to photograph a stationary object. Shoot it in sections, and then stitch the individual segments together on the PC using a program that lets you create a panorama from a grid of horizontal and vertical images, like Microsoft Digital Image Suite or ArcSoft Panorama Maker. When you're done, you'll end up with a much higher-resolution image—because it'll have a lot more pixels than a single photo would have— that you can make a poster from. Figure 14-6 shows how I took six sequential photos, each one measuring about 3.3 megapixels, and ended up with a huge, super high-resolution 8-megapixel shot that's plenty big for just about any print I could possibly want to make.

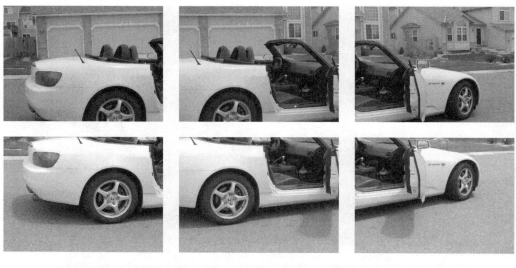

FIGURE 14-6 You can stitch several smaller images together to make a huge print.

Make a Virtual Reality Panorama

The panoramas we've talked about so far are very wide or tall images that go beyond the ordinary aspect ratio people expect to see when they look at a picture—that's what helps make them look so striking. You have another option entirely.

Perhaps you've seen virtual reality movies on the Web or in online encyclopedias like Encarta. They present a scene in a small window that, when you click-and-drag the mouse inside, spins around so you can see a full 360 degrees, as if you were actually there. When you think about it, isn't that just a 360-degree panorama in which you only see a small piece at once? Indeed, that's the secret behind these VR movies. And that means there's nothing particularly magical about them. You can make your own VR movies and share them in e-mail or on the Web. The most common format for these interactive panoramas is Apple's QuickTime, as the following shows.

To make your own VR movies, you need to take a series of images that can be assembled into a complete 360-degree panorama. You also need special panorama software. The best—and most affordable—such programs that I've managed to find are Ulead's Cool 360 and ArcSoft Panorama Maker. Both of these excellent programs let you create panoramas and save them in QuickTime format, which most people can view on their computer without any additional software (if they don't already have QuickTime installed, it's available free from Apple's web site). Panorama Maker even has an option to let you save your VR movie as a web page, which makes it easier to post on the Web.

Straighten Out Architecture

Our eyes, working in collusion with our brain, deceive us all the time. You'd be surprised, in fact, how much they preprocess the world around us. Ordinarily, for instance, everything seems to be in sharp focus, despite the fact that our eyes can only focus on one thing at a time, and everything

else should be correspondingly blurry. And our eyes certainly don't make very tall buildings look like they're all akimbo. Digital cameras, though, with their limited ability to capture perspective and no brain to make adjustments on the fly, do exactly that. What am I talking about? Check out the following illustration, which I took in Las Vegas.

If you look closely, you can see that the Paris Hotel behind the Eiffel Tower is not square and true. Instead, it leans in at the top, as if it's narrower up there than it is at the base. That's a problem, because most real buildings aren't shaped that way. And to be sure, this one isn't either. It's a distortion caused by perspective—one that we usually don't think about in real life, but it leaps out of pictures in a pretty obvious way.

I think you'll agree that we'd all like to avoid this sort of thing. Perspective distortion creeps into photos whenever you're shooting something very tall, and it gets worse the closer you are when you take the picture. As a result, you need to tip the camera up to include all of it in the frame, and it's that action—setting the lens at an angle to the subject—that creates the distortion.

One way to minimize this problem is by selecting your subjects carefully. You can avoid perspective distortion by shooting shorter buildings, since you can keep the camera level with the ground when you take the shot. Likewise, if you want to shoot a tall object, you can try to do it from farther away. If you can get distant enough, there's no reason to angle the camera, and perspective errors won't haunt your shot. Check out the following illustration, for instance: the faux Arc de Triomphe is small enough that I could shoot it without adding any distortion.

Eliminate It on the PC

That said, perspective distortion is sometimes unavoidable. Thankfully, there's an easy way to eliminate it from your photos afterwards using an image editor like Photoshop Elements.

Open a photo with some perspective issues and then choose Filter | Correct Camera Distortion. There are a number of distortion fixes on this screen, but the one that deals with architecture wonkiness is called Perspective Control. Move the Vertical Perspective slider to the left or right until the building looks square; the walls of the building should be parallel to the gridlines in the dialog box.

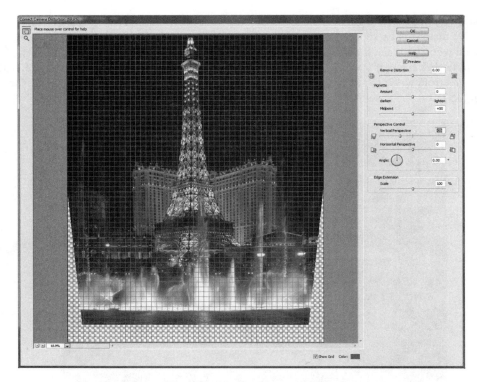

When you're ready, click the OK button, and the problem should be fixed. To finish it off, you might want to use the Crop tool to trim away the unwanted (and slightly distorted) background.

Improve Your Sky

I bet if you browse through your photos, you'll find many of your outdoor photos lack a certain punch—the sky is washed out, cloudless, or otherwise a little boring.

There's a good reason for that. When you compose a photograph, you usually concentrate on the primary subject and pay little heed to the sky itself. Because the sky is a lot brighter than your subject, the camera overexposes it and your sky ends up looking at least a little bleached. Even if the sky is properly exposed, it sometimes just doesn't cooperate, and you'll have a cloudless, boring sky that doesn't match the mood you were trying to get. By adding some snap back into to your skies, you can dramatically improve your so-so photos.

Multiply Your Sky

The easiest way to fix a bleached sky is to multiply it. What does that mean? Well, you open a photo, select the sky, and copy it to the clipboard. Then you paste copies of the sky back into the image, using a seldom-used tool to *multiply* the colors in each layer of sky to produce deeper,

darker colors. If even a little blue is peeking through your sky, this technique is ideal because it's so easy to do.

For starters, find a picture with a weak sky. Open it in Photoshop Elements.

Now try these steps:

1. Click on the Magic Wand tool in preparation for selecting the sky. The *Magic Wand* is a handy selection tool because it grabs parts of the photo that share similar colors. Set the tolerance in the Tools Options dialog box to about 30.

2. Click the Magic Wand squarely in the middle of the sky: you should see selection marks appear around a big blotch of sky. Use the SHIFT key and click all around the sky until you've selected the entire thing, without also grabbing any non-sky parts of the picture. If there are trees in the scene, you might need to zoom in and click between a lot of branches.

3. Make sure you've selected the entire sky—you can zoom in and pan around the image to double-check. When you know you have it all, copy the selected sky to the clipboard by choosing Edit | Copy from the menu.

4. Next, choose Layer | New | Layer Via Copy.

5. Now for the magic trick that makes all this effort worthwhile: the multiply effect. In the Layer palette on the right side of the screen, set the Blend Mode to Multiply.

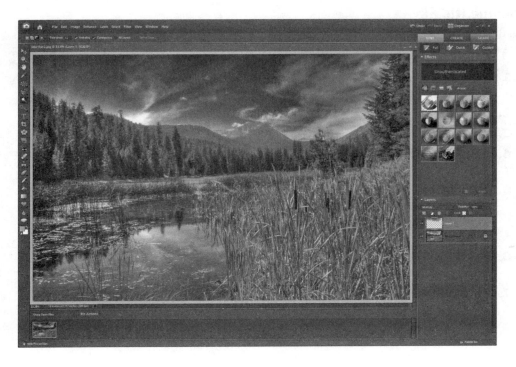

You should see the colors in your sky immediately deepen. If you don't think that was enough of a change to suit you, don't worry. Here's where your artistic judgment comes in: because the sky is already copied into your clipboard, you can continue to paste new layers of sky into your image until you get the deep and colorful effect you're looking for. Using this technique, you can transform an anemic, pale blue sky into an angry, stormy scene in minutes.

Replace the Sky

The multiply technique isn't the only way to punch up a lame sky. You can also steal the sky from another photo, as I'll show you now.

For starters, you're going to need a great photo of the sky. When I see a pretty blue sky, a swirling, cloudy day, a stormy afternoon, or a beautiful sunset, I grab my camera and start shooting. Use the Exposure Lock feature on your camera to set the exposure based on the sky or simply fill the entire frame with sky—either way, you'll capture all the color and intensity that you see through the viewfinder in the final image.

Shoot your sky shots with your camera's highest resolution because you never know what resolution you'll eventually need. You might also want to take some pictures in Landscape mode and others in Portrait mode, so you have a selection of skies for any situation. Store your collection of sky images in a special folder, and you'll always have options available when you want to replace a bland sky.

Evict the Old Sky

Ready to try this technique? Load a picture with a weak sky in Paint Shop Pro. Then follow these steps:

1. Just like last time, use the Magic Wand with the Tolerance set at a moderate level (like 30) to select the sky in the photo.

2. After the sky is completely selected, press the DELETE key to remove it from the photo.

3. Open the image with the substitute sky in Photoshop Elements.

4. Click the original photo in the Photo Bin at the bottom of the screen to switch back to that image.

5. Drag the new sky image from the Photo Bin to the canvas. You should see it appear in a new layer. Drag it around as needed until it's positioned properly in the frame, and resize it by dragging a corner until it fills the sky "hole" left when we deleted the old sky in step 2.

6. Finally, in the Layer palette, drag the sky layer under the original layer, so the sky is behind the image and only peeks through the foreground selection.

7. If you like the results, save the new image. You're done!

Chapter 15

Create Special Effects

How to...

- Simulate a Hollywood-style blue screen effect
- Create Chroma Key effects like a news-show weather map
- Insert friends and family into pictures of celebrities
- Take science fiction shots of laser battles
- Shrink your friends and put them in jars
- Make double exposures
- Add artistic and painterly effects to your photos
- Decolorize your photos
- Pack your photo with colors using High Dynamic Range
- Get infinite depth of field with focus stacking

I remember going to the movies when I was a kid and being wowed and amazed by special effects: stop motion, blue screen, animated laser combat, matte paintings. While I'm sure a lot of people were just thinking things like "wow" and "cool," I was thinking, "I wish I could do that." I was intrigued by the possibilities of trick photography, and I wanted to be able to do it myself.

Such special effects have always been possible for anyone with the time, money, equipment, and determination. I had nothing but determination. But when I got my first photo processing program back in 1987, I realized I could finally do what I'd always wanted to: special effects and trick photography on a budget.

Indeed, digital photography opens a lot of doors for us mere mortals. In this chapter, I'll tell you how to do some of the tricks that can make your images go beyond simple reality. You might not want to try all the techniques in this chapter, but I think there's a little fun in here for just about everyone. And not all the "tricks" in this chapter are of the lasers-and-robots variety. I'll also show you how to achieve hyperrealistic photos—photos that feature beautiful effects impossible to achieve with a standard digital camera.

Make a Hollywood-Style Blue Screen

What's a blue screen? Well, *blue screen* is the generic term for a technique in which action is photographed or filmed in front of a solid-colored backdrop. Later, in postproduction, special-effects technicians substitute a different scene in place of the screen. So, a scene that looks like it happened in midair or in France or on the moon actually happened in front of a huge blue (or green) tarp. Separate footage is added in place of the tarp, and voilà. That's movie magic.

You can achieve the same kind of results yourself, whether you use a real blue screen or jump in with no preplanning at all.

How to ... **Make a Weather Map**

Let's start with the kind of shot you plan ahead for, which makes it a tad easier to get good results.

First, think about the evening news. You've seen the weather forecaster stand in front of a map of the United States and point to cold fronts a million times before, but have you ever thought about how that bit of TV magic happens? Obviously, the forecaster isn't standing in front of a real map. Instead, it's a blue or a green screen—a solid-colored rectangle. An engineer uses a technique called *Chroma Key* to replace the rectangle with video from another source. What happens is this: the engineer selects the color of the blue screen and identifies it as a "key." The second video source then overwrites anything in the scene that has the key-valued color.

You can create your own Chroma Key effect yourself. Let's say that you want to try your hand at a special effect—you have a picture in which you'd like to replace the view out of a window with a completely different scene. It's just a matter of selecting the window (or all the little squares of glass that make up the window) and substituting a different photo. Here's how to do it:

1. Open the picture with the window that you want to modify.

2. Choose one of the selection tools from the toolbar. Depending upon the image, you might want to "trace" the window with the Magnetic Lasso tool, or, if the window is very uniform in color, you might have better results with the Magic Wand. You can even start with one tool and fine-tune the results with another (as long as you work in the Add to Selection mode). In this example, I used the Polygonal Lasso tool for the straight edges of the window, and then used the Magnetic Lasso tool to catch all the unusual shapes and curves.

3. Open a second image in Photoshop Elements. This will be the image you insert into the first image to replace the view as a sort of weather map effect.

4. With the second image selected, copy the image to the clipboard by pressing CTRL-A (to select the entire photo) and then choosing Edit | Copy.

5. Choose Edit | Paste Into Selection. You should see the second image pasted into the first image.

6. Click the Move tool and drag the new image around in the selection until it's composed to your liking.

You can use this technique in all sorts of ways. In addition to making your windows look out over an unusual vista, you can have a plain board become a famous painting or create your own news or weather effects. Experiment—it's fun and easy to do.

Blue Screen without the Screen

A common variation on the blue screen technique is to borrow an element from one photo and insert it into another.

1. Open the photo of the person or subject that will be transplanted into another scene.

2. Create a selection area around the entire subject you want to transplant to another scene. Most of the time, you probably want to start with the Magnetic Lasso tool, but you might also have good results with the Magic Wand. In this case, the background was so uniform that I selected it with the Magic Wand and then used the Select | Inverse command to only select the airplane:

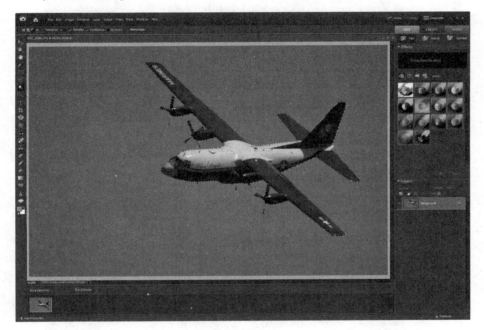

3. When the selection is complete, choose Edit | Copy from the menu.

4. Open the second image.

5. Choose Edit | Paste. Your selection should appear in the second scene, but it might not be the right size.

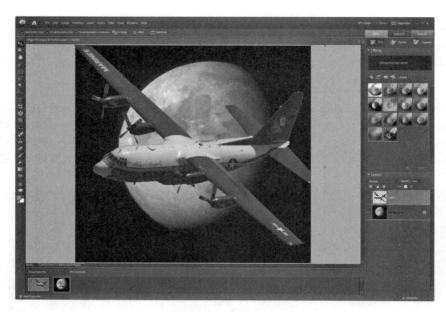

6. To resize the pasted-in image, click a corner of the pasted picture's frame. While clicking, drag the image to resize it to taste. Finally, reposition the image until it looks about right, and then click the check mark to save this change.

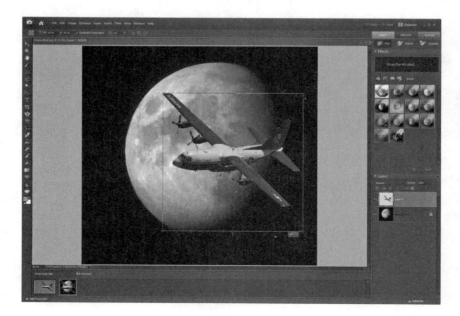

Fine-Tune the Selection Manually

The technique I just described works fine a lot of the time, but it's just not accurate enough to create a truly convincing special effect, especially if you are trying to cut a person out of a photo, for example, and you have to contend with a lot of hair, which mixes into the background. You can get even better results with a Background Eraser.

The Background Eraser deletes the background from around the subject of your image, making it easy to copy and paste it into other images. It usually works quite well, often able to leave individual hairs on someone's head intact, while deleting unwanted backgrounds from around them. Select the Background Eraser from the Tool Palette. The only setting you generally need to set is the eraser's size; it shouldn't be too large, for reasons you'll see in a moment.

Position the eraser near the edge of the subject you're trying to isolate. Click, hold, and paint away the background. Be careful not to get more than half of the eraser over your subject, or you'll erase a bit of that, too. If the eraser is too large, make it smaller so you can control how much of it covers your subject at any moment. Work in bits: click, erase a little, and release the mouse. If you try to do the whole image in a single stroke, but you make a mistake, the Undo button will set you back to square one and you'll have to do it all over from scratch. It's best to work in sections to avoid having to redo your work because of a glitch.

The Background Eraser erases regions of similar color. It works best when a clearly defined edge is between the subject and background you're trying to erase. If the color of the subject and background are too similar, the tool will take bits of the subject along with the background; so work carefully and keep an eye on what the tool is doing. After you're done erasing the background, just select the image and you can use it any way you like.

Fine-Tune the Selection Automatically

Another solution: try the Magic Extractor. The Magic Extractor is a more automated way to erase the background from around someone or something in a photo. In fact, you might want to start here, and then fine-tune the edges with the Background Eraser. Here's how to use it:

1. Open the photo in Photoshop Elements.

2. Choose Image | Magic Extractor.

3. With the Foreground Brush tool selected, click, dab, and draw lines through the subject that you want to keep. Make sure you clearly indicate all the various bits of the subject, especially where the subject's colors or contrast change.

4. Click the Background Brush tool and use the same technique to mark the bits of the photo you want to get rid of. The image should look something like this:

5. Click Preview. If the program guessed badly at where the edges should be, use the Foreground and Background tools to mark additional corrections and then click Preview again to see if it has improved.

6. When you're happy with the result, click OK, and you'll get an image with your subject completely isolated. Make any corrections manually using the Background Eraser, and you're done.

Fine-Tune the Selection with a Knock-Out Program

Last, but not least, don't forget that if you really get into this sort of thing—separating elements of your photos from their background—there are specialized tools available that make this task easier and more accurate than what you can accomplish with a generic photo editor like Photoshop Elements. One of the best such programs that I've found is called EZ Mask, from www.digitalfilmtools.com. The downside: it only works with Photoshop, not Photoshop Elements. But while the interface is very similar to Elements' Magic Extractor, it's dramatically more accurate, able to differentiate fine hairs on someone's head from a noisy background, with very little effort on your part.

Shake Hands with Elvis

Now the moment you've been waiting for—the opportunity to combine pictures of yourself or friends with famous celebrities and historical figures. It's not all that hard, especially now that you know the basic principles from working with blue screen–style effects and image replacements. Let's suppose your friend, Kristen, has always wanted to meet Elvis. It's too late to set up a meeting (unless your buddy Bigfoot keeps in touch with the aliens that abducted him), but you can do the next best thing. In the following steps, I'll show you how to combine a picture of her with an old shot from the Nixon administration.

1. First, you need a suitable picture of both the King and Kristen—open them in Photoshop Elements.

2. Now for a little housecleaning. You need to erase as much of Nixon as you reasonably can from the Elvis photo, using the Clone Stamp tool and techniques covered back in Chapter 14. In this case, I used easily cloned elements of the picture, like the wall, trim, and flags, to wipe away the former president. I didn't really need to erase all of him because we're going to position Kristen over part of this image, but the more of Nixon I could eliminate, the better, since we want Kris to look like she's really in the scene. This is what it looked like when the image was getting close to good enough to paste in Kris:

3. Now for the tricky part. You need to use a selection tool to copy Kristen, but avoid including any of the background. You can use the Magic Wand, Freehand tool—whichever you're most comfortable with. In this photo, I used the Magic Extractor, which did a flawless job since the background was simple and mostly white. After erasing the background, I used the Rectangular Marquee tool to select her.

4. Copy Kristen to the clipboard, and then switch to the other image. Choose Edit | Paste. Kristen will appear onstage next to Elvis. If she's not the right size, click the Move tool and then resize Kristen by dragging a corner of the image until the two subjects are sized about right.

5. Position Kristen in the new image, arranging her so their hands meet.

To make the illusion more convincing, you can try to sharpen Kristen a bit to match the original Elvis photo before you copy and paste her. Finish up by cropping away as much of the

obviously faked background as you can, and save your image. The CIA will know it's a fake, but it's probably fine for your purposes.

Shoot a Sci-Fi Firefight

When I was in college, I took my geeky love of *Star Trek,* added a dose of photography, and came up with a hobby that could pretty much only be done around 3:00 A.M. Although it didn't help my grades much, it was a lot of fun to create special effects like phaser blasts and disintegration halos. The best part? It was all done "in the lens," which means you can try it yourself if your camera supports very long exposures. You can compare techniques and see if the digital way is easier. Here's how I did it in college:

1. Set the camera up on a tripod in total darkness and start a long exposure.

2. Using a flash, expose the subject (like someone holding a phaser) and the target person. The flash needn't be mounted to the camera—you can just take a flash unit and hold it in your hand, flashing the subject once or twice. Don't end the exposure yet.

3. Get behind the subject, and, pointing a flashlight directly at the camera, walk to the target of the phaser blast, trying to keep the flashlight moving in a straight line so it traces what will look like a solid laser beam on the film.

4. Outline the target with the flashlight, again pointing it at the camera.

5. If you want to make the target look like he or she is disintegrating, ask the subject to leave the scene, and then flash the rear wall once.

6. Stop the exposure.

That's a lot of work, and the results are often hit or miss. Against all odds, you can sometimes get a half-decent one, as in the illustration below.

The Disintegrating Subject

With a program like Photoshop Elements, you can create this special effect a lot more efficiently. Here's an alternate way to create a similar image:

1. Take a picture of two kids posed, ready to have some special effects magic done to them. *Star Trek* clothing is optional.

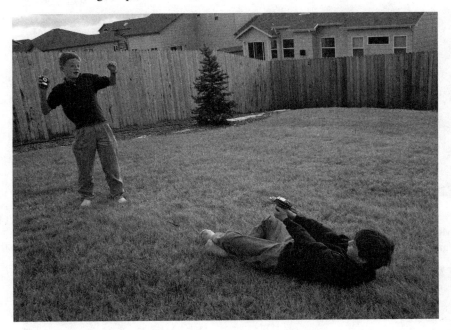

2. Open the image in Photoshop Elements and immediately choose Layer | Duplicate Layer to make a second copy of the image in a new layer. Click OK.

3. In the Layer Palette on the right side of the screen, turn the top layer off so you can see the result of your work as you make changes to the bottom layer. To do that, click the eye to the left of the top layer. Then click the bottom layer to select it.

4. As a first step toward making the target glow in the bottom layer, carefully create a selection region around the subject. You might want to use the Magnetic Lasso tool. As you drag it around the body, it'll automatically snap to the subject's body, but don't be shy about helping the tool find the right edges by clicking at appropriate locations. When you do all the way around your subject, double-click.

5. Next, you want to make the selection bigger than his body. To do that, choose Select |
Modify | Expand and select perhaps 10 or 20 pixels. Then feather the selection in the
same way—choose Select | Feather and set the feather to 5 or 10 pixels.

6. Now it's time to add an effect to make the subject glow. Choose Enhance | Adjust Lighting | Brightness/Contrast and jack the brightness and contrast up to maximum. Click OK, and you should see a bright white region where the subject used to be.

7. Next, make the top layer visible again by clicking the eye you turned off in step 3. The glow should disappear because the copy of the original, unretouched image is now on top.

8. In the Layer Palette, click the top layer to select it, and then reduce the layer's opacity until you get the effect you like—it'll probably be in the neighborhood of 20 to 40 percent.

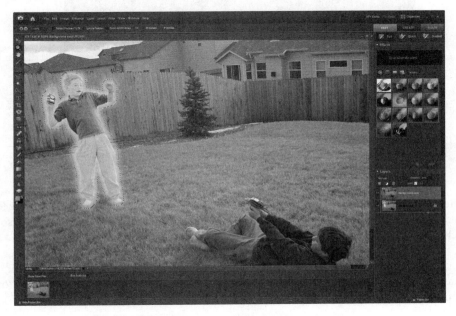

9. Turn off the selection by choosing Select | Deselect.

You can also do variations on this. To get the target to disintegrate, take two pictures using a tripod so you have identical framing. In one image, include the subject; in the other image, just shoot the background without the subject. When you combine the images using the layer strategy I previously discussed, it'll look like the subject is evaporating.

The Laser Blast

We've now made a pretty convincing disintegration scene, but what about the phaser beam? As I already mentioned, using a flashlight is an inexact science—it's hard to get a straight line, as you can see in Figure 15-1.

With a paint program, though, you can get a perfectly straight beam. In most paint programs, holding down the SHIFT key while you draw a line locks the brush into following a perfectly straight path.

FIGURE 15-1 It's fiendishly difficult to "draw" a straight line through the air with a flashlight doing it the old-fashioned way.

In Photoshop Elements, click on the Brush tool in the Tool Palette, and then select the color you want by double-clicking the Foreground Color box and choosing a color. (You might also want to change the width of the line in the Options Palette at the top of the screen.) Position the paint brush where you want the beam to start—such as at the tip of the phaser—and then left-click. Hold down the SHIFT key and click the end point, such as somewhere on your disintegrating subject. The program draws a perfectly straight line between the two points. You can see how this particular shot came out:

Put Your Kid in a Jar

Have you ever been impressed by the fanciful digital art in magazine ads that depict the impossible or the far, far-fetched? I can't promise that you'll soon be able to photograph a cow driving your car or aliens posing with your dog while it plays the piano, but let me show you how easy it is to do something both cute and clever—you'll trap your kid in an old mayonnaise jar. Hopefully, when you see how easy it is to pull this stunt off, you'll want to make up a few clever gags of your own.

This is going to be easy. You'll take a few pictures and combine them in layers within Photoshop Elements, resizing them to achieve the effect we want. Do this:

1. Start by finding a nice, big jar (when I tried this shot, I used a clear plastic peanut butter jar, but a mayo jar or any large, clear container is ideal). Photograph someone peering inquisitively into it.

2. Next, take the person who'll be trapped inside the jar and pose him or her in front of a big backdrop. This is where a blue screen–style background (discussed earlier in the chapter) comes in handy, but you can also use a basement wall, garage door, or some other background of uniform color. Don't have anything like that? Just shoot the picture outdoors and we'll deal with it.

3. Open both images in Photoshop Elements, but you'll start working on the trapped kid first.

4. If you managed to photograph the subject in front of a fairly uniform background, it'll be easier, but this technique will work with almost any background. Use the Magic Extractor (Image | Magic Extractor), Background Eraser, or the Magic Wand tool to select just the kid. Using a little feathering can help you out later.

5. Once the subject is selected, copy it to the clipboard by choosing Edit | Copy from the menu.

6. Bring the jar photograph to the front and choose Edit | Paste to add the kid as a new layer. Your kid should appear onscreen in the photo.

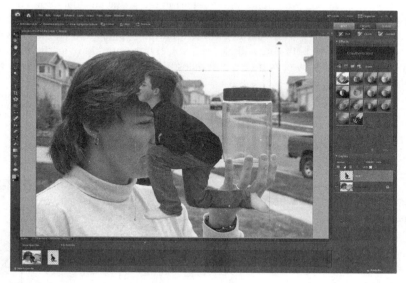

7. Now it's time to shrink the new addition down to size. Select the Move tool and click a corner of his frame. Drag it to resize him.

8. Click the subject and drag it on top of the jar. If it fits, fine. If not, tweak its size until it fits properly in the jar.

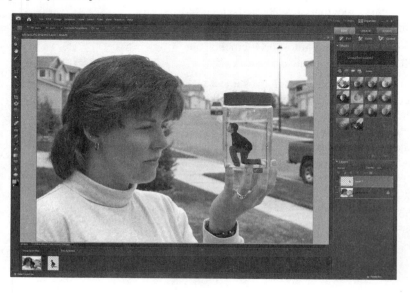

Once you tweak the size and position of the captured kid, your photo is done (see the following image). You can also try other things, though, to improve the photo:

- Try to photograph both pictures with similar lighting to make a more believable picture.

- Be careful about the angle from which you shoot the jar-kid to match the jar's perspective in the first photo.

- Select the mom's fingers, copy them to the clipboard, and paste them on top of the jar-kid as yet another layer. This way, you can increase the illusion that the subject is, indeed, inside the jar, not just pasted on top of it.

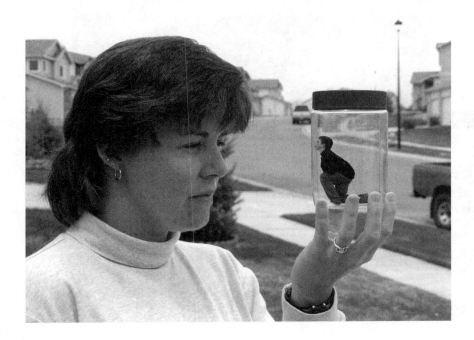

Make an Ethereal Double Exposure

Now let's return to Earth for an easy trick that mimics double-exposure photography. In the world of film photography, double exposures are fun but hard to do well. You can go for far-out stuff that combines two completely different kinds of subjects or a simple artistic effort like the double-exposed flower in Figure 15-2. This is a specific kind of double exposure known as the Orton Effect, so-named for Michael Orton, a photographer who popularized this glowing, ethereal look.

FIGURE 15-2 A double exposure like this one can add an ethereal quality to your photograph.

Make a Simple Double Exposure

The good news is that double-exposure shots take seconds to do and don't require any of the elaborate planning or in-your-head exposure calculations you'd need to do with film. Here's how:

1. Open two photos you plan to combine in Photoshop Elements.

2. Select one photo and press CTRL-A to select it, then choose Edit | Copy to put it in the clipboard.

3. Switch to the other photo and choose Edit | Paste. You should see the first photo appear over—and completely obscure—the selected photo.

4. In the Layer Palette, click the top layer, and then drag the opacity slider for the top layer until you can start to see the underlying image. Setting the slider at 50 percent will give you equal amounts of both pictures, though you might want one of the images to be significantly more prominent. If so, drag the slider back and forth until you get just the right multiple-exposure effect.

Give Your Photo the Orton Glow

That process gives you a simple double exposure. If you want to make it glow using the Orton Effect, then you only need to make one small change. To get the image in Figure 15-2, you could take one photo in sharp focus and a second exposure with the flower out-of-focus, and then

combine them, with the opacity of the out-of-focus image set around 35 percent. You don't even have to go to all that trouble, though. Just take a single photo and follow these steps:

1. Open the photo in Photoshop Elements.

2. Choose Layer | Duplicate Layer and click OK. Do this a second time so there are three identical layers in the photo. If it helps you keep the layers straight, you can rename them so the middle layer is called "Sharp" and the top layer is named "Blurry."

3. Next, you'll simulate overexposing the photo. Click the middle layer ("Sharp") in the Layer Palette and change the blending mode from the default—Normal—to Screen. You won't see a difference, because you just screened the middle layer.

4. Right-click the sharp layer and choose Merge Down from the menu. The sharp layer will disappear, having just been merged into the original background layer.

5. Now it's time to work on the top layer ("Blurry"). Click the layer so it is selected, and then choose Filter | Blur | Gaussian Blur. The amount of blur (controlled by the Radius setting) will depend upon the size of the photo. If you are working with a large photo (6 megapixels or more), I'd try something between 14 and 25. The key is to add a significant amount of blur without completely obscuring all the detail. Click OK.

Plug-ins Expand Your Image-Editing Options

Many image editors, including Paint Shop Pro, can use something called a *plug-in,* or a *plug-in filter,* which are filters originally designed for Adobe Photoshop. Photoshop filters have become something of a standard in image-editing software, and many programs can use these filters. You can download filters from the Web, purchase them in stores, or get them with other image editors.

With the blurry layer still selected, change the blend mode from Normal to Multiply. That's it, but to finish off the photo you might want to adjust the image's overall brightness or increase the brightness of the midtones. You can do that by tweaking the Levels (Enhance | Adjust Lighting | Levels). You might also want to adjust the opacity of the top layer a bit.

Paint Like Van Gogh

An easy way to transform your images into unique works of digital art is with the filters that are built into image editing software like Adobe Photoshop, Photoshop Elements, and Corel Paint Shop Pro. A *filter* is graphics-talk for a tool that lets you edit or manipulate your image. It's called a filter because when you run it, software changes your image according to a specific mathematical process, filtering the original data in a certain way to deliver a modified image. A common and relatively boring example of a filter is *sharpening,* which adds contrast to the pixels in an image, increasing the apparent sharpness.

Filters can do a lot more than just sharpen (or blur) your images. Hundreds of filters are out there, and many programs come with a few to get you started. The best way to find out what a filter does is to experiment. I say that because it's one thing to read an explanation of the filter, but it's quite another thing to process a picture with each filter to see the effect. In general, you probably won't use many of these filters very often. But it pays to try them out, because you never know when a certain effect will be just what you're looking for. Table 15-1 provides a quick summary of the most common filter types you might run across.

There's no limit to the kinds of effects you can achieve with filters, though beware: many of them are somewhat clichéd. Use your judgment when applying them. Check out Figure 15-3. Here you can see the original strawberries, as well as what they look like with Brush Stroke, Stained Glass, and Colored Pencil filters applied.

Lots of companies sell add-on plug-in filters for Photoshop and other graphics programs. More plug-in packages are available for Photoshop, Photoshop Elements, and Paint Shop Pro than I have room in this book to list, but I'll mention two. *Corel's Virtual Painter,* for instance, includes a dozen effects like pastel, silk screen, pointillism, and watercolor that help you look like an old-world painter.

Filter	Description
Blur	Averages nearby pixels to give the impression of blur, poor focus, or motion.
Sharpen	Increases apparent sharpness in an image by increasing the contrast between pixels, either throughout an image or only along edges.
Edge	Typically enhances and traces edges—regions defined by high-contrast borders between pixels.
Noise	Adds or removes "noise" in an image. Noise manifests itself in digital images as specks of high-contrast color, like snow in a TV transmission.
Geometric effects	These tools distort and skew parts of an image. They're good for displaying an image in a different perspective. You can change the orientation of an image in three dimensions or perhaps distort images within circles, cylinders, and other shapes.
Artistic effects	This is the general name for a slew of filters that do everything from add bas-relief, watercolor, charcoal, mosaic, and more to your images. This is where you should go when you want to make your image look like it was hand-painted or give it a unique, nonphoto-realistic look.

TABLE 15-1 Common Filter Types

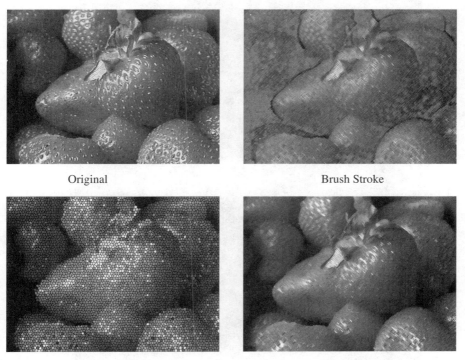

Original Brush Stroke

Stained Glass Colored Pencil

FIGURE 15-3 A variety of artistic effects are applied to the same original image.

Xenofex 2, from Alien Skin Software (**www.alienskin.com**) is another great program. It includes 14 filters that add lightning or a gorgeous blue sky to your images, or transform an image into a TV-style graphic, complete with old-fashioned, picture tube-esque curved edges, and video scan lines. You can add burnt edges to a picture, shatter it like broken glass, or turn it into a virtual jigsaw puzzle. And that's only about half the effects. Figure 15-4 shows a night photo that's been transformed with the addition of an oversized moon, plus lightning and a TV effect from Xenofex 2.

Decolorize Your Pictures

This effect is a lot of fun. Surely you've seen television commercials in which everything is black and white except for one item—a person, perhaps, or the featured product—which is in full color. It's an effective trick because your eyes are drawn to the color image in a sea of gray.

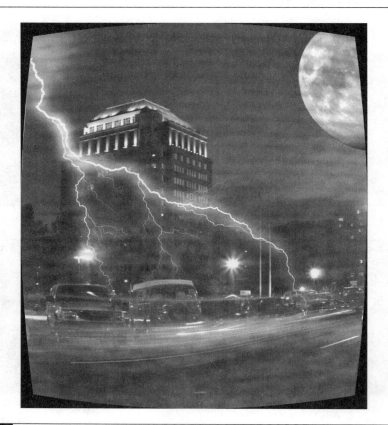

FIGURE 15-4 A creepy sci-fi look after just a few minutes in an image editor with filters

On television, this effect is typically done with two cameras. On the PC, though, you can do it after the fact with a single image—you didn't even have to have this effect in mind when you originally took the shot. Best of all, it's not hard to do. It's particularly easy if your image editor supports layers. The basic idea is this:

- Stack two copies of the image in separate layers.
- Convert one to grayscale.
- Select most of the image in the color version.
- Delete the selection, leaving a small color subject on top of the grayscale image.

Specifically, here's how to do it in Photoshop Elements:

1. Open the image you want to use and make a copy of it by choosing Layer | Duplicate Layer and click OK.

2. Select the top layer and convert it to a grayscale picture. To do that, choose Enhance | Adjust Color | Adjust Hue/Saturation and then reduce the saturation to −100 (all the way to the left). Click OK.

3. Use Selection tools to trace out the subject you want to appear in color. Trace as carefully as possible.

4. When you're done, press DELETE to cut away the bits you want to appear in color. Immediately, the color bits from the bottom layer should poke through.

5. Choose Select | Deselect to finish.

You should now have a grayscale image with a single element in color. Save the image with a new name.

Add Digital Motion Blur

Life is full of little paradoxes. They bother to display nutritional information on the wall at McDonalds, for instance. And, in the world of photography, people often try to capture the essence of motion in pictures, which are by their very nature totally static, two-dimensional, and frozen in time.

That's what makes motion-themed photos so compelling, though: the notion that you can somehow capture motion and freeze it for all eternity on an unchanging computer screen or sheet of photo paper. Back in Chapter 3, we talked about motion blur techniques when you actually took the picture; now let's add it digitally after the fact. My guinea pig is a C-130 cargo plane that I photographed at an air show.

In the following photo, the C-130 is frozen with a pretty fast shutter speed, but we'll make it look like it's moving.

As you can see, I've stopped the action so thoroughly that even the propeller blades hang frozen in the air. As a result, the picture lacks soul. Do this to your picture:

1. Start by adding another layer to your picture, which you can use to help fine-tune the motion blur effect later. Choose Layer | Duplicate Layer and click OK.

2. Make sure that the top layer is selected by clicking it in the Layer Palette.

3. Choose Filter | Blur | Motion Blur. In the Motion Blur dialog box, you can set two important options: the angle of the blur and distance, which is the strength of the effect. Set the distance to around 40 pixels, and then adjust the angle of the blur until it's roughly in line with the direction of the subject's motion.

4. I've added blur, but unfortunately, it just looks, well, blurry. It's as if someone bumped into me right as I took the picture. Use the Eraser to fine-tune the blur. Click the Eraser tool, which does just what it sounds like—it erases pixels from the picture. But since you have the original image in the layer underneath, the Eraser will let you combine blurry and nonblurry sections of the picture by revealing pixels from underneath.

5. Set the Opacity to 100 and adjust the size of the eraser, if necessary, so you don't wipe away too much of the picture with each stroke.

6. In my case, I use the Eraser to sharpen the leading edges of the plane—the nose, the wings, and the tail section—and sharpen the inner sections of the body as well, leaving just the trailing edges blurred. My final image looks something like this:

Blur the Background

That's one way to add motion blur to an image. It's akin to keeping the camera stationary while you snap a picture of a moving subject. Another technique you might want to try is akin to panning (see Chapter 7). For that, you want to blur the background and leave the subject intact.

To do that, select the subject using whatever technique you prefer. But, because you want to apply motion blur to the background, you need to invert your selection—that will select the entire background, leaving the subject itself unselected. Choose Select | Inverse. Next, choose Adjust | Blur | Motion Blur. Again, set the angle and strength, and then click OK. You should see a pretty plausible example of motion blur (as in this illustration):

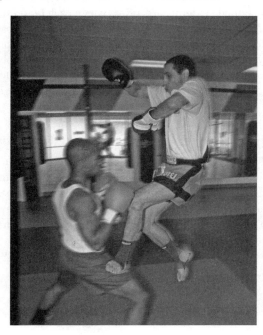

Hyperreal Photography

It's a curious thing that you can consider reality a special effect, but remember something I've said a few times throughout this book: digital cameras don't capture photos the way you see them with your own eyes. For one thing, you can see a far deeper range of colors than any digital (or film) camera is capable of capturing. And then there's the issue of focus—we tend to think of everything in our field of view as in focus, while a photo of the same scene can only have one thing in sharp focus, and everything else is somewhat fuzzy. So let's use the magic of digital special effects to make your photos jump off the screen with more color or deeper focus than is usually possible. In other words, let's make your photos hyperreal.

All About High Dynamic Range

Throughout history, art has always been concerned with approximating reality. For centuries, painters strove to progressively improve their technique to better replicate the world around them. But when photography arrived on the scene in the 1800s, some people thought painting would become a dead art form because cameras could so perfectly reproduce reality.

Nothing could be further from the truth. Cameras approximate the scenes they photograph in myriad ways, not the least of which is their inability to capture the full range of light and color in any given situation.

You've probably seen this yourself when you try to photograph a scene with a lot of contrast, such as bright sunlight and shadow or the setting sun at dusk counterpoised with city lights. If you measure a camera's exposure latitude in terms of f-stops (where each f-stop setting on your camera double or halves the amount of light reaching the sensor compared to the subsequent f-stop), then you can say that digital cameras have a total latitude of about six stops. The problem is that real-life situations tend to have many, many more f-stops of exposure information embedded in them. The typical solution? You needed to pick the part of the picture you were most interested in (such as the shadowy part under the trees or the bright, sun-baked green field near the horizon) and set the camera accordingly.

The HDR Alternative

That's no longer the case. These days, you can take pictures with a much deeper exposure latitude that accurately depicts the full range of colors, brightness, and contrast in a scene. You can get a dozen stops of exposure information rather than just six. No, the sensitivity of digital cameras themselves hasn't improved—and I don't expect that to change anytime soon. Instead, High Dynamic Range (also known as HDR) photography relies on a technique in which you take a series of photos, each with a different exposure, and combine them afterwards on the PC.

Intrigued? Check out some of these photos taken by HDR enthusiasts: www.flickr.com/groups/hdr/pool/.

So how do you get started with HDR? Since HDR requires that you take a series of photos, I highly recommend using a tripod. Yes, it's possible to hand-hold your camera, but the results may not be as good, and you'll be relying on your software's ability to line up each photo perfectly—something I've never known to happen quite to my satisfaction.

Begin by setting your camera on the tripod and line up your scene in the viewfinder. To trigger the camera, I also recommend a remote control (many cameras work with an infrared remote), a remote cord, or the camera's self-timer. Any of these solutions minimizes camera shake at the moment of exposure.

If your camera has a manual focus mode, I also recommend using it. Since you're going to take anywhere between three and nine separate exposures of the same scene, you really want the focus to be identical in each shot. Here's what I do: I press halfway down on the camera's shutter release, which allows the camera's automatic focus mode to lock in the perfect focus. Then, I change the camera from auto-focus to manual focus, locking in that focus for all my subsequent photos. If your camera does not work that way, you might need to be a little extra careful about making sure the focus doesn't change between shots.

Finally, you need to control the exposure so each photo has a slightly different setting. The easiest way to do this is to use your camera's bracket exposure control. Bracketing is a setting that tells the computer to take a series of photos with a range of exposure—such as one stop underexposed, the correct exposure, and one stop overexposed. My camera lets me adjust the amount of exposure change (such as a half-stop or a full stop between photos) and the number of exposures in the series (3, 5, 7, and even 9). If your camera has a bracket mode, this is definitely the way to go—set it up, hold down the shutter release, and the camera will run through the entire bracketed series, one shot after the next, stopping when it's done.

TIP *It's important to use Aperture Priority mode when shooting a series of photos for HDR, so the depth of field and resulting focus doesn't change from one photo to the next.*

If your camera doesn't have a bracket mode, then you'll have to get a little more creative. You can bracket the photo yourself by taking the first picture at normal exposure, then using the exposure compensation dial (usually marked with a plus/minus symbol) to underexpose and overexpose subsequent images. Take a series of shots with the exposure control set to –1, –2, –3, +1, +2, and +3, for example. Throughout the process, remember to be careful not to move the camera or each shot won't be aligned properly.

There are a variety of programs available that are designed to combine HDR photos. Adobe Photoshop CS2, for example, has an HDR feature. So does Ulead PhotoImpact. There are also some stand-alone HDR utilities out there. If you want to try something a little less expensive than Photoshop, you can download the free trial version of Photomatix Pro from www.hdrsoft.com/. There's no time limit on how long you can use Photomatix, but it does inscribe a watermark across each of your photos unless you pay $99 for the full license.

Using Photomatix Pro

To use the program, do this:

1. Choose HDR | Generate and then click Browse.

2. Choose the series of photos that you want to process and then click OK.

3. In the Generate HDR dialog box, select the check box to align the source images—this lines up your photos in case you were handholding the camera or the tripod moved a bit between shots. Click OK.

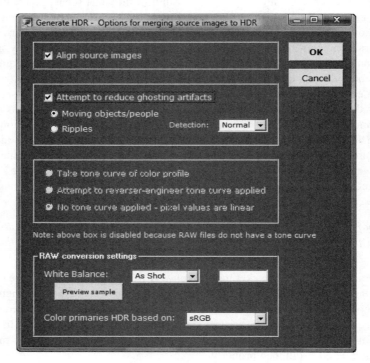

4. After a little processing time, you'll get a result. Don't worry—it won't look very good, but that's okay. This image is holding way more contrast information than the computer display is capable of showing. If you like, you can use the HDR Viewer window like a periscope to peer around in your photo and get a preview of all the detail hidden inside.

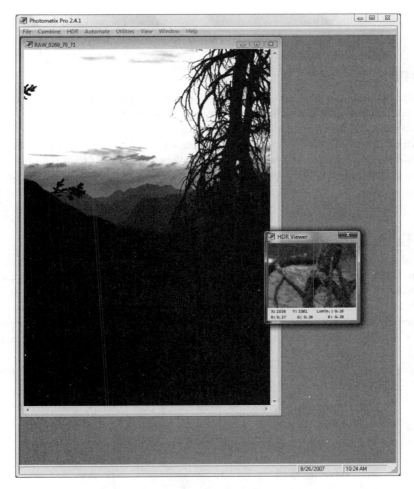

5. The final step is to optimize the image for the screen. Choose HDR | Tone Mapping.

6. On this final screen, you can tweak many aspects of the photo, such as the white and black level, the color saturation, and contrast levels. The defaults will probably look fine, but the two most useful values to fiddle with are Strength and Color Saturation. Feel free to experiment. That said, you'll probably find that often, you can just click OK—the results will look impressive without much tweaking.

High Dynamic Range photography isn't the ideal solution all the time. Because it relies on a series of photos, it's not appropriate for action photography—or, in fact, photos in which pretty much anything moves at all. It needs meticulous setup, with a tripod and enough patience to configure a series of bracketed images. And you need, of course, the software to glue it all

together at the end. But if you can deal with those shortcomings, you can make some photos that are nothing short of stunning.

Stacked Focus

Even more than dynamic range, depth of field is perhaps the most striking difference between photography and what you see through your own eyes. Unlike your normal vision, cameras can't keep everything in focus all at once. Instead, you get something called depth of field; one point in a photo will be in sharp focus, and everything in front and behind will be somewhat fuzzy.

Indeed, half the artistry of photography is choosing the right depth of field for a given photo. You might set your camera to give you a deep depth of field so most of the photo is in focus, or keep it shallow so your subject stands out against a sea of soft blue. Most of the time, though, it's very difficult to get your entire scene in focus. Photography is all about tradeoffs.

Miracle Cure for Depth of Field

Until now, that is. There are a number of programs that allow you to get the equivalent of infinite depth of field in your photos, with sharp focus from the foreground all the way back to the rear. How is this possible? By taking multiple photos of the same scene and stacking them afterwards into a composite that features only the sharpest bits of each image.

One of the best is Helicon Focus, available at http://helicon.com.ua/pages/focus_overview.html. Helicon Focus has a 30-day free trial and costs $30 thereafter. I'll use that program to demonstrate focus stacking.

Want to give it a try? Suppose you wanted to take a close-up photo of some small toys, arranged like this:

That's easy enough to do, but when you get in close for your macro photo, you find that only a very tiny slice of the image is in focus. You can put the astronaut in focus, or perhaps the globe, but not both at the same time, as in these examples:

To use Helicon Focus, just shoot them all. Put your camera on a tripod, focus on the nearest part of the scene, and snap the image. Then vary the focus slightly and shoot again. Lather, rinse, repeat—take as many photos as you need to ensure you get a series of images with various focal points in sharp focus from the front to the back of the scene. For this scene, I found I only needed five or six photos to get the astronaut, the globe, and the foot of a speaker way in the back of the scene. Then do this:

1. Start Helicon Focus.
2. Click File | Add New Items. Choose your set of images.
3. On the right side of the screen, click Run. After a few moments, you'll see a composite image.

4. On the program's Parameters tab, you can tweak the settings to try to get a better final result. Vary the position of the Radius and Smoothing sliders to get a sharper or more natural looking image. I have found that for macro photos, I need to lower both radius and smoothing. For more ordinary photos of the world at large, the defaults are pretty good.

Like HDR, this technique has limitations. You can't use it to shoot scenes with moving objects, and you really should use a tripod, because each frame needs to line up precisely with every other frame. And for best results, use a remote control or the camera's self-timer, since pressing the shutter release (especially for macro shots like my example) will reduce the sharpness and detail of the final image. But if you can put up with all those limitations, you'll be treated to an entirely new kind of photo—one in which the focus is always infinite.

Part IV

Using Your Images

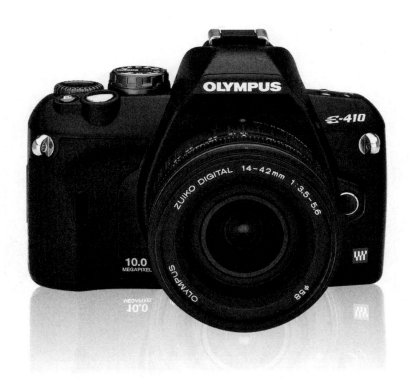

Chapter 16

Digital Photo Projects

How to...

- Turn images into wallpaper for the Windows desktop
- Add small images to letterhead in Word
- Create greeting cards on the PC
- Make a photo collage
- Make photo filmstrips
- Make your own newsletter
- Create a fake magazine cover
- Entertain kids with digital photos
- Turn your digital camera into a pinhole camera

Over the course of this book, I've shown you how to do all sorts of things to your photos—everything from the mundane, like sharpening, cropping, and brightening your images, to adding sophisticated special effects, like Chroma Key, high dynamic range, and abstract effects.

In this final chapter on image editing, let's talk about various ways you can turn your photos into multimedia works of art, gifts, and family activities. I'll even show you some simple tricks for creating stuff like Windows wallpaper, greeting cards, and letterhead with your images.

Cool Projects for Your Digital Images

Now that you know how to edit, manipulate, and embellish your images, you probably want to apply those skills by using images in projects that go beyond e-mailing images to your friends. One of the benefits of digital images, of course, is the ease with which you can incorporate them into projects like posters, greeting cards, newsletters, and business cards. Let's take a look at how you can get started doing this yourself.

Use Digital Images as Wallpaper

Let's start with something that's not only easy, but also can make your PC a bit more fun. Your Windows desktop can display any kind of image as long as it's been saved in a JPG, GIF, or BMP format. If your desktop still has that same old background that it had when you took it out of the box, you can use an image from your digital camera to brighten things.

To display your image on your desktop, do this:

1. Make sure your image is in JPG, BMP, or GIF format. As you know by now, most of your digital images are already in JPG format, so you're probably ready to go. Windows can't display a TIF or RAW image on the desktop, though.

2. Using Windows Vista, right-click the desktop, choose Personalize, and then click Desktop Background (or just choose Properties if you use Windows XP). The Display Properties dialog box appears.

3. Click the Browse button to choose the image. (If you're using Windows XP, be sure you're on the Desktop tab.)

4. Notice that you have a few options: you can choose to center the image, stretch it, or even tile it (if it's small enough to repeat across your desktop).

5. Click OK to close the dialog box.

If your image is too small for the display, it'll either be tiled to fill the screen or centered in the display with a lot of blank desktop around it. For photographs, I think centering looks good—tiling photographs just looks busy and annoys me (see Figure 16-1). Of course, it's your computer—you can experiment and arrange your display any way you like.

If the various members of your family all have their own separate login for the computer, everyone can select their own desktop background, and the appropriate one will start when each person logs onto the PC.

(a)

(b)

FIGURE 16-1 The same image shown (a) centered, (b) tiled, and (c) stretched

(c)

FIGURE 16-1 The same image shown (a) centered, (b) tiled, and (c) stretched (*Continued*)

Turn Your Pictures into Screensavers

The same is true of the Windows screensaver—everyone in the family can select their own, and it'll start displaying after a certain period of inactivity. These days, most monitors don't need screensavers to protect them from old-time dreaded "burn in," but screensavers are still fun to watch, which is why so many people use them.

Let Windows show off your digital photos. To use it, do this:

1. Using Windows Vista, right-click the Desktop, choose Personalize, and then click Screensaver (or, if you're using Windows XP, choose Properties and then, on the Display Properties dialog box, click the Screensaver tab).

2. From the Screensaver list, choose Photos. (In Windows XP, it's called My Pictures Slideshow.) Now, you can click OK and Windows will use some smart default settings to show the pictures on your hard disk whenever you stop using the computer for some short period of time. But you can customize the settings by clicking Settings.

3. When you're happy with the screensaver, click OK twice.

Make a Photo Collage

As the saying goes, everyone loves a parade. And a photo collage is a veritable parade of photos, which probably explains why they are so darned popular. A collage (which is just a collection of photos arranged on a single page) is easy to do and is a great way to showcase and share a collection of pictures from a special occasion. An easy way to make one:

1. Since a collage is just a collection of photos, you'll need a blank page on which to arrange them. You can make your collage small (for e-mail, perhaps) or large (for printing), but let's create this one big enough to print nicely on an inkjet printer. Choose File | New | Blank File and, when you see the New dialog box, specify a size of 8.5×11 inches. Since Photoshop Elements needs to know how many pixels to put in this blank page, also set the resolution to 200 pixels/inch. Click OK.

2. That will create a blank image that's 1700×2200 pixels. You should now have a blank canvas, ready to be populated with pictures. Now you're ready to start adding stuff. Find a picture that you want to add to your collage and open it in Photoshop Elements. This is the sort of situation where I like to use Windows Photo Gallery—I find a photo I like and drag it into the Photoshop Elements window.

3. Once the picture is open, tweak it however you like. Adjust colors or exposure if the photo needs any help. While you're working on it, crop the picture to taste using the Crop tool. You should be able to see your photo and the blank canvas in the Project Bin at the bottom of the screen, like this:

4. Now it's time to insert your first picture into the collage page. If you want to select the entire photo, press CTRL-A. If not, use the Rectangular Marquee tool to choose part of the image and choose Edit | Copy. Then switch to the blank canvas (double-click it in the Project Bin) and choose Edit | Paste. The picture should appear in the blank image, but it's entirely possible that it's bigger or smaller than you'd like it to be in the collage page. That's fine; we'll fix that in a moment.

5. Select the Move tool in the toolbar. Click in the picture you just pasted and drag it until you can see the lower right corner of the picture. Move the pointer over the bottom right corner of the picture. Now click and drag the corner to resize the photo, and click the check box at the bottom of the photo when you're happy with the size. You can also position the mouse over the middle of the photo to move it around on the page.

6. Now that you've positioned the first picture in your collage, adding more is a piece of cake. You can use this technique to add any number of images, give them unique sizes and positions, and make your collage as visually interesting as you like. Pictures can overlap or have white borders, it's all up to you. You can see what my collage looks like after using this technique in Figure 16-2. If you get "stuck," remember that you need to click OK to the resize check box before Photoshop Elements will let you switch to another photo in the Project Bin. And if you accidentally create a selection with the Marquee tool instead of moving a photo with the Move tool, choose Select | Deselect from the menu. Finally, you can control which photos appear on top by right-clicking the photo and using the Bring to Front menu item.

FIGURE 16-2 Create your own collage from a bunch of photos to present your images in a creative way.

Add an Image to Letterhead

If you use Microsoft Word and send a lot of letters, you might want to try this next project—creating your own personal letterhead with an embedded photo. I'll tell you how to do this using Word 2007, but the technique is very similar with older versions of the program. Here's what to do:

1. Open Microsoft Word. If you don't already have a new blank document open, create one.

2. Design the letterhead any way you like. You should set your formatting to single space and try to keep your text smaller than about 11 points. Here's what mine looks like:

3. To insert a photo, first position the cursor at the start of the letterhead text (in front of your name, for instance). Choose Insert | Picture and locate the image you want to include. The image will appear in your document.

4. After the photo appears in your document, you'll probably need to resize. Click and drag a corner until it's just about the right size.

5. Making sure the photo is still selected, click on the Format ribbon. Click Text Wrapping and then choose In Front of Text.

6. Now you can position the image in the letterhead region of your document, such as to the left of your name. If you like, add an effect to the photo using one of the picture styles in the Format ribbon.

7. Finally, you can finish the letterhead by drawing a thin horizontal line under the text and image (see Figure 16-3). To do that, click the Insert ribbon and find the Line tool in the Shapes drop-down. Then click the Line tool and drag out a horizontal line, holding down the SHIFT key at the same time. The line will snap to the horizontal automatically.

Create Your Own Greeting Cards

You can make greeting cards using your computer in two ways: the easy way and the not-as-easy-but-still-not-very-hard way. The easy way is by using one of the many greeting card software packages on the market (see Figure 16-4). Not only can you import your digital camera images into these programs, but they also come with a considerable collection of clip art and premade card templates.

FIGURE 16-3 Images can make your letterhead look quite elegant (unless it's a picture of me…).

If you don't have one of those programs, you can still make your own greeting cards in a program like Microsoft Publisher or Microsoft Word. Because Word is the lowest common denominator—almost everyone has it—let's create a card in that. Before we get started, though, it's worth pointing out that you can make a greeting card on the PC in two common methods: the single-fold and the dual-fold.

Single-fold cards are simply made from 8.5×11-inch paper or cardstock and folded once down the middle, so the card measures 5.5×8.5 inches. This is a slightly oversized card, but it's the one I usually use. The alternative is a dual-fold card that's folded once lengthwise and again widthwise, for a card that measures 5.5×4.25 inches. The disadvantage to this kind of card is it's a bit small and it has a potentially ugly double-fold along one edge (see Figure 16-5).

FIGURE 16-4 Programs like Microsoft Greetings Workshop let you import your own digital images into their greeting card templates.

Single-fold

-side	one-
Back	Front

-side	two-
	Inside Right

Dual-fold

	Front
Inside Right	Back

FIGURE 16-5 You can make either single-fold or dual-fold cards on your PC with almost any program.

To make dual-fold cards in Word, one of the panels needs to be printed upside down. So it's easiest to use Word for single-fold cards, as in this example:

1. Open Word and create a new document.

2. Change the document into a landscape orientation. To do that, click the Page Layout ribbon, click Orientation, and then click Landscape.

3. Now you need to give the document two columns. Each column will be a panel on the finished card. While still on the Page Layout ribbon, click Columns and then choose Two.

4. Now you can enter your text. The left column on the first page is the rear of the card. If you want to, you can add something to the bottom of the rear panel like commercial greeting cards have. Press ENTER enough times to get to the bottom of the page.

5. Now it's time for the front of the card. That's the right column on the first page, so press ENTER to get there. You'll probably want to insert an image there using Insert | Picture. You can place text above or below the image, or you can integrate the text in the image in a program like Photoshop Elements first. Be sure to experiment with large and stylish fonts for this card.

TIP *Microsoft's WordArt is a cool way to dress up a greeting card in Word. Choose Insert | Picture | WordArt to insert WordArt into your project. WordArt lets you turn plain text into a fancy 3-D piece of art.*

6. The inside of the card is on the second page. The left inside panel is the left column, and the right inside panel is the right column. Enter text and images as necessary to lay out the card you want to create.

7. When you're done, you need to print your card manually so it doesn't print the second page of the document on a second sheet of paper. To do that, you have two choices:

■ Load only a single sheet of paper in the printer. When the first page is printed, turn the paper over and load it back in for the second pass, *or*

■ Change the printer settings. Open the Printer Properties dialog box and change the printer's paper source to Manual.

TIP *If you're printing on an inkjet printer, make sure you wait a few minutes for the first side to dry before turning the paper over and printing the second side. See Chapter 17 for more information on printing.*

Make a Photo Filmstrip

When I showed this particular project to my daughter, I said that I didn't really know what to call it. My intention, as I explained to her, was to arrange photos in a line to look like an old-fashioned filmstrip, with the center picture popping with color, but all the other images somewhat bleached or devoid of color. Sort of like a horizontal collage, with some color tricks applied for good measure. I envisioned making this sort of thing as a gift, with a recent picture in the center and older snapshots on either side. Here's what I showed her as my working example:

She suggested calling it a "lifestrip," and I suppose that's a pretty good title. Here's how to make your own:

1. First, pick a series of pictures to include in your own filmstrip. Five to seven pictures is a good number. Pick your pictures and load them all into Photoshop Elements, so they appear in the Project Bin.

2. Now we need to make sure each and every one of the pictures is exactly the same height. That'll be important later, when we paste them into the filmstrip. If you were planning to make a small lifestrip—just 300 pixels high, for instance—you'd probably want to make all of the pictures 300 pixels square. Select one of your pictures and then click the Crop tool. In the Options palette, enter 1 in both the Width and Height boxes, so you get a square crop frame. Then crop the photo using this setting, so you get a square image cropped to taste.

3. After the photo is cropped square, choose Image | Resize | Image Size and set the width and height to 300 pixels (if the Constrain Proportion option is checked, you'll only have to type 300 once and it'll automatically get added to the other dimension). Click OK. You've now cropped your picture and sized it to fit perfectly in the lifestrip panel.

4. Go ahead and repeat the process on all the other pictures.

5. When you're done resizing your photos, it's time to make the filmstrip. Choose File | New | Blank Image. In the New dialog box, create an image that's the combined width of all the images and exactly the same height as each picture—in this example, you might choose 1500 pixels wide and 300 pixels high. Click OK.

6. Select a picture, press CTRL-A, and choose Edit | Copy from the menu. Switch to the filmstrip and choose Edit | Paste. Click the Move tool and drag the picture to the far left of the filmstrip. Notice that the picture will try to "snap" to the edge of the photo, so it's easy to make sure it's in the right spot.

7. Now it's more lather, rinse, and repeat: copy each picture and paste it into the strip, then position each picture beside the next. You should now have a strip that looks like this:

8. Finally, you can use saturation to draw attention to the center picture. Click the Move tool and click the center picture. Then choose Enhance | Adjust Color | Adjust Hue/ Saturation from the menu. Drag the Saturation slider up to about 20, then click OK. You should see the center picture "pop" a bit, since its colors have been enhanced.

9. Now start on the far left of the lifestrip. Click on the furthest picture and choose the Hue/Saturation/Lightness control again. Lower the saturation to about –60 and click OK. Lower the saturation of all the other pictures (except the center one, of course) in a similar way.

When you're done, you can save and print your project. As an alternative, you don't have to paste the pictures into a strip: you can instead make seven individual prints and mount them on your wall in individual frames.

Create a Newsletter

Equipped with Microsoft Publisher or a similar page layout program, you can create professional and attractive newsletters for the office, family, or your club or organization. Publisher comes with most versions of Microsoft Office, and I highly recommend it for generating your own newsletters (as well as business cards and other projects). Publisher is a wizard-based program. All you have to do is follow the directions to set up the overall look and feel of your document, and then fill in the text and replace the placeholder images with your own pictures.

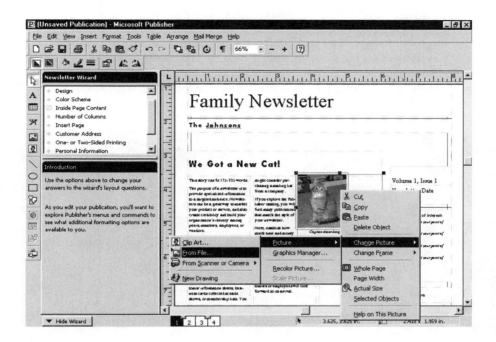

Make a Magazine Cover

At gift time, I believe photos are some of the most personal and most appreciated gifts you can give. But just handing someone an 8×10-inch photo lacks that certain *je ne sais quois,* as the French like to say. So I like to do things with my pictures that are a bit unusual. The next time a birthday rolls around, here's a clever gift you can make all by yourself, without any help from a bakery: a framed mock magazine cover featuring your guest of honor.

This is easy to do. All you need is an appropriate, high-resolution photo and an image-editing program to make some surgical changes. Then send it to the printer and it's ready for framing. Because this will eventually be printed on an inkjet printer at 8×10-inch size, you should start with a 2- or 3-megapixel image. For this example, I'm going to make the debut issue of *Kristen* magazine using this image:

1. The first order of business is to give your picture a magazine-like outline. Load it into your image editor and add a blank border area around your image. You can make it any color you like but, for my picture, I think a nice fire-red border will be very magazine-ish. In Photoshop Elements, choose Image | Resize | Canvas Size. At the bottom of the dialog, click Canvas Extension Color and choose a color. Next, in the new size area of the dialog, choose Relative and enter a border dimension of about .5 inches.

2. Click OK to create the border. You should see a red border added around the outside of the image.

3. What's a magazine without a catchy title? Mine will be called *Kristen* magazine—after all, it's the place people go when they want to read all about Kris. Click the Horizontal Text tool and create your title and other text around the page.

4. From here, it's all up to you. Add some "cover lines" to your magazine to make it look more like a real publication. Add an issue date, some revealing new feature, and more. If you're ambitious, you can photograph a bar code from a real magazine and paste it into the cover. My first draft looks something like this:

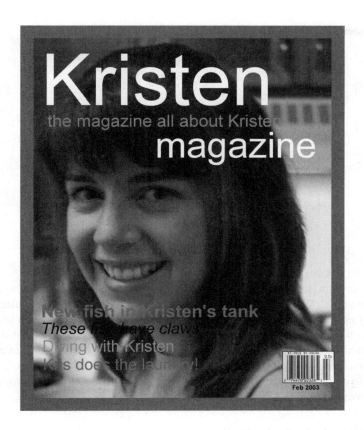

Photo Projects for Your Kids

Adults aren't the only ones who love photography; kids seem to have an innate love of picture taking as well. If you need proof, just give a kid a disposable camera and watch his or her eyes light up! And I know that it was my dad's generosity with lending me his camera that cemented my lifelong love of photography.

These days, there are quite a number of digital cameras that are cheap enough for the younger set. So if your children or grandkids have their own digital camera—or access to the family camera—sometimes they need a few fresh ideas to keep taking pictures.

Conduct a Mystery Photo Contest

When they first get access to a camera, it seems like kids will never run out of cool things to take pictures of. But after a while, the thrill wears off and they stop taking pictures of everything that moves. So when your kids need some inspiration, suggest that they conduct a Mystery Photo Contest. If they're so inclined, it could become a weekly event in your household.

What is a Mystery Photo Contest, you ask? Picture something like this:

What is it? Well, that's what the contest is all about.

Armed with a camera, task your kids with sniffing out ordinary objects in the house and around the neighborhood. When taken close-up, many common things take on unusual and even otherworldly appearances—especially if they're shown upside down or at an unexpected angle. If you don't want to entrust your kids with a digital camera, don't forget that if you have a scanner, you can also send them off to shoot pictures with a cheap disposable film camera, and you can scan the pictures into your PC later.

By the way, if you guessed "cap from a container of glue," then you're ready for a Mystery Photo Contest of your own.

Make a Photo Jigsaw Puzzle

When is a digital photo also a game the whole family can play? When it's a jigsaw puzzle.

If you're looking for a new and unique activity for the family, consider turning pictures the family members take into jigsaw puzzles, which you can then solve together, or give to the kids to solve on their own. You can make pictures into real, live puzzles by gluing a print of your photo onto a piece of cardboard (the thicker the better), and then cutting it carefully into curved pieces.

If you're not that handy with glue and scissors, you can solve your puzzles on the computer screen. Consider BrainsBreaker, for instance; it is an onscreen jigsaw puzzle game that lets you create puzzles out of any picture on your computer.

You can download a free trial of BrainsBreaker at www.brainsbreaker.com. If you like it, the complete program costs $20.

Make a Photo Journal

There's a little reporter in every kid, or so it seems. If you want to nurture that aspect of your kid's intellect, suggest that they create a photo journal. Here's how it works: your kid picks one

day each week to carry a digital camera around and snap pictures of anything that he or she finds interesting. There's just one rule: take pictures. Lots of pictures.

When the camera comes home at the end of the day, your child can transfer the pictures to the PC, and then organize the images into a journal, complete with captions for each picture. You can keep these journals on the PC—in a program like PowerPoint, for instance—or print them and bind them into homemade books.

There's an added benefit to the photo journal: not only does your kid have fun, but you get glimpses into his or her day that you can keep and look back on for years to come.

Photo Gifts

Looking for ways to turn your photo collection into gifts you can give away to friends and family? The photos on their own can be cool, but using them as part of a larger project can be even better. Here are a few ideas to get you started.

Do Something Arty

Is there a little Andy Warhol in you? Perhaps you're a little more Roy Lichtenstein or Claude Monet. No matter what your taste, you'll probably find something at www.photowow.com. These folks take your photos and turn them into posters in the style of pop art, collages, cartoons, and montages. There are three dozen basic designs to choose from, and a slew of additional variations to customize the look of your image. It's a clever and unexpected way to use your photos, but be warned: the prices here are not for the faint of heart. 11×14-inch prints cost about $100, and 48×60-inch posters (which are admittedly quite large) cost anywhere from $200 to $500, depending upon the specific style and the paper finish.

Turn Pictures into Postage

Or how about the other end of the spectrum: instead of $500 photos you can hang on the wall, try 41 cents for a stamp the size of a postage stamp. Actually, it literally is a postage stamp. The concept: upload your favorite photo, and Stamps.com then sends you a sheet of perfectly legal U.S. postage stamps. So to test it out, I made a sheet of stamps using my orange tabby's face. Just a few months later, though, the Postal Service asked Stamps.com to suspend the service. I thought it was over forever, and I was glad to have acquired a sheet of personalized photo stamps before it was too late.

Well, Stamps.com is back. You can make a sheet of twenty 41-cent stamps based on a personal photo for about $22. And they're not the only game in town. You can also try www.pictureitpostage.com, which offers essentially the same service for the same price.

Make a Holiday Scrapbook

One way to get more eyes on your photos is to actually print them. I've become fond of scrapbook tools that let you create a bound book of prints from your digital photos. And there's no shortage of ways to create these books. Online photo printers like Shutterfly.com, snapfish.com, and ofoto.com

How to ... Create Gifts from Pictures

Many web sites and local photo stores can take your digital images and use them to create all sorts of interesting gifts, like coffee mugs, T-shirts, refrigerator magnets, jigsaw puzzles, and even food (your picture can be added in edible food dyes to cookies, cakes, and candies). Sites like ClubPhoto.com, ofoto.com, and PhotoWorks.com (check out Chapter 18 for more sites) all offer these basic services. If you're shopping for a picture-apron or you want to eat some vacation shots, check out these web sites.

all let you assemble hardcover and softcover photo books from your own photos for reasonable prices (in the neighborhood of $30). For even more flexibility with your photo book design, you might consider a program like Epson's StoryTeller, which includes not just an easy-to-use photo layout program, but also the raw materials (like paper, binding material, and cover) to make a book. It's available at http://tinyurl.com/y8kaa3. Prices range from $20 to $30, depending upon the size of the book you want to make.

Make a Digital Pinhole Camera

At the risk of dating myself, I feel compelled to say that when I was a kid, I did all the things budding geeks were supposed to do. I made a crystal radio (a simple radio that worked without any need for a battery) and a pinhole camera. A pinhole camera is perhaps the simplest kind of photographic device, because it uses no lens. A tiny pinhole in a well-sealed cardboard box is really all you need to focus an image on film.

You can experience some of the last-millennium excitement of making your own lens-free digital camera. For the best results, you need a Digital SLR (so you can remove the lens), a body cap (the cover that screws onto the camera body when there's no lens attached), some heavy foil, and electrical tape. Ready to play along?

Drill Some Holes

To begin with, you'll need to make a hole in the camera's body cap (the small cover that protects the camera's mirror and sensor when there's no lens on the camera). I wouldn't poke a hole in my only body cap, so stop into your local camera shop and get a spare. They cost about $3 each, and it's always handy to have one or two in case you need to remove the lens for more than few moments (such as when you are getting ready to clean the sensor or if you're sending the camera away for servicing).

The size of this hole isn't especially important; I drilled a 5/32-inch hole in the center of the cap using an ordinary household drill. (I should probably point out that I removed the body cap from the camera first.)

Next, you need to make a smaller hole in some heavy foil—this is the real pinhole. A disposable pie tin works great for this. Cut a small circle out of the tin that will fit inside the back of the body cap and then use a thin, sharp pin or needle to make a tiny hole in the metal.

When you're done, use some electrical tape to position the pie tin on the body cap so the two holes line up, with the small hole in the center of the circle.

Take Some Pictures

Now remove the lens from your camera and insert the body cap. You've just made a pinhole camera—instead of expensive, multi-element, precision optics, your camera is now focusing using the low-tech principle that an extremely small hole will cause a relatively sharp image to resolve on the sensor.

From here it's all about experimenting. You'll almost certainly want to use a tripod, because the tiny hole means you'll need to use long shutter speeds. You should set your camera to its manual exposure mode and start with a 1-second exposure. Check your results and go up from there; I found a 15-second exposure was good outdoors at midday for my particular pinhole, like this sundial snapshot.

Teaching Tool

Why do this? Well, it's fun, and a completely unexpected way to use your digital camera. In addition, your pinhole camera is a good prop to use for teaching kids about the basic physics of photography. Try making several tin plate body cap inserts, for example, with different size holes. You can vividly demonstrate how the smaller the hole, the sharper the image—but also the darker the preview, and the longer the necessary exposure. An infinitely small hole would give you perfectly focused results, but the exposure time would be rather lengthy, since only one photon of light could get through to the sensor at a time.

Try It with a Point and Shoot

If you have a point-and-shoot camera, you can try this experiment, but the results won't be as good, since you can't remove your lens. You'll need to drill the hole in the camera's lens cap (again, I suggest that you do it to a spare). When you try taking pictures, set your camera lens to the longest telephoto setting available. And then use your camera's manual focus mode to focus on infinity. That'll give you the most authentic pinhole effect.

Chapter 17

Print Your Pictures

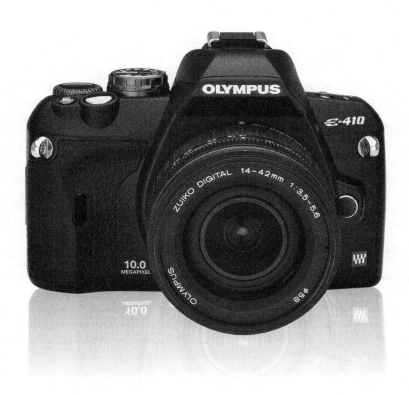

How to...

- ■ Choose the printer that's right for you
- ■ Distinguish among laser, inkjet, and dye-sublimation printers
- ■ Shop for a printer
- ■ Match resolution to print size
- ■ Choose the right kind of paper for your print job
- ■ Print an enlargement with Photoshop Elements
- ■ Configure your printer for paper and quality
- ■ Determine what side of the paper to print on
- ■ Care for prints after they come out of the printer
- ■ Let someone else print for you

A lot of the time, it all comes down to this: no matter how versatile the digital medium is, a digital camera isn't very useful unless you can make prints. Great prints. Prints that look every bit as good as what you used to get from your old film camera and the local photo shop.

If that sounds like something you would say, you're in luck. Print technology has improved to the point that it's possible to make your own prints that look just as good as (or better than) what you used to get from a film camera. Using a digital camera and your computer, you can tweak your prints so they look exactly the way you want them to, and you can print them any way you like, from wallet size all the way up to near-poster 13×19 inches. If you prefer, you don't even have to print the photos yourself; online printing services and local stores can do it for you.

In this chapter, I'll talk about everything you need to know to get great prints from your digital images. When you're done, you'll be able to frame your creations, and no one would guess that the pictures came out of a computer printer.

Use the Right Printer

Not all that many years ago, there was a time when computer printers had a reputation for, shall we say, substandard output. Of course, everyone thought it looked pretty good at the time, but there was no way anyone would mistake what came out of a computer printer for a real photograph. Printers couldn't depict enough colors. The resolution was too low. Obvious bands of different intensity colors ran through images like Venetian blinds on a window. And those were just the most vexing of the output problems.

Then, a few years ago, it all started to change. Around the same time that scanners became affordable and digital cameras began to hit the scene, printer manufacturers had new incentives to make their products work better. By the late 1990s, most mainstream printers could create passable prints from computer images, and the top-of-the-line printers made prints that were essentially photo-realistic.

In the last few years, not a lot has changed. For most practical applications, it's not possible to make prints look much better to the casual viewer, so printer manufacturers have turned their attention to other aspects of digital printing, like making the prints last longer before they fade and making the printers themselves easier to use. I'll discuss this area in more detail in the section "What to Look For."

Choose a Printer

Before we get started printing, let's talk about the printers themselves and how to choose the right one. Buying a printer isn't an easy decision because not only are many different brands of printers competing for your attention—and lots of different models from each manufacturer—but you also have to figure out what kind of printer you want. In general, most people will gravitate towards an inkjet printer. But, to be sure, let me tell you about the variety of printers you can choose from.

Laser Printers

Laser printers are like specialized photocopiers. Using the digital image in the computer's memory as a template, a laser printer electrically charges a piece of paper. The printer then allows *toner*—a fine ink-like powder—to come into contact with the paper. (See Figure 17-1 for a look at a typical toner cartridge.) The toner sticks to the paper in places where it has an electrostatic charge and, finally, the toner is permanently melted into the paper by a hot fusing wire.

Laser printers have a lot of advantages. They can print quickly (many personal laser printers can generate as many as eight or ten pages per minute), and the toner lasts a long time, yielding a low cost per page. My HP LaserJet 1200 prints about 3000 to 5000 sheets of paper for each $80 toner cartridge. Those advantages add up to a good all-around office printer that handles most

FIGURE 17-1 A toner cartridge, partially inserted in a color laser printer

common print jobs pretty well. Personal laser printers can be had for between $100 and $500, with many excellent models priced under $300.

Inexpensive laser printers only print black and white images, though color laser printers are available, starting around $500. Unfortunately, laser printers, both black and white and color models, tend to be better at printing text than graphics. They simply don't have the ability to create the range or the density of colors found in inkjet and other printers, so the results are not the sort of thing you'd want to frame and hang on the wall. Inexpensive laser printers also limit you to a print size of 8×10 inches, while you can get wide format inkjet printers capable of printing near-poster sizes. Bottom line: color laser printers might be okay for printing business graphics (like PowerPoint slides) and making fast draft prints of photos, but they're not up to the task of making framed photos. On the other hand, keep in mind that you can print a large quantity of prints quickly and inexpensively with a laser printer. My family, for instance, prints a family newsletter on a color laser printer at the holidays. That's something to consider if you need to print photos in bulk and the goal isn't to hang the images on the wall. (Though be sure not to try printing on the shiny side of photo paper, because laser ink won't stick to it—you'll just get a goopy, inky mess.)

Inkjet Printers

If you want to print images, I think inkjet printers are the best all-around printing solution for most people. They produce excellent color output and can also print text at a reasonable speed, as long as you don't need to print a lot of it.

Inkjet printers are, in some ways, a simpler technology than laser printers. Simply put, they work by spraying microscopic droplets of ink onto paper. You can see an inkjet's internals—complete with ink cartridges—in Figure 17-2. Of course, it gets a lot more complicated than that. Printer manufacturers exert a lot of effort making sure that the dots are small; that they combine with other dots to mimic thousands of distinct colors; that they dry fast enough so they don't spread, run, or smear; and that the paper is optimized to handle the ink's chemical characteristics. It's a highly technical business.

Nonetheless, we generally don't have to worry about most of that stuff. What matters is that they create stunning output and they're pretty affordable, typically running between $50 and $400 (though professional-caliber inkjets can cost more than a thousand dollars).

Don't worry about image quality from a good inkjet printer. Inkjet technology has improved to the extent that it can be difficult to distinguish between a print from a film camera and a quality inkjet print made on photo-grade paper. My walls are covered with digital images that I've printed, matted, and framed (see Figure 17-3). No one can tell the difference, or even particularly cares about the difference between film and digital prints anymore.

Dye-Sublimation Printers

A small but important segment of the printer market is occupied by dye-sublimation printers (also called *dye subs* for short). Look inside a dye-sublimation printer, and you'll see a long roll of transparent film that appears to be sheets of red-, blue-, yellow-, and gray-colored

FIGURE 17-2 The print head slides back and forth across the page, spraying dots of ink as it goes.

FIGURE 17-3 These pictures were printed on an Epson Stylus Photo 1270.

FIGURE 17-4 Dye-sublimation printers make great, continuous tones photos thanks to easily replaced rolls of dye.

cellophane (see a dye-sub printer and cartridge in Figure 17-4). The film is composed of solid dyes corresponding to the four basic colors used in printing: cyan, magenta, yellow, and black (CMYK). The print head heats as it passes over the film, causing the dyes to vaporize and permeate the glossy surface of the paper before they return to solid form. Because the dye gets absorbed and goes just below the surface of the paper, the process is called *dye sublimation.* Because the color infuses the paper, it's also less vulnerable to fading and distortion over time. Dye-sub printers also create "continuous tone" images—they have no dots whatsoever, something you tend to get with inkjet printers (and can see if you look closely at a print, such as with a magnifying glass). Bottom line: the results from dye-sub printers are nothing short of stunning—they typically look just as good as prints from film or photos in a magazine.

The downside: dye-sub printers are not very efficient when it comes to printing text, so if you invest in a dye-sub printer, consider it a second printer, which you'll only want to use when you're expressly printing photos. Also keep in mind that most dye-sub printers are somewhat small. Typically billed as "compact photo printers," dye-subs generally create 4×6-inch or 5×7-inch prints. You can also find a couple of 8×10-inch dye-sub printers, but nothing larger. Canon's popular line of Selphy printers, for example, make 4×6-inch prints and are priced between $100 and $300. The great thing about these kinds of printers is that they make it easy to get traditionally sized 4×6-inch photos without fiddling with any special printer settings.

Need bigger prints? Full-page, 8×10-inch dye-sub printers are priced beyond $1,000. These printers are more commonly used in the professional arena, where publishers can inexpensively make test prints that show what output from the final printing press eventually looks like.

You May Need Two Printers

I have two printers. I use an HP LaserJet 1200 for routine text printing—I do a lot of that—and an Epson Stylus Photo 1280 for all my image printing.

Do you need two printers? It might seem a bit decadent at first, but it might be quite practical, depending on how much printing you do. Both inkjets and lasers are reasonably affordable these days, but an inkjet alone will lead to slow and comparatively expensive routine printing. That's why I have one of each. I can also see the value in having a dye-sub photo printer for making 4×6-inch photos if you have friends or family that like getting prints.

Make no mistake: output from dye-sublimation printers looks great. But, given all the disadvantages, I think you're better off choosing an inkjet unless you want to make a lot of 4×6-inch prints. And, because pictures from inkjets look so good—just about as good as from a dye-sub—there's hardly a reason to choose otherwise.

What to Look For

Okay, so let's suppose that you want to buy an inkjet printer. At least, that's the assumption I'm making. If you don't agree with me, you're shopping on your own. Actually, I'll talk about laser printers as well. I hope you're happy.

Where do you start? Walk into a store and all printers tend to look more or less the same. And, in my humble opinion, most salespeople are not particularly helpful unless you already have a pretty good idea of what you want. So use this checklist to help choose your printer:

- **Resolution** Resolution is measured in dots per inch (dpi). Virtually all laser printers print at 600dpi or 1200dpi. In the inkjet world, resolution varies quite a bit, though many printers will typically be advertised as either 2880dpi or 1440dpi. These numbers are deceiving, though—for all intents and purposes, all inkjet printers really print around 300dpi. I explain why in the section "The Right Resolution."

- **Number of colors** This is irrelevant for a laser printer, of course, but when shopping for inkjet, look for a printer that uses a pure black cartridge instead of mixing all the other colors to mimic black. (The result is a muddy gray-brown instead of black, and these printers use up their ink exceptionally fast.) Better inkjet printers use five or more independent ink color cartridges to create more realistic photo prints, but four cartridges (black plus three colors) is the absolute minimum you should accept. You can also save money on replacement inks by buying a printer that has separate cartridges for each color. That's way, when one color runs low, you don't have to replace all the inks at once.

■ **Speed** You should pay attention to the printer's speed, measured in pages per minute (ppm) and resolution. Slow laser printers run at 8ppm; the fastest are around 24ppm. Remember that inkjets print much more slowly, and I don't think the speed rating for an inkjet is especially important; color is their selling point, not speed.

■ **Eyeball the prints** No matter what the specs say, a printer is only as good as the prints. If you can, try out printers in the store before you buy. (If that's not possible, check out reviews at dedicated photo web sites like dpreview.com.) Most computer stores have demo models set up that spit out prints when you press a test button. And, as I mention in the section "Work with Paper," the paper is just as important to print quality as the ink and the printer itself.

■ **Ease of use** Once you get the basic specs down, you might want to consider some less-tangible factors like ease of use. Most printers come with status monitor software that lets you get important information about your printer—like how much ink is left—right from the Windows desktop. If you have a notebook PC or a handheld computer, you might want to print directly to your printer via the wireless infrared port. Few printers have infrared support, however, so you'll have to shop around. An emerging feature is Bluetooth printing. *Bluetooth* is a wireless networking standard that cell phones, PDAs, laptops, and other gadgets can use to exchange data. Epson is one of the first printer companies to directly support Bluetooth printing, and it sells a Bluetooth adapter for a handful of its inkjet printers. Other companies, like AnyCom and MPI, sell Bluetooth adapters for common printers.

■ **Direct printing** Many printers let you connect your digital camera directly to the printer—or insert the camera's memory card into the printer. This lets you circumvent the PC for fast and painless printing.

■ **Size and capacity** Although most major manufacturers like Epson, Canon, and HP make good printers that generate excellent results, they differ dramatically in terms of what kind of paper they can print on. Most printers print up to 8.5×11 inches. You'll have to buy a wide-format printer if you want to create 11×17- or 13×19-inch prints.

■ **Dye versus pigment** If you're shopping for an inkjet printer, you should know that most models use dye-based inks, while some higher-end or professional designs rely on pigment-based inks. If you're concerned about generating prints that are highly resistant to fading, investigate pigment-based printers. On average, you'll find that most (dye-based) inkjets can make fade-resistant prints last for 10 to 20 years. Pigment-based printers generate prints that last for 100 years. On the other hand, cheaper dye-based inks are somewhat brighter and more vivid than more expensive (but longer-life) pigment-based inks.

Print Your Images

So you're all ready to print. You've downloaded your pictures from your camera to your PC. You have a printer connected to the computer. Let's talk about the things you need to ensure great prints.

The Right Resolution

The resolution of your image is one of the most important factors that determine how good your pictures look when printed. Printers do vary but, in general, they tend to support this print resolution:

Type of Printer	Resolution (in dpi)
Laser	600 or 1200
Inkjet	200–300
Dye sublimation	300

Experimentation is key, though. Choose a high-quality image and sample it at several different sizes. Print each one and compare them to see where the quality threshold lies with your printer. In other words, what minimum resolution do you need to eliminate obvious pixels and jaggedness from your prints?

Suppose you want to print an image on an inkjet printer. Let's assume that 300dpi is about right for your printer. To determine how big your image should be (in other words, how many pixels it needs) before you print it, just multiply the output size you want (in inches) by 300. The following chart illustrates the minimum dimensions of your image for a variety of common print sizes with an inkjet printer:

Print Size (inches)	File Size (pixels)	Approximate Camera Resolution Needed
4×6	800×1200	1 megapixel
8×10	1600×2000	3 megapixel
11×17	2200×3400	6 megapixel
13×19	2600×3800	10 megapixel

Wow. Surprised? It takes a lot of pixels to make high-quality prints. So what does that chart mean—that you should have a 10-megapixel camera to make a 13×19-inch print with a wide-format inkjet printer?

Well, yeah, that's exactly what it's saying. But there's good news: you can cheat. Many printers will still give you great results, even if you feed them an image that's underpixeled. In other words, suppose you have a 1600×1200-pixel image. You might still get quite decent results by printing it at 11×17 inches, or perhaps even 13×19. Try it out and see.

The expected viewing distance also plays a role. Here's what I mean: If you're printing a 5×7-inch photo that people will hold in their hands, then you'll want the best resolution—you'll want to send a 300dpi photo to your printer, for example. But if you're printing a 20×30-inch poster that's going to hang on the wall, 200dpi is probably fine. In fact, you might even be able to get away with 150dpi. Why? People won't get as close to the photo, so the greater viewing distance will make it harder to see individual pixels. So remember that the farther you stand from a picture, the lower the print resolution can be.

Increase Print Size with Resampling Software

Need to print an image at a certain size—like 8×10 inches, for instance—but don't have nearly enough pixels to make the picture come out sharp? Or perhaps you have a 6-megapixel picture that you want to crop down to a much smaller size, yet still turn it into a poster. You might want to try resampling the picture with a program like Genuine Fractals or pxl SmartScale.

Programs like these can digitally enlarge your image while preserving quality using a complicated mathematical procedure that does a pretty good job of reducing noise and digital artifacts.

Make no mistake: these programs aren't magical and can't add information to a picture that wasn't there to begin with. But they can sometimes do an amazing job nonetheless. In my experience, you can often increase the size of a photo by several factors with little to no visible loss in print quality. That's pretty cool.

Genuine Fractals (available from www.ononesoftware.com) is available in several versions, with a consumer version selling for about $50, though it won't input an image any bigger than 1500×2100 pixels, and it won't let you enlarge the image to a file size any bigger than 64MB. That makes this version affordable, but means you can only use it to work with images that are 3 megapixels or less. You can also get a $150 version that has no file size limits.

Pxl SmartScale, on the other hand, also available from www.ononesoftware.com, is available for about $150.

Using either program is a piece of cake. Essentially, you simply choose to save your picture in the new, resampled format from any plug-in compatible program, like Adobe Photoshop or Paint Shop Pro. When you open your saved file in SmartScale, for instance, you can choose how much to enlarge (or resample) it via a set of controls that look like this:

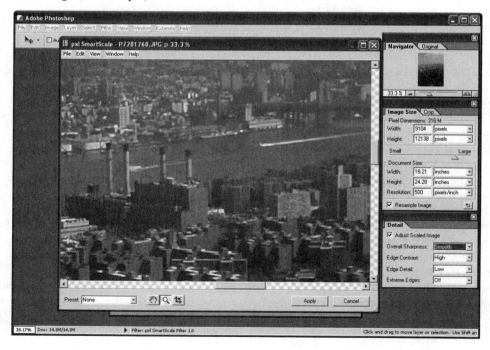

Did you know?

The Real Resolution of an Inkjet

Confused? I said earlier that inkjet printers come in resolutions up to 2880dpi, yet now I claim they print around 300dpi. Which is it? How can one number be so different from the other?

I agree: it is confusing. The simplest answer is that printer companies aren't being entirely honest with you. The resolution they advertise on the box isn't a measure of how many pixels per inch (ppi) the printer can accurately lay down on paper. If it were, 2880dpi inkjets would be capable of printing photos of professional magazine quality, and that's clearly not the case. So something else must be going on.

Indeed. Here's the deal: the advertised resolution of an inkjet printer is a measure of the accuracy of mechanical systems like the step motor that drives the print head around on the page and the precision of the nozzles themselves to make tiny dots of ink on the paper. Certainly, you want the printer to be as accurate as possible, but, in reality, it takes several steps for the print head to make a single pixel on the paper—and it's those pixels of color, in the end, that limit the printer's maximum resolution. So, an inkjet with a resolution of 2880dpi isn't necessarily a whole lot better than an inkjet with a resolution of 1440dpi or 300dpi. Visually, prints made with one printer might look slightly better than the other, but certainly not twice as good. It's like buying a 3GHz computer. It's faster than a 1.5GHz PC, but it's not twice as fast, because a lot of factors affect computer speed besides just the processor.

Put another way, a printer with a lousy step motor can visibly degrade the quality of a print. But buying a printer that has a 10000 dpi resolution via the way that companies like Epson measure that sort of thing today will only result in more perfectly formed ink dots. Those ink dots, when combined with many other ink dots, collectively form the pixels that represent your photos. And those pixels are limited by other factors.

An inkjet printer's top resolution—if it's marketed as something insanely high, like 2880dpi—is not as important as other factors, such as using a sharpening filter on your image before printing and choosing the right paper.

So what resolution should you use when you print? The honest-to-goodness dpi of most inkjet printers is still in the range of 150–300dpi, usually just about 240dpi. If you start with a sharp image and plan to use high-quality inkjet paper, you might see a small difference in image quality if you feed the printer a 300dpi image. But the difference will be small, and you can generally get great results with as little as 200dpi. If you send images to the printer that have a dramatically lower resolution, like 100dpi, you'll be able to tell the difference.

Too Much or Too Little Resolution

As I already mentioned, to get good results when printing a 4×6-inch print from an inkjet printer, you need to start with a photo that has at least 800×1200 pixels. That will help you avoid pixels and jagged edges in the final image. What happens if you print an image that doesn't have enough pixels for the size you want to achieve? You get something like Figure 17-5.

That's what happens when you print too few pixels for the size you're shooting for. What about too many pixels? Can an image that's too high-res ever be a problem? The answer is generally not. Too many pixels isn't really a problem, though it does make your image file bigger than it has to be, and it can potentially slow everything down. The bottom line is this: if you pack more pixels than you need into an image—above 200dpi, for instance—odds are good that you won't improve image quality very much. Instead, you'll just make the file bigger, which takes more storage space on your hard disk and can slow down the printing process.

TIP *Test your own printer by generating prints in high-quality mode at 150, 200, and 300dpi. Use these to figure out what the resolution threshold of your printer is, and strive to use that setting as often as possible.*

Of course, all this advice is specifically for someone who wants to know how much resolution an image needs to print well at a certain output size. If the output size isn't important—if you don't care if the print is 4×6 or 8×10, for instance—but you simply want to make sure to have a sharp, quality print, then just print the image smaller. Cramming, however, many pixels you actually have together on paper in less space will make the print sharper.

Most image-editing programs have an option to let you print the image at full-page size or at the image's normal size. If you choose normal size, the image will print smaller than full page and probably look just fine. It's only when you force the image to print at a certain size that the image's original resolution becomes important.

FIGURE 17-5 When bad things happen to good pictures: this sort of thing happens when you try to print a low-resolution image too large.

Understand dpi

Some image editors and print programs use dpi instead of, or in addition to, pixels. And I've found that a lot of people are flambuzzled when it comes to understanding the relationship among resolution, dpi, print size, and pixels. What is a dialog box really telling you when it says an image is 4×6 inches, 72dpi?

Only Pixels Matter

The important thing to understand is that measurements like "4×6 inches" and "72dpi" are meaningless while the image is still on a PC. A computer deals only in pixels. An image can be 640×480, 1280×1024, or 2240×1680 pixels, for instance. And the "size" of the image on a computer screen depends on two things: the screen size of the Windows desktop and the zoom factor of the application displaying the image. If you show a 640×480 pixel image on a Windows desktop that's only 640×480 itself, the image takes up the whole screen. If you show it on a PC that's using a 1280×1024 pixel screen, then the image will be tiny, because the screen can show more pixels when set to that display mode.

So repeat after me—and this is really important—*there's no such thing as a 72dpi digital photo.* Even if a program appears to be telling you that a picture is 72 or 144 or 300dpi, it's simply not true. Likewise, if someone asks you for a 300dpi digital image, that alone is not enough information to give them what they're asking for. They really need to tell you either how many pixels they want (such as 2000×3000 pixels) or dpi at a particular print size (as in 300dpi at 8×10 inches, which a little math would tell you is a 2400×3000-pixel image). Dpi has meaning only when you take a picture that has a certain number of pixels and you then print it on paper at a certain size.

Your View May Vary

So far, so good? It's important to point out that "zoom" can also be a factor when you view photos on screen. Some image programs automatically fit images to the screen, shrinking them as necessary. Other (usually older) programs try to display the image at full size, which can result in images that you have to pan around to see properly because they're larger, pixel for pixel, than the computer screen itself. Consider the photo in Figure 17-6. On the left, see how Windows Vista's Photo Gallery automatically sizes the photo to fit in the window. You can use the program's zoom control to zoom in and inspect small details of the photo at your leisure, and a single click takes you back to the whole image. But that same photo, seen in Windows Mail (called Outlook Express in Windows XP), makes no attempt to show the whole image in a window. It shows the photo at full size, so you need to scroll around to see it all.

The bottom line: when still in the virtual world of a computer, the only image size that has any real meaning is the number of pixels used to create it.

Dpi and the Printed Page

Only when you're getting ready to print a picture does a size like "4×6 inches" have any meaning. If you assume there's a one-for-one relationship between a pixel and a printed dot, then the size the image prints at is determined by dividing the number of pixels in the image by the dpi rating you hope to print with.

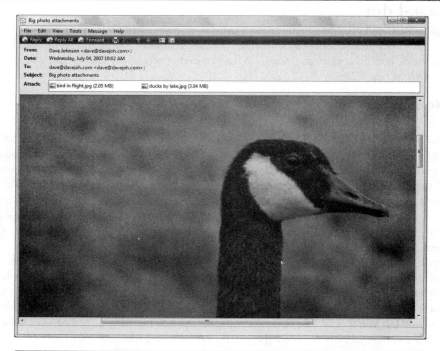

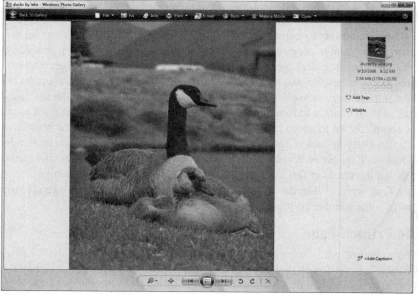

FIGURE 17-6 How a program displays a photo is not an indication of the image's pixel resolution.

Consider the same 2240×1680-pixel image. It can make a:

- **7.5×5.5 inch print** when set to 300dpi (good for a color laser printer)
- **15×11 inch print** at 150dpi (which might look okay coming from an inkjet)
- **31×23 inch print** when set to 72dpi (on a computer screen), if displayed at full size

Remember, dpi and print size is just a way to measure how large you can print a digital image—the numbers that really tell you the true size of the image are the number of pixels.

Work with Paper

Here's a common scenario: you see great, photo-realistic prints in a computer store and think, "That's the printer for me. It's only $150 and it makes outstanding pictures!" So you buy the printer and bring it home. But when you get the printer set up and send your first few images to it, you're devastated. The output is horrible. The prints look flat and lifeless. The paper curls. What went wrong?

It's the paper. What you failed to consider is the choice of paper is so important to the quality of your prints that it's essentially *more important than the printer itself*! A handful of printers on the market can generate photo-realistic prints. But, unless you use quality paper, they will all disappoint you.

Which Paper Is Best?

Unfortunately, choosing paper isn't easy, even if you know you want to get the best. There are a lot of choices, and it isn't generally clear which kind is best based on the name or description on the package. This is especially true for inkjet printers. I honestly don't know why paper manufacturers make this so hard; it seems counterproductive to sales.

As a general rule, you'll find store shelves stocked with paper divided into four quality levels: inkjet paper, high-quality inkjet paper, photo quality paper, and glossy photo paper.

Paper for Laser Printers

If you have a laser printer, you might be wondering what kind of paper is appropriate for that printer as well. I suggest you use ordinary 20-pound laser or copier paper. Decent laser paper shouldn't cost more than about $7 per 500 sheets (a ream). I'd be reluctant to buy really inexpensive paper ($3/ream or less) because loose paper fibers in budget-priced paper can, over time, clog your printer, affecting its performance and, eventually, even damaging it.

So where do you start? Let's begin with daily use that doesn't involve printing photos—I suggest you use either plain paper or inkjet paper. Even when printing on plain paper, use quality stock because cheap paper can plug the nozzles and decrease the effective resolution of the printer. For general-purpose printing, you can use the same stock I recommend for laser printers. Of course, I'm assuming the majority of what you print is test prints, text, and other routine output. If every print you make is destined for the Louvre, then you might want to skip directly to the section where I talk about photo paper.

When you're ready to step up to some higher-quality printing, you have a number of choices on store shelves (see Figure 17-7). Here's a general overview of the various grades available.

- **Plain paper** As I've already mentioned, this is good for general text and ordinary graphics printing. The paper is inexpensive, but the ink tends to absorb quickly into the paper and blur the image. The paper also curls and distorts.

- **Inkjet paper (and high-quality inkjet paper)** This is a step up and embeds clay or some other ink fixture into the paper to stop the inks from spreading before they dry. For most printing, you won't notice a big difference, but this paper makes for better draft-quality photographic prints.

FIGURE 17-7 With so many choices on store shelves, it pays to experiment with a few to find the paper that delivers the best output with your printer.

- **Photo paper** A variation of coated paper, photo paper is generally bright-white coated paper that's designed explicitly for photographs. If you're looking for paper in an intermediate price range that can give decent results, try this stuff.

- **Glossy photo paper** The best paper around, this stuff is expensive, generally costing about a dollar a sheet. Certainly you won't use it all the time, but if you plan to frame a picture or give your digital "prints" away to family or friends, definitely use the special photo paper. Note, you can only print on one side of photo paper; the back side looks like the back of a photograph and generally has a logo printed there. I don't recommend printing on the back of glossy paper, even on a laser printer.

Did you know?

Other Specialty Papers

In addition to ordinary plain, coated, and photo paper, printer manufacturers and paper vendors sell a variety of other specialty papers. You might want to investigate these papers because they can be a lot of fun and enable you to do all sorts of things with your printer that you never imagined possible:

- **Greeting card paper** Greeting card paper and matching envelopes let you make your own greeting cards with your printer and some greeting card software.

■ **Transparency paper** This clear film media is perfect for printing color overhead slides for business meetings. You can use this to print PowerPoint slides or any other kind of image or document.

■ **T-shirt transfer paper** This special paper is an iron-on transfer that you can run through your printer and then apply to clothing. When you print on T-shirt paper, be sure to use special T-shirt transfer software, or just reverse your image before you print using your favorite photo-editing software. (Create a mirror image of what you want it to look like.)

■ **Fabric sheets** This unique kind of printing media is fabric that gives your prints texture. You can print on it just for its own sake or use the print to make cross-stitch designs and other craft projects.

Which Brand?

What brand of paper should you use? Should you use Epson in an Epson printer and Canon paper in a Canon printer, or should you buy paper from a company like Ilford—known in 35mm photography circles for their excellent paper—instead? This is a good question. Obviously, each printer company wants you to use its own brand of paper with its printer.

In truth, vendors like Canon, Epson, and HP go to great lengths to fine-tune their paper to match their inks so colors won't bleed and they'll be as vivid as possible. My own Epson Stylus Photo 1270 does best with Epson's Premium Glossy Photo Paper, and I tend to use that paper almost exclusively. When I first got the printer, I tried a dozen different kinds of papers, including paper from companies like Ilford and Tetenal, which came highly recommended by computer and photography store salespeople. After being disappointed with all those other brands, I tried Epson's own Premium Glossy paper, and was blown away—the results were dramatically better. I've had similar experiences with other printers, though I have to admit they weren't as dramatic as with the Epson printer, which was clearly engineered with specialty paper in mind.

So what should you do? If you have a few dollars to spare, buy a bunch of different paper packages and try them. Print the same image on different kinds of paper and lay them out, side-by-side, in good light. Determine which one is best, and then stick with that brand of paper.

Unfortunately, once you decide to buy Epson paper for your Epson printer or HP paper for your HP printer, you still have a lot of decisions ahead. The paper section at the local office supply store is fraught with seemingly similar choices.

Epson offers the broadest—and possibly the most confusing—selection of papers, with names like DURABrite, Premium Glossy, Photo Quality Glossy, and ColorLife. But I can make it simple for you. As a general rule, Epson's best paper—for pictures you plan to frame or share, for instance—is Premium Glossy Photo Paper. For less formal photo printing, Epson also sells a less-expensive All Purpose Glossy Paper.

But you'll get the best results when you match the paper to the kind of ink you are using. Epson's Premium Glossy Photo Paper is the right choice for most Epson printers, but if your printer uses DURABrite ink, then use the DURABrite Ink Glossy Photo Paper instead.

HP's Premium Plus is the top of the line photo paper for HP printers, but for routine photo printing, you might be more inclined to print on HP Premium paper (which, HP claims, is slightly better than the kind of paper used by your local photo lab).

Canon has made their paper even easier to choose. Just look for the colored stripe that runs down the center of all their paper packages; papers with a gold stripe are premium blends intended for the highest quality prints, while bronze identifies the paper as an everyday variety.

How to ... Make a Print

Now that you have all the parts in place, it's time to print. I'll show you how to make a print of a specific size in Adobe Photoshop Elements; other programs use a similar method. Of course, if printing the picture at a very specific size (like 5×7 or 8×10) isn't important to you, just click the Print button and get it over with. But, if you want to print your image so it fits properly in a traditional picture frame, here's how. Specifically, let's say you're going to make a print at 8×10 inches. Do this:

1. Load the paper in your printer. Make sure you put it in with the appropriate side set for printing, and only load a single sheet at a time.

2. Open the picture you want to print in Photoshop Elements. The first thing you want to do is crop it to print at the right proportion. Click the Crop tool and then choose the print proportions (such as 8×10) from the Aspect Ration menu in the options bar. Drag it through the image, creating a crop of your image.

3. Finer tune your crop, if necessary, by positioning the crop box precisely on the screen and resize it by dragging one of the corners. Because the aspect ratio is locked, it'll keep the proper proportions for your 8×10-inch print. When you're happy with the final result, click the check box to complete the crop, and you'll get an image that's proportioned exactly right for an 8×10-inch print:

4. Now we're going to select the paper size and orientation. Choose File | Print from the main menu. You should see the Print dialog box. Because it gives us more flexibility with print options, click Print Multiple Photos.

5. If you have more than one printer installed, choose the printer you want to use. Then click the Printer button to open your printer's preferences and find the paper size selector. Choose Letter or 8.5×11, if it isn't already selected. While you're there, select the appropriate type of paper, such as inkjet paper or photo glossy. Click OK to close the printer dialog box.

NOTE *If you don't tell the print driver about the kind of paper you're printing with (like Premium, Photo, or Plain paper), the results will invariably be disappointing.*

6. In the Select Print Size and Options menu, choose 8"×10".

7. Click Print.

8. When the paper comes out of the printer, leave it there to dry for several minutes. Don't handle it until you're sure it's dry. Otherwise, you could smudge it.

Which Side Is the Right Side?

Often, it matters which side of the page you print on. Plain-old laser paper is the same on both sides, so if you print on a laser printer or you use plain paper in an inkjet, it doesn't matter. But if you print on specialty paper in an inkjet printer, make sure you load the paper the right way. Keep these tips in mind:

- Usually, the brighter or shinier side of the paper is the printing side. Occasionally, it's rough, like sandpaper.

- If you're printing on photo paper, the back will probably have a company logo on it.

- Many paper types label the paper with small marks to indicate the proper print side.

Be sure you look carefully at the print directions the first time you try a new paper. Ink won't adhere well—or at all—to the wrong side of specialty papers, and you could end up with a real mess in and around your printer if the ink runs everywhere.

Can you print on both sides of the paper? I get that question a lot. And the answer is this: it depends. Don't ever try to print on the back of glossy premium paper, but you can usually print on both sides of inkjet and high-quality inkjet paper without any trouble. If I'm printing a newsletter or a greeting card, I might print the pictures on one side and use a laser printer to add text to the back. You can also find paper that's intended for double-sided printing. Check the paper aisle of your computer or office store to see what's available.

Care for Your Prints

All picture colors tend to fade over time, but inkjet photos tend to fade somewhat faster. In fact, inkjet inks are sensitive to ultraviolet light, and your images will fade faster if exposed to direct sunlight for extended periods. If you plan to frame pictures and leave them exposed to sunlight, consider using UV-shielded glass, available at some framing shops.

TIP *Keep original image files on your hard disk or archived on CD or DVD, so you can reprint them when the fading becomes noticeable.*

Some newer printers are marketed specifically as models that create prints with more *lightfastness* than older printers. You can probably guess that *lightfastness* is a print's capability to resist fading when exposed to light. In particular, a number of Epson models offer a lightfastness of 10 or more years—check out this chart of Epson photo papers, for instance:

Epson Photo Paper	6 years
Epson Premium Glossy Photo Paper	10 years
Epson Matter Paper Heavyweight Paper	25 years
Epson ColorLife Photo Paper	27 years

In addition, you can find some inkjet printers designed to offer extremely long resistance to fading, such as pigment-based inkjet printers, like the Epson Stylus Photo 2200. Intended for serious photo enthusiasts and professionals, pigment-based inkjet printers are a bit more expensive than dye-based inkjets, but they can deliver a print life of over 100 years. By comparison, 35mm prints tend to be lightfast for only about 50 years; so newer printers can create prints that last longer than traditional prints.

No matter what kind of printer, ink, or paper you use, you should protect your prints from fading from the moment you print them. Here are a few precautions you can take:

■ Cover the print with glass or plastic as soon as it's completely dry (wait 12–24 hours after the print is complete). Contaminants in the air can fade a print quickly, but if you put it under glass or in a photo album, the print is no longer in direct contact with air and, thus, is protected. Some ink and paper combinations can cause a print to fade dramatically in a matter of days if left exposed to the open air.

■ Keep the print out of direct sunlight, even when under glass. Hang the print where the sun doesn't shine directly on the wall. You can also use special glass that's treated to block UV rays, which will help extend the life of your print.

■ Avoid handling the print in such a way that you touch the ink with your fingers.

If you've spent much time in the world of 35mm photography, you might also be familiar with acrylic UV-blocking sprays that you can apply to prints. These sprays "fix" the print and give it a longer life before fading, especially when the print will be framed and hung where it could be exposed to direct sunlight. Can you—or should you—use these sprays on digital images?

Well, that depends. I'd avoid using a photo-fix product designed especially for traditional film-based prints. I've tried it, and it seems to work, but I've neither been able to test a wide variety of ink and paper combinations nor have my tests observed the prints for a long period of time. Indeed, I asked several printer companies what their opinions are of these sprays and, for the most part, they were all a bit wary. Epson, for instance, said this: "We recommend avoiding UV sprays since the effect on lightfastness of one color ink could be different than another ink, and may actually lead to the visual acceleration of fading or color shifting." On the other hand, a few companies make a special spray just for inkjet printers, and I think these "inkjet fix" sprays are a lot safer for your digital prints.

Calibrate Your Monitor

A lot of people run into a problem with their printers that can be summarized thusly: "I just printed a photo on good quality paper, and it doesn't match what's on the monitor."

This common problem stems from the fact that the two output devices—the printer and monitor—are calibrated differently. If you want what's on the screen when you edit a photo to exactly resemble what comes out of the printer, then you need to correct one or the other so they're in agreement. It's easier to adjust the output of the monitor (printers don't come with any sort of calibration tools), so that's what most people commonly do.

If you don't mind spending money, a few solutions are available that are designed to help you calibrate your monitor. OptiCAL, from Pantone (www.pantone.com), is a popular program—but, priced around $200, it's probably too rich for you unless you happen to be a true graphics professional. A lot of folks like ColorBlind Prove IT (www.color.com), which works with a sensor (called a spider), that clips onto the front of your monitor to help calibrate it. Priced around $300 with the sensor, ColorBlind is also a bit pricey—but it's a good deal if you want the most accurate results for the least effort. Finally, Colorific (www.colorific.com) offers an affordable color-matching and monitor calibration system. It's priced at a reasonable $50, but the truth is it's possible to calibrate your monitor manually, without buying any software at all. It does take a good eye and some judgment, though.

Set Your Display Properties

If you're ready to optimize your monitor, the best place to start is with the Windows Display Properties. You can do a few things here to render images on screen more accurately and to improve the overall look of your display at the same time.

If you use Windows Vista, right-click a blank portion of the desktop and choose Personalize. Next, click Display properties. (If you use Windows XP, right-click the desktop and choose Properties from the drop-down menu.)

You should now see the Display Settings dialog box. The most important thing to check is the screen resolution. If you have an LCD display (flat-screen monitor), then the resolution should match the native resolution of the monitor. If you need to, check your monitor's user guide for a recommended value. For other kinds of monitors, if the resolution is too low, you won't see as much on screen, and digital images won't look as sharp. Experiment by increasing the resolution and clicking the Apply button. Keep the resolution comfortable; if the text and icons get too small for your taste, revert to a lower resolution. Personally, I think 1024×768 is a good value for a 17-inch display, and try 1280×1024 if you have a 19-inch monitor. A 24-inch widescreen monitor, like the one in the following illustration, probably has a native resolution of about 1900×1200 and will only look sharp and clear with that setting.

Widescreen monitors, which have 16:9 or 16:10 aspect ratios, are quite popular these days. Be sure to use the right display resolution for yours. Because the screen is wider than a normal monitor, you can't use the same resolution that you relied on with your old screen, which had a 4:3 aspect ratio, or all your photos will look stretched and "fat." For best results, check the user guide for the monitor's native resolution.

TIP

One other thing to check: the color quality. If it's set too low, then images will look dramatically different on screen than they do when printed. Be sure to choose either 24-bit or 32-bit from the Color menu and click the OK button for the changes to take effect.

Print a Test Photo

The most important tweak you can make is to match the monitor's settings to a real print from your inkjet printer. So load a picture you like—choose a daylight photo that includes a person with natural skin tones—into your image editor and print it at highest quality on to a sheet of good, glossy photo paper. Let the picture dry out of direct sunlight for a few hours to let the colors set permanently.

Now you're ready to get to work. Make sure your monitor is set up the way you usually use it, with the same level of ambient light as you typically have when editing photos. Eliminate any harsh glare by closing window shades or angling the monitor.

Next, set the monitor's contrast and brightness levels to their halfway point. Most monitors have buttons or dials on the front of the case; you might need to experiment or check your monitor's user guide. Now open the image file on the monitor and set the picture you printed right next to the monitor, so you can look from one image to the other. From here, it's just a matter of adjusting the brightness, contrast, and color levels until the printed and onscreen images agree with each other.

Unfortunately, there's no magic bullet for monitor calibration. It takes a good eye to tweak the red, green, blue, brightness, and contrast levels to match a test image, like the one we just made. But tons of useful web sites are out there that can lend a hand with fine-tuning your monitor. If you want to read more, check out one of these web sites that offer monitor calibration tutorials:

- www.bryce-alive.net/calibrate/
- www.epaperpress.com/monitorcal

Let Someone Else Do the Printing for You

Let's be honest: most of this chapter was about making prints on your own. And there was a time when the only way to get prints from your digital camera was to set up an inkjet printer, pick the right paper and toner, make your own prints and wait while they dry, and resupply the paper and toner when you were finished. This process can be time consuming, though, and these days, I'd be remiss not to mention another alternative: upload your photos to an online photo service, or take your memory card to a local photo printer.

You can experience good and bad results from any photo printer in town or on the Web, so it pays to spend a few dollars and have some sites make some test prints for you. Some of the most common online printing services include:

■ Shutterfly (www.shutterfly.com)

■ Snapfish (www.snapfish.com)

■ PBase (www.pbase.com)

■ SmugMug (www.smugmug.com)

In general, most photo printing sites work the same way. You upload a batch of photos and store them in an online photo album, then select the pictures you want to print. After clicking through a short ordering process, the prints are made much like traditional 35mm prints and then mailed to your home. They are very affordable—usually just a few cents per print—and you can make enlargements and photo gifts using the same service.

Did you know?

The Difference Between Home and Professional Printing

So, you can make your own prints from home or order prints from professional photofinishers. Which is better? Which should you do? For the most part, it all comes down to the actual printing method.

Professional photofinishers use a process called continuous tone printing, while inkjet printers at home use halftone printing. *Continuous tone printing* gets its name from the fact that the pigments used to make the picture work like the grains on film—they can exhibit gradual color change without any abrupt transitions because the printer can generate any desired color for each dot. It's the best and most realistic way to print a picture.

Inkjet printers can't create continuous tones; instead, they lay down dots of distinct color. And, as you may remember from school, when you place two colors right next to each other and step back, the human eye perceives a third color, rather than the primary colors. That's the essence of *halftone printing* at home: lots of little color dots creating rainbow effect.

While halftone printing can look great—just check out the sample prints in the printer section of an electronics store to see for yourself—professional prints will usually look better because continuous tone printing can generate sharper images from the same number of pixels.

Technology aside, online printing has a few other advantages. You don't have to mess with ink, paper, and configuring your printer. If you want to do red eye correction and cropping, you can usually do that right from the web page before you order the prints. And you can order multiple prints and have them mailed directly to any number of different recipients, so you can send pictures to everyone in your family with very little effort.

Order Prints Online

Suppose you want to try out this brave new world of online photo printing. Let's visit Shutterfly and order a few pictures by following these steps:

1. If the pictures you want to print aren't already stored on Shutterfly, begin by adding them. Click the Add Pictures tab at the top of the page. Choose whether to add the pictures to an existing album already on Shutterfly or to create a new one. Then click Next.

2. It's time to add the pictures to Shutterfly from your computer. You can either drag file icons from Windows directly onto the drag-and-drop area of the web page or click Choose Pictures and pick them from the dialog. After you select some pictures, they'll upload automatically. Bigger image files will take longer to complete. When they're done, click View Pictures.

3. Click a picture in your album and you'll see it appear in the View & Enhance tab. Note that the Prints Best Up To information under the picture suggests a maximum print size based on the resolution of the image.

4. If you want to make any changes to the picture before it prints, now is the time. You can use the tools right on the Shutterfly web site to remove red eye, crop, and otherwise modify your picture.

5. Click Order Prints. On the next page, you can select how many and what size to print. The default quantity and size in each order is one 4×6 print. Also located at the top of this page is an option to select which type of paper finish you would like: matte or glossy. By default, the filename of each picture will be printed on the back of each print. You can, instead, choose to type in your own custom text up to 80 characters. When the order is set up the way you want it, click Next.

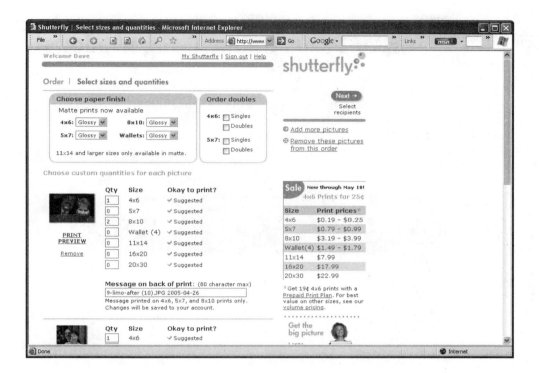

TIP *If you are planning to make three copies of a single picture and you want to send one of each to three different people, only specify one print on this page. When you select the recipients on the next page, each will get one print. If you select two prints on this page, each recipient will get two copies.*

6. Select the recipients for your prints. It's easy to send prints to as many people as you want. On the Select Recipients page, simply check the boxes next to the names of the people you want to send prints to. You can customize each recipient's order on the next page. To add someone new to the list, click the Add New Address button.

7. Once you finish selecting recipients and have reviewed your order, click the Next button to select payment options. Review your billing info (and edit it, if necessary), enter a gift certificate code if you have one, then choose a payment method (credit card or check), and click Place My Order Now.

A confirmation and thank you appears, letting you know your order has been placed. An order number and further instructions are provided (for instance, instructions on how to cancel your order within the first hour of placing it, or instructions on sending a check for payment). Your prints will arrive in a few days.

How to ... Order Prints Online Using Windows

You can visit a specific photo printing site like Shutterfly, or you can let Windows do the legwork for you: Windows Photo Gallery has an online photo ordering tool built right in.

Just open Windows Photo Gallery and choose one or more photos to print. Then click Print | Order Prints. You'll see the Order Prints dialog box.

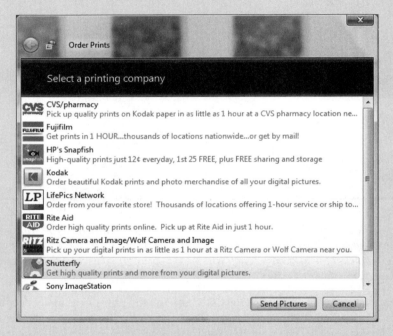

From here, all you need to do is choose a photo printing service, like Shutterfly, Snapfish, Walgreens, or any other store listed in the menu. Then you fill in your order information, provide a credit card, and sip some lemonade while you wait for the photos to arrive in the mail.

Chapter 18

Share Your Pictures

How to . . .

- Send and receive images via e-mail
- Choose the right file format for e-mailing pictures
- Compress images for e-mail and disk
- Prepare images for display on the Web
- Share photos on the Web
- Display images on a digital picture frame
- Sell your photos online

Taking pictures is one thing; sharing them with friends, family, and coworkers is something else entirely. Of course, this is one area where your digital camera has a leg up on film cameras. To share traditional prints with someone, you need to physically give them a copy. That means visiting the photo finisher and having duplicates made. Or, you could scan the images and distribute them electronically.

Digital camera images are electronic to begin with, though, and that makes everything a whole lot easier. Want to share your images? E-mail them. Or, you can post them to the Web or show them off with a digital picture frame or even try to sell them on a stock photography web site. In this last chapter of *How to Do Everything: Digital Camera,* I'll show you how to easily make your images available to other people.

Send Images via E-mail

E-mail is perhaps the most common way to share digital images with people who live far apart. Not only is e-mail good for casually lending images to friends and family, it's also the medium of choice for professionals. For example, when I create images for print in newspapers, magazines, and books, I typically send the files via e-mail unless they're so large that e-mail is impractical.

So how do you do it? Sending pictures within e-mail is simply a matter of including one or more images as attachments in your mail message. *Attachments* are binary files—as opposed to plain text—that your mail program can deliver to another person's mail system.

Most of the time, attachments work just fine. Occasionally, though, you'll run into problems sending images as attachments. That's because the original Internet wasn't designed to accommodate the sending of binary files like pictures via e-mail, and encoding schemes were "tacked on" after the fact.

Beware of Large Files

Many e-mail systems can't deal with a single e-mail file that's bigger than about 2MB—a few older e-mail systems even have a 1MB limit. On the other hand, some broadband users (like cable modem and DSL) can receive files as large as 10MB without trouble. The moral is that

it isn't always easy to know how large attachments can be with any given e-mail system, and, if you send a very large file to someone, it can get "stuck" in their mail server, clogging up messages that are trying to come in afterward. Alternately, it can arrive in your recipient's e-mail account as a couple of huge messages filled with gibberish text. Bottom line: It's a good idea to check the file size of your attachments (see Figure 18-1) before sending them. To be sure that they'll be small enough (in megabytes), I recommend resizing copies of images that you plan to send down to around 800×600 pixels.

NOTE *When you attach a digital image to an e-mail message, the attachment usually ends up about 10 percent larger than the original image because of the encoding necessary to send it across the Internet.*

Shrink Images for E-mail

Having a lot of resolution in a photo is a good thing for printing, cropping, or zooming in to see a lot of detail, but many-megapixel digital images are sometimes difficult to send through e-mail. Consequently, you should send smaller versions of your pictures.

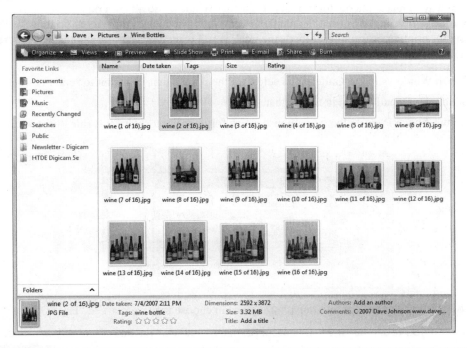

FIGURE 18-1 This 3.32MB file is, for many folks, simply too large to e-mail effectively. Resize it so it's under a megabyte before you e-mail it.

In general, I'd recommend that e-mail-bound images should be cropped and/or resized down to 800×600-pixels (or so) and saved in JPG format. If you remember to do that, you should never get any complaints from friends or family that your images are too big and are clogging their e-mail systems.

There are several ways to do that:

- You can resize a copy of your photo in your favorite image-editing program (see Chapter 13 for details).

- You can use the photo resizing tool built into Windows. This is the method I recommend, since it's easiest.

- You can get a specialized program for cropping and resizing images.

NOTE *Remember that e-mail systems don't really care about the size of any particular picture; they only care about the total size of all the attachments in an e-mail message. So even if you resize your photos, your e-mail can still run into trouble if you attach 50 of them.*

Let Windows Resize Your Photos for E-mail

The easiest way to resize photos for e-mail is to just let Windows do all the grunt work for you. The downside to this method is that the recipient gets small versions of the photos, so they won't be suitable for printing or framing. If that's the goal, you'll want to share your photos in a different way. But if you don't mind sharing a "shrunk" version of your photos, here's what to do:

1. Open Windows Photo Gallery and select all the photos that you want to send in e-mail.

2. Click the E-mail button in the toolbar.

3. In the Attach Files dialog box, choose a size for your photos. Use this rule of thumb:

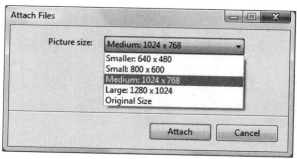

a. If you're only sending one photo, you can choose the size marked "large."

b. If you're sending a small handful of images, choose "medium."

c. If you are sending a lot of photos in the same e-mail message, choose "small" or "smaller."

4. Click Attach.

5. The photos will be resized and automatically attached to an e-mail message for you.

Of course, your original photos are unaffected—Windows only resizes the copies of the photos that are being sent in e-mail.

Use a Specialized Resizing Program

If you don't mind spending a few dollars, you can get a specialized program for cropping and resizing images as well. A Smaller Image, from TriVista (www.trivista.com), for example, is a great little program for prepping your photos for e-mail.

This simple $15 program is designed from the ground up to crop and resize photos. After you drag an image into the application window, you can move a cropping frame around the screen until you've composed the picture just the way you want. The cool part is this: you can configure the cropping frame's proportion based on how large you want the resulting photo, so there's absolutely no guesswork. Set the end photo size to 640×480, for instance, and the cropping frame is proportioned exactly right for the job. You can also scale the cropping frame to include more or less of the original image in the new, resized photo. It's all very clever and makes you wonder why no one ever thought of that before.

A Smaller Image also includes sharpness, brightness, and contrast controls, an optional graphic border for your images, and a simple text tool for adding captions. If you frequently resize photos for e-mail, the Web, or printing, A Smaller Image is a handy tool.

How to ... View and Save Photos Someone Sent to You

Not all e-mail programs are great for viewing photos. Outlook, for example, isn't bad; to see a photo attached to an e-mail, you can double-click the attachment icon to open the photo in Windows Photo Gallery, or you can click the Preview button to see a small version of the image in Outlook itself.

But some programs are terrible. Windows Mail (and, if you have Windows XP, Outlook Express), for example, shows the photo at "full size" and makes no effort to fit the photo to the screen. So if someone sends you a 6-megapixel image, you need to scroll around to see the photo a little bit at a time. Ugh—what were they thinking?

The easiest way to deal with that is to save your photo attachments to the Pictures folder, where you can browse and view them the way they were meant to be seen. In Windows Mail, click the attachment icon (which looks like a paperclip) and then click Save Attachments.

Share Photos using SneakerNet

SneakerNet is an old geeky term meaning "put it on a disk, walk over to another person, and hand it to them." And because JPG images are so small, you can copy a bunch of images to a storage medium like a floppy disk and pass them around that way. After all, everyone has a floppy disk drive, right?

The New Floppy Disk: CD-R and USB Keys

Well, not quite. A few years ago, floppy disks were ubiquitous. But these days, many new computers don't even come with floppy drives at all. In a few years, little kids will have no more idea what a floppy disk is than a phonograph needle or a phone booth.

The heir to the floppy throne? There isn't just one. Recordable CDs and DVDs are popular, but so are USB memory devices—sometimes called USB keys, key drives, or thumb drives. You can use either of these to copy and share massive numbers of photos via good ol' SneakerNet.

Getting photos onto a USB memory key is a snap. Just insert one into your computer's USB port and wait for the AutoPlay window to appear, then choose Open Folder to View Files.

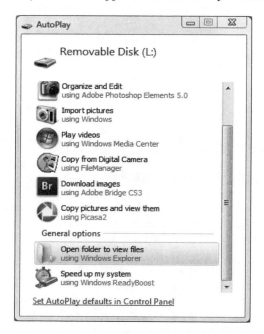

Then drag any photos you want to share from your Pictures folder (or wherever you've stored them) to the open USB memory key folder window.

Sharing files via CD or DVD is almost as easy. CDs hold 650MB of data each, while DVDs store a whopping 4.7GB each. That's a lot of room for photos. Windows XP has CD burning built in, but if you have Windows Vista, you can burn CDs or DVDs. Here's how:

1. Insert a recordable disc into your computer's recordable CD or DVD drive.

2. In the AutoPlay dialog box, click Burn Files to Disc Using Windows.

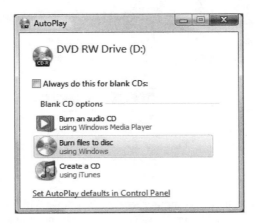

3. In the Burn a Disc dialog box, click Next.

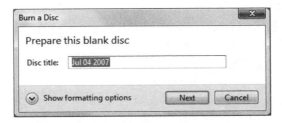

4. Wait while the disc is formatted. When it's done, you'll see an empty disc folder.

5. Open the folder that contains the photos you want to share, and then drag the selected images into the empty disc folder. As you drag files into the disc folder, they are copied automatically to the disc.

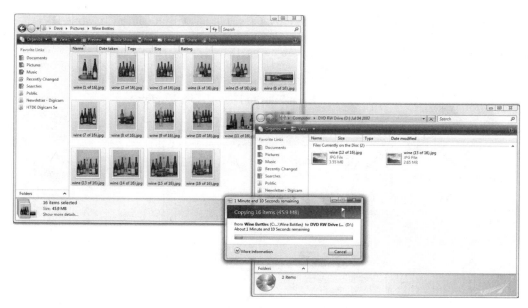

6. Click the Eject button on your computer's drive. Windows will close the current session, which makes the disc readable on other Windows Vista and Windows XP computers.

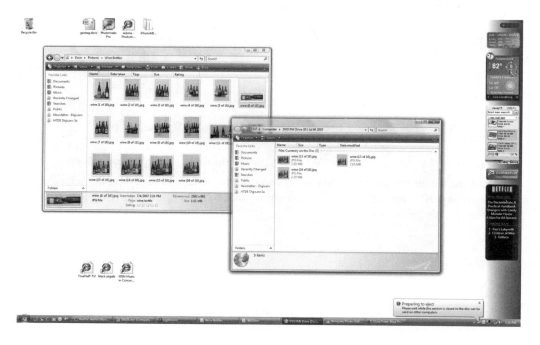

Strategies for Sharing Lots of Images

If you need to send someone a lot of images and you want to minimize the total file size, you have a few ways to get the data to the recipient. Often, you'll need to combine these techniques. Here are some things you can try:

- Use file compression to make your photos take up less disk space. Just select your pictures, right-click, and choose Send To | Compressed (zipped) Folder. If you're trying to share TIF photos, this can save a lot of space, but compressing JPG images probably won't change much (since JPG files are already heavily compressed to begin with).

- If you have a lot of photos, break your image collection into several e-mail messages, with each message weighing in at less than 1 or 2MB.

- If you don't care a lot about image quality, use the compression feature in the JPG format to reduce file size. With many images, you can compress the image significantly before you start to see any obvious degradation because of compression. This is great if you're just passing images around among friends, though I'd be more careful about images you're planning to print. And I'd only do this to copies of your photos, so you don't permanently degrade the originals.

- Instead of e-mail, mail a CD or a DVD. Because a CD disk holds 650MB of data and a DVD stores 4.7GB, you have an awful lot of room to work with. It's certainly more efficient than using the Internet.

Share Photos on the Web

Certainly, you can design a web site that shows off your pictures to friends and family, and there are quite a few tools around to help you do just that. If you aren't thrilled by the idea of learning your way around a web design program, though, there's an easier solution—one that requires no programming, no eye for page design, and no particular Internet skills. The solution? A photo-sharing web site.

These sites take the arcane drudgery out of designing web sites from scratch and posting photos to the Internet by enabling you to upload images to an existing web site via a simple interface. The site itself arranges your images into an attractive layout, complete with thumbnail views (which you can click to see a full-sized version of the image), captions, and often even printing services that can print your favorite images and mail the hard copy directly to you. These sites are a convenient way to publish your images online for friends, family, and strangers to browse, and you needn't learn anything about web site creation.

There are a lot of photo-sharing sites to choose from. Here is a list of some of the most popular ones that you can choose from:

Site	Storage	Special Features
AOL Pictures pictures.aol.com	Free for unlimited	
dot photo pro www.dotphotopro.com	Free for unlimited	Designed for professionals selling photos online
Fotki www.fotki.com	10MB free $50/year for unlimited	Emphasis on community features
Flickr www.flickr.com	100MB uploads per month free $25/month for unlimited	The gold standard for photo sharing (this is my favorite)
ImageStation www.imagestation.com	Free for unlimited storage	
Picasa picasa.google.com	Free for unlimited storage	Integrated text messaging, photo editor, and photoblogging tools
PBase www.pbase.com	$23/year for 500MB $60/year for 1500MB	
SmugMug www.smugmug.com	$40/year for unlimited	Excellent features for serious photographers include customizable themes, backup DVDs, and printing services

Upload Photos to a Sharing Site

Getting your photos online is pretty simple. To start with, pick a site. You can choose one of the sites I've listed in the preceding table, or you can go with another site I haven't mentioned. Even sites that charge a subscription fee usually have a free version or a trial period you can use to get your feet wet. Let's suppose you wanted to try Flickr. Here's what you need to do:

1. If you don't already have an account at Flickr, create one by clicking Sign Up. Don't worry—this is free.

2. After you have an account, log in and open your Flickr page. You can get there by going to flickr.com and then clicking the link marked You at the top of the page.

3. Click Upload Photos.

4. Click Browse, find the pictures on your computer, and then click Open. You can upload as many as six photos at once.

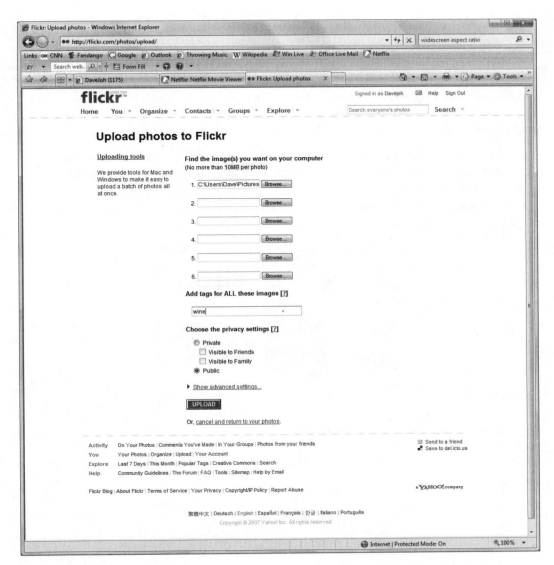

5. You can optionally assign tags to each of the pictures (if you want to associate more than one tag with a picture, put a space between each tag), and then click Upload.

That's the standard way to upload photos, but there's a far more convenient method available as well—install the Uploadr tool on your computer. Using this program, adding photos to your Flickr page is as easy as dragging and dropping files. To install Uploadr, open your Flickr page and then click the Tools link in the Help section at the bottom of the page. On the Tools page, click the link for your version of Windows and follow the instructions to install it.

TIP *Even if you maintain your own personal web site or blog, you can save yourself the time and trouble of arranging digital images on a photo page by linking from your own web site directly to your album on a photo-sharing site. That's what I do; to see it in action, go to www.davejoh.com and click the Dave's Photos link to see how I connect to Flickr.*

Once you've installed Flickr Uploadr and you're ready to upload pictures to Flickr, you don't even have to open your web browser. Instead, start Flickr Uploadr from the Start menu (it's now a program installed on your PC). Then do this:

1. You'll need to authorize the program the first time you use it—click Authorize, wait for your web browser to open your Flickr page, and then click Continue. After the first time, you'll never see this again.

2. Drag pictures from your Pictures folder or from Windows Photo Gallery into the Flickr Uploadr program window.

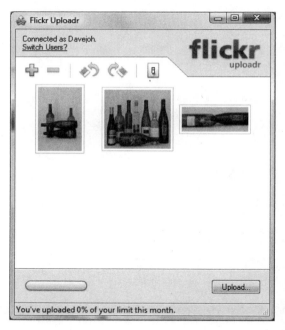

3. When you're done, click Upload.

4. You can optionally add tags to your photos and assign the images to a photo set on your Flickr page. When you're done, click Finish to upload them.

TIP *You can customize Flickr Uploadr by clicking Settings and then specifying how Flickr should resize your pictures. I recommend that you select Always Resize the Longest Side To and then choose an option like 1280 pixels. This way, Uploadr will not ask you to resize each and every picture you upload; it will do it for you automatically.*

Tag Your Photos Online

It seems like there's a human compulsion—driven perhaps at the genetic level—to share pictures we've taken. That's why photo-sharing sites are so popular. Whether the pictures are of your pet, European vacation, grandkids, or car, there's nothing quite as satisfying as showing them to someone else.

But once you upload your photos, how to make them easy to find? With tags. We first discussed tags way back in Chapter 12, and they're as useful on the Internet as they are on your own PC. Numerous web sites, such as Flickr, Fotki, SmugMug, AOL Pictures, and Picasa all support tags to find pictures by specific keywords.

Here's an example: Are you a fan of alt rock musician Kristin Hersh? Then visit Flickr and search for the tag "Kristin Hersh." You'll turn up (at the time I wrote this chapter) about 1000 photos of her. The cool thing is that these photos weren't all taken by the same person. Instead, a common tag has allowed many people to act as a collective to share their photos. And the tagging system at Flickr and other photo-sharing sites makes it possible to discover this sort of thing all the time.

FIGURE 18-2 Digital picture frames put an always-changing slide show of your digital images right on a tabletop.

Show Off Images in a Digital Picture Frame

Another way to display digital images is in a digital picture frame. Digital picture frames are LCD displays mounted in a picture frame. Equipped with a memory card or Internet access, a digital picture frame can show off your photos in a continuous slide show. Digital picture frames are readily available. There are many models available from companies like Philips, Kodak, Mustek, and Digital Spectrum.

These frames are post-modern versions of traditional picture frames, with the twist that they can cycle through dozens or hundreds of photos in an evening (see Figure 18-2). Many support standard memory card formats, like CompactFlash or SD, so loading them with photos is as easy as copying pictures from your computer to a memory card and then inserting the card in the picture frame. Other frames can pull photos from photo-sharing sites like Flickr or connect (via Wi-Fi or an Ethernet cable) to your computer and access the photos there.

Here is a handy chart showing some of the most popular digital picture frames:

Digital Picture Frames	Find It At
Digital Spectrum	www.dsicentral.com
Kodak	tinyurl.com/2soprw
Mustek	www.mustekdirect.com
Pacific Digital	www.pacificdigital.com
Philips	www.consumer.philips.com/photoframe

Show Pictures on TV

No one likes to admit it, but we all spend the best hours of our lives in the family room within a stone's throw of the television. So while the Web and framed enlargements are two good ways to show off your pictures, nothing beats watching them on the familiar old television. Heck, I can even think of a non-couch-potato reason to show your pictures on a TV: it's the biggest screen in the house, so everyone can see your photos without craning their necks.

Thankfully, showing your digital images on television is easy. Most digital cameras have video-out ports built right in that can directly display the contents of your camera's memory card on a TV screen. Don't lose the video cable that comes with your camera, though; one end is a standard RCA jack for connecting to the video-in port of a TV or VCR, but the other end is a specialized connector for your camera. It's expensive to replace and is only available from the camera manufacturer.

Your camera is designed to take any picture on your camera—even big 3 megapixel ones—and fit it on the TV screen. That's fine, but it can be slow because the camera has to read a lot of useless data from the memory card, pack it down to a smaller image size, and, finally, pump it to the TV. If you want to make a faster slide show, use your PC to convert the images to 640×480-pixel images, and then copy them back to a memory card. Insert the card in your camera, and you're ready to rock and roll.

TIP *You're not limited to showing pictures you took with the digital camera on the TV. Most cameras will output any image on the card to the television. This means you can convert PowerPoint slides, graphics, and other images to JPEG images, store them on a memory card, and display them on a TV. That makes your camera a portable general-purpose projector system.*

Sell Your Digital Photos for Fun and Profit

It seems that there's something glamorous about being a professional photographer. I'm guessing it all goes back to seeing Greg Brady help the high school football team win the big game with his daring sports photography in an episode of *The Brady Bunch*.

If you, too, have been seduced by the allure of getting paid for your photos, I have some good news for you: thanks to the Internet, it has never been easier to sell your work. In the old days, photographers had to negotiate with stock photo agencies and send negatives through the mail. These days, you can just upload your digital files to online agencies—and many of them are friendly to casual photographers who might not be experts at the stock photo sales game.

What Is Stock Photography?

That's a good question. Stock photography is the meat and potatoes of many working photographers—it's simply images of landscapes, buildings, landmarks, people, animals, and events that can be sold to and used by a wide variety of media outlets. Stock photos are routinely used in web sites, magazines, newspapers, corporate publications, and more. The same photo can

be sold over and over again, because the organizations that buy them don't get exclusive rights. So if you have a great photo of a windsurfer, you can theoretically sell it to a sports magazine, an inspirational poster company, and a web site. And the stock photo agency does all the work.

Online Stock Photo Agencies

Ready to try your hand at the world of photo sales? Why not? After all, all it takes is one or two sales and you can call yourself a "professional photographer"! And it doesn't take a lot of effort, either. Just sign up for an account at an online stock photo agency, upload some photos, and wait expectantly.

There are a number of stock photo agencies on the Web. Two of the best such agencies that I have found are istockphoto.com and shutterstock.com.

Both sites pay photographers for their sales, but these two sites have very different pay structures. Istockphoto.com, for example, offers royalty rates of 20 percent for most photos, on sales that range from a buck to $40, depending upon print size. Shutterstock, in contrast, pays $.25 per sale. That doesn't sound like much (and let's be honest: *it's not*), but Shutterstock boasts that at 2000 downloads per month, you can rack up $500/month. In real life, you'll probably see a fraction of that unless you have a lot of really great photos and can consistently upload new stuff to freshen up your portfolio. A friend of mine claims to have made $300 in the last three months, or about $100/month. Not bad, when you consider the fact that he doesn't think of himself as a professional photographer.

Keep in mind that selling photos for stock photography is not necessarily something that's easy to do, even if you are an all-around good, serious photographer. Stock agencies look for certain things in a photo that you might not be used to providing, like extremely low digital noise and razor sharp images. They also look for specific subjects and actively discourage photographers from uploading photos with common themes that they already have a million of (no sunflowers, please!). If your photos are rejected by stock agencies, don't take it personally. The stock photo business isn't for everyone.

What Is a Photo Really Worth?

You might be curious what the going rate for a photo actually is. Should you get $5, $50, or $500 for your work? Are you being ripped off with each quarter that rolls in? Well, the truth is that you're not going to get rich from selling your work online. But print publications often pay a bit better. If you ever get a note from a magazine or a corporate publication looking to use one of your photos, what's a reasonable amount of money to agree on? Believe it or not, my own 14-year-old daughter was recently contacted by the editor of a trade magazine in the energy industry. They wanted to use a photo she had taken of a lake that she had posted on her blog. Off we went to the Stock Photo Price Calculator: photographersindex.com/stockprice.htm

Here you can get ballpark numbers for various kinds of publications and photo sizes. If a local magazine offers you $100 to publish one of your photos, for example, I'd take it.

The Old-Fashioned Way

Finally, keep in mind that you can still sell your work the old-fashioned way. I know plenty of folks that print, matte, and frame a slew of their best photos and offer them for sale at craft and art shows in their local areas. If you're sufficiently motivated, this can be a really fun way to sell your work. You get to meet real people, chat with them about your photos, and get the satisfaction of physically handing them your work and knowing that it'll probably be hung in their home. Also, you're likely to make more on each individual sale than you would by selling through a web-based stock photo service. And it gets you outside in the fresh air. What could be better than that?

Index